POST-COLONIAL CULTURES
IN FRANCE

Using a diversity of critical and theoretical approaches from the disciplines of cultural studies, literary studies, migration studies, anthropology and history, *Post-Colonial Cultures in France* explores the cultural implications of international migration and globalization within post-colonial France. France today is the locus of a rapidly expanding range of cultural practices by artists of African, Caribbean and Asian origin. *Post-Colonial Cultures in France*, edited by Alec G. Hargreaves and Mark McKinney, breaks new ground by offering the first systematic survey of these developments. Concentrating on the former colonial center rather than on ex-colonial territories, this volume extends the field of post-colonial studies into France itself.

With contributions from a team of specialists, *Post-Colonial Cultures in France* covers a wide range of art forms including film, television, literature, popular music and the visual arts. The contributors show how minorities of recent immigrant origin are challenging the myth of France as a culturally distinct and homogeneous nation-state. These essays examine the interaction between minority artists, Third World cultures and the majority population in France. They show how increasingly global networks of communication and exchange are generating new affiliations and ethnicities in a complex struggle between neo-colonial and post-colonial forces.

Edited by **Alec G. Hargreaves**, Professor of French and Francophone Studies, Loughborough University, England, and **Mark McKinney**, Assistant Professor of French and Francophone Studies, Miami University, Ohio.

POST-COLONIAL CULTURES IN FRANCE

EDITED BY ALEC G. HARGREAVES AND
MARK McKINNEY

LONDON AND NEW YORK

First published 1997
by Routledge
11 New Fetter Lane, London EC4P 4EE

Simultaneously published in the USA and Canada
by Routledge
29 West 35th Street, New York, NY 10001

© 1997 in editorial and selection: Alec G. Hargreaves and Mark McKinney, in individual contribution:
the contributors

Typeset in Perpetua by Solidus (Bristol) Limited
Printed and bound in Great Britain by
Biddles Ltd, Guildford and King's Lynn

British Library Cataloging in Publication Data
A catalogue record for this book is available from the British Library

Library of Congress Cataloging in Publication Data
Post-colonial cultures in France / edited by Alec G. Hargreaves and Mark McKinney.
p. cm.
Includes bibliographical references and index.
1. France–Civilization–1945– –Foreign influences. 2. Popular culture–France–History–20th century.
3. Decolonization–Social aspects–France. 4. Minorities–France. 5. Multiculturalism–France.
6. France–Cultural policy.
I. Hargreaves, Alec G., 1948– . II. McKinney, Mark, 1961– .
DC33.7.P66 1997 97-7027
944.083–DC21 CIP

ISBN 0–415–14487–6
0–415–14488–4 (pbk)

à Valérie Dhalenne
for Patricia Hargreaves

CONTENTS

PLATES

Front cover (paperback only), clockwise from upper right:

- "Icône Famille El-Guettaa" (June 1991) by Mohammed El-Guettaa. This mixed-media sculpture was conceived prior to the use of gas cylinder bombs by terrorists in 1995: see below, p. 206, n. 5.
- Linda Lê
- Art installation in Bassens by Malik Ben Messaoud
- Cover of MC Solaar's single, *Bouge de là*

CONTRIBUTORS

David Blatt teaches in the Department of Political Science at Oklahoma State University. He received a PhD in Political Science from Cornell University in 1996 for a dissertation on "Immigrant Politics and Immigrant Collective Action in France, 1968–1993," and has published in the journal *Nationalism and Ethnic Studies*.

Steve Cannon is a Senior Lecturer in French at the University of Sunderland, UK. He has published on French cinema in *Nottingham French Studies* and *French Cultural Studies* and is currently working on hip-hop in France.

Richard L. Derderian teaches in the Department of History at the University of North Carolina at Chapel Hill where he completed his PhD in 1996. His research has centered on multiculturalism and second-generation North African artists in contemporary France. He has recent and forthcoming articles in *Contemporary French Civilization* and *Hommes et migrations*.

Driss El Yazami played a leading role in editing newspapers such as *Sans Frontières* and *Baraka*, and now runs the Paris-based organization Génériques, specializing in research and documentation relating to the history of immigrant minorities in France. He edits the organization's review, *Migrance*, and is coordinating a guide to public and private sources of information on the history of foreigners in France from 1880 to 1962, due for publication in 1997.

Alec G. Hargreaves is Professor of French and Francophone Studies at Loughborough University, UK. His recent publications include *Voices from the North African Immigrant Community in France: Immigration and Identity in Beur Fiction* (Oxford/New York: Berg, 1991; second, expanded edition 1997), *Immigration, "Race" and Ethnicity in Contemporary France* (London/New York: Routledge, 1995) and, co-edited with Jeremy Leaman, *Racism, Ethnicity and Politics in Contemporary Europe* (Aldershot, Hants./Brookfield, Vermont: Edward Elgar, 1995).

Nicki Hitchcott is Lecturer in French at the University of Nottingham, UK. She

completed her PhD on African Women's Writing in French at University College London in 1994. Her most recent publication is *African Francophone Writing: A Critical Introduction* (Oxford/New York: Berg, 1996), co-edited with Laïla Ibnlfassi.

Dalila Mahdjoub is a freelance artist based in Marseilles. She has published her work in journals such as *Revue Sixtus* and *Revue de l'Observatoire*.

Mark McKinney is Assistant Professor of French and Francophone Studies at Miami University, Oxford, Ohio. He completed his PhD on Maghrebi-French fiction at Cornell University in 1994. He has recent and forthcoming publications in *Sites: The Journal of Contemporary French Studies*, the *CELFAN Review* and *The Feminist Companion to French Literature* (Westport, CT: Greenwood Press, forthcoming).

David A. McMurray teaches in the Anthropology Department at Oregon State University, Corvallis, Oregon. His most recent publication is "Arab Noise and Ramadan Nights: Rai, Rap and Franco-Maghrebi Identities," co-authored with Joan Gross and Ted Swedenburg, in Smadar Lavie and Ted Swedenburg (eds), *Displacement, Diaspora, and Geographies of Identity* (Durham, NC: Duke University Press, 1996).

Mireille Rosello teaches literature and culture of French expression. She has published *Littérature et identité créole* (Paris: Karthala, 1990), a bilingual edition of Césaire's *Cahier d'un retour au pays natal* (Edinburgh: Bloodaxe Books, 1995), and *Infiltrating Culture: Power and Identity in Contemporary Women's Writing* (Manchester University Press, 1996). She is currently completing a manuscript on *Declining Stereotypes: Representation and Ethnicity in Contemporary France*.

Carrie Tarr is Senior Research Fellow at Thames Valley University, London, UK. Her work on gender, sexuality, and ethnicity in classic and contemporary French cinema has been widely published, and she is currently working on a book on the cinema of Diane Kurys for Manchester University Press.

Chris Warne is Lecturer in the French Studies Department at Keele University, UK. His research interests are broadly concerned with the nature of popular culture in twentieth-century France. His publications include a chapter in Sheila Perry and Maire Cross (eds), *France, Populations and Peoples*, vol. 2: *Voices of France* (London: Cassell Academic, forthcoming), and he is currently preparing a book on youth and society in post-war France.

Jack A. Yeager is Professor of French, Francophone Studies and Women's Studies at the University of New Hampshire at Durham. His publications include *The Vietnamese Novel in French: A Literary Response to Colonialism* (Hanover, NH/London: University Press of New England, 1987) and the co-edited *Post-*

Colonial Subjects: Francophone Women Writers (Minneapolis, MN: University of Minnesota Press, 1996) as well as recent articles in *Québec Studies, L'esprit créateur,* and *Présence francophone.*

ACKNOWLEDGEMENTS

The initial exchange of ideas from which this volume emerged took place at Cornell University, where we are grateful in diverse and important ways to Susan Tarrow, Philip E. Lewis and Jonathan Ngaté. We also benefited from the early advice of Dina Sherzer (University of Texas at Austin) and Margaret Majumdar (University of Glamorgan, Wales). Mitchell Greenberg at Miami University gave crucial support. Invaluable practical assistance was given by Marcia Simmons at MU, together with Paul Byrne and Jette Batty at Loughborough University.

Except where otherwise stated, translations into English are by the authors of individual chapters. We are grateful to the many artists, publishers and producers who supplied materials, answered questions and gave generously of their time in many other ways.

Thanks also to Samuel B. Bacharach for a memorable ride to New York City, and to Béatrice Romet. Special thanks to Arlette, Catherine and Pierre Dhalenne, and to Suzanne and Daniel Cochez, together with Carol, Christine, Eric, JoAnne, Norris and Susan McKinney, and Will Dorward for their love and support (and to Christine for her professional photographic advice).

Our greatest debts are to Valérie Dhalenne and Patricia Hargreaves.

We gratefully acknowledge permission to reproduce copyright materials granted by the following:

Alhambra films (Plates 4.6 and 4.7)

Ghada Amer (Plate 11.3: photograph by Stéphane Corréard)

Christian and Mathieu Bourgois (cover of paperback, bottom left)

Cinétévé (Plates 5.1 and 5.2)

Editions Dupuis (Plate 10.2: Lax and Giroud, *Les oubliés d'Annam*, vol. 2, Marcinelle, Belgium: Editions Dupuis, 1991, p. 37)

Mohamed El-Guettaa (cover of paperback, top right and Plate 11.6)

Driss El Yazami (Plate 7.1)

Flach Pyramide International (Plates 4.3 and 4.9)

Humano SA, Genève – Les Humanoïdes Associés (Plate 10.1: Pierre Christin and Annie Goetzinger, *La voyageuse de petite ceinture*, 1985, p. 40)

Pierre Grise Distribution (Plate 4.8)

K.G. Production; a Mehdi Charef film, a Michèle Ray-Gavras Production (Plate 4.5)

Rachid Khimoune (Plates 11.1, 11.2: photographs by Pierre Terrasson)

Kodansha Ltd (Plate 10.3: Baru, *L'autoroute du soleil*, Tournai, Belgium: Casterman, 1995, p. 19)

Dalila Mahdjoub (cover of paperback, center left and Plate 11.7)

Chérif Medjeber (Plate 11.5: photograph by Sophie Lupoglazoff)

La Société Horizon (Plate 4.4)

Soleil Productions (Plate 10.4: Farid Boudjellal, *L'oud: La trilogie*, Toulon: Soleil Productions, 1996, p. 80; Plate 10.5: Farid Boudjellal, *Jambon-Beur: Les couples mixtes*, Toulon: Soleil Productions, 1995, p. 28)

Le studio canal + (Plate 4.10)

Djamal Tatah (Plate 11.4: photograph by Dalila Mahdjoub)

Plates 4.1, 4.2, 4.3, 4.4, 4.5, 4.9 and 4.10 are reproduced courtesy of BFI Stills, Posters and Designs.

Every attempt has been made to obtain permission to reproduce copyright material. If any proper acknowledgement has not been made, we would invite copyright holders to inform us of the oversight.

AGH
MM

PART I
OVERVIEW

INTRODUCTION

The post-colonial problematic in contemporary France

Alec G. Hargreaves and Mark McKinney

INTRODUCTION

Post-colonial studies have recently become one of the most dynamic fields of scholarly inquiry and debate in the English-speaking world.[1] In France, the post-colonial problematic is seldom encountered in political or cultural discourse (Apter 1995). Yet the phenomena embraced by this term represent a crucial dimension of contemporary French society, which offers a rich field of inquiry for students of the post-colonial condition.

Within France, the most widespread (but by no means exact) conceptual equivalent of the post-colonial field is *francophonie*. Both terms are profoundly ambiguous, above all in relation to the interface between cultural and political phenomena. In its most literal sense, *francophonie* denotes a purely cultural trait: the ability to speak French. More commonly, it denotes the global community of French speakers and more specifically still, organized efforts, particularly at the state level, to strengthen that community. Thus beneath the surface of a seemingly cultural concept, political imperatives generate much of the momentum behind the idea of *francophonie* (cf. Ager 1996). This is true not only in the sense that *francophonie* derives much of its impetus from political elites, but also because the cultural spaces to which the term is applied are defined by geopolitical boundaries. So-called francophone countries are those *outside* the boundaries of French sovereignty in which French is spoken in some significant degree (though

often by only a minority of the population). Most of those countries are former French colonies. Indeed, the term *francophonie* gained its current meaning in the immediate aftermath of decolonization, when it served to emphasize continuing cultural links between France and her former colonial possessions (cf. Miller 1990: 181–201). Many of those critical of the idea of *francophonie* view it as a form of neo-colonialism, through which France continues to assert cultural (and perhaps even political) hegemony over formerly colonized peoples.

If the notion of *francophonie* is distrusted as a conservative or reactionary project, the post-colonial is generally seen as a more politically correct concept, though it too contains many ambiguities. Unlike *francophonie*, the political dimensions of which are masked by a term which superficially appears to denote a purely cultural field of reference, the post-colonial highlights a political condition characterizing certain forms of cultural production, i.e. the legacy of colonial domination out of or against which cultural practices are seen to emerge. In its own way, the "post" in post-colonial often connotes a political assertion akin to, or rather in contradiction with, that underlying *francophonie*: to speak of a post-colonial condition is to affirm the right to political and cultural self-determination. Yet by defining cultural projects in terms of a common reference to an earlier period of colonial domination, there is a risk of ensnaring formerly colonized peoples within the very hegemony which theorists of the post-colonial are concerned to break (McClintock 1992). If cultural practitioners originating in former colonies are no longer constrained by the legacy of the past, what purpose is served by labeling their efforts as post-colonial? Fully realized, the post-colonial condition appears as a contradiction in terms.

These tensions are nowhere more acute than in relation to minorities originating in ex-colonies who have now settled in France. French-speaking to a very large extent, yet culturally distinct in other ways and still marked by exclusionary memories of the colonial period, these minorities defy the political logic of *francophonie* by being residents and in many cases citizens of France while appearing to many among the majority population to belong elsewhere. Cutting across the binary logic that opposes "insiders" to "outsiders," they are creating what Homi Bhabha has described as a hybrid "third space" that allows for the emergence of new cultural forms, "new structures of authority, [and] new political initiatives" (Bhabha 1990: 211; cf. Bhabha 1994: 19–39).

Conditioned initially by the colonial intrusion overseas and more recently by migration into the former colonial metropolis, post-colonial cultures are also imbricated in wider processes of globalization (Featherstone 1990). Constraints on international communications, which formerly limited the extent to which

individuals might participate physically and/or mentally in more than one society, are being constantly eroded (cf. Anderson 1994 on "long-distance nationalism"). Rapid and relatively cheap airline service makes international travel far easier than in the past (albeit subject to rigid controls on permanent migration), and electronic media such as television facilitate the international circulation of cultural products on an unprecedented scale, pervading the homes of mass audiences on a daily basis. Within this context, as Stuart Hall (1996: 247) has observed, the post-colonial perspective

re-reads "colonisation" as part of an essentially transnational and transcultural "global" process — and it produces a decentered, diasporic or "global" rewriting of earlier, nation-centred imperial grand narratives. Its theoretical value therefore lies precisely in its refusal of this "here" and "there," "then" and "now," "home" and "abroad" perspective.

It would nevertheless be illusory to suggest that diasporic cultures belong in equal measure to each of the spaces in which they participate. Despite growing cooperation among European Union member-states, immigration controls, including the crucial field of residence rights, remain in many ways a bastion of national sovereignty. Residence rights — or the lack of them — facilitate or limit access to important cultural processes. While no state holds a monopoly over the means of cultural reproduction, some key cultural institutions — most obviously, formal educational systems — remain constrained in many ways by national boundaries. To a lesser extent, this is also true of the mass media, despite a clear trend towards the erosion of national controls (cf. Hargreaves, below, Chapter 5). For these and other reasons, the formative experiences of artists brought up in (ex-)colonial territories are significantly different from those of second- or third-generation members of minorities within the former colonial metropolis, which differ in turn from those of the majority population. National parameters remain therefore salient features in the analysis of cultural practices. Post-colonial cultures are indeed implicitly defined, even if only antithetically, with reference to current or former relations between (ex-)imperial nations and their overseas dominions.

To date, most studies of cultural practices grounded in French colonization and its aftermath have focused primarily on the (ex-)colonial periphery.[2] To paraphrase the title of a seminal study of post-colonial writing in English (Ashcroft *et al.* 1989), the emphasis has been on the empire writing back. In the essays assembled in the present volume, the focus shifts to the empire riding in, traversing the center itself. Our contributors explore the significance of the post-colonial condition in a wide variety of cultural practices in France during the

1980s and 1990s. In the analysis of these practices, it is useful to distinguish three main groups of actors: those based in the former colonial periphery, whose works are mediated to the center in a variety of ways; minorities of Third World (i.e. ex-colonial) origin now settled in France; and the majority population, associated with "mainstream" French norms. In the next section of our introductory essay, we focus in more detail on the second of these groups, through which the (former) empire has established a significant physical presence within the (ex-)colonial metropolis and who are at the heart of this volume. We then go on to outline some key features involved in transnational and transcultural exchanges and consider recent critiques of post-colonial theory before concluding with a more detailed discussion of the relevance of the post-colonial paradigm to cultural practices in contemporary France. In this way, we seek to delineate the overall context within which subsequent chapters are to be read.

Drawing on a wide range of materials and methodologies, the various contributors seek to illuminate in ways pertinent to their specialist areas a range of shared concerns. How far are the cultural practices of Third World minorities marked by the legacy of the colonial period? What specific features of current cultural practices are derived from pre-migratory traditions, and how have these been modified through settlement in France? How do gender and class impact upon those practices? In what ways and to what extent may one speak of neo-colonialism as a significant force in majority French culture and society, and how does this affect the creative processes of post-colonial minorities? How does the presence of those minorities impact on the majority population in France and the redefinition of its self-image after the end of empire? Do minority cultures function essentially as part of or apart from the "national" culture of France? How do established immigrant minorities relate to exiled or expatriate artists from former colonial territories? In what ways do external diasporic networks and/or inter-ethnic contacts between minorities affect processes of cultural production and consumption? What kinds of audience (majority, minority, crossover, local or global) are addressed by minority cultural practitioners? How far may one speak of a minority public sphere? What means of production and diffusion, and what sources of private or public support are available to minorities, and how have these affected their cultural output? These are the key questions which the contributors seek to explore.

THE POST-COLONIAL PRESENCE IN FRANCE

France has long been a place of temporary or permanent residence for people originating in (ex-)colonies, among whom five partially overlapping groups may be distinguished. Although the distinctions between these categories are useful for analytical purposes, it should be noted that the borderlines are sometimes blurred. Not uncommonly, particular individuals have a foot in more than one camp.

Small but influential elites originating among colonized peoples have often spent time in the (former) colonial metropolis. In many cases, they arrived as students and then extended their stay for varying periods. During the colonial epoch, they often enjoyed greater freedom on French soil than in the overseas empire. In addition, the centralized nature of the colonial system had the effect of concentrating within France educated elites from many different parts of the empire, helping to generate a collective awareness of their shared history of colonial oppression. Experiences of this kind played a major role in shaping the political and cultural elites who were to lead the struggle for independence. The *négritude* movement, for example, which developed in Paris during the 1930s, brought together black intellectuals from French colonies in Africa and the Caribbean as well as influential African-American mentors (Dewitte 1985). In parallel with artistic works, the political dimensions of the anti-colonial struggle were voiced in newspapers and magazines published in France by activists originating in almost every corner of the overseas empire (Génériques 1990; cf. El Yazami, below, Chapter 7).

While not without influence in France, most of those involved in these movements were primarily concerned with the political and cultural destinies of overseas territories. This was also true, initially at least, of a second, overlapping category of intellectual migrants, who may be broadly classified as post-colonial exiles. In many former colonies, the regimes that replaced French rule soon became corrupt and/or authoritarian, pushing dissenters to flee elsewhere, often to France. Other intellectuals have come to France because it offers better professional prospects, for example in the university and publishing sectors, than can be found in their home countries (cf. Potts 1990: 160–2 on the "brain drain").

Despite the importance of career opportunities in leading many of them to France, expatriate intellectuals are seldom associated with a third type of post-colonial presence, that arising from economic migration. This is in part because

the vast majority of economic migrants from (ex-)colonial territories are located much further down the socio-professional ladder. In France, the classic image of an immigrant is that of an illiterate manual worker of Third World (i.e. ex-colonial) origin executing menial tasks in industrial and other sectors which are unattractive to the majority population. Although there are, of course, exceptions, this stereotype is grounded in the sociological fact that most immigrants from (former) colonies are indeed from poorly educated, often rural backgrounds, and the jobs they have found in France have generally been unskilled and badly paid. Unlike the first two, this third category is composed mainly of people who lack the formal education and skills which are necessary to function effectively in elite cultural spheres. Their cultural practices, primarily oral in character, are badly documented and little studied.

Small numbers of economic migrants came to France during the colonial period. During the First World War, on top of almost 600,000 colonial troops France recruited more than 200,000 civilian workers, mainly in the Maghreb and Indochina, to assist in the war effort of metropolitan France. Most were repatriated when hostilities ended (Amar and Milza 1990: 155–7). Throughout the twentieth century, France was to draw heavily on migrant labor, but until after the Second World War most of this came from Europe. It was not until the 1950s and 1960s that mass migration from the colonial empire, then in dissolution, began to supplant European sources of labor, and not until the 1980s that non-Europeans (mainly from Third World countries) came to outnumber Europeans among the migrant population in France.

Former French colonies in the Maghreb – Algeria, Morocco, and Tunisia[3] – have been the single most important region of origin. More recently, former colonies in sub-Saharan Africa have also become significant sending countries. In addition, the last remnants of the overseas empire still administered by France, known as the DOM-TOM (*Départements et Territoires d'Outre-Mer* [Overseas Departments and Territories]), often look to France for employment opportunities. A quarter of the population born in two of the Overseas Departments, the Caribbean islands of Guadeloupe and Martinique, now live in metropolitan France (Marie 1993).

Asylum-seekers and refugees fall into a fourth analytical category. Often thought of as the preserve of ideologically committed intellectual elites (of the kind referred to in category two), political exile is a condition experienced by people from diverse social strata, and the scale of their exodus sometimes amounts to a form of mass migration. Thus at the end of the Algerian war of independence in 1962, tens of thousands of Muslim auxiliary soldiers known as *harkis*, who had

fought under French orders, fled to the former colonial metropolis in order to escape reprisals from triumphant Algerian nationalists. Most *harkis* were poorly educated and possessed few marketable skills with which to ascend the social ladder in France. In this respect they resembled those among their fellow-countrymen who came to France as economic migrants.

A new wave of asylum-seekers, originating in former French Indochina, entered France following the 1975 Communist victory in the Viet Nam war, a conflict which, stoked by the neo-colonial involvement of the US, had raged for over twenty years after formal decolonization in 1954. This latest influx has strengthened the Vietnamese community in France and yielded a new generation of writers, such as Linda Lê, whose works are analyzed by Jack A. Yeager (Chapter 15, below). Compared with the *harkis*, those who fled Indochina tended to come from more middle-class backgrounds. In some cases, fears of political persecution were less important than the desire to maximize economic opportunities, which it was felt would be stifled by the Communist regime in Viet Nam. Today, the blurring of political and economic motives is cited as a prime factor in France's high rejection rate of asylum-seekers from many Third World countries (Wihtol de Wenden 1994).

A fifth component of the post-colonial presence in France consists, not of migrants, but of their descendants. With the permanent settlement of migrants, the birth of their children and grandchildren marks the emergence of minority ethnic groups for whom France is in a very real sense home, rather than a country of adoption. Unlike the majority of economic migrants, whose formal cultural skills were limited, second- and third-generation members of minority groups have all been educated in France, and they are better equipped to make active use of cultural forms ranging from print and film to electronic media and the fine arts, as the essays contained in this volume amply show.

The different categories in this five-fold typology should be understood as typological abstractions, rather than as watertight compartments into which the (post-)colonial presence in France can be neatly divided. The different groups often overlap and engage in collaborative cultural practices, as Driss El Yazami, for example, shows in his study of France's minority ethnic press (below, Chapter 7). The blurring of categorical distinctions has been heightened since the end of decolonization by a steadily accelerating trend towards the globalization of economic, cultural, and political relationships. In these circumstances, the distinction between migrant intellectuals, engaged in cultural practices focused primarily around their countries of origin, and minority ethnic groups settled within France, for whom the ex-colonial metropolis is the main locus of cultural

production, is at best rough and ready, and at worst misleading.

Where, for example, would one classify an author such as Tahar Ben Jelloun? Born in Morocco, Ben Jelloun took up residence in France as a student and now divides his time more or less equally between the two countries. In 1987, when he won the Prix Goncourt, France's most prestigious literary prize, a number of bookstores moved his works from their "Maghrebi Literature" shelves to "French Literature." He is the holder of a French passport and a member the French *Légion d'honneur* [Legion of Honor], and has written extensively about the migrant experience in France, but acknowledges that in the eyes of second-generation Maghrebis born in France his voice is more that of "le pays de leurs parents que le pays d'adoption" [their parents' country rather than their country of adoption] (Spear 1993: 32).[4] A regular commentator on current affairs in the French media, he told an American interviewer:

Je ne me sens absolument pas déraciné ici [Paris]! Je suis bien ici *et* au Maroc. J'ai mon pays, c'est le Maroc. Je me sens totalement marocain. Mais en France je me sens aussi concerné par la France et par ce qui lui arrive.

I don't feel uprooted in the least here [Paris]! I feel at ease here *and* in Morocco. My country is Morocco. I feel completely Moroccan. But in France I feel just as concerned by France and by what happens in it.

(Spear 1993: 33)

An expatriate in the sense that she was born in the West African state of Cameroon and now resides in Paris, Calixthe Beyala owes her literary reputation primarily to novels depicting West Africans in France, where they are published and read by a large audience. In many ways, Beyala has now been incorporated into "French" literature, despite her distant origins and the "exotic" dimension which her works bring to the former colonial metropolis (cf. Hitchcott, below, Chapter 12). Similarly, the seemingly insatiable appetite of multinational recording companies for "world music" – "new" styles and performers imported from "exotic" locations to which they must still in some sense be felt to belong (even when no longer residing there) if they are to fit their commercial niche – is steadily transforming the contours of popular culture within France and other First World countries (cf. Warne, below, Chapter 8).

CULTURAL SPACES

How far do post-colonial cultures stand as part of, or apart from, the dominant elements in the cultural space bounded by the territorial limits of France? Beneath this deceptively simple question, which the contributors to this volume seek to address in a variety of ways, lie a multiplicity of issues which revolve in varying degrees around the theorization of culture(s). If culture (in the singular) may be defined generically as the human construction of meaning, cultures (in the plural) consist of distinctive types of signifying practice shared by particular groups. At their core, cultures are built on circuits of communication linking together producers, transmitters, and receivers of particular patterns of signification, by which those concerned are in some degree bound together. The more such a circuit is tightly knit and isolated from others, the more distinctive and coherent is the culture which it sustains. Colonization and, more recently, post-colonial migration are obvious examples of forces cutting across established cultural, as well as political, boundaries. There is also a broader sense in which globalization, characterized by the constant widening of processes of human exchange, further undermines the pretensions of nation-states as politically bounded territories marking the limits of discrete and at the same time homogenous cultural communities.

Few, if any, individuals are entirely mono-cultural. Although they may not always realize it, most people participate – whether as producers, consumers or intermediaries – in a variety of cultural communities. To the extent that a sense of identity is derived from such communities, multiple identities are the norm, rather than exceptional features of personal experience. The proliferation of ever more sophisticated communication networks implies, moreover, a constant challenge to simplistic notions of neat demarcation lines between "national" cultures. To a greater or lesser degree, all cultures are engaged in a constant process of renewal, which is driven in part by borrowings from elsewhere. In these circumstances, physical contiguity is no guarantee of cultural affiliation. Minorities within a given topographical space may seek to deterritorialize its dominant paradigms by working within cultural circuits that cut across its boundaries (Deleuze and Guattari 1975). Conversely, the material conditions of certain types of cultural practice may force minority producers and receivers to pass through intermediaries – publishers, broadcasting organizations, journalists, etc. – implicated in and dominated by other cultural circuits. Chris Warne's discussion of the "world music" industry (below, Chapter 8), Nicki Hitchcott's

analysis of the critical reception of Calixthe Beyala's novels (below, Chapter 12), and Dalila Mahdjoub's comments on the vicissitudes of institutional support for Maghrebi artists in France (below, Chapter 11) illustrate these processes well.

At a first level of analysis, at least three different types of cultural space are open to France's post-colonial minorities: the dominant norms of the majority population, diasporic spaces associated with the country of origin and with other minority groups in France and elsewhere, and separatist enclaves detached from both of those fields. In practice, each of these seemingly distinct and internally unified spaces – the potential or actual coexistence of which is itself a challenge to the traditional concept of the nation-state – is far less clearly bounded than it may appear at first sight.

Diasporic spaces, often associated with nostalgic notions of pre-colonial cultures, are indelibly marked by the European intrusion, carrying irreversible changes into the (ex-)empire and back to the center. Such transitions are exemplified by figures such as Ben Jelloun and the doyen of black African writers, Léopold Sédar Senghor. Born in French West Africa, where he was educated in Catholic mission schools, Senghor helped to found the *négritude* movement while a student in Paris before leading Senegal to independence, becoming the country's first President in 1960. When he retired from politics twenty years later, he settled with his French wife in Normandy, and was elected shortly afterwards to the *Académie française*, one of France's most elite (and conservative) cultural institutions. To mark his ninetieth birthday in 1996, he was jointly feted by French President Jacques Chirac and his Senegalese counterpart, Abdou Diouf, at a UNESCO reception in Paris (*The Times* 1996b).

The majority of France's post-colonial minorities are to be found in more humble milieux, foremost among which are the *banlieues* (literally, "suburbs"), which in the 1990s have become a byword for socially disadvantaged peripheral areas of French cities containing relatively dense concentrations of minority ethnic groups (Hargreaves 1996; cf. Rosello, below, Chapter 14). Often referred to by journalists as ghettos,[5] the *banlieues* are the structural equivalents of British and American inner-city areas, and as such would appear to offer a natural space in which to develop a separatist cultural agenda. Yet the markers – graffiti, music, dancing, dress codes, etc. – through which young *banlieusards* (literally, "suburb-dwellers") seek to reterritorialize the anonymous public housing projects in which they are corralled are saturated with references to global networks of multiethnic youth culture in which they participate daily through the mass media (Roy 1991 and 1993; cf. Hargreaves, below, Chapter 5 and Cannon, below, Chapter 9).

No less importantly, despite all attempts to ignore or disguise the fact, "French"

culture is itself shot through with influences and affiliations stretching far beyond the "hexagon," a popular term for the topographic configuration of metropolitan France. A few weeks before celebrating Senghor's ninetieth birthday, President Chirac had welcomed to France the Polish primate of the Roman Catholic Church. The Pope had come to celebrate the 1,500th anniversary of an event widely regarded as the founding act of the French nation-state, the conversion of the Frankish King, Clovis, to Christianity – a global religion founded in the Middle East, the main Western arm of which is administered from Vatican City in Rome.[6] Chirac's administration was at the same time fighting a hopeless rearguard action against the ever-widening inroads made by the English language and American popular culture into the everyday cultural practices of the French. The latest innovation in this unequal struggle consisted of revised quotas, introduced at the beginning of 1996, requiring radio stations to prioritize "French" songs over those in other languages. One of the ironies of these and earlier quotas has been to facilitate the emergence of rap as a major force on the contemporary music scene in France. Short of new songs meeting the official quota criteria, broadcasters have filled their vacant air time with rap recordings by minority ethnic *banlieusards* featuring French-language vocals adapted from black American models (*Le Monde* 1996a; cf. Cannon, below, Chapter 9).

Jean-Marie Le Pen, the openly racist leader of the extreme right-wing Front National,[7] draws much of his electoral support from sections of the majority population who are vulnerable to economic and other forms of insecurity arising from globalization (Jenkins 1996). They like to believe that by ridding the country of Third World immigrants and reasserting the racial and cultural "purity" of the nation, they can restore France to a golden age of unity and prosperity. The (unacknowledged) Middle Eastern origins of the Catholic faith, championed by Le Pen as a key constituent of French nationhood, have already been commented on. Warne (below, p. 148, n. 2) draws attention to a similar irony in the case of *oi*, a form of rock cultivated by far-right skinheads whose assertions of white supremacy and cultural purity are implicitly undercut by the (again unacknow- ledged) role of the African diaspora in the foundations of white rock and roll. Today, classic "French" rock and roll, naturalized as an integral part of French popular culture, is regularly celebrated in the nostalgic concerts of its founding icon, "Johnny Halliday": a Belgian who in the 1950s abandoned his real name, Jean-Philippe Smet, in favor of a new one deliberately chosen for its American resonance. The heterogeneity inherent in "French" popular culture is explored in more detail with particular reference to the Arab world by David A. McMurray (below, Chapter 2).

CRITIQUES OF POST-COLONIAL THEORY

Before looking more closely at specifically post-colonial aspects of cultural practices in France, it may be helpful to consider some of the main critiques which have been formulated in the wider debate over the post-colonial paradigm. These may be broadly summarized as follows: (1) epistemological shortcomings of the term "post-colonial" and the field which it denotes: not only does the concept have severe limitations; much post-colonial theory replicates what it purportedly critiques; (2) failure to resolve a widespread crisis in theory: post-colonialism is one of the many other "posts" (post-structuralism, post-modernism, post-Marxism, post-feminism, etc.) which are the symptoms of a crisis of critical theory that these new tendencies fail to overcome; (3) politics of location: the creation of post-colonial studies as a field of academic inquiry is closely linked to and dependent on the rise to prominent positions in Western universities of Third World scholars; (4) political and methodological mystification: post-colonial theory arises out of and tends to obfuscate global structural adjustments of power and mutations of capitalism. Let us consider each of these critiques in turn.

(1) Various critics have objected that the "post" in post-colonial reinserts the teleology of Eurocentric history that much post-colonial theory purportedly attempts to debunk: everything is referenced with respect to the – too vaguely defined – era of European colonialism (Shohat 1992: 103–8; McClintock 1992; Dirlik 1994: 344). Moreover critical distinctions between different chronologies of (de-)colonization are elided by the post-colonial, which conceptually works to suppress the critique of colonialism, neo-colonialism, (neo-)imperialism and other forms of oppression at work in the present: since the world is "post-colonial" we can all celebrate that fact. Critics have suggested that this is part of the reason for the current acceptance of the term in the Western academy, in place of earlier, more oppositional terms such as "Third World" or "anti-colonialism" (Shohat 1992: 99; McClintock 1992: 86, 93; Dirlik 1994: 344). On the other hand, the attempt by one analyst (Jameson 1986) to broadly conceptualize "Third World literature" without taking into account the problems with three worlds theory left him open to the criticism that he had thereby reproduced the binary thought of Eurocentrism (Ahmad 1987, 1992). In place of such reductionism and essentialism, critics have proposed more complex typologies and narratives of (neo-)colonialism, (neo-)imperialism and (de-)colonization. McClintock (1992: 88–9), for example, distinguishes between colonization (internal and imperial), partial

decolonization, imperialism with or without colonies, break-away settler colon-
ies, and deep settler colonization: "Different forms of colonization have,
moreover, given rise to different forms of de-colonization. Where deep settler
colonization prevailed, as in Algeria, Kenya, Zimbabwe, and Viet Nam, colonial
powers clung on with particular brutality."

Others have critiqued a new international division of intellectual labor between
the producers of post-nativist and anti-Eurocentric literary works and the Western
university theoretical establishment that generally appropriates these texts as
paradigmatic examples of post-modern and/or post-colonial writing (Jeyifo 1989;
Spivak 1990: 223; Appiah 1991). In this manner, critics charge that not only
temporal but also geopolitical perspectives on the object of study are rendered
hazy by the post-colonial lense:

> Does the "post" indicate the perspective and location of the ex-colonized (Algerian), the
> ex-colonizer (French), the ex-colonial-settler (*Pied Noir*), or the displaced hybrid in First World
> metropoli[s] (Algerian in France)? Since the experience of colonialism and imperialism is shared,
> albeit asymmetrically, by (ex)colonizer and (ex)colonized, it becomes an easy move to apply the
> "post" also to First World European countries. Since most of the world is now living after the period
> of colonialism, the "post-colonial" can easily become a universalizing category which neutralizes
> significant geopolitical differences between France and Algeria . . .
>
> (Shohat 1992: 103)

Post-colonial theorizations that lump these different perspectives together under
one term (Ashcroft *et al*. 1989) are criticized for the homogenizing amalgamation
that they produce (Shohat 1992: 102–3; McClintock 1992: 86–7; Dirlik 1994:
336).

It has also been objected that a post-colonial fetishization of cultural difference
(Dirlik 1994: 346) can give rise to a new orientalism:

> It is as if, in a certain way, we are becoming complicitous in the perpetration of a "new orientalism."
> . . . The "new orientalism" views "the world as immigrant." It is meretricious to suggest that this
> reminder undervalues the struggle of the marginal in metropolitan space. It is to remember that that
> struggle cannot be made the unexamined referent for all postcoloniality without serious
> problems.
>
> (Spivak 1990: 222–8)

Against the tendency to indiscriminately celebrate the post-modern play of hybrid
difference, it has also been argued that critics must be sensitive to the continuing
need of oppressed peoples to conceive identity in terms better adapted to survival
and liberatory struggle (Yúdice 1989; Gilroy 1993: 99–103).

(2) Most critics of post-colonial theory have argued that, like post-modernism

and the other "post" theoretical positions on which it is modeled, it arose as an attempt to fill a crisis in theory provoked by the apparent inability of previous overarching theoretical models – whether Marxism, three worlds theory, anti-colonial nationalism, etc. – to explain adequately an increasingly fragmented yet globalized world and to provide an effective vision for radical change (Appiah 1991; McClintock 1992; Shohat 1992; Dirlik 1994). The abandonment of earlier paradigms and their replacement with an eclectic array of theoretical positions drawn from domains such as psychology, French post-structuralism, and British cultural studies are felt to have left post-colonial theory without the capacity to articulate the links between post-coloniality and global capitalism (McClintock 1992; Dirlik 1994: 352), or to account for the persistence of women's oppression (McClintock 1992: 91–3).

(3) One explanation that critics have proposed for the spectacular growth of post-colonial theory is the increasing prominence of Third World critics in Western universities (Spivak 1990; Appiah 1991; Dirlik 1994). They are taken to task for their "comprador" (Appiah 1991: 348) implication in oppressive institutions and structures, their appropriation of marginality for their own purposes (Ahmad 1992; Dirlik 1994), and their refusal to let the subaltern speak (Parry 1987, on Spivak, among others; cf. Spivak 1988). It is further claimed that the inordinate amount of theoretical attention given to cultural hybridity and to the ability of subjects to change location serves as a cover for the refusal by post-colonial critics to acknowledge the real benefits of academic prestige and power that they enjoy, and to adequately theorize identity in terms of class location, and society in terms of material relationships (Dirlik 1994: 342–7). One reply to the charge of privilege is that post-colonial critics and theory remain relatively weak in the academy, in spite of their increasing institutionalization and prominence (Robbins 1994).

(4) An explanation sometimes suggested for the increasing importance of post-colonialism and multiculturalism in the academic institutions of the North and West is that capitalism now has need of a more culturally flexible ideology and work force in order for it to continue its global expansion (Dirlik 1994: 353–6). This expansion has meant the creation of a world market not only for capital and products, but also for labor, with the result that former or neo-colonies (the Maghreb, West Africa) and still-colonized regions (the DOM-TOM) were and are tapped for their cheap labor power (Potts 1990). Given the conditions of global capitalism, critics of post-colonial theory call not necessarily for its abandonment, but at least for its reorientation towards contemporary problems, whose

complexity may articulate, but is not reducible to, colonial divisions (Appiah 1991; McClintock 1992; Shohat 1992; Dirlik 1994).

THE POST-COLONIAL CONDITION IN FRANCE

Despite the dangers and limitations inherent in the post-colonial problematic, there are in our view two main sets of reasons for regarding it as a valuable heuristic device in the study of cultural practices in contemporary France. The first set relates to the cultural and historical legacy of the colonial periphery. All immigrants bring with them cultural baggage that differentiates them from the majority population. While the weight of that baggage may lessen as migration gives way to permanent settlement, with second- and third-generation strands eventually outnumbering migrants among the minority population, it continues in varying degrees to influence minority groups. Although it would be wrong either to exaggerate the differences between European and non-European migrants or to understate the rapid pace at which *francisation* [Frenchification] occurs in contemporary France's urban milieux (cf. Gallissot 1989), those who come from (former) overseas colonies in Africa or Asia are originally marked by cultural traditions which, compared with the norms prevailing in France, are on the whole more distant than the mores of Europeans.[8] French is one of a string of interrelated Romance languages traversing the boundaries of southern European states. Like France, the countries in which most European migrants have their origins have a long history of Christian, mainly Catholic, belief. The mother tongues and religious beliefs of most non-European migrants are drawn from cultural fields with no comparable presence in European history. The most important of these religions, Islam, to which most Maghrebi and many West African immigrants adhere, was indeed for many centuries the external enemy against which Europe defined itself (Hay 1968).

While France's former empire embraces enormous cultural diversity – Buddhism and Confucianism in Indochina, Islam in North and West Africa, and a variety of other religions in many parts of Africa and Oceania – most of the migrants originating there have in common a greater cultural distance *vis-à-vis* the majority population in France than is found among Europeans. There is in this sense a prima facie case for studying these minorities together. That case is strengthened by their shared history of colonial subordination, for which there is

again no direct parallel among France's European neighbors. The unequal relations which characterized the colonial system and the conflicts which eventually culminated in the liquidation of the overseas empire have left many scars on colonized peoples, memories of which are transmitted to succeeding generations, whose cultural practices continue to display the marks of this experience.

A second set of factors shaping the post-colonial condition is to be found within France itself, which is no less deeply marked by the colonial experience, and more particularly by the trauma of decolonization. Close to three million Frenchmen – almost an entire generation of young men – fought between 1954 and 1962 in France's unsuccessful attempt to resist by force of arms the rising tide of Algerian nationalism. With the advent of independence, practically the whole of Algeria's million-strong *pied-noir* (French settler) population fled to France, carrying with them bitter feelings of exile and dispossession. Like the Viet Nam war in the minds of Americans, memories of the Algerian war in France are both repressed and omnipresent (Rioux 1990; Stora 1991). The very limited presence of an explicitly "post-colonial" discourse in France is in many ways a reflection of lingering neo-colonial reflexes. If Algerians, the largest minority ethnic group in France, are also the most distrusted and disliked by the majority population, this is in no small measure due to the images of racial inferiority and enmity inherited from over a century of colonization and almost eight years of guerrilla warfare that brought France itself to the brink of civil war (Hargreaves 1995: 152–9). Not surprisingly, the Algerian war and its still-lingering after-effects feature in significant works by artists of both majority and minority ethnic origin (cf. below, Tarr, Chapter 4; McKinney, Chapter 10; Hargreaves, Chapter 13).

In their everyday dealings with the majority population, Maghrebis as a whole (whether of Algerian, Moroccan, or Tunisian origin) cannot escape the generally unstated and often unconscious but nonetheless potent legacy of the colonial era, which continues to color majority perceptions of minority groups. These (mis-) perceptions frequently elide national and ethnic differences, and construct other, racialized barriers. Anyone with a physical appearance suggesting Maghrebi origins is apt to be seen as an "Arab" and to be taken for an Algerian. For Moroccans and Tunisians, who gained national independence with far less bloodshed than occurred in neighboring Algeria, there is a doubly unjust stigma in being regarded as Algerian, with all that that connotes in French eyes. Within Maghrebi states, a significant proportion of the population is not Arab at all, but Berber. This is the case in several regions which have been prominent in migratory flows to France, such as the Rif in Morocco and Kabylia in Algeria, where most

of the population is Berber- (rather than Arabic-)speaking. These differences are completely effaced in everyday French usage of the word *Arabe*, which is applied indiscriminately to virtually anyone connected with the Maghreb other than the *pieds-noirs* (there is very little awareness of Sephardic Jews as another distinct component of the North African population). In a wider sense, *Arabe* is used more or less interchangeably with *Musulman* (Muslim) to cover people of Middle Eastern appearance (not all of whom are Arabs or, for that matter, Muslims) along with Maghrebis.

These aspects of the neo-colonial gaze affect second- and third-generation Maghrebis as much as their immigrant forebears. In recent surveys, seven out of ten second-generation Maghrebis say they feel closer to the culture of the French population than to that of their parents (SOFRES 1995: 160). Nine out of ten say they want to be integrated into French society (Muxel 1988: 928). No less remarkably, two-thirds say they are ready to defend France by force of arms should the country be attacked (SOFRES 1995: 169). Yet when majority French respondents are asked whether they see second-generation Maghrebis as French or Arab, less than a third say they see them as French (CNCDH 1991: 210). A report by the labor inspectorate has found massive discrimination in the employment market against young Maghrebis and other (post-)colonial minorities, including those from the (still colonized) DOM-TOM (IGAS 1992: 49–50). Almost 80 percent of violent acts officially classed as racist and more than 90 percent of racist murders in France are committed against Maghrebis, though they account for less than 40 percent of the foreign population (CNCDH 1994: 18).

Reflecting on this neo-colonial gaze, Mohammed Kenzi, the son of an Algerian immigrant worker, recalls that the formal independence of Algeria in 1962 did little, if anything, to improve the condition of the migrant population in France:

Nous allions continuer à survivre dans ces conditions misérables, rejetés et haïs, nous demeurions les éternels esclaves sous la domination du maître d'hier, à la seule différence qu'on ne nous surnommait plus les fellaghas, mais ratons ou bougnoules . . .

We were to continue living in wretched conditions. Rejected and hated, we were destined to remain the same old slaves, dominated by our former masters. The only difference was that they no longer called us rebels, but dirty Arabs or wogs . . .

(Kenzi 1984: 36)

During the war, *fellaghas* (literally, "road-blockers"), an Arabic term used as a self-descriptor by Algerian guerrilla fighters, was extended in the usage of many French people to brand Algerians in general as "rebels" against French authority. While *fellaghas* lost its currency with the end of the conflict, other highly

pejorative terms inherited from the colonial period such as *ratons* (dirty Arabs) or *bougnoules* (similar in meaning to "wogs" or "niggers") still served to label North Africans in France. The very word *Arabe* was so contaminated in French usage by disparaging colonial connotations that a conscious effort was made in progressive circles to replace it with a relatively unfamiliar and consequently less tainted term, *Maghrébin*. The entry of this term into widespread usage is directly contemporaneous with decolonization. It did not, however, signal the end of attitudes inherited from the days of empire. Today, disdainful notions of racial or cultural inferiority similar to those prevalent during the colonial period are frequently implicit in popular usage of the word *Maghrébin*, which has become virtually synonymous with *immigré*, another highly tainted term.

During the 1970s, young Maghrebis in the *banlieues* of Paris began calling themselves *Beurs*. This *verlan* (backslang) expression was formed by inverting the syllables of the word *Arabe*. As a neologism, *Beur* had many advantages. It lacked the pejorative connotations associated with *Arabe*, and enabled its users to speak of themselves without having to choose between one of the ready-made national or quasi-national identities (French or Arab/Algerian) constantly proffered to them (Barbara 1986). During the mid-1980s, the term became widely used in the French mass media, leading many young Maghrebis to reject it as a neo-colonial projection. In a 1988 interview Sakinna Boukhedenna, who was born in France of Algerian parents in 1959, stated: "Moi, si je dis le mot 'Beur,' c'est comme si on reconnaît qu'on est encore colonisé" [If I were to use the word "Beur," it would be like saying that we're still colonized][9]. For Boukhedenna, the media's adoption of the *Beur* label signified a refusal to accept Arabs in France on their own terms; replicating the logic of African Americans who in the 1960s had inverted the stigmatizing gaze of whites by declaring that black is beautiful, she insisted on calling herself an Arab.

Similar tensions are apparent in the title of Soraya Nini's 1993 novel, *Ils disent que je suis une Beurette* . . . [They call me a Beurette . . .], which incorporates the feminine substantive *Beurette*. The author herself had intended to entitle the novel *L'entre-deux* [In Between], but for commercial reasons the publisher proposed that it be called *La Beurette,* which Nini found alien. Her reservations remain evident in the compromise formula on which they finally agreed: "J'ai accepté *Ils disent que je suis une Beurette* car ce sont les autres qui nous appellent ainsi et non moi qui l'utilise" [I accepted *They Call Me a Beurette* . . . because other people call us that; it isn't a term I use].[10] Summing up the now widespread rejection of the *Beur* label, the rock musician and novelist Mounsi (1995: 72–4) has recently dismissed it as a neo-orientalist, neo-exoticist construction.

Such neo-colonial tendencies are apparent not only in everyday attitudes and behavior as well as in popular and mainstream cultural forms such as film (Tarr, below, Chapter 4), television (Hargreaves, below, Chapter 5), and comics (McKinney, below, Chapter 10), but also in the social and political institutions of contemporary France. A key element in the ideology of French colonialism was the myth of assimilation, according to which colonized "natives" were to be turned into cultural clones of their colonial masters and eventually granted equal political rights (Betts 1961). In the overseas empire, the French commitment to assimilation was always more rhetorical than real: few resources were devoted to the "civilizing mission," and the promise of political equality was perpetually deferred, since it was fundamentally at odds with the whole colonial system. Paradoxically, it is during the post-colonial period that assimilationist reflexes have worked their way more fully into the formulation of public policy towards migrants from ex-colonies now settled on French soil.

Within France, there are strong centralizing traditions on both the left, stretching back to the French Revolution, and the right, drawing partly on the legacy of pre-revolutionary monarchical regimes. These tendencies are reflected in long-standing public hostility towards the recognition of regional minorities, as well as in the expectation that immigrants and their descendants should assimilate to the dominant culture. The Socialist administration which came to power in 1981 briefly flirted with a mild form of multiculturalism, labeled *le droit à la différence* [the right to difference], but as David Blatt shows (below, Chapter 3), this was to prove short-lived. Today, all the main political parties except for Le Pen's exclusionary Front National are united in arguing for *intégration* [integration], a term which is not without ambiguity, but which more often than not is used as a polite circumlocution for assimilation (Hargreaves forthcoming). There is an entrenched reluctance to accept, still less encourage, expressions of cultural diversity reflecting the multiethnic origins of the "national" population.[11] Media hysteria during the Islamic head-scarf affairs of 1989 and 1994, when a number of state schools sought to prohibit Muslim girls from covering their heads in class, typifies this intolerance (Hargreaves 1995: 125–31). There can be little doubt that French sensitivity towards Islam is conditioned in part by the role of that religion as an emblem of national identity among Algerians during the war of independence, memories of which continue to weigh heavily in French perceptions of minority groups. The Islamic revival witnessed since the Iranian revolution of 1979, now visible just across the Mediterranean in the quasi-civil war raging in Algeria since 1992, has further strengthened ancient fears of Europe's Oriental Other, with whom immigrant minorities are readily amalgamated. Neo-colonial perceptions are thus a key

contextual factor in the everyday experiences in which the cultural practices of minority groups are forged.

In the theoretical debate surrounding the post-colonial condition, a distinction may be drawn between "soft" and "hard" approaches. On the one hand, in its soft version the "post" in "post-colonial" is taken by some critics to mean "'after,' 'because of,' and even unavoidably 'inclusive of' the colonial; on the other hand, it signifies more explicit resistance and opposition, the anticolonial" (Hutcheon 1995: 10). In an effort to avoid ambiguity, Boehmer (1995: 3) distinguishes between *post-colonial* practices, defined by a descriptive, chronological relationship with the end of empire, and a *postcolonial* stance, grounded in resistance to (neo-)colonial oppression. Extending Boehmer's typology, it is possible to distinguish a third type of relationship with the end of empire, which we may designate as *post/colonial*, i.e. essentially detached from the post(-)colonial problematic.

Endemic to contemporary France, the neo-colonial gaze is a constant reminder of the still unfinished process of decolonization. As such, it constitutes one of the inescapable parameters within which the cultural practices of post-colonial minorities are framed. Yet it is vital to understand that minority ethnic artists see that parameter more as a challenge to be confronted or bypassed than as a naturally constituted boundary. While they are all in a sense framed by the *post-colonial* moment, most of these artists are engaged to a significant degree in *postcolonial* strategies, and they are attracted in not a few cases by *post/colonial* vistas. Researchers and analysts must therefore recognize that one of the great dangers inherent in the post-colonial problematic is that of reifying the very categories which minorities seek to relativize and/or subvert. These tensions are explored by Mahdjoub (below, Chapter 11), who argues that the ethnic criteria by which post-colonial minorities are defined are increasingly devoid of artistic significance. By implication, the long-term viability of the "post(-)colonial" category is called into question.

While Mahdjoub's essay indicates that post/colonial tendencies are of real and perhaps increasing significance, most of the cultural practices of minorities originating in France's former empire may be fairly described in varying degrees as post(-)colonial in both the hyphenated and unhyphenated senses. In analyzing those practices, neither the editors nor the contributors to this book regard the post-colonial problematic as a dogma to be applied uncritically to the cultural processes under discussion. Rather, it is our view that this optic can yield significant insights into many aspects of multiethnic France without necessarily saying the final word about any of them.

NOTES

1 Recent surveys include Williams and Chrisman (1993), Barker *et al.* (1994), Benson and Conolly (1994), Ashcroft *et al.* (1995), Chambers and Curti (1996).

2 Only recently have critics in French studies begun to scrutinize the (post-)colonial construction of French national and minority identities, as, for example, in some of the essays in Lionnet and Scharfman (1993), Kritzman (1995) and Ungar and Conley (1996). On (post-)colonial French and francophone film, we now have an important collection of essays edited by Sherzer (1996). However, the present volume is, to our knowledge, the first in-depth multi-art-form study devoted specifically to post-colonial minority cultures within France.

3 In French and/or international law, none of these territories was formally classified as a colony. Officially regarded as an integral part of French territory, Algeria was subject to the French Interior Ministry instead of the Colonial Ministry. Morocco and Tunisia were officially "protectorates," nominally retaining internal autonomy while enjoying the external "protection" of the French Foreign Ministry. In reality, all three territories were under French colonial rule, albeit in different institutional guises.

4 The published version of Thomas Spear's interview with Ben Jelloun is an English translation. Spear kindly permitted one of the present authors to consult the original French transcript, from which we quote here. We have also slightly reworded the published translation.

5 For a critique of this usage, see Wacquant (1992), who underlines the fact that ethnic concentrations are less intense in French cities than in the USA.

6 These celebrations were accompanied by a heated debate – opposing in particular right-wing Catholics on the one hand and more secularly-minded citizens on the other – over the appropriateness of Clovis as a symbol of French national identity (*The Times* 1996a). The Rector of the Great Mosque of Paris also protested over the exclusion of France's Muslim minority by the organizers of the commemoration (*Le Monde* 1996b).

7 Explicit affirmations of racism by Le Pen in the summer of 1996 (*Le Monde* 1996c) led the government to draft tough new anti-racist legislation (*Le Monde* 1996d).

8 We are well aware of the racist purposes that the notion of cultural distance has sometimes served in France and elsewhere. Our own use of this concept should not be taken to imply any hierarchical ordering of different cultures.

9 Interview with Alec G. Hargreaves, April 21, 1988.

10 Letter from Soraya Nina to Alec G. Hargreaves, June 1, 1994.

11 The state-funded Fonds d'Action Sociale pour les travailleurs immigrés et leurs familles (FAS) does support cultural activities among minority groups, but only on condition that such activities are judged to assist "integration" (Hargreaves 1995: 205–6). Cf. Derderian (below, Chapter 6) and Mahdjoub (below, Chapter 10).

REFERENCES

Ager, Dennis (1996) *"Francophonie" in the 1990s: Problems and Opportunities*, Clevedon/Philadelphia/Adelaide: Multilingual Matters.

Ahmad, Aijaz (1987) "Jameson's rhetoric of otherness and the 'national allegory,'" *Social Text*, vol. 6, no. 2, Fall, pp. 65–88.

—— (1992) *In Theory: Classes, Nations, Literatures*, London/New York: Verso.

Amar, Marianne, and Pierre Milza (1990) *L'immigration en France au XXe siècle*, Paris: Armand Colin.

Anderson, Benedict (1994) "Exodus," *Critical Inquiry*, vol. 20, no. 2, Winter, pp. 314–27.

Appiah, Kwame Anthony (1991) "Is the post- in postmodernism the post- in postcolonial?" *Critical Inquiry*, vol. 17, no. 2, Winter, pp. 336–57.

Apter, Emily (1995) "French colonial studies and postcolonial theory," in *SubStance*, nos 76–7, pp. 169–80.

Ashcroft, Bill, Gareth Griffiths, and Helen Tiffin (1989) *The Empire Writes Back: Theory and Practice in Post-Colonial Literatures*, London/New York: Routledge.

Ashcroft, Bill, Gareth Griffiths, and Helen Tiffin (eds) (1995) *The Post-Colonial Studies Reader*, London/New York: Routledge.

Barbara, Augustin (1986) "Discriminants et jeunes 'Beurs,'" in Georges Abou-Sada and Hélène Milet (eds), *Générations issues de l'immigration: Mémoires et devenirs*, Paris: Arcantère, pp. 123–8.

Barker, Frances, Peter Hulme, and Margaret Iversen (eds) (1994) *Colonial Discourse/Postcolonial Theory*, Manchester/New York: Manchester University Press.

Benson, Eugene, and L.W. Conolly (eds) (1994) *Encyclopedia of Post-Colonial Literatures in English*, London/New York: Routledge, 2 vols.

Betts, Raymond F. (1961) *Assimilation and Association in French Colonial Theory and Practice*, New York: Columbia University Press.

Bhabha, Homi (1990) "The third space," interview by Jonathan Rutherford, in Jonathan Rutherford (ed.), *Identity: Community, Culture, Difference*, London: Lawrence & Wishart, pp. 207–21.

—— (1994) *The Location of Culture*, London/New York: Routledge.

Boehmer, Elleke (1995) *Colonial and Postcolonial Literature: Migrant Metaphors*, Oxford/New York: Oxford University Press.

Chambers, Iain, and Lidia Curti (eds) (1996) *The Post-Colonial Question: Common Skies, Divided Horizons*, London/New York: Routledge.

CNCDH (Commission Nationale Consultative des Droits de l'Homme) (1991) *1990. La lutte contre le racisme et la xénophobie*, Paris: La Documentation française.

—— (1994) *1993. La lutte contre le racisme et la xénophobie*, Paris: La Documentation française.

Deleuze, Gilles, and Félix Guattari (1975) *Kafka: Pour une littérature mineure*, Paris: Minuit.

Dewitte, Philippe (1985) *Les mouvements nègres en France, 1919–1939*, Paris: L'Harmattan.

Dirlik, Arif (1994) "The postcolonial aura: Third World criticism in the age of global capitalism," *Critical Inquiry*, vol. 20, no. 2, Winter, pp. 328–56.

Featherstone, Mike (ed.) (1990) *Global Culture: Nationalism, Globalization and Modernity*, London: Sage.

Gallissot, René (1989) "Au-delà du multiculturel: Nationaux, étrangers et citoyens. Urbanisation généralisée et transnationalisation," *Revue internationale d'action communautaire/International Review of Community Development*, no. 21/61, Spring, pp. 27–33.

Génériques (1990) *Presse et mémoire: France des étrangers, France des libertés*, Paris: Mémoire-Génériques/Editions ouvrières.

Gilroy, Paul (1993) *The Black Atlantic: Modernity and Double Consciousness*, Cambridge, MA: Harvard University Press.

Hall, Stuart (1996) "When was 'the post-colonial'? Thinking at the limit," in Iain Chambers and Lidia Curti (eds), *The Post-Colonial Question: Common Skies, Divided Horizons*, London/New York: Routledge, pp. 242–60.

Hargreaves, Alec G. (1995) *Immigration, "Race" and Ethnicity in Contemporary France*, London/New York: Routledge.

—— (1996) "A deviant construction: the French media and the 'banlieues,'" in *New Community*, vol. 22, no. 4, October, pp. 607–18.

—— (forthcoming) "Multiculturalism," in Laurence Bell and Christopher Flood (eds), *Political Ideologies in Contemporary France*, London: Pinter.

Hay, Denys (1968) *Europe: The Emergence of an Idea*, rev. edn, Edinburgh: Edinburgh University Press.

Hutcheon, Linda (1995) "Colonialism and the postcolonial condition: complexities abounding," *PMLA*, vol. 110, no. 1, January, pp. 7–16.

IGAS (Inspection Générale des Affaires Sociales) (1992) "Enquête sur l'insertion des jeunes immigrés dans l'entreprise," Paris: IGAS.

Jameson, Fredric (1986) "Third-World literature in the era of multinational capitalism," *Social Text*, vol. 5, no. 3, Fall, pp. 65–88.

Jenkins, Brian (1996) *Theorising Nationalism: A Map of the Terrain*, inaugural professorial lecture, Portsmouth, Hants: University of Portsmouth.

Jeyifo, Biodun (1989) "On eurocentric critical theory: some paradigms from the texts and sub-texts of post-colonial writing," *Kunapipi*, vol. 11, no. 1, pp. 107–18.

Kenzi, Mohammed (1984) *La menthe sauvage*, Lutry: Bouchain.

Kritzman, Lawrence D. (ed.) (1995) "France's identity crises", special issue of *SubStance*, nos 76–7.

Lionnet, Françoise and Scharfman, Ronnie (eds) (1993) "Post/colonial conditions: exiles, migrations and nomadisms," special issue of *Yale French Studies*, no. 82.

McClintock, Anne (1992) "The angel of progress: pitfalls of the term 'post-colonialism,'" *Social Text*, vol. 10, nos 2–3, pp. 84–98.

Marie, Claude-Valentin (1993) "Les Antillais en France: Histoire et réalités d'une migration ambiguë," *Migrants-formation*, no. 94, September, pp. 5–14.

Miller, Christopher L. (1990) *Theories of Africans: Francophone Literature and Anthropology in Africa*, Chicago/London: University of Chicago Press.

Le Monde (1996a) "Les réseaux FM protestent contre les quotas de chansons francophones," January 10.

——— (1996b) "Restructurations et contestation à la Mosquée de Paris," April 5.

——— (1996c) "M. Le Pen: 'Oui, je crois à l'inégalité des races,'" September 1–2.

——— (1996d) "Le projet antiraciste de M. Toubon vise explicitement le Front National," September 22–3.

Mounsi [Mohand Nafaa Mounsi] (1995) *Territoire d'outre-ville*, Paris: Stock.

Muxel, Anne (1988) "Les attitudes socio-politiques des jeunes issus de l'immigration maghrébine en région parisienne," *Revue française de science politique*, vol. 38, no. 6, December, pp. 925–40.

Nini, Soraya (1993) *Ils disent que je suis une Beurette . . .* , Paris: Fixot.

Parry, Benita (1987) "Problems in current theories of colonial discourse," *Oxford Literary Review*, vol. 9, nos 1–2, pp. 27–58.

Potts, Lydia (1990) *The World Labour Market: A History of Migration*, trans. Terry Bond, London: Zed Books.

Rioux, Jean-Pierre (ed.) (1990) *La guerre d'Algérie et les Français*, Paris: Fayard.

Robbins, Bruce (1994) "Secularism, elitism, progress, and other transgressions: on Edward Said's 'voyage in,'" *Social Text*, vol. 12, no. 3, Fall, pp. 25–37.

Roy, Olivier (1991) "Ethnicité, bandes et communautarisme," *Esprit*, no. 169, February, pp. 37–47.

——— (1993) "Les immigrés dans la ville: Peut-on parler de tensions 'ethniques'?" *Esprit*, no. 191, May, pp. 41–53.

Sherzer, Dina (ed.) (1996) *Cinema, Colonialism, Postcolonialism: Perspectives from the French and Francophone World*, Austin, TX: University of Texas Press, pp. 229–48.

Shohat, Ella (1992) "Notes on the 'post-colonial,'" *Social Text*, vol. 10, nos 2–3, pp. 99–113.

SOFRES (1995) *L'état de l'opinion 1995*, Paris: Seuil.

Spear, Thomas (1993) "Politics and literature: an interview with Tahar Ben Jelloun," in Françoise Lionnet and Ronnie Scharfman (eds), "Post/colonial conditions: exiles, migrations and nomadisms," special issue of *Yale French Studies*, no. 82 pp. 30–43.

Spivak, Gayatri Chakravorty (1988) "Can the subaltern speak?" in Cary Nelson and Lawrence Grossberg (eds), *Marxism and the Interpretation of Culture*, Chicago, IL: University of Illinois Press, pp. 271–313.

——— (1990) "Poststructuralism, marginality, postcoloniality and value," in Peter Collier and Helga Geyer-Ryan (eds), *Literary Theory Today*, Ithaca, NY: Cornell University Press, pp. 219–44.

Stora, Benjamin (1991) *La gangrène et l'oubli*, Paris: La Découverte.

The Times [London] (1996a) "Pope in political minefield as French feud over visit," September 19.

——— (1996b) "France fetes African statesman," October 11.

Ungar, Steven, and Tom Conley, (1996) *Identity Papers: Contested Nationhood in Twentieth-century France*, Minneapolis, MN: University of Minnesota Press.

Wacquant, Loïc J. D. (1992) "Banlieues françaises et ghetto noir américain: De l'amalgame à la comparaison," *French Politics and Society*, vol. 10, no. 4, Autumn, pp. 81–103.

Wihtol de Wenden, Catherine (1994) "The French response to the asylum seeker influx, 1980–93," *Annals of the American Academy of Political and Social Science*, vol. 534, July, pp. 81–90.

Williams, Patrick, and Laura Chrisman (eds) (1993) *Colonial Discourse and Post-Colonial Theory: A Reader*, New York/London: Harvester Wheatsheaf.

Yúdice, George (1989) "Marginality and the ethics of survival," in Andrew Ross (ed.), *Universal Abandon? The Politics of Postmodernism*, special issue of *Social Text*, vol. 7, no. 3, Winter, pp. 214–36.

LA FRANCE ARABE

David A. McMurray

FRANCO-ARAB POPULAR CULTURE

Living in Lyon, France, during the academic year 1995–6 was a bit like being on the set of a French remake of *Invasion of the Bodysnatchers*. Thirty years after the original movie, the pod people in the imaginary French version are played of course by North African Arabs who, according to doomsday analysts like Le Pen, have been so successful in their stealth invasion that contemporary French history, unless the true French nation wakes up and reacts quickly enough, will in the future be characterized as having been an inexorable slide from "French Algeria to Algerian France" (Dely 1996: 9). Shortly after this lurid pronouncement by Le Pen, Brigitte Bardot publicly seconded his warning in graphic terms on the eve of the Muslim feast of Aid al-Kabir. France was indeed being invaded, in her words, by "a surplus of foreigners, especially Muslims" that insidiously opened mosques while churches closed and that slit the throats of French animals to meet the requirements of their own foreign blood rituals (Bardot 1996: 2). Finally, twelve famous chefs joined in with their own clarion call about the threat to the national cuisine, which was "threatened by globalization." *Le Figaro* picked up the cry to defend the French culinary heritage, even describing its importance as a "tricolor crusade against a cuisine bastardized by culinary cross-breeding." A young chef by the name of Philippe Groult, perhaps more conscious than the others of the specifics of the imminent danger, called out valiantly for all to give up such hideous hybrids as "couscous made from red beans flavored with Thai herbs" (Noce 1996: 25).

It was early in April 1996 that I had my own epiphany. One day, I realized that in the space of a week I had been to four movies that had something to do with

Arabs[1] – okay three, if you won't allow me Scorsese's *Casino* with Joe Pesci selling stolen jewelry to Arab (?!) diamond merchants in Los Angeles. The first was *Sale Gosse* (by Claude Mouriéras, starring Anouk Grinberg and Axel Lingée, opened on March 27) in which Lingée, a young teen, tries to ignore his sorry *banlieusard*[2] existence by living out the dream that he is the offspring of a Touareg warrior of the desert. The next day I found myself watching *Chacun cherche son chat* (by Cédric Klapisch, starring Garance Clavel, Zinedine Soualem, Renée Le Calm, opened on April 3) in which Soualem plays a brain-damaged Arab buffoon of the *11e arrondissement* who helps our heroine find her lost pet. The third film to catch my attention was *Pédale douce* (by Gabriel Aghion, starring Patrick Timsit, Fanny Ardant, Richard Berry, Michèle Laroque, and Jacques Gamblin, opened on March 27) wherein Gamblin performs a seductive homosexual striptease with all of the requisite limp-wrist Oriental dance gestures to the accompaniment of Dalida's Arabic song "Salma ya Salama."

What is going on here? Why all of this Arab-ness in one week of French film-going? Why do I get the impression all of a sudden that French popular culture is saturated with Arab signifiers? I asked myself. It could just be coincidence. Or perhaps I am extrapolating unjustly from my casual observations. I have been on-again off-again paying attention to manifestations of Franco-Arab cultural hybridity (Gross *et al.* 1994), so maybe I am too close to the subject to judge it fairly.

During the rest of the week I found myself continuing to marvel at what looked to be a very high level of Arab content in all aspects of French popular culture, so high that I resolved to trail it more closely. I decided to choose one week and during that week to keep close track of any and all references to Arabs, people of Arab heritage, and the Arabo-Islamic world that cropped up, whether direct or indirect, whether central or tangential. I chose April 13–19, 1996 as my week to observe, and decided to concentrate on television and music radio as my sources. The week was not arbitrarily chosen in that, first, it followed on the heels of my celluloid revelation; second, the dates coincided with the Saturday–Friday format of France's most interesting television magazine, *Télérama*, which I used as my bible to guide me and my videocassette recorder through the audiovisual maze that awaited us.

The findings revealed by my rigorous methodology are recorded in what follows. Needless to say, my study demonstrates the extraordinary plenitude of Arab-ness in French popular culture. The prophets of societal pollution are correct: the extent of Franco-Maghrebi cultural production, general French interest in the Arab world, and the sheer number of "mixed-blood" sports heroes

all lend credibility to the notion that French culture is already irremediably hybridized. From the soccer field to the recording studio, from Sunday morning talk shows to prime-time docudramas, Arabs are everywhere. Why they might be so omnipresent in the flesh as well as in the French popular imagination are questions I want to address more seriously in the last section of the chapter. But first let me give you an idea of the density of signifiers of Franco-Arab cultural hybridity by summarizing what went on in France from Saturday, April 13, through Friday, April 19, 1996. My account of television offerings for the week is a very brief summation followed by a slightly more fleshed-out musical synopsis.

ARABS ON THE FRENCH TUBE

Arabo-Islamic content and/or Arab or Franco-Arab personalities made appearances all over the French television dial during the week in review. Hardly a genre of television fare escaped. By my count, Arab influence appeared most often in documentaries, ten of them to be exact, covering subjects as diverse as the Suez Canal, Moroccan fishing, the Algerian War of Liberation, Jean Genet's Arab world travels – even the life of a successful Franco-Tunisian businessman.

The talk-show genre in both its highbrow and lowbrow forms chalked up the next largest number of programs with Arab content throughout the week. Authors like the Algerian, Malek Chebel, held down the high side, while comedians and actors such as Smaïn warmed the couches of the more popular programs.

Musical variety hours made a strong bid during the week as well, thanks in particular to the energies of the popular Franco-Egyptian producer/presenter, Nagui. He was joined in the genre by rock concert summaries that detailed the performances of rock groups, with Franco-Arab groups being scattered among them.

Feature-length films by or about Arabs did not trail far behind. In fact, in terms of the amount of time taken up, this may be the number one genre. In any case, the French had their choice of at least four films that week, including such classics as *Lion in the Desert* and *Death on the Nile*, accompanied by an old 1960s turkey about white slave trading, entitled *Vengeance du Sarrasin*, and another racist piece of drivel from the 1980s about *banlieue* immigrants called *L'Arbalète*.

The genre of sports television held its own during the week. No fewer than

three soccer matches were televised, all three featuring Arab-origin players in key roles. This is not so surprising when you realize that since 1944 approximately 2,000 players of foreign origin have played soccer on French teams in the first and second divisions (or 15 percent of all top division players); 227 from North Africa and 333 from sub-Saharan countries. Algerians have been the most numerous, followed by Senegalese, Moroccans, and players from the Ivory Coast (Bozonnet 1996: 16). What is surprising, however, is the soccer statistic that in 1958, while the Algerian War was raging, a full 50 percent of the French national team was composed of players of Algerian origin (Boudjedra 1995: 194–5).

Finally, I found some Arab-related programming in the genres of morning cartoons (*Aladdin*, etc.), made-for-television films (*Sa vie à elle*) and in advertising (Omar Sharif popped up several times during the week for about five seconds each time to urge French viewers to buy a horse-racing magazine), but to a lesser extent.

ARABS ON THE AUDIO AIRWAVES

Let me begin with a rundown of the Beur[3]/Arab music in rotation during our week. That information is gathered on an every-other-week basis by an industry publication called *Le bulletin de l'industrie du disque et des médias*, (hereafter referred to as *Le bulletin*), which compiles music playlists from major and minor radio stations plus the television Channel M6. The publication of *Le bulletin* cuts through my week so I have had to combine information from both the April 15 issue (covering the two weeks from the 1st through the 14th) and the April 29 edition (covering the two weeks from the 15th through the 28th) (Anonymous 1996a, 1996b).

The first category covered by *Le bulletin* goes under the name of "Le choix des programmateurs partenaires du 150," which means it's a rundown of the playlists of regional member station music programmers who provide the information needed to determine the 150 most-played songs in France in each two-week period. Some interesting choices appear on their lists.

S. Scudier of 12FM in the southern French city of Rodez lists *Le bruit et l'odeur* ("The Noise and the Smell") by Zebda (Barclay/Polygram 1995) at the top of his list (*Le bulletin* April 29, 1996: 6). Scudier's choice of Zebda may have been motivated by his own regionalist sensibilities. I say that because Zebda ("butter" in Arabic) is a group of ragamuffin rappers from the *banlieues* of Toulouse who

were nursed along by the Occitan intellectual, Claude Sicre of the group The Fabulous Trobadors, and who thus share his enthusiasm for locally focused popular culture. The album title is, of course, a reference to Jacques Chirac's complaint about immigrants in France,[4] a condition from which the majority of the band's members are only one generation removed (the singer/songwriter/leader of the group, Magyd Cherfi, is Beur, as are the other two singers, Hakim and Mustapha Amokrane).

Le bulletin (April 15, 1996: 26) mentions that C. Métayer, programmer for Vichy FM, was giving a lot of airtime during our week to the Beur Karim Kacel's *L'orage est passé* ("The Storm Has Passed") (WMD 1995). Were it not for his North African origins, Kacel would not merit a mention here, for the only acknowledgement of his Arab heritage on the album amounts to some Arabic vocal riffs on the track, "Mourir de rire." Otherwise he is a mainstream French variety singer with little to distinguish him from the pack.

Finally, C. Espinasse of station Fugue FM in Compiègne reported giving maximum airtime to the CD *A ma manière* (East West 1996) by the late, great Dalida (*Le bulletin* April 29, 1996: 6). Dalida popped up twice during the week in question: here on the radio, and then again singing in Arabic on the soundtrack to the highest-grossing movie of the week, the gay comedy mentioned earlier, entitled *Pédale douce*.

I had no idea at the time of the connection between the Franco-Italo-Egyptian Dalida and the gay community in France. I asked around and soon found out that she is something of a local deity, the equivalent of a Judy Garland, Barbra Streisand, and Maria Callas rolled into one. My informants told me that hardly a night goes by in a Lyon gay club without at least one song of Dalida's being played.

For those of you in the dark about the centrality of Dalida to French popular culture – no, make that Mediterranean popular culture – I recommend the hagiography by Catherine Rihoit called (in big red letters) *Dalida* (1995). There, in 500 pages, you will find out all you want to know about the diva.

Let me condense down to the essentials the rest of Dalida's interesting Franco-Arab biography: Dalida, born on January 17, 1933 in the popular quarter of Shoubra, was a third-generation Italian-Egyptian whose father played first violin at the Cairo Opera. In the early 1950s, she won the "Miss Egypt" beauty pageant and then emigrated to Paris to begin her singing career, which went quite well almost from the start because she hooked up with Eddie Barclay and then married Lucien Morisse, the gatekeeper at the then quite important radio station Europe 1.

Dalida's long and tempestuous relationship with the Arab world continued after she had left Cairo. Not the least of her accomplishments was the fact that she became, at the request of Ben Bella, the first French-language singer (she had yet to record in Arabic at the time) to perform in independent Algeria – and that after having just previously been a poster girl for the French paratroopers. A couple of years later, in 1966, she was almost booed off the stage in Casablanca and was then placed under guard for insisting on singing "Hava Naguila" during her performance. That transgression, combined with her appearances in Israel, got her placed on the Arab boycott list, which meant that Arab national radio stations refused to give her airtime and her records could not legally be sold in the Arab world. She continued to perform in less-doctrinaire Beirut, however.

In August 1977, Dalida and her impresario brother, Orlando, determined that it was time for her to recapture the Arab market. They contacted a Cairiene composer and had him arrange an Egyptian folk tune called "Salma ya Salama." The song immediately became a hit throughout the Arab world. The song's oriental undulations were reportedly so irresistible that, even in the midst of the disco fever of the time, the song became a huge European success. To cap it all, the Israelis played "Salma ya Salama" as the welcoming song for Sadat as he descended from the plane on his historic visit to Jerusalem in November of that year. Finally, and to bring things full circle, an informant in Cairo tells me that Dalida has five or six tapes out on the market now, in 1996, in Egypt.

There is a second category in *Le bulletin* called the "Playlist," which is a rundown of what the big deejays on the major French stations are broadcasting to the national audience on a biweekly basis. One of those national deejays, Patrick Chompre of station Radio France Inter, listed "Eau et vent" off the album *Lapis Lazuli* (Reseau/Sony 1995) by Abed Azrié as one of his newest choices (*Le bulletin* April 29, 1996: 11). Abed Azrié was born in Syria but has lived in France for the last eighteen years (Lee 1996). He claims to belong to no particular Arabic musical tradition, though the texts on this album are taken from various Sufi writers (Omar Khayyam, Emir Abdelkader, etc.) of the past. More-traditional instruments such as the violin, nay, qanun, and darbuka are mixed with the various sounds of a synthesizer to provide accompaniment for the languorous, soft and smoky baritone voice of Azrié. The overall effect of the slow, moody tempo, the melancholic, plaintiveness of the voice, and the juxtaposition of electronic and acoustic instruments comes closest to what gets labeled "New Age" music in the United States. No such category yet exists in France, so he is to be found in the "World Music" section of most music stores (cf. Warne, below, Chapter 8).

Add to Abed Azrié, Cheb Mami, the "Prince of Raï," whose song "Mama"

(Virgin), in a Cutee B remix single, was selected for major airplay during our week by deejay Loïc Dury of the very influential Parisian station, Radio Nova (*Le bulletin* April 15, 1996: 25). When I read this, I asked a Franco-Algerian secretary at Lyon II university, whom I know to be a big fan of raï, for her preference between Khaled and Cheb Mami and for her thoughts as to why Mami would be getting airtime right now. She responded: "Mami isn't so vulgar. I think his musical style is more authentic, and his music more thoughtful, more nuanced than Khaled's. And Mami's not bad-looking either." I think she might be on to something here. Mami certainly had the reputation back in Algeria of being more of a ladies' performer (Daoudi and Miliani 1996: 104). I have a hunch that Mami's place in raï circles in France is increasingly important today for much the same reason; namely, he appeals more and more to the female raï-buying market, a niche less likely to identify with the, shall we say, flamboyant Khaled, who periodically has risqué run-ins with wine, women, and politics that are eagerly followed by the press (his antics provide the stuff of whole chapters in his authorized biography: Belaskri 1995). Mami, by contrast, plays the sexual adolescent, the prude, and the apolitical. He won't be baited. He claims to be concerned, for instance, by the conditions of life of Franco-Arab *banlieusards*, but refuses to play the role of spokesman. As he puts it, "Journalists ask too much of us. We're not intellectuals or political. And in any case, making raï music well known is already a struggle" (Azoulay 1996: 50).

J.F. Villette and R. Demange of Voltage FM list "Le seul remède" (RCA/BMG 1995) by a young Beurette rapper as one of their picks of the week (*Le bulletin* April 15, 1996: 25). Melaaz (she claims it as her real name) is a teens/early-twenties French resident of Little Kabylia origin.[5] She got her start in the posse of MC Solaar in the late 1980s–early 1990s because they both came of age in Villeneuve-Saint-Georges and so knew each other, according to the magazine cover interview she did for *L'Affiche* last year (Cachin 1995).

Melaaz counts as one of the few female rappers with any visibility in France in spring 1996 (Princesse Erika being the other one right now). The video clip of Melaaz's single, "Je marche en solitaire" (BMG/Ariola), with its ubiquitous hands of Fatima motif, rotated constantly on MCM video programs.

The only "Arab" song on Melaaz's album is titled "Lehna" (on side A) where, unfortunately, Berber/Arab phrases are used more as scratched refrains, while the content of the song is carried by the French lyrics. Why she chose to avoid attempting a real ragga rap using Arabic or Berber remains unexplained. She does mention in the interview that she left Little Kabylia at the age of three, so her Arabic/Berber may be a bit rusty.

The same J.F. Villette and R. Demange of Voltage FM also list the single "Louled" (Delabel/Virgin) by K-Mel (Kamel Houairi) as another one of their picks of the week (*Le bulletin* April 15, 1996: 25). K-Mel, like Melaaz (and like Isabelle Adjani and Mouloudji and one of the members of the all-male a cappella group Pow Wow), is of Little Kabylia origin and is best known as the head of the very successful rap group Alliance Ethnik. *Le Monde* recently crowned him "the premier Beur idol of French youth," according to Mezouane (1996: 20). At the end of March 1996, K-Mel and Alliance Ethnik were getting airplay on a nationally important youth music station, NRJ, thirty-seven times a week. In 1995, Alliance Ethnik sold over a million copies combined of their three singles: "Respect," "Simple & Funky," and "Honesty and Jalousie" (Charvet 1996: 10) and were heard on radio stations in France an average of forty-eight times a day (Grumel 1996: 85). So you know they are the hottest group on Delabel's rap list. The song "Louled" (meaning "child" in Arabic and "birth" in Berber) selected by the above-mentioned deejays was a solo number by K-Mel commissioned by the comedian Smaïn for his film *Deux papas et une maman* (Hakem 1996: 90). The video clip for the song, compiled from scenes from the film, received maximum rotation during our week because the movie it was advertising was due to open the following week. The song has nothing going for it other than that it may be a French popular culture milestone representing possibly the first time a Franco-Arab movie producer contacted a Franco-Arab rapper to crank out a generic song to publicize a film with a Franco-Arab star. No mean feat, I guess, if you look at it that way.

ORIGINS OF FRANCO-ARAB CULTURAL HYBRIDITY

I want to reiterate that my main purpose in this chapter is to demonstrate the extraordinary plenitude of all things Arab in French popular culture, whether it be in the fields of music, television, movies, radio, or sports. By my calculations, the amount of television time alone in which Arabo-Islamic themes or personalities figured approached thirty hours for the week under observation. Another week would no doubt render different results, or some of my choices could be argued to have been too tangential for consideration. Nonetheless, I think that the sheer density of Arab-ness in French popular culture must be conceded.

Now as to why that is the case. Perhaps the most important explanation is that it has always been so; French culture has always been heterogeneous. The inspirational interconnections between the French and the Andalusian, Persian, Egyptian, and Levantine worlds, to name only a few, have always formed part of the French cultural bedrock. As Alcalay (1993) puts it, the mythical beast in the French imagination is the notion that there exists a purified, exclusive "French" culture, which is the product of the creative genius of the homogeneous French nation. That particularly widespread belief should be seen, he argues, as the more ideologically charged position, more in need of unpacking than the anti-exclusivist position supported here.

Yet even if you concede the point that French culture has always been a hybrid, the cultural heterogeneity of each age and the accompanying structural relationships between cultures still must be seen as springing from specific historical conditions. It is those that I would like to make a stab at enumerating for the present epoch. I can come up with four interrelated explanations for the richness of Arab signifiers in the contemporary French context. The first and perhaps most intriguing involves the erotic, psychodynamic aspects of the relationship between France and the ex-North African colonies. Malek Alloula's *Colonial Harem* (1986) maps out the terrain historically. The task now would be to examine how much of it remains in the contemporary setting. Not much, I think. The eroticization of brown, Arab bodies seems to play very little role in French advertising, for instance – at least my casual attempts to run down examples have not paid dividends. Likewise, little of the pornography advertised for sale in France appears to play with fantasies inspired by attraction/repulsion for Arabs. There is one porno star of some renown from Morocco named Dalila (Drouet 1996), but she is the only one that I could locate. There are some recent cinematic instances of the objectification of Arab bodies. For example, the 1995 film *Bye-Bye* (Karim Dridi, director) uses the competition between the brown and white male leads as an opportunity to undress the Beurette object of their attraction. The 1994 made-for-television film *L'été de Zora* (Marc Rivière, director) and the 1995 feature film *Raï* (Thomas Gilou, director) both include key scenes where the bodies of Franco-Arab female characters are paraded out for consumption by the (presumably French) male gaze. (Not that it changes things, but in reality, neither of the women involved was of Arab origin.)

These few cinematic examples, to my mind, suggest a paucity of powerful, specifically Arab erotic imagery in France at the moment. Looking back over the week's television programming, I can only single out a few cases of an intense psycho-sexual attraction/repulsion at work. The film *L'Arbalète* by Serge Gobbi

with its vicious Le Pen-like portrayal of Arabs and other immigrants as so many jungle creatures would fit the bill. Otherwise, most of the imagery seems worn out by today's standards. I am thinking, for instance, of the risible virility of an old-age Omar Sharif. The oriental allure he once exercised over his Western audiences has diminished considerably, to say the least. Or the thrill of pirate adventure as in *Le Sarrasin* and its erotic association with white abduction/seduction, still powerful in 1960, seems silly today. One could make the case, perhaps, that cartoons like *Aladdin* begin the process of schooling children to associate the Arab world with erotic violence, but even that strikes me as a stretch.

I would make an exception for the discourse from the right that increasingly uses powerful sexual imagery to demonize the Arabs. For example, almost every Front National pamphlet makes reference somewhere to the increase in the number of "robberies and rapes" in the immigrant *banlieues*. Or here in Lyon, the far right constantly rages against the recently opened (1994) Great Mosque that "gives the finger to the Basilica of Fourvière" (Creux 1995: 24). But the extreme right's sexualized imagery figures hardly at all (yet) in dominant French cultural production. Perhaps the mainstream avoids sexualized Arab imagery exactly because of the right's corner on that particular angle. Perhaps such images are too loaded with negative connotations to make the kinds of appeals advertisers are looking for. Both explanations are plausible. Or perhaps the fear that the Franco-Arab community might take offense at publicity campaigns, television programs, or movies using nude Arab bodies causes producers to pause. Again, that is possible. But I do not put much stock in any of them as explanations. I wonder, rather – admitting my outsider status and great hesitation to bark up this alley – if there is not something too close about Arabs? I wonder if perhaps the lack of much phenotypic distinction between most "white" French and most "brown" Arab bodies means that the attempt to manufacture a distinction based on such difference as exists just does not excite attention in the contemporary setting (what with the rise of sun-tanning in France or, working in another way, the presence of North Africans in the most mundane settings in even the smallest towns). The nude Arab figure is not far enough removed from the nude French figure to suggest much in the way of exotic alterity to today's viewer. Whatever the reason, I think it is fair to say that the sexualized Arab of the French imagination, though admittedly quite a potent force on the far right in France, appears less important as an explanation for the presence of "the Arab" in mainstream French popular culture.

A second, less intriguing explanation derives from France's Gaullist Arab

policy. Remember that after the 1967 War and the crushing victory of the Israelis, de Gaulle withdrew his support for Israel and began to curry a "special relationship" with the Arab world. It was no accident that decades later, the Institut du Monde Arabe opened in Paris – not London or Washington or Bonn. French universities are chockfull of Oriental Institutes, centers for the study of the Mediterranean world, Arabic language and culture programs, and so forth. Granted, the colonial legacy plays a role here, but the successive support of French governments plays an equally important role. In fact, during our week in question, Chirac visited Lebanon and then delivered a speech in Cairo on the necessity of France continuing to develop a coherent Mediterranean policy.

I think the development in French academic and political circles of this critical mass of interest in the Arab world motivates much of the didactic public television programming on Arabo-Islamic themes. These documentaries represent, to my mind, a kind of ideological expression of the geo-strategic interests of the French state in the Middle East and North Africa, interests which take the media form of more or less organized, official encouragement of general curiosity about the Arab world.

There is a third explanation for the plethora of Arab entertainers, sports figures, and themes in French popular culture, which stems from the psycho-economic reproduction of colonial relations of dependence even after independence; in other words, from neo-colonialism. I am thinking here of the kind of paternalistic mentality in France which makes many French comfortable with Arabs, "good" Arabs, you know, Arabs who serve, who stay in their place, like Arab greengrocers, waiters, cleaning women, or secretaries; Arabs who are like us only of different origin; particularly Berbers, they're the best, the funniest and smartest and most honest and hardest-working. Arab food is good, too. Some of it. Couscous. Tabouli. Anyway it's cheap.

I know I am on slippery terrain here, but I can't help but think that there is often a paternalistic streak at work when white French sports fans or a televison audience sit down comfortably to watch Arabs or Franco-Arabs perform. I am thinking of the popularity of the benign assimilationist goofiness of Smaïn here, poking fun at Franco-Arab foibles (his "Beur for President" routine, etc.) for the delectation of his white French fans. Or take the way Arab-origin athletes are often portrayed as having "made it," of having escaped, as if the natural tendency of the run-of-the-mill Arab in France were to lie about in poverty.

A more concrete neo-colonial influence on the level of all things Arab in French popular culture stems from the persistence of French as the prestige language in North Africa. Because the French, unlike the more mercantilist-

minded British, saw the colonial mission as mainly a civilizing one, they worked harder at implanting French as the dominant means of communication in their colonies. The North African elite chose to continue the use of French after independence in order to insure the reproduction of their own dominance (see Laroui 1973); so today, Arab world entertainers and athletes (and doctors and architects, etc.) can move easily up to the former colonial metropolis to further their careers without worrying about a language barrier. The general draining of talent from Arab North Africa to France is thus one of the most important consequences of this francophone hangover.

A fourth reason for the abundance of Arab-ness in French popular culture stems from the post-colonial and post-industrial transformations of metropolitan France, the most important features of which are, in brief: de-industrialization and the immiseration of large segments of the working class; an increase in ethnicity-based hatred, fear and violence – of which immigrant populations are the main targets; and the establishment of permanent North African communities now including second and even third generations. These developments, I would argue, have laid the groundwork for the rise to prominence of the popular cultural expression of the marginalized Franco-Maghrebi population – particularly its youth. The multiethnic *banlieues*, those bleak zones of high-rises, minimal public facilities, substandard schooling, and exceptional rates of unemployment (70 percent of the children of immigrants in Lyon between sixteen and twenty-five have no jobs: Begag 1990: 6) are the true loci of the "immigrant" problem as well as the focus of the community's creative defiance, which takes as one form the creation of a variety of powerful, expressive cultural styles (see Gross *et al.* 1994). What I find interesting is that the popular cultural – particularly musical – production of these most marginalized and dispossessed segments of French society has come to claim so much of the nation's attention, almost to the point of dominating it musically. There is something about the oppressive deprivation suffered by those living on the French margins and the anger and despair it engenders in them that gets channeled into the creation of a vital cultural life. The disproportionate presence of *banlieue*-originated styles in French youth culture – in the language, in dress, in speech, and particularly in music – testifies to the dynamism of marginal existence. Dominant players in popular cultural production and distribution at the national level attempt to shape and control the creatively resistant energies emerging on the national periphery, but they don't completely succeed. It would seem that the urge to be expressively creative about the startlingly awful realities lived by youth on the margins cannot easily be contained. How ironic, then, that the irrepressible creativity of the maligned and

marginalized multiethnic *banlieues* may be the best bulwark against a dominant French discourse that seeks to deny the most important feature of French popular culture; namely, that it is heterogeneous to the core.

NOTES

1 For present purposes, the semantic field of "Arab" is to be understood as that of everyday French usage. The complexities and ambiguities of this are discussed above, pp. 18–20.

2 For an explanation of this term, see above, p. 12.

3 On the background to this term, see above, p. 20.

4 In a June 1994 speech, Chirac sympathized with French people who disliked the "noise and the smell" associated with immigrants (Guyotat 1994).

5 Kabylia is divided by the Djurdjura mountain range into Great Kabylia to the west and Little Kabylia to the east. The majority of Kabyle immigrants in France come from Great Kabylia.

REFERENCES

Alcalay, Ammiel (1993) *After Jews and Arabs: Remaking Levantine Culture*, Minneapolis, MN: University of Minnesota Press.

Alloula, Malek (1986) *The Colonial Harem*, trans. Myrna Godzich and Wlad Godzich, introduction by Barbara Harlow, Minneapolis, MN: University of Minnesota Press.

Anonymous (1996a) "Le choix des programmateurs partenaires du 150," *Le bulletin de l'industrie du disque et des médias*, April 15, p. 26, April 29, p. 6.

——(1996b) "Playlist," *Le bulletin de l'industrie du disque et des médias*, April 15, p. 25, April 29, p. 11.

Azoulay, Eliane (1996) "Momo, Mami, Mama . . .," *Télérama*, February 14, pp. 48–50.

Bardot, Brigitte (1996) "Mon cri de colère," *Le Figaro*, April 26.

Begag, Azouz (1990) "The 'Beurs,' children of North-African immigrants in France: the issue of integration," *Journal of Ethnic Studies*, vol. 18, no. 1, pp. 1–14.

Belaskri, Yahia (1995) *Khaled*, Paris: SOGECOM-EDITION.

Boudjedra, Rachid (1995) *Lettres algériennes*, Paris: Grasset.

Bozonnet, Jean-Jacques (1996) "Ces champions français venus d'ailleurs," *Le Monde*, June 26.

Cachin, Olivier (1995) "Melaaz sans malaise," *L'Affiche*, July–August, pp. 17–19.

Charvet, Richard (1996) "Etat des lieux de la nouvelle génération de rap et de ses posses," *Le bulletin de l'industrie du disque et des médias*, Supplement no. 13, March 25, pp. 10–12.

Creux, Sylvie (1995) "Lyon: une mosquée livrée clefs en main," *Les Dossiers de Minute*, Fall, pp. 24–6.

Daoudi, Bouziane (1996) "La Villette dont le prince est Cheb Mami," *Libération*, February 17–18.

Daoudi, Bouziane, and Hadj Miliani (1996) *L'aventure du raï: Musique et société*, Paris: Editions du Seuil.

Dely, Renaud (1996) "Le Pen agite 'la colère du peuple,'" *Libération*, April 15.

Drouet, Jean-Baptiste (1996) "Dalila: réaliser ses fantasmes, c'est sombrer dans la folie," *Vidéo 7*, no. 165, April, p. 14.

Gross, Joan, David McMurray, and Ted Swedenburg (1994) "Arab noise and Ramadan nights: raï, rap and Franco-Maghrebi identity," *Diaspora*, vol. 3, no. 1, pp. 3–39.

Grumel, Nicolas (1996) "Rap et quotas: L'état est dans la place," *Radikal*, no. 19, pp. 84–7.

Guyotat, Régis (1994) "M. Chirac: 'Il y a overdose,'" *Le Monde*, June 21.

Hakem, Tewfik (1996) "K-Mel," *L'Affiche*, no. 34, May, p. 90.

Laroui, Abdallah (1973) "Cultural problems and social structure: the campaign for Arabization in Morocco," *Humaniora Islamica*, vol. 1, no. 2, pp. 33–46.

Lee, Hélène (1996) "Les maîtres anciens mystiques d'Azrié," *Libération*, June 18.

Mezouane, Rabah (1996) "K-Mel: a star is Beur," *L'Affiche*, no. 34, May, p. 20.

Noce, Vincent (1996) "Soufflé nationaliste en cuisine," *Libération*, June 10.

Rihoit, Catherine (1995) *Dalida*, Paris: Plon.

IMMIGRANT POLITICS IN A REPUBLICAN NATION

David Blatt

INTRODUCTION

As the chapters in this collection make clear, post-colonial ethnic minorities in France have succeeded in recent decades in forging a space within the national culture through their production of a rich and influential output in a wide range of artistic and cultural domains. By contrast, in the political arena, ethnic minorities have had limited success in establishing a recognized presence. Although immigration is at the very center of political conflict in France, as actors, ethnic minorities remain on the periphery of the political process.

This chapter attempts to explore and account for the limited political participation of ethnic minorities in France in light of the interplay between government policies, collective action, and political discourses concerning national identity, ethnicity, and immigrant incorporation. For a time in the 1970s and early 1980s, ethnic minorities enjoyed political opportunities that gave rise to protest movements against racism and in favor of immigrant rights, and to an associational movement that appeared particularly dynamic among the children of North African immigrants. This development, however, ran up against resurgent popular and political xenophobia, rooted in the French colonial heritage and the struggles over decolonization, in which post-colonial immigrants and their descendants served as a lightning rod for fears about worsening socio-economic conditions, the breakdown of public order in urban areas, and the erosion of national identity and culture. The increased political saliency of immigration issues helped revive a traditional French discourse on integration and the nation-state that insists on the preservation of republican principles of undifferentiated

citizenship and a firm rejection of any public recognition of ethnic and cultural identities. The widespread commitment of French political elites to traditional republican conceptions of citizenship and national identity has in turn narrowed the opportunities for ethnic minorities to participate in the political process and preempted any effective strategy by ethnic minorities and their supporters that could create space for identity-based participation in the political process. Yet this willful refusal to recognize ethnicity has been of little effect in stifling the eruption of ethnic conflict in a society in which historical memories and contemporary conditions serve to arouse ethnic identities and rivalries among both majority and minority populations.

The first section of this chapter sets out the initial emergence of immigrant social movements and the weakening of these movements as the immigration debate became politicized following the electoral breakthrough of the extreme right. I then turn to the construction of the elite political consensus in the latter part of the 1980s in opposition to multiculturalism and ethnic politics, to show how the consensus reflected both political circumstances and traditional conceptions about ethnicity. Finally, I consider how the consensus in favor of the republican model of integration has hindered and weakened subsequent efforts by minorities to develop an organized, collective presence in the French political arena.

THE EMERGENCE OF IMMIGRANT COLLECTIVE ACTION

During the three decades following the end of the Second World War, the foreign population in France doubled, from 1.7 million in 1946 to 3.4 million in 1975, essentially in response to the needs of industry for cheap manpower during a period of rapid economic expansion. French post-war politicians and planners had hoped to fill the country's labor and demographic needs by selecting "culturally compatible" immigrants from northern and southern Europe (Hollifield 1994: 147). However, stiff competition from other recruiting countries for European immigrants and France's ties with its former colonies ensured that Third World immigrants made up a steadily rising component of the foreign population. By 1982, there were close to 1.5 million foreigners from Algeria, Morocco, and Tunisia alone residing in France, with Africans accounting for 43 percent of the total foreign population (INSEE 1992: 16).[1]

Until the late 1960s, immigration was largely kept out of the arena of political

debate, competition, and mobilization. The official expectation shared by French authorities, homeland governments, and migrants alike was that this migration of foreign workers would be of a short-term nature, leading to the eventual return of most migrants rather than to their permanent settlement (Rogers 1985). With the notable exception of the protest activities mounted by the Algerian community during the struggle for independence, immigrants were effectively precluded from intervening in French politics. Immigration issues were regulated by French ministries and government agencies in consultation with French employers and trade unions, governments in sending countries, and officially recognized homeland associations (Wihtol de Wenden 1988).

This pattern of depoliticized immigration policy-making and immigrant political quiescence began to crumble after 1968. On the one hand, governments under Presidents Pompidou and Giscard d'Estaing, reacting both to economic pressures and to concerns over social conflict arising from the settlement of North African immigrants, moved to restrict migration flows and force the departure of unemployed foreigners or those whom the authorities regarded as a threat to public order (Costa-Lascoux 1989: ch. 1; Silverman 1992: chs 2–3; Weil 1991: ch. 4). On the other hand, immigrants themselves – supported by committed allies among left and extreme-left parties, trade unions, and religion-based solidarity associations – undermined the government's efforts to enforce a strict guardianship over immigrant populations and deny them opportunities to develop autonomous forms of organization and participation (cf. Weil 1991: 96). Immigrants and their allies succeeded in mounting militant protest campaigns against restrictive government policies, squalid housing arrangements, discriminatory workplace conditions, and widespread racial violence against Arab immigrants in particular (Miller 1981; Verbunt 1980). Collective action among immigrant workers and their supporters was guided by a leftist discourse denouncing the exploitation of capitalists and imperialists and supporting liberation and self-determination for oppressed nations and classes.

The election of François Mitterrand and the Socialists in 1981 signaled an important shift in the state's approach to immigrant political participation and a corresponding change in forms of immigrant collective action. Recognizing that immigrant settlement was permanent, and concerned about the potential for disruption if immigrants were excluded from political participation, the Socialists adopted several measures aimed at incorporating immigrants into the political process. A law passed in October 1981 extended to foreigners full freedom of association, a measure intended to permit immigrants to participate fully in associational life and to favor their adaptation to French society (*Presses et immigrés*

en France 1981: 20). This measure was accompanied by a substantial expansion and reorganization of the Fonds d'Action Sociale pour les travailleurs immigrés et leurs familles (FAS), which channeled additional state funding to immigrant organizations and incorporated government-designated immigrant representatives into its decision-making councils. A further dose of formal representation was provided by the creation of the Conseil National des Populations Immigrées, as a consultative body on immigration policy.

The Socialist government's efforts to recognize and promote immigrant participation and representation created opportunities for the emergence of a vibrant and diverse immigrant associational movement in the early 1980s (Jazouli 1992; Wihtol de Wenden 1994; Ireland 1994). The most dynamic and prominent group of actors were the children of North African immigrants, the self-designated Beurs,[2] who had first attracted public attention during the "hot summer" of 1981 when minority ethnic youths in the *banlieues*[3] of Lyon embarked on a spree of nighttime vandalism known as *rodéos* (Jazouli 1992: 19–26). With freedom of association recognized, and in many cases subsidized, young people of North African origin launched a flurry of associations organized around cultural production, the provision of leisure activities, and efforts to combat the racism they suffered at the hands of French institutions and individuals.

While many new Beur associations pursued an essentially non-political role as providers of various kinds of community services, several adopted a more overtly political engagement. Two kinds of politically engaged associations can be broadly distinguished (cf. Delorme 1984; Jazouli 1992: 26–43; Blatt 1995: 164–5). The first, represented by Radio Beur and the Association de la Nouvelle Génération Immigrée, tended to be made up of middle-class professionals (artists, teachers, social workers) of North African descent who were attempting to reconcile diverse cultural attachments into a hybrid Beur identity that reflected both French and Arab experiences and traditions. Where such actors tended to adopt a moderate and institutional political approach, associations such as Rock Against Police, the Agence IM'média, and Za'ama de Banlieue (later Jeunes Arabes de Lyon et sa Banlieue) reacted with a more militant, confrontational approach to the racism, police harassment, and daily struggles suffered by working-class *banlieue* youth. While the first type of association represented a tendency seeking to organize on the basis of a shared, if imprecise, cultural identity, the latter stressed a territorially based identity as *banlieue* youth. Both, however, emphasized the need to develop a movement that was autonomous of French political and social actors in reaction against paternalistic treatment by French solidarity associations that reproduced colonial relations.

From their inception in local neighborhoods and cities, minority ethnic youth associations attracted national prominence in the fall of 1983 with the March for Equality and against Racism, which the media labeled as the *Marche des Beurs* [March of the Beurs]. This six-week march through France, which culminated in a triumphant rally of 100,000 in the streets of Paris and a private audience with President Mitterrand, unfolded to the backdrop of the Front National's electoral breakthrough in a municipal by-election in Dreux and a fresh wave of grizzly anti-Arab violence. The participation of clergy and solidarity activists in the March gave the event an inclusive, humanitarian tone, which attracted support from prominent government ministers and rank-and-file French anti-racists. At the same time, the majority of marchers were youths of North African origin, and throughout the country, new or recently created youth associations mobilized to welcome the marchers and organize local events.

The success of the March stimulated concerted efforts in 1984 to organize youths of immigrant origin into a nationally based movement. However, while several hundred youths representing some fifty associations met in Lyon in June 1984 for a national conference, the efforts to create a structured, united movement were unsuccessful. The Beurs split over the strategic and ideological question of whether to pursue an ethnically inclusive movement involving other cultural communities and supportive elements of French society, or to construct an autonomous North African movement as a necessary first step to becoming a partner in a wider dialogue and movement (Idir 1985; Jazouli 1992: 81–8). Advocates of the former, inclusive strategy launched a national rally in the fall of 1984 known as Convergence 84, which was marked, however, by bitter battles between its minority ethnic youth organizers and their traditional allies among solidarity organizations and anti-racists (Belghoul 1984b, 1985; Jazouli 1992: 88–92).

The Beurs' difficulties in organizing an autonomous movement reflected both internal and external obstacles that confronted the young and fragile movement. Internally, Beur associations were riven by factional conflicts over leadership, goals, and political strategy, reflecting the movement's political inexperience and the absence of any consensus over how properly to define the collective identity of the population to be organized and mobilized. Externally, the conditions that provided opportunities for the *Marche des Beurs*, namely the disturbing spread of popular and political racism, proved a double-edged sword. From 1983 to 1986, the rise of the extreme right, which reflected and further fueled popular anti-immigrant sentiment, pushed the Socialist government toward a more restrictive stance on immigration policy and increasing caution about being seen as too soft

or sympathetic to immigrants. As the Front National and those sharing its views focused on North Africans as the primary social and cultural threat to the nation, the Beurs' political visibility became particularly risky. Although the Socialist government supported the *Marche des Beurs* and continued to facilitate local immigrant associational activity, relations between the government and minority groups became increasingly strained. The government adopted tougher measures to control migration, and the Beurs adopted a discourse that criticized the government's treatment of immigration and insisted on political autonomy.

It was within this context that SOS-Racisme appeared in December 1984, with its hand-shaped badges proclaiming "Touche pas à mon pote" [Hands off my buddy]. Compared to groups that mobilized upon a Beur, Franco-Maghrebi, or *banlieue* youth identity, the identity, message, and political strategy of SOS-Racisme were perfectly suited to gain broader popular and elite support. Where the Beurs were seen to represent a single community, SOS-Racisme was self-consciously pluricultural and directed its appeal to French youths of all origins. Whereas many Beurs denounced anti-racist slogans as insufficient to address the structural mechanisms and historical antagonisms that oppressed and excluded post-colonial minority immigrant youths, SOS-Racisme limited itself to a simple, resonant moral message that tended to equate racism with the extreme right. And where the Beurs rebuffed political overtures as cooption, SOS-Racisme was willing to work closely with Socialist ministers and the President's top advisors.[4] Its timely message and sophisticated use of political contacts and celebrity endorsements to gain constant access to the media allowed SOS-Racisme to mobilize a powerful anti-racist movement in the spring of 1985 and to become the recognized interlocutor in the media and the corridors of power on issues of racism and immigration.

With the spectacular rise of SOS-Racisme, the already divided Beur movement became further fragmented and disorganized (Battegay 1990: 111; Jazouli 1992: 94–111). Some of the more creative Beur leaders attempted to respond to the rise of SOS-Racisme by building an alliance with older immigrant associations organized around the theme of a "new citizenship" which would grant full rights of citizenship based on residency rather than nationality (Poinsot 1993; Silverman 1992: ch. 5). Others continued to mobilize local campaigns against the racist practices of the police and judiciary in the cities (Boubeker and Abdallah 1993). Yet if a diverse and at times dynamic associational movement survived, the movement lacked the unity, organizational structure, common purpose, and links with external forces to assume a sustained political role.

THE REPUBLICAN CONSENSUS

We have seen that during the period 1968–84, with support first from political allies on the left and then from government authorities, minorities of recent immigrant origin had assumed a growing role as recognized and effective actors in the political process. This dynamic was slowed, however, by the difficulties immigrant and minority associations experienced forming credible organized representatives, and by the electoral success of a movement espousing a virulently anti-immigrant platform. These developments encouraged the Socialist government to favor an ethnically mixed movement focusing in its campaigns against the rise of the extreme right. SOS-Racisme, at least initially, celebrated the emergence of a multicultural "Black Blanc Beur" [black white Beur] society while insisting that French youths of all origins were best served by uniting in a single pluralistic movement (Désir 1985).

However, as the political climate on immigration hardened, even the soft form of multiculturalism promoted by SOS-Racisme came to be seen as dangerous. In the political discourse that has reigned virtually unchallenged since the late 1980s, "multiculturalism" and such related terms as "difference," "communities," and "ethnic minorities" have been interpreted as signaling the actual or potential breakdown of French society into the tribal warfare and entrenched ethnic-based segregation characteristic of Lebanon, the former Yugoslavia, and American inner city ghettos.[5] For mainstream politicians and intellectuals alike, the only means of avoiding the fragmentation of the nation into separate and hostile ethnically based communities is the reaffirmation of the unitary nation-state and adherence to France's assimilationist model of immigrant incorporation, labeled the republican model of integration.[6]

According to its French defenders, the republican model conceives of integration as a process by which individuals subordinate their particularist origins and accept membership in a unitary nation-state defined by reference to shared universalist values, in contrast to the multicultural model associated with the United States and Great Britain, which preserves particularist identities and fosters group-based integration into the multicultural nation-state. Whereas multicultural states recognize ethnic communities and preserve cultural differences, republican states recognize only individuals and individual rights, and strive to overcome differences. Under the republican model, ethnic origin is deemed unacceptable as a basis for organization and mobilization by political actors, or for the conferring of rights, recognition, or entitlements by public authorities.

The rejection of multiculturalism in favor of the republican model of integration first established a political consensus with the hearings and unanimous report of the Commission des Sages (Committee of Experts) mandated to consider proposed changes to the French Nationality Code in 1987 (Long 1988; cf. Safran 1990: 62). Since 1988, the republican model has been reaffirmed by a long series of government statements, parliamentary committees, and reports issued by the cross-party Haut Conseil à l'Intégration. A discourse warning against the dangers of recognizing ethnic differences and tolerating multiculturalism has especially dominated debates over the role of Islam and the eruption of violence in the *banlieues* (cf. Silverman 1992: ch. 4). While political actors have remained divided on appropriate measures and policies to encourage immigrant integration, the objective of preventing the emergence of ethnic communities and ethnic politics is widely accepted and invoked as the paramount consideration that should guide policy.

The adoption of the assimilationist republican model against more pluralistic approaches for integrating immigrant populations should be understood in light of both entrenched French ideological and institutional patterns, and particular political circumstances. Advocates of the republican model of integration could point to the model's deep ideological roots and to the country's long tradition of absorbing and assimilating successive waves of immigrants (Noiriel 1988; Schnapper 1991). The unitary conception of the nation as one and indivisible and the rejection of public recognition of particularist identities were deeply rooted in French Jacobinism and Republicanism. Yet prior to its resurgence in the mid-1980s, the republican model had declined as both ideology and practice. The assimilationist conception of the nation had fallen into intellectual disfavor in the post-colonial era in favor of greater acceptance of ethnic pluralism, especially on the left (Safran 1990; Vichniac 1991), while migration policies under both conservative and socialist governments until the late 1980s made no explicit reference to any model of immigrant incorporation and deviated from the principles of the republican model in important respects (Weil and Crowley 1994; Feldblum 1993). Thus, even if the republican model could invoke a long historical tradition, deeply embedded national self-understandings, and a set of institutionalized practices, traditions alone cannot account for why the model was reconstructed and adopted by political elites as the theory behind their approach to managing immigration issues.

To explain the revival of the republican consensus, we must understand first how ethnicity became a central dimension of the immigration debate in the 1980s. If there were always strong ethnic undertones to government policies to control

migratory flows, immigrants were not widely perceived as a threat to national identity so long as they were defined in the first instance as temporary workers who could be returned home. As residency became permanent, however, the religious affiliation, ethnic origin, and citizenship status of millions of immigrants and their children were presented by far-right politicians and intellectuals as endangering the very survival of the French nation. The discourse of a nation under threat of being invaded and overwhelmed by Arab Muslims, reworking old fears that stretched back to the colonial era, was propagated in everyday political debate, full-length books, and the popular press.[7] One of the defining moments in the immigration debate, for example, came in 1985 when *Figaro Magazine* pictured on its cover the head of Marianne, the symbol of the Republic, fully enveloped by an Islamic veil with the headline "Will we still be French in 30 years?". The cover promised to reveal the "the secret figures" that, in thirty years' time, would put French national identity in danger and determine the future of French civilization (*Figaro Magazine* 1985). The feature articles attempted to show that non-Europeans would soon constitute a frightening proportion of the national population, based on the (erroneous) demographic assumption that the immigrant birthrate would remain unchanged.[8]

Yet even if a combination of the colonial legacy and contemporary social problems made the French population particularly receptive to scaremongering about the Arab Muslim threat, we must still consider the political stakes involved in the battle between competing models of immigrant incorporation. Politically, parties of both the moderate right and the left were in need of a position on immigration issues with which they could protect themselves from charges of embracing the racist conceptions of the extreme right, which were denounced by the anti-racist movement, while at the same time not appearing soft on immigrants or unresponsive to the concerns about national identity raised by anti-immigrants on the right. The concept of *intégration* implied the simultaneous rejection of an exclusionary conception of the nation associated with the far right, which saw immigrants as unassimilable and called for their expulsion, and a multicultural conception of the nation associated with fractions of the left and immigrant rights activists, which encouraged the preservation of minorities' cultural identities. *Intégration* was additionally framed as a mid-point between the opposite poles of *insertion*, the buzzword of government policy of the 1970s and early 1980s, which was interpreted to imply the perpetuation of immigrants' cultural differences and/or the recognition of constituted communities, and *assimilation*, which evoked a coercive abandonment of cultural affinities (Bonna-fous 1992; Gaspard 1992). By endorsing a middle ground between opposite

poles, mainstream political elites sought also to consensualize and depoliticize the explosive immigration debate, which boosted the Front National each time it erupted.

If the adoption of the republican model is largely explicable by the urge of political elites to adopt a moderate approach capable of securing a political consensus while distinguishing themselves from the extreme right, the model's virtually unchallenged hegemony reflects the prior decline of political support for pluralistic discourses of national identity. By the time the republican model was adopted in the late 1980s, multiculturalism had *already* been largely discredited and abandoned by intellectuals and activists alike. As the right attacked multiculturalism in the name of preserving French (i.e. European, Christian) identity and culture, the idea of respecting and promoting differences, usually expressed as *le droit à la différence* [the right to difference], was assailed from the left as well. An early blow actually came from a prominent Beur artist and activist, Farida Belghoul, who publicly attacked the *droit à la différence* as a veiled mechanism of exclusion. Belghoul invoked France's colonial history to warn how, in a hierarchical social structure, presumed cultural or ethnic differences could be used to justify and perpetuate inequality (Belghoul 1984a). Even more damaging were the widely praised works of Pierre-André Taguieff, the leading French scholar of contemporary racism, who did much to legitimate the anti-multiculturalist backlash by exposing the differentialist nature of contemporary extreme-right ideology (Taguieff 1991; cf. Warner 1995). Both racist and anti-racist ideologies were indicted as inspired by a common relativism that stressed cultural differences at the expense of resemblances and commonalities. As Judith Warner (1995: 24) explains:

The left found itself caught between a rock and a hard place. With the right arguing that immigrants had to be excluded from France because they were too different, the left took the position that France could include them – had to include them – because they were not different at all. Rather than questioning the limits of their universalist ideal, the left instead clung to it all the more strongly.

As difference and multiculturalism were assailed by intellectuals, political movements and factions that might have challenged the assimilationist precepts of the republican model of integration had declined by the late 1980s. Within the Socialist Party, the New Left factions associated with cultural pluralism gave way to a resurgent Jacobinism (Vichniac 1991; Leveau 1991: 238). New social movements in favor of regional autonomy, women, and gays, which had supported and diffused alternative discourses on national and personal identity in the 1970s,

had largely disappeared as active forces (Duyvendak 1995: ch. 6). Meanwhile, SOS-Racisme, which had initially represented itself as a multiracial movement reflecting a culturally diverse society, read the prevailing winds and adopted a discourse insisting on the role of republican institutions in allowing common values and laws to overcome cultural differences (Désir 1987, 1990). When SOS-Racisme's President Harlem Désir unveiled the association's new integrationist line in a television interview in 1987, he was applauded by a representative of the Socialist Party for having recognized "la nécessité d'intégrer les immigrés plutôt que de développer une société multiraciale en France" [the necessity of integrating immigrants rather than developing a multiracial society in France] (*Le Matin* 1987).

THE EFFECT OF THE REPUBLICAN CONSENSUS

Since the reassertion of the republican model as the officially sanctioned approach to immigration issues, the opportunities for immigrants and their descendants to develop an effective role in the political process have been considerably narrowed. Although practice has not always conformed fully to theory, political elites have tended to avoid managing immigration issues in ways that would permit the emergence of recognized immigrant representatives, while favoring policy choices that suppress the affirmation of ethnic identities (cf. Schain 1993). With few exceptions, minority actors have been denied even a consultative role in the formulation of immigrant-related policy, for fear that this would encourage the emergence of ethnic politics.

The prevailing rejection of politics organized on ethnic lines also constricted the range of strategies available to minority political actors. As resistance to ethnicity hardened, minority organizations that challenged the republican model wound up politically marginalized.[9] Other organizations, more concerned with gaining political respectability, couched their efforts in terms congruent with the republican model. The contradictions in the discourse and practice of France-Plus most clearly reveal the limits of a movement that attempted to mobilize on ethnic lines without challenging "the ideological bases of the French model that render ethnic politics incompatible with the French political process" (Feldblum 1993: 60).

Initially, France-Plus operated as an association committed to mobilizing the

electoral registration of Beurs and others in the French North African community with French citizenship, and then negotiating the placement of "Franco-Maghrebi" candidates on the lists of the major parties. This strategy appeared effective in the municipal elections of 1989, when France-Plus claimed to have sponsored some 500 victorious candidates (Hargreaves 1991: 364).[10] Yet at the same time as it functioned as a classic ethnic lobby on behalf of French citizens of North African origin, France-Plus sought mainstream political support by promoting a staunchly assimilationist discourse in favor of the republican model (Jazouli 1992: 104–11; Feldblum 1993; Geisser 1993). As Vincent Geisser has aptly noted, France-Plus was forced to address "la contradiction entre sa conception assimilationniste de la citoyenneté française . . . et son instrumentalisation de l'ethnicité maghrébine comme critère de sélection à la candidature" [the contradiction between its assimilationist conception of French citizenship . . . and its instrumentalization of Maghrebi ethnicity as a selection criterion for candidacy] (Geisser 1993: 72). It did this by downplaying its ethnic basis and opening its membership to non-Maghrebis.

If an ethnically conscious strategy was rejected as ideologically incompatible with the republican model, Beurs and other minorities have achieved minimal success in penetrating the domain of institutional politics on an individual basis. No Franco-Maghrebi has been elected to the National Assembly or appointed to the government, and only the electorally weak ecologist parties have had prominent Beur members. This situation reflects the extent to which French electoral politics is dominated by a socially narrow elite that has neither the inclination nor the capacity to integrate excluded groups. The Socialist Party in particular, which as the dominant party of the left would be the natural vehicle for Beurs looking to enter politics, has proven neither more nor less responsive to Franco-Maghrebis than to other social groups representing interests and constituencies that did not square with the internal party battle between personality-driven factions. The precepts of the republican model additionally serve to legitimize and hide the exclusion of identity-based groups and complicate the tasks of minorities attempting to gain a role, either collectively or individually, in the political process.

CONCLUSION

Since the early 1980s, the permanent settlement of post-colonial minorities in France, coinciding with an extended period of high unemployment and socio-economic uncertainties, has been exploited to revive a deep-rooted xenophobia that specifically targets North African immigrants, their descendants, and other post-colonial minority groups in France. Inherited colonial structures and attitudes, as well as unhealed scars from the era of decolonization, helped ensure that popular anxieties could be easily focused on the emergence of real or imagined Arab and Islamic identities.

Confronted with the revival of popular and political xenophobia, mainstream political elites responded by reviving and reconstructing traditional models of citizenship, which claimed to offer ethnic minorities full membership in the nation as long as ethnic origin was kept out of the public sphere and expressed only individually rather than collectively. As the political discourse on ethnicity and national identity hardened, ethnic minorities lacked either the political alliance or the organizational strength and collective identity to challenge the republican consensus and forge a collective role in the political process. The Beur movement, which in part articulated a demand for greater recognition of minority identities, was eclipsed by organizations that combined greater political experience and skill with less-threatening forms of identity.

Yet even if ethnic-based political participation has been largely excluded from the arena of institutional politics and the universe of respectable political discourse, ethnicity itself continues to play a seminal and growing role in French politics. The continued national and local strength of the Front National; the government's all-out efforts to restrict permanent or even short-term migration from Algeria; on-going clashes between youths of immigrant origin and the police in the *banlieues*; the response of the government, the French public, and immigrant communities to a series of bomb attacks perpetrated by Islamic militants during the summer and fall of 1995 – all of these phenomena attest to the salience of ethnicity in shaping both political competition and social relations among socio-economically vulnerable populations of all origins. Despite their concerted efforts, French political elites have failed to will away ethnicity by speaking and acting as if it should not and therefore cannot exist.

The limited effectiveness of the republican consensus in regulating current social and cultural conflicts is not surprising. Despite the much-heralded ability of France to incorporate and assimilate regional minorities and previous waves of

European immigrants, the acceptance of former colonials as full and legitimate members of the French nation remains highly problematic. The universalist model of French citizenship, which was most fully elaborated in the heyday of French colonialism during the Third Republic, never fully encompassed Muslims or other colonial subjects. The awkward coexistence of republican ideals of universalism with racism and second-class citizenship during the colonial era has reproduced itself on French territory, reinforcing suspicions and distrust between majority and minority populations. At the same time, the extended economic recession has restricted minority youths' opportunities for socio-economic integration and aggravated feelings of rage. So long as a colonialist legacy of ethnically based discrimination and limited socio-economic opportunities continues to exclude ethnic minorities from the full benefits of citizenship, the unfulfilled promises of the republican model of integration will breed bitterness and disappointment. In political terms, the refusal of French political actors and institutions to accomodate ethnically based political organizations eager to participate *within* the political system may well breed greater support for hard-line alternatives eager to act *against* the political system.

NOTES

1 Most French census data distinguish only between French nationals and foreigners. This blurs over the distinctions between French nationals, those who have been naturalized, and the children of foreigners granted French nationality at birth or at adulthood. For a good treatment of French nationality provisions, see Brubaker (1992).

2 On the etymology of this term, see above, p. 20.

3 For an explanation of this term, see above, p. 12.

4 Many Beur activists would accuse SOS-Racisme of being the direct creation of the President's closest advisors, including the Secretary-General of the Elysée. For a balanced account of SOS's origins, see Le Gendre (1990).

5 There is a substantial literature analyzing and deconstructing the French discourse on ethnicity. Among the most useful works are Silverman (1992: ch. 4); Wacquant (1992); Champagne (1991); and Warner (1995).

6 The principles of the republican model of integration were elaborated most clearly and proudly in the initial report of the Haut Conseil à l'Intégration (1991). Within the large secondary literature on the republican model, see Silverman (1992); McKesson (1994); Feldblum (1993); and Hollifield (1994) for useful discussions.

7 Two well-publicized books on the endangered nation were Griotteray (1984) and Le Gallou (1984).

8 The cover feature included articles by demographer Gérard Dumont and fiction- and travel-writer Jean Raspail. Raspail's futuristic early-1970s novel *The Camp of the Saints* presented an apocalyptic vision of Europe overrun by the Third World's teeming masses. See Connelly and Kennedy (1994).

9 A notable example was the association Mémoire Fertile, which attempted to mobilize first-generation and Beur associations around the concept of a "new citizenship" in which citizenship and democratic participation would be disassociated from nationality. See Poinsot (1993).

10 Although France-Plus's figures were widely accepted by journalists and academics, they were later

revealed to be grossly exaggerated. A detailed study by Vincent Geisser (1993) put the total number of elected municipal councilors of Maghrebi origin (including members of the *harki* community) after 1989 at around 150 (cf. *Libération* 1993). On the origins of the *harkis*, see above, pp. 8–9.

REFERENCES

Battegay, Alain (1990) "La déstabilisation des associations Beurs en région Rhônes-Alpes," *Annales de la recherche urbaine*, no. 49, December, pp. 104–13.

Belghoul, Farida (1984a) "Le droit à la différence: Une forme voilée de l'exclusion," in *Vivre ensemble avec nos différences. Compte-rendu des Assises Nationales Contre le Racisme, 16–18 mars 1984*, Paris: Editions Différences, pp. 18–19, 74.

—— (1984b) "Lettre ouverte aux gens convaincus," *Presses et immigrés en France*, no. 125, December, pp. 1–6.

—— (1985) "La gifle," *IM'média Magazine*, no. 2, pp. 14–16, 39.

Blatt, David (1995) "Towards a multi-cultural political model in France? The limits of immigrant collective action, 1968–94," *Nationalism and Ethnic Studies*, vol. 1, no. 2, Summer, pp. 156–77.

Bonnafous, Simone (1992) "Le terme 'intégration' dans le journal *Le Monde*: Sens et non-sens," *Hommes et migrations*, no. 1154, May, pp. 24–30.

Boubeker, Ahmed, and Mogniss H. Abdallah (eds) (1993) *Douce France: La saga du mouvement Beur*, special edition of *Quo Vadis: La revue de l'Agence IM'média*.

Brubaker, W. Rogers (1992) *Citizenship and Nationality in France and Germany*, Cambridge, MA: Harvard University Press.

Champagne, Patrick (1991) "La construction médiatique des 'malaises sociaux,'" *Actes de la recherche en sciences sociales*, no. 90, December, pp. 64–76.

Connelly, Matthew, and Paul Kennedy (1994) "Must it be the rest against the West?" *Atlantic Monthly*, December, pp. 61–84.

Costa-Lascoux, Jacqueline (1989) *De l'immigré au citoyen*, Paris: La Documentation française.

Delorme, Christian (1984) "Le 'mouvement Beur' a une histoire," *Les cahiers de la nouvelle génération*, no. 1, pp. 18–46.

Désir, Harlem (1985) *Touche pas à mon pote*, Paris: Grasset/Fasquelle.

——(1987) *SOS désirs*, Paris: Calmann-Lévy.

—— (1990) "Défense et illustration de l'antiracisme," interview in *Le Débat*, no. 61, September–October, pp. 42–58.

Duyvendak, Jan Willem (1995) *The Power of Politics: New Social Movements in an Old Polity. France, 1965–1989*, Boulder, CO: Westview Press.

Feldblum, Miriam (1993) "Paradoxes of ethnic politics: the case of Franco-Maghrebins in France," *Ethnic and Racial Studies*, vol. 16, no. 1, January, pp. 52–4.

Figaro Magazine (1985) "Dossier: Serons-nous encore français dans 30 ans?", October 26–November 1.

Gaspard, Françoise (1992) "Assimilation, insertion, intégration: les mots pour 'devenir français,'" *Hommes et migrations*, no. 1154, May, pp. 14–23.

Geisser, Vincent (1993) "Les élus issus de l'immigration maghrébine: L'illusion de médiation politique," *Horizons maghrébins*, nos 20–1, pp. 61–79.

Griotteray, Alain (1984) *Immigrés: Le choc*, Paris: Plon.

Hargreaves, Alec G. (1991) "The political mobilization of the North African immigrant community in France," *Ethnic and Racial Studies*, vol. 14, no. 3, July, pp. 350–67.

Haut Conseil à l'Intégration (1991) *Pour un modèle français de l'intégration. Premier rapport annuel*, Paris: La Documentation française.

Hollifield, James F. (1994) "Immigration and republicanism in France: the hidden consensus," in Wayne Cornelius, Philip L. Martin and James F. Hollifield (eds), *Controlling Immigration: A Global Perspective*, Stanford, CA: Stanford University Press, pp. 143–75.

Idir, Saïd (1985) "La bataille des généraux sans troupes," in *La Beur génération*, special issue of *Sans Frontière*, nos 92–3, April–May, pp. 35–8.

INSEE (1992) *Recensement de la population de 1990. Résultats du sondage au vingtième*, Paris: INSEE.

Ireland, Patrick (1994) *The Policy Challenge of Ethnic Diversity: Immigrant Politics in France and Switzerland*, Cambridge, MA: Harvard University Press.

Jazouli, Adil (1992) *Les années banlieues*, Paris: Seuil.

Le Gallou, Jean-Yves (1984) *La préférence nationale, réponse à l'immigration*, Paris: Albin Michel.

Le Gendre, Bertrand (1990) "A quoi sert SOS-Racisme?" *Le Monde*, January 9.

Leveau, Rémy (1991) "Les partis et l'intégration des 'Beurs,'" in Yves Mény (ed.), *Idéologies, partis politiques et groupes sociaux*, Paris: Presses de la Fondation nationale des sciences politiques, pp. 229–44.

Libération (1993) "Cent cinquante élus d'origine maghrébine," March 15.

Long, Marceau (1988) *Etre français aujourd'hui et demain. Rapport de la Commission de la Nationalité présenté par M. Marceau Long au Premier Ministre*, 2 vols, Paris: La Documentation française.

McKesson, John A. (1994) "Concepts and realities in a multiethnic France," *French Politics and Society*, vol. 12, no. 1, Winter, 16–38.

Le Matin (1987) "La classe politique sous le charme d'Harlem Désir," August 21.

Miller, Mark J. (1981) *Foreign Workers in Western Europe: An Emerging Political Force*, New York: Praeger.

Noiriel, Gérard (1988) *Le creuset français. Histoire de l'immigration, XIXe–XXe siècles*, Paris: Seuil.

Poinsot, Marie (1993) "Competition for political legitimacy at local and national levels among young North Africans in France," *New Community*, vol. 20, no. 1, October, pp. 79–92.

Presses et immigrés en France (1981) nos 84–5, July–August.

Rogers, Rosemarie (1985) "Introduction," in Rosemarie Rogers (ed.), *Guests Come to Stay: The Effects of European Labor Migration on Sending and Receiving Countries*, Boulder, CO: Westview Press, pp. 1–28.

Safran, William (1990) "The French and their national identity: the quest for an elusive substance?" *French Politics and Society*, vol. 8, no. 1, Winter, pp. 56–66.

Schain, Martin (1993) "Policy-making and defining ethnic minorities: the case of immigrants in France," *New Community*, vol. 20, no. 1, October, pp. 59–77.

Schnapper, Dominique (1991) *La France de l'intégration*, Paris: Gallimard.

Silverman, Maxim (1992) *Deconstructing the Nation: Immigration, Racism and Citizenship in France*, London/New York: Routledge.

Taguieff, Pierre-André (1991) "La lutte contre le racisme, par-delà illusions et désillusions," in Pierre-André Taguieff (ed.), *Face au racisme*, vol. 1, Paris: La Découverte, pp. 11–43.

Verbunt, Gilles (1980) *L'intégration par l'autonomie*, Paris: CIEMI/ L'Harmattan.

Vichniac, Judith (1991) "French Socialists and *droit à la différence*: a changing dynamic," *French Politics and Society*, vol. 9, no. 1, Winter, pp. 41–56.

Wacquant, Loïc J.D. (1992) "Banlieues françaises et ghetto noir américain: De l'amalgame à la comparaison," *French Politics and Society*, vol. 10, no. 4, Fall, pp. 81–103.

Warner, Judith (1995) "Political correctness goes haute," *Village Voice*, September 5, pp. 22–4.

Weil, Patrick (1991) *La France et ses étrangers: L'aventure d'une politique de l'immigration, 1938–1990*, Paris: Calmann-Lévy.

Weil, Patrick, and John Crowley (1994) "Integration in theory and practice: a comparison of France and Britain," *West European Politics*, vol. 17, no. 2, April, pp. 110–26.

Wihtol de Wenden, Catherine (1988) *Les immigrés et la politique: Cent cinquante ans d'évolution*, Paris: Presses de la Fondation Nationale des Sciences Politiques.

—— (1994) "Immigrants as political actors in France," *West European Politics*, vol. 17, no. 2, April, pp. 91–109.

PART II
MASS MEDIA

FRENCH CINEMA AND POST-COLONIAL MINORITIES

Carrie Tarr

INTRODUCTION

As a medium for constructing subjectivities and identities, Western cinema normally works to (re-)produce ethnic hierarchies founded on the assumed supremacy of white metropolitan culture and identity, largely through the absence or marginalizing of the voices and perspectives of its troubling ethnic Others. French cinema, like French culture in general, has been notoriously reluctant to address its colonial heritage, either in terms of a critique of empire or in the light of its contemporary multicultural and multiethnic social formation (Stora 1992).[1] Nevertheless over the last fifteen years a number of French films, from *Grand frère* (Girod 1982) and *Fort Saganne* (Corneau 1984) to *La haine* (Kassovitz 1995) and *Les caprices d'un fleuve* (Giraudeau 1996), have centered on France's colonial past or the presence in France of diaspora blacks, Asians and Arabs. *La haine*, winner of the Cannes Film Festival in 1995 and the French Césars in 1996, significantly challenges certain hegemonic (white, middle class, republican) understandings of Frenchness by foregrounding the shared alienation of white, black and Beur youth in the multiethnic Parisian *banlieue*.[2] However, independent filmmakers wishing to critique the dominant culture and explore alternative subjectivities and identities are still obliged to do so by entering into a dialogue with it. In order to evaluate French cinema as the site of competing discourses about what it means to be French, it is necessary to bring an intertexual analysis to bear on both mainstream French cinema (across a range of genres including epics, literary adaptations, comedies, *policiers*,[3] and now *banlieue* films) and cinemas of the periphery (including films by independent white, especially women, French

filmmakers, filmmakers from France's former colonies, each with their specific histories and cultures, and French filmmakers who are the descendants of immigrants from those former colonies).

In the period in question, French and/or European production money has funded francophone filmmakers from the Caribbean, from North and sub-Saharan Africa and from South-East Asia, as well as "second-generation" members of post-colonial minority communities in metropolitan France. Access to funding, technical expertise, distribution and exhibition is of primary importance in determining what films get made and whether they get seen. In France, the *avance sur recettes* [advance on box office receipts] provides opportunities for new filmmakers, but prioritizes films that promise box office success or promote an auteurist vision of cinema rather than films that explore social issues. Funding has been problematic for "second-generation" filmmakers: Mehdi Charef (*Le thé au harem d'Archimède* 1985) was fortunate in being sponsored by Costa-Gavras and Michèle Ray; Malik Chibane took seven years to fund the making of *Hexagone* (1994) after refusing to introduce either a star role or a central white character; Zaïda Ghorab-Volta took ten years to get *Souviens-toi de moi* (1996) completed and distributed. Similarly, Med Hondo failed to get the *avance* for his 1994 adaptation of Didier Daeninckx's political thriller *Lumière noire* (Signaté 1994),[4] while Mathieu Kassovitz refused the *avance* for *Métisse* (1993) and *La haine* because of the constraints on his creative control.

The system inevitably encourages self-censorship, and there is no structural support for minority filmmakers within the French film and TV industry comparable to the BFI and Channel Four in Britain. As a consequence, filmmakers from France's former colonies, many of whom have studied and/or worked in France, or live in France on a more or less permanent basis (especially Algerians who are unable to work in Algeria) find themselves making films that primarily address a French/European art-house audience. For example, Ferid Boughedir has described Souleymane Cissé's successful magic realist film *Yeelen* (1987) as "escapist Africa offering a journey for the European spectator, with no contemporary political reference" (Boughedir 1995). *Le cri du coeur* (Ouédraogo 1995) alienated French audiences, who were anticipating images of an exotic Africa, with its discomfiting tale about diasporic displacement in Lyon. In contrast, *Le camp de Thiaroye* (Sembène 1988), which challenges French colonial narratives by relating the brutal massacre of Senegalese soldiers at the end of the Second World War, was not funded or distributed in France. The reliance on French funding and French audiences means that films made by overseas or metropolitan minority filmmakers may be unable to make significant

challenges to dominant French discourses.

Distinguishing films made by minority filmmakers from mainstream French cinema presents other conceptual problems and is in some senses a self-defeating task. First, classifying films in terms of the filmmaker's ethnic identity overlooks the fact that cinema is the product of collective work and aspirations. Producers, screenwriters, musicians and actors, as well as the technical team, all contribute to the overall meanings of a film, and some form of multiethnic collaboration is a precondition of most if not all of the films under consideration in this chapter. For example, Cheik Dukouré wrote the screenplay for *Black mic mac* (Gilou 1986), Smaïn was involved in getting *L'oeil au beurre noir* (Meynard 1987) into production, and *Le fils du Mékong* (Leterrier 1991) depends on the music and screenplay of its star actor, Tchee. Second, it presupposes and reifies difference rather than enabling an analysis of how difference is articulated across a range of cinematic texts, and implicitly positions ethnic minority filmmakers precisely as minor and thereby inferior. It also implies that the filmmaker's ethnicity, be it Beur,[5] black, Asian, or *gitan*, is in some way the source or guarantee of a text's authenticity or political correctness, which is particularly awkward in the case of filmmakers of mixed ethnic origins. Since the ultimate aim of this analysis is to demonstrate that categories such as ethnicity are culturally constructed and that identities are necessarily multiple and fluid, something one becomes rather than is, something one does rather than has (Shohat and Stam 1994: 346), it seems counter-productive to mobilize ethnic difference as the organizing principle in the selection of texts for discussion. Third, the concept overlooks the role of the audience in making meaning. Whereas texts may privilege particular discursive points of view, audiences have a certain amount of freedom in deciding whether or not to take up those positions. Hence the importance for minority audiences of the role of the Vietnamese actress Linh Dan Pham in *Indochine* (Wargnier 1992) or the cast of black actors in *Black mic mac* and *Black mic mac 2* (Pauly 1988).

However, since the majority of films made by ethnic minority filmmakers constitutes a body of texts that consciously seek to intervene in debates about ethnic and national identities, a comparative study of ethnic minority- and white-authored French films may still be strategically productive. Arguably, ethnic minority filmmakers bring a "double consciousness" to bear on their experiences, a biculturalism that, in itself, challenges the hegemony of dominant French republican culture. And even if textual meanings are not fixed, but shifting and plural because of their already often multiple authorship and their different socially situated audiences, they may still be inflected by an awareness of the ethnic identity of a director, as mediated through the ways in which a film is marketed

and reviewed. Constraints of space mean that this chapter cannot cover all films that explicitly or implicitly contribute to discourses on post-colonial identities and multiculturalism in France. Hence, there is no discussion here of the cycle of films made by *pied-noir* director Alexandre Arcady, for example, nor of Michel Boujenah's representations of *les Tunes* (Tunisian Jewish immigrants), nor of Tony Gatlif's reclamation of gypsy culture in films such as *Les princes* (1983) and *Latcho Drom* (1993), nor of the ways in which knowledge of Isabelle Adjani's mixed-race background might inflect a reading of her roles. Instead, it will compare discourses on France's colonial role, "race," immigration and integration in a selection of key film texts, with a particular emphasis on the values ascribed to the culture of the ethnic Other, and on the mixed-race couple and interracial male friendships as tropes which allow allegorical readings of the relationships between the (former) colonizer and the (former) colonized. It addresses first those films that are geographically located in the (former) colonies, then films set in metropolitan France, subdivided in turn into texts of the 1980s, when immigration and integration became key political issues of the Mitterrand years, and texts of the 1990s, when there is both a wider acceptance of France as a multicultural society and an intensification of right-wing discourses on "race" and ethnicity.

THE COLONIES (AND AFTER)

In recent years, France's imperial past has been invoked through a number of big-budget French productions – based on fictional or historical sources – whose success can be linked with the general success of the French heritage film. *Fort Saganne* pits Charles Saganne (Gérard Depardieu) against the exotic, untameable desert and its nomads in a curiously ambiguous exploration of French heroism and martyrdom in the colonial cause (Plate 4.1). *Indochine* allows the spectator an imaginary repossession of the colony, not only through the way Eliane Devries (Catherine Deneuve) masters the rubber plantations and the indigenous workers, but also through her symbolic role as adoptive mother, first of the Vietnamese princess, Camille (Linh Dan Pham), then of the mixed-race son of Camille and French naval officer Le Guen (Vincent Perez). *Dien Bien Phû* (Schoendorffer 1992) is shot entirely from Western points of view, emphasizing France's loss rather than Viet Nam's (short-lived) gain. *L'amant* (Annaud 1992) turns Marguerite Duras's sophisticated semi-autobiographical novel into a voyeuristic sex tour that reclaims

Plate 4.1 Gérard Depardieu repossesses the colonial landscape in *Fort Saganne*

1930s Saïgon for the nostalgic Western imagination, devoid of an articulate, critical Vietnamese presence (Tarr 1995a). These films, then, silence or marginalize the voices of the colonized, and lend themselves to the neo-colonialist project of repossessing the colony in fantasy through the visual recapture of its reified landscape. The mixed-race couple functions as a source of a sexual fantasy that cannot ultimately be condoned, whereas the child of such an illicit union desires only to be integrated into the society of the (former) colonizer.

The most significant corrective to the heritage movie view of empire within white-authored French cinema is to be found in the work of three women filmmakers: *Chocolat* (Denis 1984), *Le bal du gouverneur* (Pisier 1990) and *Outremer* (Rouan 1990), each of which is loosely based on the director's autobiographical experiences of growing up in the colonies. Whilst tinged with period nostalgia, these films also offer a critical perspective on the arrogance and blindness of the *colons* [colonizers] and the dehumanizing effects of colonialism and racism, which make the formation of the mixed-race couple either impossible or doomed. They refuse to celebrate the colonial landscape and point to the necessity of letting go of the colony and recognizing the autonomy of the Other.

Nevertheless, these films still foreground a European perspective, which is displaced in the work of filmmakers from the former colonies. *Rue case-nègres* (1983), Euzhan Palcy's remarkable feature film debut, is a low-budget adaptation of Josef Zobel's novel set among Martinique sugar-cane workers, which lovingly foregrounds the culture of its black protagonists. But the central relationship between the tough black grandmother and the determined young child tends to undercut the angry scenes in which the excesses of colonial exploitation are momentarily exposed and condemned. And the assumption that progress is possible only through the French education system makes this a problematic and ambivalent film. In *Siméon* (1992), Palcy again celebrates the spiritual and fantasy world of African-Caribbean culture, making the most of special effects and the music of Kassav. But the film also recognizes the complex and ambivalent relationship between Martinique and dominant French culture through the musicians' reliance on French financial backing. A similar acknowledgement of post-colonial dependency is to be found in *Le ballon d'or* (Cheik Dukouré 1994), a fairytale narrative centered on a young boy who dreams of becoming an international soccer player, which nevertheless problematizes France's recruit-ment of francophone African sporting talent. More fundamental challenges to French colonial myths are to be found in re-workings of history like *Sarraounia* (1986), Med Hondo's homage to the African warrior-sorceress queen who repelled a French colonial expedition in the 1890s, or *Les silences du palais* (Tlatli 1994), which focuses on women working in the palace kitchens of the Bey of Tunisia at the time of the struggle for independence. Both these films reclaim the culture, space and point of view of hitherto silenced voices in France's colonial history.

In contrast, Vietnamese filmmaker Tranh Anh Hung and Cambodian filmmaker Rithy Panh, both of whom are resident in France and dependent on French funding, sidestep a critique of the effects of empire in their films, concentrating instead on the lived experience of their indigenous subjects. *L'odeur de la papaye verte* (Hung 1993), actually filmed on studio sets in France, is set in Saïgon in the 1950s and explores the sentiments of a young servant girl from the mountains. *Gens de la rizière* (Panh 1994) is a meditation on the hardship of peasant life at the time of the Khmer Rouge. *Cyclo* (Hung 1995) is an angrier, more expressive film, charting the degradation of a pedal-cab driver amid the poverty and violence of contemporary Ho Chi Minh City, a very different location from those used in the French Indochinese cycle of films mentioned above. The French-trained musician of *L'odeur de la papaye verte* may opt symbolically for the "authentic" peasant girl rather than the westernized woman, but for Richard Gott these films constitute

"a virtual reality empire . . . unrecognizably transmogrified into an oriental theme-park of the imagination" (Gott 1996). Interestingly, even when Beur filmmaker Rachid Bouchareb (whose Algerian father fought for the French in Indochina) opts to make a film about Viet Nam (*Poussières de vie* 1995), he addresses the plight of young Amerasians abandoned by their GI fathers, rather than the after effects of French imperialism.

This survey suggests that, if dominant films work to reassert the superiority of French metropolitan culture and alternative minority films foreground an indigenous (lost?) cultural heritage, few films set in the (former) colonies have been able or seriously willing to problematize France's colonial role and *mission civilisatrice* [civilizing mission] and its effects on a contemporary multicultural and multiethnic France. A comparison of two mid-1990s films about French colonialism in Africa, *L'exil du roi Behanzin* (Deslauriers 1996) and *Les caprices d'un fleuve* (Giraudeau 1996), is instructive. The low-budget, poorly distributed film, *L'exil du roi Behanzin*, scripted by a Martinique writer, is unusual in privileging the point of view of the dignified African king (Delroy Lindo), allowing a mutual respect to develop between the king and his French captors, and providing a (limited) critique of French colonial policy. *Les caprices d'un fleuve*, on the other hand, is a spectacular big-budget, neo-colonial action film set in Senegambia at the time of the French Revolution. Although it includes debates about slavery and human rights, its focalization through the point of view of its dashing, music-loving exiled governor (Bernard Giraudeau) works conventionally to repossess the colonial landscape and people. Both films feature France Zobda in the secondary role of a beautiful *métisse*, and both figure the move towards an acceptance of the culture of the ethnic Other through the formation of an impossible mixed-race couple, for which ultimately it is the women who pay the price. *L'exil du roi Behanzin* ends with the exiled African king safely contained through death, but *Les caprices d'un fleuve* leaves the spectator with the French governor literally left holding the (mixed-race) baby, the film's putative narrator whose cultivated French voice-over betrays no trace of his African roots since he has presumably been unproblematically assimilated into the culture of the father.

"IMMIGRATION" AND AFTER: THE 1980S

Michel Cadé identifies two principal discourses relating to the filmic representation of post-colonial minorities in metropolitan France: "le premier insiste sur

l'élément de trouble que constitue dans le corps de la nation l'arrivée d'éléments étrangers; le second considère ce que ces éléments apportent de positif à un pays souvent décrit comme au bord de l'épuisement" [the first emphasizes the troubling effects of foreign arrivals within the body of the nation; the second looks at their positive contribution to a country often seen as being on the brink of exhaustion] (Cadé 1993: 255). Few French-authored films account for the presence of immigrants in France through subjective, historically situated, realist dramas. Rather, representations of immigrants conventionally function as signs of otherness and trouble in popular genres like the *policier* and comedy. In the *policier*, ethnic minorities are regularly associated with criminality, though this convention is contested in films that specifically situate the immigrant as victim. In comedy, their function as carnivalesque (if stereotypical) figures of excess lends itself to both negative and positive readings of ethnic difference.

In the underworld of white-authored *policiers* such as *La balance* (Swaim 1981), *Police* (Pialat 1985) and more recently *L627* (Tavernier 1992), the existence of a multiethnic migrant population is constructed through negative stereotypical cameo roles linked with crime, violence, drugs, and prostitution.[6] In *Grand frère* (Girod 1982), in which a young boy and his prostitute sister (Souad Amidou) harbor a criminal (Gérard Depardieu), the Beur characters are allowed more complex roles but end up being sent back to Algeria (Plate 4.2). However, films

Plate 4.2 Souad Amidou plays a prostitute in *Grand frère*

like *Tchao Pantin* (Berri 1983), *Train d'enfer* (Hanin 1984) and *Les innocents* (Téchiné 1987) depict the immigrant as the tragic victim of racism at the same time as they displace their concern onto the reactions of the *Français de souche* [indigenous French] played by white French actors. *Tchao Pantin* stars Coluche as the lonely garage manager whose life takes on meaning when he decides to avenge the death of his ill-starred young immigrant friend (Richard Anconina). *Train d'enfer*, based on a true story, is principally concerned with how an upright white police superintendent handles the investigation of the murder of a young Arab immigrant who is found thrown from a train. This film challenges the neo-Nazi sentiments which are voiced in it, and incorporates actuality footage of the 1983 March for Equality and against Racism, but it does not allow its ethnic minority characters any real subjectivity. In *Les innocents*, Jeanne (Sandrine Bonnaire) is the unwitting catalyst of the death of two youths, a white racist and a young Arab (Abdel Kechiche). Téchiné's film offers Kechiche a significant narrative role, but one that is marked by perverse sexuality and a tragic end.

These films challenge anti-Arab French racism in the spirit of SOS-Racisme's slogan "Touche pas à mon pote" [Hands off my buddy] but the spectacle of ethnic minorities in subordinate roles as the (relatively) helpless victims of aggression can hardly be empowering for minority audiences. Indeed, *Pierre et Djamila* (Blain 1986) shows how invidious the representation of the Arab as victim can be. The film reworks the Romeo and Juliet scenario through a tentative love affair between a young Arab schoolgirl and a white French youth, which ends with Pierre getting knifed by Djamila's fundamentalist brother and Djamila committing suicide rather than face the prospect of an arranged marriage. It thus manages to place responsibility for the double tragedy on the immigrant family and its irreducible cultural difference, rather than attribute it to French racism.

Along with Beur cinema (to be discussed below), the most significant genre of the 1980s to engage positively with cultural differences in a multiethnic France has been white-authored comedy. *Black mic mac*, produced by Monique Annaud, was a surprise box-office success.[7] A wild farce set in "Afrique-sur-Seine" [Africa-on-the-Seine], the Goutte d'Or district of Paris, the film's narrative is set in motion by an investigation led by a French health inspector (Jacques Villeret) into a hostel housing African immigrants. The tortuous plot involves the impersonation of a marabout by mischievous young Lemmy (Isaac de Bankolé in a César-winning role), and an improbable romance between the inspector and Lemmy's cousin's friend Anisette (Félicité Wouassi). The hostel is eventually reprieved, but the ending suggests that the protagonists' future lies in a new life in Africa rather than in Paris. Similarly, the members of a black community who attempt to run

a plantation in *Périgord noir* (Ribowski 1988) are ultimately forced to return to Africa, but with their white friends in tow. *Black mic mac 2*, starring black comic impersonator Eric Blanc, revolves around Marco Citti as an undercover policeman who loses a winning lottery ticket in Belleville, demonstrating yet again that access to the exotic black community needs to be structured and legitimated through the mediation of a white French character.

Although these films refuse a "miserabilist" approach[8] and offer a number of costarring roles for ethnic minority actors, their construction of cultural difference does not necessarily result in the dominant culture's recognition of the value of biculturalism or hybridity. Indeed, *Black mic mac* has been criticized as deeply compromised by its cliché-ridden construction of the black community (Petty 1989). Similarly, in *Romuald et Juliette* (Serreau 1989), the African-Caribbean cleaner (Firmine Richard) can be read as a stereotypical black mamma figure[9] whose narrative function serves primarily to highlight Daniel Auteuil's comic performance as the white company executive. These 1980s comedies open up the possibility of romance between white males and black females as a way of regenerating an effete French culture. However, Arab and Beur characters, along with black males, are notably marginalized in such scenarios. Even *L'oeil au beurre noir*, which stars Smaïn and Pascal Legitimus and sets out to deconstruct French racism and stereotypical expectations of ethnic minorities (Rosello 1996), ends with the two men forlornly accepting that Virginie (Julie Jézéquel), their object of desire, prefers her white boyfriend.

A subtle analysis of the effects of the dominant culture on the immigrant, and vice versa, is to be found in the work of Claire Devers and Claire Denis. In *Noir et blanc* (1985) Devers provides a striking sado-masochistic twist to the master–servant relationship of colonial times. A white accountant (Francis Frappat), sent to do the books for a gymnasium, connives with the black masseur (Jacques Martial) to be gradually stretched to death in a paroxysm of pain and pleasure. After *Man no run* (1989), a documentary about the French tour of African pop group Les Têtes brûlées, Denis made *S'en fout la mort* (1990), set in the bleak underground spaces of Rungis, the wholesalers' market near Orly. The story is narrated through the voiceover and point of view of Dah (Isaac de Bankolé), a Beninese immigrant, who – with his African-Caribbean friend Jocelyn (Alex Descas) – is employed to train cocks for illegal cockfights (Plate 4.3). The film dwells lovingly on the rituals of the training of the cocks and the spirituality which Jocelyn brings to the task, but the process eventually becomes draining and self-defeating, and Jocelyn is finally stabbed to death. The film draws powerful, intelligent performances from its black actors at the same time as it demonstrates

Plate 4.3 A powerful performance from Alex Descas in *S'en fout la mort*

how black men are the victims of white (female) desire, sexual jealousy, and racism. Both films, in their tragic and gruesome closures, invite thoughtful speculation from their audiences about race relations and the problematic place exercised by the black male body in the Western imagination. Denis's subsequent film, *J'ai pas sommeil* (1994), based on the life of mass murderer Thierry Paulin and featuring black homosexual Camille (Richard Courcel), is equally ambivalent in its complex construction of alterity.

Not surprisingly, films by ethnic minority filmmakers have also constructed the immigrant as victim and taken a pessimistic line on the possibility of integration, following in the wake of the "miserabilist" films of the 1970s. Such films include *Les sacrifiés* (1982) by Algerian director Okacha Touita, which explores the destructive effects of internal power struggles on Algerian immigrants living and working in France at the time of the Algerian war, and *Miss Mona* (1987), Mehdi Charef's second feature film, which is structured through the downward spiral of degradation and despair experienced by Samir (Ben Smaïl), an illegal immigrant in Paris, as a result of his socio-economic situation and his friendship with aging homosexual transvestite Miss Mona (Jean Carmet). However, Abdelkrim Bahloul (an Algerian filmmaker resident in France) managed to treat the topic of

immigration successfully in a more comic vein. In *Le thé à la menthe* (1984), Hamou (Abdel Kechiche), a hapless young Algerian living off his wits in Barbès, is confronted, on the arrival of his mother (Chaffia Boudra) and her eponymous mint tea, with his failure to integrate. The film ends with him reluctantly accompanying his mother to the airport (a theme which was interpreted as providing unwitting support for the right's policy of funding the repatriation of North African immigrants). Similarly, the love affair between an Algerian Jewish woman (Catherine Wilkening) and a second-generation Arab (Karim Alloui) in a Chinese-run hostel in Belleville, the topic of *Un amour à Paris* (1988) by Algerian filmmaker Merzak Allouache, starts off as a comedy but has a more realistic tragic ending which prevents the mixed-race couple from forming (Plate 4.4).

The most significant representations of a multiethnic France in the 1980s, however, are to be found in two films by Beur filmmakers, *Le thé au harem d'Archimède* (1985) by Mehdi Charef (Plate 4.5) and *Bâton Rouge* (1985) by Rachid Bouchareb. These films address the troubled hybrid identity of second-generation members of minority ethnic groups through a style that avoids "miserabilism" and stresses the new youth culture of the *banlieue* and its strong African-American influences (Bosséno 1992; Tarr 1993). The dilemma of being torn between two cultures had been explored from an explicitly female point of view in Farida

Plate 4.4 The doomed mixed-race couple in *Un amour à Paris*

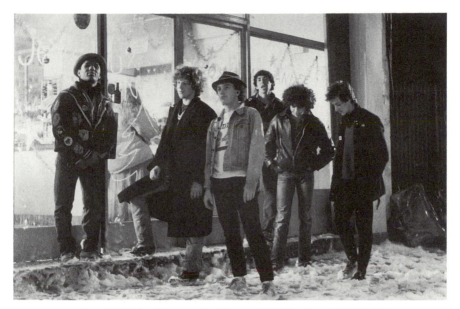

Plate 4.5 Multiethnic youth culture in *Le thé au harem d'Archimède*

Belghoul's two short fiction films, *C'est Madame la France que tu préfères?* (1981) and *Le départ du père* (1983), and in Charlotte Silvera's *Louise l'insoumise* (1984), a period piece evoking the unhappiness of a young girl caught between the values of her repressive Tunisian Jewish immigrant family and the children she meets at school. It was also explored in *Laisse béton* (Le Péron 1984), which offered a representation of life in the *banlieue* through the troubled friendship between two young boys, Nouredine (a Beur) and Brian (a white French boy brought up in America), who shoplift together to save money for a trip to the USA. Brian eventually betrays his friend to the police and the film then focuses on the renewal of his relationship with his father rather than the young Beur's emotional upheaval. But the film also constructs a sympathetic representation of a sexy young Beur through the figure of Nouredine's older brother, Rachid (Youcef Rajai), a boxer who sleeps with Brian's mother but steers clear of drugs and crime.

Both *Le thé au harem* and *Bâton Rouge* build on audience sympathy for the figure of the streetwise young Beur. In *Le thé au harem*, Madjid (Kader Boukhanef) is an unemployed youth who joins forces with his friend Pat (Rémi Martin) to commit various petty crimes, pick up girls, drink and smoke, and eventually face the prospect of prison. But the film highlights Madjid's fractured identity, torn between survival on the estate and the pressures put on him by his strong, warm-hearted Algerian mother (Saïda Bekkouche) and his silent, passive father. *Bâton*

Rouge more explicitly marginalizes the Arab father figure and North African cultural references in its exploration of the possibility of assimilation. Three friends set out for America – two Beurs and one white musician – but while the white youth finds romance with an African-American woman singer, the other two are forced to return to France where, with the help of Karim's little brother, they manage to put together a multiethnic collective to set up a Burger Bar in the suburbs. The feel-good ending of *Bâton Rouge* is apparently based on a true story, but the closing freeze-frame suggests wishful thinking rather than actuality. Instead of foregrounding ethnic differences (as in 1980s white-authored French comedies), these two films focus on possibilities of integration and assimilation through narratives structured around close relationships between Beur and white youths within the shared culture of the *banlieue*, and insist on the Beurs' rightful presence in France at the same time as they problematize it. It is interesting, therefore, that neither film envisages the possibility of the Beur youth forming a couple, mixed or otherwise. And the bid for assimilation means that the specificity of the ethnic minority culture is either marginalized or denied, in part through the foregrounding of white characters and in part through the notable absence or silencing of the immigrant father figure, whose history marks him as most radically Other to dominant French culture.

THE 1990s

Mainstream French comedies of the 1990s indicate significant shifts in the representation of ethnic minorities and mixed-race relationships. For instance, in *Mohamed Bertrand-Duval* (Métayer 1991), a bankrupt company director (Alex Métayer) discovers life and love in a community of Arabs and gypsies camped near Marseilles; and in *La thune* (Galland 1991), in an opposite trajectory, a young Beur (Sami Bouajila) sets up a successful business, thanks to his relationship with the daughter of a white French businessman. In *Les trois frères* (Les Inconnus 1996), Pascal Legitimus and two white Frenchmen discover that they are half brothers; whereas in *Les deux papas et la maman* (Smaïn and Longval 1996), the Beur character (Smaïn) is invited to take over the task of fathering a child on behalf of his impotent white friend (Antoine de Caunes). If contemporary French comedies are to be believed, a relatively unproblematic multicultural French society is now able to integrate the socially mobile ethnic minority Other into the new extended family.

However, films from the cinemas of the periphery tell a different story. In 1991, French cinema produced its first comic representation of "Saïgon-sur-Seine" in *Le fils du Mékong* (Leterrier 1991). Aided and abetted by Jacques Villeret as a "demi-frère des pauvres" [half-brother of the poor], four young "boat people" survive the pitfalls awaiting the naive immigrant in the sophisticated metropolis and eventually find commercial success through the popularity of their hybrid Vietnamese *yé-yé* music in the South-East Asian communities of Paris and America. Nevertheless, the foursome are still denied entry to a Parisian nightclub, a trope of exclusion to be found in a number of Beur films and fiction, and Tchee becomes romantically involved with a Vietnamese girl, not a French one. The film refuses a critique of French colonial history in Indochina, but implies that, because of French racism, the Vietnamese community in Paris opts for cohabitation rather than integration. In Anne Fontaine's first film, *Les histoires d'amour finissent mal en général* (1993), the Beurette (Nora) is unable to establish a meaningful relationship with either her Beur fiancé or her white French lover. And the romantic pairing of a French girl and a North African boy at the end of Abdelkrim Bahloul's disappointing second film, *Un vampire au paradis* (1992), is only possible in a North African setting, thanks to the death of the unhappy immigrant vampire (Farid Chopel). However, the comedy that most radically destabilizes dominant assumptions about integration into the majority culture is Mathieu Kassovitz's first feature, *Métisse* (1993), which requires its working-class Jewish central protagonist to adapt to the unorthodox hybrid family unit set up by the eponymous African-Caribbean *métisse*, her upper-middle-class African lover, and her baby-to-be.

The first Beur film of the 1990s was Bouchareb's second feature *Cheb* (1991), a key film in the representation of the second generation's problems of identity and lack of belonging in either France or Algeria (Petrie 1992).[10] *Cheb* forcefully attributes the exclusion of the Beurs to social inequalities and French racism rather than to cultural differences. In a new departure for Beur-authored cinema, it also recognizes the ways in which gender and sexuality are sites of oppression and (potentially) resistance, and forgoes the fantasy of unproblematic interracial friendships. The central character Merwan (Mourad Bounaas) is deported from France after a conviction for stealing, and finds himself doing national service in a hostile Algeria, where the Algerian landscape, magnificent as it is, only serves to emphasize his displacement. For his thoroughly westernized girfriend, Malika (Nozha Khouadra), who has been left by her family in Algeria without a passport, Algeria also represents the curtailment of freedom. But when Merwan escapes back to France to find himself doing French national service under his new,

assumed identity, his situation is still that of the alienated Other.

With *Cheb*, Beur cinema seemed to have reached an impasse. But the return of the right and the beginning of Jacques Chirac's presidency have been marked by a resurgence of interest in the representation of the multiethnic *banlieue* by a new generation of independent filmmakers. In 1994, Malik Chibane (of Algerian origin) completed the making of *Hexagone* on a shoestring budget, in itself a remarkable achievement (Tarr 1995b). Hailed as the first film by a Beur for Beurs, the film nevertheless has many similarities with the Beur films of the 1980s in its focus on sympathetic young males desperate to escape from the *banlieue* (Plate 4.6), and the need to make light of drugs and criminality in the Beur community. Importantly, though, through its lack of white characters, its use of voiceover and its multiple narrative strands, it allows the principal Beur roles an unusual degree of subjectivity and even incorporates significant roles for Beurettes. By minimizing the issue of racism and the role of the police and state in maintaining racial subordination, and by confining the representation of North African culture to the parents' generation, the film makes a clear plea for integration and even posits a slight hope for the future of the mixed-race couple.

In his second film, *Douce France* (1995), Chibane apparently returns to the 1980s' format of the interracial friendship between a white and a Beur youth.

Plate 4.6 The sympathetic male leads of *Hexagone*
(Courtesy of Alhambra Films)

However, in this case, the pair are slightly older and Moussa (Hakim Sahraoui) is actually a son of a *harki*,[11] a foregrounding of cultural difference that serves primarily to indicate that such difference no longer has any relevance. Thanks to the artificial plot device of the discovery of a cache of stolen jewelry, the two friends set up business together, one running a bar, the other running a legal practice in the back room. The film focuses on their relationship with two Beur sisters, Souad (Séloua Hamse), a modern young woman working for a Quick burger bar, and Farida (Fadila Belkebla), a pious Muslim who teaches French and distributes bread to the poor (Plate 4.7). Racism and racial violence are treated comically, and the shooting by police of a drunken immigrant is exploited as an opportunity for Jean-Luc (Frédéric Diefenthal) to build up his business. Moussa's parents' plans for an arranged marriage are primarily an excuse for local color, since the modern Algerian bride rejects a marriage that is not based on love, and even Farida finally throws away her veil. *Douce France* demonstrates the extent to which the second generation is established and integrated, and leaves spectators with the unusual final image of a liberated Beurette literally in the driving seat. Fedjria Deliba's prize-winning short *Le petit chat est mort* (1992) and Zaïda Ghorab-

Plate 4.7 Competing images of femininity within the new immigrant family in *Douce France*

Photograph: Muriel Huster (Courtesy of Alhambra Films)

Volta's semi-autobiographical film *Souviens-toi de moi* (1996) also explore the familiar terrain of strained relationships within the immigrant family, but from a young woman's perspective (Plate 4.8). Ghorab-Volta's film, the first (nearly) full-length feature by a Beurette, also introduces new themes by invoking the central character's reflections on her dying love affair with a white Frenchman and the strength of female friendships, both in France and between women in Algeria.

Two other post-colonial minority filmmakers released their first feature films in the mid-1990s. In *Krim* (1995), Ahmed Bouchaala (of Algerian origin) constructs a world of obsession through the story of an Arab in Lyon who is released from prison for murdering his wife and goes in search of his longlost daughter. *Pigalle* (1994), the award-winning film by Franco-Tunisian filmmaker Karim Dridi, centers on a couple of white French misfits but also features a sympathetic young Beur who has been left to fend for himself on the streets of Pigalle. In *Bye-Bye* (1995), Dridi explicitly evokes the multiethnic world of Marseilles through the eyes of two second-generation North African brothers, Ismaël (Sami Bouajila) and Mouloud (Oussini Embarek) (Plate 4.9). The trope of interracial male bonding is brought into play but then shown to be an illusion when Ismaël is rejected by Jacky (Frédéric Andrau) for screwing his (Beurette)

Plate 4.8 A woman's perspective on strained relationships within the immigrant family in
Souviens-toi de moi
(Courtesy of Pierre Grise Distribution)

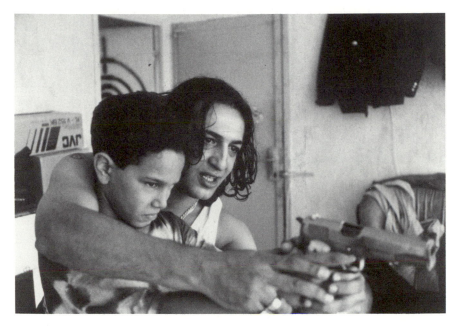

Plate 4.9 Mouloud (Oussini Embarek) discovers Marseilles's criminal underworld
in *Bye-Bye*

girlfriend. Not only is the Beur couple not allowed to form, but the Beurette is
constructed here in the classic female role of sexual object and provoker of
"trouble in the text." The film offers a new emphasis on the extended immigrant
family and the multiethnic community, with more fully individualized characters
capable of challenging stereotypical expectations. But it also reasserts the
specificity of the Beurs' identity problems in France, and it is not clear how the
two brothers can say bye-bye to the past and carve out new identities for
themselves. Dridi's vision of integration is rather more pessimistic than that of
Chibane.

For white French representations of the multiethnic *banlieue* 1995 was also a
key year. Thomas Gilou's *Raï* reworks the now depressingly familiar scenario of
a group of young Beurs faced with unemployment, drugs, police violence, and the
impossibility of finding a way out, but the casting of former porn star Tabatha Cash
as its central female protagonist makes it difficult to take the film seriously.
Kassovitz solves the issue of female characters by dispensing with them altogether
in the principal roles of *La haine*. This film mobilizes a trio of young men from
different ethnic backgrounds – Jewish, black, and Beur – but insists on their
common bonding within a hybrid oppositional youth culture based on music,

drugs, petty crime, unemployment, hatred of the police and exclusion, in a world where police *bavures* [blunders] can kill white as well as Beur youths (Plate 4.10). However, the problematic of *La haine* is not so much ethnic difference as social difference, the fracture in French society, of which ethnic difference is only a relatively minor element (Reader 1995; Tarr 1997). Similarly, *Etat des lieux* (Jean-François Richet), though centered on a white working-class male, takes for granted the multiethnic composition of the *cité* and includes several entertaining scenes foregrounding performances by black youths. These cinematically exhilarating films express a healthy anger at the injustices and inequalities of contemporary French society, and hopefully announce the advent of a dynamic new politically conscious multicultural French cinema in the years leading up to the millennium. Nevertheless, their assumption that integration has been achieved, if only within a multiethnic underclass white (male) youth culture, is one that is strongly contested in films like Dridi's *Bye-Bye*.

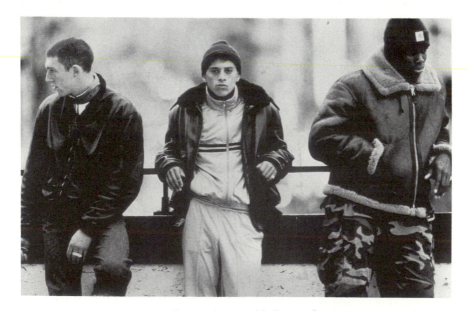

Plate 4.10 The Jewish, Beur, black trio of *La haine*

CONCLUSION

Over the last fifteen years, mainstream French cinema has tended to illustrate, both through heritage films and through popular genres like the *policier*, France's unwillingness to confront its colonial past and post-colonial present. Although mainstream comedies seem to have moved away from drawing attention to the comic difference of the ethnic Other (who is then contained or expelled) in favor of allowing the ethnic Other to be incorporated into French society (to quite a surprising degree), this is a move that continues to erase the realities of ethnic and cultural difference. At certain key moments (the mid-1980s and the mid-1990s), filmmakers from the periphery have successfully addressed the tensions informing the lives of France's post-colonial minorities. In the 1980s, Charef and Bouchareb attempted to work through the options available to young Beurs stuck in the *banlieue* estates, by focusing in particular on interracial friendships with other (white) working-class youths. In the 1990s, Chibane, Bouchaala, Dridi, and Ghorab-Volta have reworked the same or similar themes, indicating both enduring anxieties about exclusion and the continuing existence of an audience for such representations. Films made by a fresh generation of white independent filmmakers like Kassovitz and Richet suggest that there is a new, wider interest in social issues as valid subject matter for films and that such subject matter potentially challenges hegemonic assumptions about French national identity. However, even if these films draw attention to France and its *banlieues* as sites of ethnic diversity and social injustice, they primarily address a popular white French audience and are not concerned with the exploration of the specificities of ethnic difference. What the two sets of filmmakers from the periphery have in common, despite the differences in their relationship to ethnic minority culture, is the potential to articulate exclusion and double consciousness in a way that challenges the hegemony of dominant French culture. Nevertheless, there is still a need for a greater plurality of representations with regard to ethnic minority subjectivities and identities,[12] and the continuing structuring absence in French cinema of the stable mixed-race white/Beur couple is a measure of the continuing exclusion from the national culture of France's most prominent post-colonial minority.

NOTES

1 The volume recently edited by Dina Sherzer (1996) makes a major contribution to the exploration of this neglected space. A special issue of *CinémAction* on *L'histoire de France au cinéma* (1993) includes a limited list of French films representing the colonial period, supplied by Pierre Guibbert, and an article by Marcel Oms, whose discussion of contemporary French history and cinema omits any consideration of immigration. It is not insignificant that *La battaglia di Algeria/Battle of Algiers* (Pontecorvo 1966) was made with mostly Algerian money and is rarely screened in France. More recently, however, Bertrand Tavernier's documentary film, *La guerre sans nom* (1992), starts to excavate an alternative history of France's traumatic relationship with Algeria through the memories of former conscripts sent out to war in 1956 (though it still focuses on white European points of view).

2 On the background to this term, see above, p. 12.

3 Roughly translated, "crime films."

4 Hondo is a Paris-based Mauritanian exile, whose early films were critical of French racism, e.g. *Soleil O* (1969) and *Les bicots-nègres vos voisins* (1973).

5 See above, p. 20, for a discussion of the word "Beur." Although it has become a problematic label rather than an empowering one, the notion of Beur cinema now has a certain critical currency and is used here for lack of a more satisfactory alternative.

6 Two alternative *policiers* are *Les keufs* (Balasko 1987), in which Isaac de Bankolé plays opposite Balasko, and *L'union sacrée* (Arcady 1989), which attempts to emulate the success of the American action/police buddy film. In *L'union sacrée*, two rival police officers, a Jewish *pied-noir* (Patrick Bruel) and a son of a *harki* (Richard Berry), sort out their differences and combine to put an end to a fundamentalist Islamic terrorist plot. The film is problematic in its construction of racial harmony and multiculturalism in France in that both stars are Jewish *pieds-noirs*, and the cameo roles played by Arab actors are uniformly deviant.

7 Monique Annaud, who went on to produce *Black mic mac 2* and *Le ballon d'or* among others, lived for twenty years in Senegal, and Jean-Jacques Annaud's first film, *La victoire en chantant* (1976), was a sardonic look at French colonialism in Africa.

8 The term "miserabilist" was used to condemn militant-activist films made in the 1970s, including films by immigrant filmmakers such as *Mektoub* (1970) and *L'autre France* (1974) by Ali Ghalem. See Smith (1995) for a discussion of the representation of immigration in French cinema of the 1970s.

9 This stereotype is further reworked by Bertrand Blier in *Un deux trois soleil* (1993).

10 This theme was explored a decade earlier in a comedy by Algerian filmmaker, Mahmoud Zemmouri, *Prends dix mille balles et casse-toi* (1980).

11 On the origins of the *harkis*, see above, pp. 8–9.

12 Current projects include Merzak Allouache's *Salut cousin!*, about Algerian immigrants in Clichy, Bahloul's script about racism in Marseilles, Bouchaala's *Cité Cosmos*, and the adaptation of Azouz Begag's successful novel *Le gone du Chaâba*.

REFERENCES

Printed sources

Bosséno, Christian (1992) "Immigrant cinema: national cinema – the case of Beur film," in Richard Dyer and Ginette Vincendeau (eds), *Popular European Cinema*, London/New York: Routledge, pp. 47–57.

Boughedir, Ferid (1995) "African cinema and ideology: tendencies and evolution," Screen Griots, Africa and the History of Cinematic Ideas Conference, London: British Film Institute (unpublished paper).

Cadé, Michel (1993) "Ces immigrés qui ont (aussi) fait la France," in *L'histoire de France au cinéma*, special issue of *CinémAction*, pp. 251–67.

Gott, Richard (1996) "Vietnam mon amour," *Guardian*, March 14.

Guibbert, Pierre (1993) "Les films et les faits," in *L'histoire de France au cinéma*, special issue of *CinémAction*, pp. 271–87.

Hall, Stuart (1992) "European cinema on the verge of a nervous breakdown," in Duncan Petrie (ed.), *Screening Europe*, London: British Film Institute Working Papers, pp. 45–53.

Oms, Marcel (1993) "La France contemporaine," in *L'histoire de France au cinéma*, special issue of *CinémAction*, pp. 215–49

Petrie, Duncan (1992) "Change and cinematic representation in modern Europe," in Duncan Petrie (ed.), *Screening Europe*, London: British Film Institute Working Papers, pp. 1–8.

Petty, Sheila (1989) "*Black mic mac* and colonial discourse," *CineAction*, Fall, pp. 51–4.

Reader, Keith (1995) "After the riot," *Sight and Sound*, vol. 5, no. 11, pp. 12–14.

Rosello, Mireille (1996) "Third cinema or third degree: the 'Rachid system' in Serge Meynard's *L'oeil au beurre noir*," in Dina Sherzer (ed.), *Cinema, Colonialism, Postcolonialism: Perspectives from the French and Francophone World*, Austin, TX: University of Texas Press, pp. 147–72.

Sherzer, Dina (ed.) (1996) *Cinema, Colonialism, Postcolonialism: Perspectives from the French and Francophone World*, Austin, TX: University of Texas Press.

Shohat, Ella, and Robert Stam (1994) *Unthinking Eurocentrism*, London/New York: Routledge.

Signaté, Ibrahima (1994) *Med Hondo, un cinéaste rebelle*, Paris/Dakar: Présence africaine.

Smith, Alison (1995) "The problems of immigration as shown in French cinema of the 1970s," *Modern and Contemporary France*, vol. NS3, no. 1, pp. 41–50.

Stora, Benjamin (1992) "Rebonds – Indochine, Algérie, autorisations de retour," *Libération*, April 30.

Tarr, Carrie (1993) "Questions of identity in Beur cinema: from *Tea in the Harem* to *Cheb*," *Screen*, vol. 34, no. 4, Winter, pp. 321–42.

—— (1995a) "The lover's guide to Indo-China," *Contemporary French Civilization*, vol. 19, no. 1, Winter–Spring, pp. 85–98.

—— (1995b) "Beurz n the hood: the articulation of Beur and French identities in *Le thé au harem d'Archimède* and *Hexagone*," *Modern and Contemporary France*, vol. NS3, no 4, pp. 415–25.

—— (1997) "Ethnicity and identity in *Métisse* and *La haine*," in Tony Chafer (ed.), *Multicultural France: French Working Papers Series 1*, Portsmouth: University of Portsmouth.

Filmography

Allouache, Merzak (1988) *Un amour à Paris*.

Annaud, Jean-Jacques (1976) *La victoire en chantant*.

—— (1992) *L'amant*.

Arcady, Alexandre (1989) *L'union sacrée*.

Bahloul, Abdelkrim (1984) *Le thé à la menthe*.

—— (1992) *Un vampire au paradis*.

Balasko, Josianne (1987) *Les keufs*.

Belghoul, Farida (1981) *C'est Madame la France que tu préfères?*

—— (1983) *Le départ du père*.

Berri, Claude (1983) *Tchao Pantin*.

Blain, Gérard (1986) *Pierre et Djamila*.

Blier, Bertrand (1993) *Un deux trois soleil*.

Bouchaala, Ahmed (1995) *Krim*.

Bouchareb, Rachid (1985) *Bâton Rouge*.

—— (1991) *Cheb*.

—— (1995) *Poussières de vie*.

Charef, Mehdi (1985) *Le thé au harem d'Archimède.*
———— (1987) *Miss Mona.*
Chibane, Malik (1994) *Hexagone.*
———— (1995) *Douce France.*
Cissé, Souleymane (1987) *Yeelen.*
Corneau, Alain (1984) *Fort Saganne.*
Deliba, Fedjria (1992) *Le petit chat est mort.*
Denis, Claire (1984) *Chocolat.*
———— (1989) *Man no run.*
———— (1990) *S'en fout la mort.*
———— (1994) *J'ai pas sommeil.*
Deslauriers, Guy (1996) *L'exil du roi Behanzin.*
Devers, Claire (1985) *Noir et blanc.*
Dridi, Karim (1994) *Pigalle.*
———— (1995) *Bye-bye.*
Dukouré, Cheik (1994) *Le ballon d'or.*
Fontaine, Anne (1993) *Les histoires d'amour finissent mal en général.*
Galland, Philippe (1991) *La thune.*
Gatlif, Tony (1983) *Les princes.*
———— (1993) *Latcho Drom.*
Ghalem, Ali (1970) *Mektoub.*
———— (1974) *L'autre France.*
Ghorab-Volta, Zaïda (1996) *Souviens-toi de moi.*
Gilou, Thomas (1986) *Black mic mac.*
———— (1995) *Raï.*
Giraudeau, Bernard (1996) *Les caprices d'un fleuve.*
Girod, François (1982) *Grand frère.*
Hanin, Roger (1984) *Train d'enfer.*
Hondo, Med (1969) *Soleil O.*
———— (1973) *Les bicots-nègres vos voisins.*
———— (1986) *Sarraounia.*
———— (1994) *Lumière noire.*
Hung, Tranh Anh (1993) *L'odeur de la papaye verte.*
———— (1995) *Cyclo.*
Les Inconnus (1996) *Les trois frères.*
Kassovitz, Mathieu (1993) *Métisse.*
———— (1995) *La haine.*
Le Péron, Serge (1984) *Laisse béton.*
Leterrier, Francois (1991) *Le fils du Mékong.*
Métayer, Alex (1991) *Mohamed Bertrand-Duval.*
Meynard, Serge (1987) *L'oeil au beurre noir.*
Ouédraogo, Idrissa (1995) *Le cri du coeur.*
Palcy, Euzhan (1983) *Rue case-nègres.*
———— (1992) *Siméon.*
Panh, Rithy (1994) *Gens de la rizière.*
Pauly, Marco (1988) *Black mic mac 2.*
Pialat, Maurice (1985) *Police.*
Pisier, Marie-France (1990) *Le bal du gouverneur.*
Pontecorvo, Gillo (1966) *La battaglia di Algeria / Battle of Algiers.*
Ribowski, Nicolas (1988) *Périgord noir.*
Richet, Jean-François (1995) *Etat des lieux.*
Rouan, Brigitte (1990) *Outremer.*
Schoendorffer, Pierre (1992) *Dien Bien Phû.*

Sembène, Ousmane (1988) *Le camp de Thiarroye.*

Serreau, Coline (1989) *Romuald et Juliette.*

Silvera, Charlotte (1984) *Louise l'insoumise.*

Smaïn and Longval (1996) *Les deux papas et la maman.*

Swaim, Bob (1981) *La balance.*

Tavernier, Bertrand (1992) *L627.*

Téchiné, André (1987) *Les innocents.*

Tlatli, Moufida (1994) *Les silences du palais.*

Touita, Okacha (1982) *Les sacrifiés.*

Wargnier, Régis (1992) *Indochine.*

Zemmouri, Mahmoud (1980) *Prends dix milles balles et casse-toi.*

GATEKEEPERS AND GATEWAYS

Post-colonial minorities and French television

Alec G. Hargreaves

INTRODUCTION

Until the mid-1980s, the state held a complete monopoly over television broadcasting in France. It thus enjoyed a degree of control over the small screen that was unmatched in any other cultural sector. More than any other medium, television was controlled by public agencies deeply imbued by ideals of French republicanism, which were fundamentally hostile to the formal recognition of minority ethnic groups (cf. Blatt, above, Chapter 3). Though by no means absent from the TV screen, immigrants and their descendants occupied extremely limited spaces in this, the most powerful medium of the post-colonial era. During the last ten years, the French state has lost its monopoly over the airwaves. It now owns only half the country's terrestrially based channels, and while continuing to exercise important licensing and regulatory powers over all broadcasters based in France, it finds its authority increasingly challenged by new technologies opening the flow of television images to forces beyond its control. This chapter examines the position of France's post-colonial minorities in relation to these developments.

The production and broadcasting of television programs is a capital-intensive operation. This, combined with the relative scarcity of broadcasting frequencies and the powerful role of the state, has made it difficult for minorities to play an active role as program-makers, even with advent of privatization. My analysis focuses mainly on the ways in which post-colonial minorities have been

represented on French television together with their position as consumers of TV programs. The chapter falls into three parts. The first examines the period prior to the breakup of the state monopoly. The second looks at developments in the field of terrestrially based channels since 1984, and the third considers the opportunities and constraints associated with other modes of program delivery (cassette, cable, and satellite).

FRENCH TELEVISION PRIOR TO 1984

French television was still in its infancy when formal decolonization came to a close with Algerian independence in 1962. At that time, less than a quarter of French households possessed television receivers, and broadcasts were confined to a single state channel. Television did not become an established part of most homes until the late 1960s, and as late as 1971 there were still only two channels. Although a third channel, FR3, introduced an element of diversity in 1972 by providing regional programs for the first time, all three channels were state-owned and remained subject to central control (Kuhn 1995: 109–64).

It is only in the last few years that researchers have begun to explore the ways in which immigration and minorities of recent immigrant origin have been represented on French television, and there is still a dearth of research on the period prior to the mid-1980s. This is partly a reflection of the fact that, until then, issues relating to international migration had a relatively low profile on the small screen. As a consequence, they were absent from the research agenda. More recently, researchers seeking to fill this gap have been hampered by practical constraints, in particular problems of access to archive recordings held by the Institut National de l'Audiovisuel (INA), which are only just being resolved, and the logistical problems involved in scanning a potentially large volume of archive recordings in search of limited items of relevance.

The findings of important but still fragmentary work by Lévy (1993) and Gastaut (1996) provide at least a broad indication of how post-colonial minorities were portrayed on French television during the 1970s. The cameras focused mainly on migrants of Maghrebi origin, who were seen primarily in "factual" programs rather than in entertainment shows. The emphasis was on practical problems in areas such as employment and housing and the difficulties caused by racist attitudes among the majority population. Immigrant workers were the main focus of attention; relatively little was seen of their families. The voices of

immigrants themselves were seldom heard. They featured as objects of news or documentary reports and occasional studio debates, but were rarely included among the speakers. Almost without exception, programs about immigrant minorities were made by and for the majority population.

It was not until 1976 that a program specifically conceived for migrants and their families was first aired. This was "Mosaïque," a magazine program broadcast each Sunday morning on FR3. Although watched avidly by immigrant minorities, for whom it was the only regular opportunity to see people of similar origins on TV, the program was riddled with tensions and contradictions throughout its eleven-year run. The most important of these lay in the underlying objective laid down by officials of the center-right government of the day in setting up "Mosaïque." Having halted inward labor migration from Third World countries in 1974 amid anxieties over a worsening employment market, the government wished to encourage post-colonial migrants already in France to return to their home countries. It was hoped to prepare the way for their repatriation through a mixture of folkloric studio presentations and magazine items provided by home country television stations, broadcast mainly in the mother tongues of migrants and their families. Thus beneath a superficially multicultural production lay an entirely contrary purpose: far from making a space for minority cultures within French society, the aim was to prepare for their removal (Humblot 1989).

TERRESTRIALLY BASED CHANNELS SINCE 1984

When the Socialists came to power in 1981, they abolished the repatriation policy of their predecessors and sought instead to facilitate the incorporation of post-colonial minorities within French society. Although this never amounted to a full-blown policy of multiculturalism, there was a greater willingness to accord at least a limited space to the cultural practices of France's new immigrant minorities. Beginning in 1983, an Islamic devotional program was broadcast each Sunday morning, complementing those catering for Catholics, Protestants, Eastern Orthodox Christians, and Jews. "Mosaïque" was given a face-lift, orienting it more towards the interests of second-generation members of minority groups. Among other things, this meant greater use of French, rather than mother tongues. This emphasis became more marked with the program's replacement by "Ensemble aujourd'hui" in 1987, followed by "Rencontres" in 1989. In the face of steadily

falling audiences for these programs, the state agency responsible for financing them, the Fonds d'Action Sociale pour les travailleurs immigrés et leurs familles (FAS), tried a new approach by setting up a daily program called "Premier service" in 1993. Broadcast at 7.00 a.m., it failed to attract a significant audience and was taken off the air after less than two years (Hargreaves 1993).

The reasons for this failure are complex, but they are closely bound up in part with the heavy-handed role of the state, through the agency of the FAS, in setting the parameters for "Premier service" and its predecessors. Controversial subjects – particularly those of a politically sensitive nature – were avoided or kept within officially approved guidelines. Although the shows targeted minority viewers, majority ethnic presenters were often relied upon to serve as on-screen gatekeepers, while on the production side minorities were given very few opportunities to contribute to the making of these programs.[1] Through its failure to entrust professionals of minority origin with the responsibility and resources for making programs building directly on the needs and interests of minority viewers, the state ended up producing a string of paternalistic sideshows ignored by an ever-rising proportion of the minority population.

Simultaneously with the decline of these programs, French television was undergoing major transformations in ownership and structure. France's first private channel, Canal Plus, specializing particularly though not exclusively in movies, was launched in 1984. Two further private channels, La Cinq and M6, opened in 1986. The return of the center-right parties to government was followed by the privatization of the main state channel, TF1, in 1987, leaving only two channels (later retitled F2 and F3) in public ownership. Thus within the space of just three years, the state moved from a monopoly position to a situation in which it owned less than half of the six terrestrially based TV stations broadcasting in France. Following the financial collapse of La Cinq in 1992, the balance was partially resorted by reallocating its frequency on a shared basis between two publicly owned stations: Arte, jointly run by the French and German govern-ments, broadcasting an up-market mix of entertainment and factual programs in the evenings, and La Cinquième, providing daytime educational programs.

This rapid expansion in the number of terrestrially based channels has done less than it might have to increase the diversity of television programming. The three privately owned channels, which rely for their income on advertising (or, in the case of Canal Plus, subscriptions), are impelled by commercial considerations to seek to maximize their audiences. The two main publicly owned channels, F2 and F3, also depend increasingly on advertising income, pushing them to compete for the same mass audiences. The result is an array of broadly similar general-interest

channels, none of which can see any commercial incentive in addressing minority ethnic audiences. Thus despite the mix of public and private ownership, as well as the regional dimension of F3, French television remains highly centralized and preoccupied with mainstream audiences.

Compared with the 1960s and 1970s, post-colonial minorities are more visible on screen, particularly in news and current affairs programs. This has not necessarily been to their advantage, for it basically reflects the politicization of "immigration," which, since the rise of the racist Front National in the early 1980s, has been high on the political agenda. Where TV coverage previously emphasized the material difficulties experienced by immigrant workers as cogs in the wheels of economic production, the focus has now shifted to cultural differences, particularly those associated with Islam, together with issues arising from the concentration of disadvantaged minorities in the *banlieues*[2] (Battegay and Boubeker 1993).

The almost obsessive interest of the media in France's Muslim minority arises from a complex combination of factors, foremost among which are the tardy but rapid growth in the organization of Islamic infrastructures, reflecting the rise of family settlement, and the international revival of Islam as an assertive political force, particularly since the Iranian revolution of 1979 (Kepel 1987). Although these two developments were entirely separate – only a tiny fraction of France's Muslim population originates in the Middle Eastern countries which have been most marked by revolutionary Islamic groups – this distinction has often been lost sight of in the media. Little is seen of the silent majority of Muslims originating in the former French colonies of the Maghreb now living peacefully in France.

The forms of Islam portrayed most frequently on screen are those grouped under the generic umbrella of *intégrisme* or *Islamisme* [Islamic fundamentalism]. Not surprisingly, opinion polls show that a large majority among the French public now equate Islam with fundamentalism and see it as a threat to French national identity (cf. Hargreaves 1995: 149–60). This equation has been reinforced during the 1990s by intense coverage of the state of near civil war which has broken out in Algeria between the government and Islamic insurgents whose victims have included Western, particularly French, residents: a pattern of events which has revived memories of the war of independence, which ended with French withdrawal from Algeria in 1962. With Algerians the largest single national group among the Muslim population in France, these events have appeared to render the link between immigration and Islamic fundamentalism more palpable. In a limited sense, the link became direct and explicit in 1995, when for the first time a small group of second-generation Algerians in France, disaffected with their margin-

alization in the *banlieues* and working under the direction of Islamists fighting against the Algerian government, perpetrated a series of bomb attacks in French cities.

Saturation media coverage was given to these attacks and to the hunt for the prime suspect, twenty-four-year-old Khaled Kelkal, who was eventually killed in a shoot-out with the police screened only minutes after the event on prime time TV. Driven by a seemingly insatiable appetite for threatening images of Muslims in France, broadcasters showed unaccustomed self-restraint – self-censorship would perhaps be a better term – in relation to one particular aspect of Kelkal's death. M6, which had the most complete footage, edited out a police voice calling for Kelkal to be "finished off" as he lay badly wounded on the ground. Kelkal was shot dead a few seconds later, but in the absence of the earlier sound-track viewers were left ignorant of the precise circumstances leading up to the final shots. Defending this selective representation of events, the Director of News Programs at M6, Patrick de Carolis, referred to recent statements by France's licensing and regulatory agency, the Conseil Supérieur de l'Audiovisuel (CSA), warning broadcasters not to over-sensationalize their coverage of the hunt for Kelkal (*Le Monde* 1995c). The implication that images of Kelkal being shot dead on screen were somehow less sensationalist than the censored off-camera voice calling for him to be killed seems disingenuous, to say the least.

A revealing insight into the thinking of senior figures in the French broadcasting hierarchy was given when the President of the CSA, Hervé Bourges, expressed concern that TV images of Kelkal's death might help to make a martyr of him (*Le Monde* 1995b). According to Bourges, the most worrying aspect of these pictures was that they were seen "not only by our compatriots, but also by young people in the *banlieues*" (*Le Monde* 1995d). The perception of "young people in the *banlieues*" – most of whom are French by birth and/or nationality, though many have immigrant forebears – as somehow standing outside the national community ("our compatriots") implicitly structures many aspects of French broadcasting.

Pulling back from the fine detail of this particular incident, we can see similar patterns of selection and exclusion in the overall spread of French TV programming. A systematic analysis of prime-time broadcasting on all six terrestrial channels during a two-week period in October 1991 (Hargreaves and Perotti 1993) found that immigrants and their families were most visible in news and current affairs programs focusing mainly on problems and conflicts affecting French society. Minorities of recent immigrant origin were almost totally excluded from game shows and other light entertainment programs which, as genres, provide much more convivial viewing. They were also largely absent from

drama programs such as soap operas and situation comedies, key genres in the representation of "ordinary" life in France. France's post-colonial minorities were thus largely confined to "problem areas" in the images of the national community constructed by television.

Although McMurray (above, Chapter 2) found many images of Arabs in a week-long survey of French TV output in April 1996, the underlying pattern is not fundamentally dissimilar to that of the earlier study. News programs, which were not included in McMurray's analysis, gave prominent coverage during the week of his survey to proposals by a parliamentary committee for tough new measures against illegal immigrants, a recurrent televisual image of the "threat" associated with minority ethnic groups. Most of the documentaries and feature films cited by McMurray dealt with places and events in the Arab world, rather than within France. A rare feature film set in the *banlieues*, *L'Arbalète*, depicted Arabs as part of a shady underworld confined to the margins of French society.

Perhaps the most revealing absence was in TV commercials which, as a genre, depend more than any other on creating a convivial rapport with the viewer. The only adverts featuring an Arab cited by McMurray were for a horse-racing magazine endorsed by the Egyptian film star Omar Sharif, who has no obvious connection with immigrant minorities in the *banlieues*. The 1991 study found a similar absence of minority ethnic actors or presenters in the thousands of advertisements screened during the survey period. A few commercials played on ideas of exoticism. Arabs vaunted the delights of Maggi couscous, for example, but this was presented as a traditional recipe in the context of the home country. Widespread antipathy to minority ethnic groups – encapsulated in a statement by Jacques Chirac sympathizing with those perturbed by the cooking smells associated with immigrants (*Le Monde* 1994) – no doubt dissuades advertisers from associating their products with "outsiders" who might be living just down the block.

The representations documented by McMurray fit overwhelmingly into a neo-colonial or neo-exoticist optic: for the most part, they position Arabs as outside and/or alien to French society. In both the 1991 and 1996 surveys, televised matches between French soccer teams featuring players originating in North and sub-Saharan Africa gave post-colonial minorities a visible but still essentially silent presence in popular leisure pursuits. The only major exceptions to the generally marginal, disruptive, or silent role of Arabs in the televisual construction of French society, as logged by McMurray, were the humorist Smaïn and the light entertainment producer/presenter Nagui.

Born in Algeria to unknown parents and brought up by adoptive Maghrebi parents in France, Smaïn often draws on ethnic differences in his jokes and

sketches, the general effect of which is to take the heat out of conflicts and misunderstandings by seeing the funny side of them (Smaïn 1990, 1992, 1995). Although he is one of the most popular humorists on French TV, Smaïn remains an isolated case. By an accident of timing, McMurray's survey took place the week before the release of a new feature film starring Smaïn, *Les deux papas et la maman*. The promotional buildup to the film included a round of appearances by Smaïn on TV chat shows. Had almost any other week of the year been surveyed, talk-show appearances by entertainers of post-colonial minority origin would have been found to be extremely rare.

Practically the only entertainer of Arab origin to feature regularly on French TV (Smaïn has never had a regular slot) is Nagui, the son of an Egyptian father and a French mother. Although born in Egypt, Nagui was raised in France, where he was educated in Catholic schools. His Egyptian origins place him outside the direct line of France's still sensitive colonial past and, while never concealing his Arab origins, Nagui seldom plays on them at length. Much more commonly, he is seen displaying his skills in the English language during interviews with anglophone rock stars, who are frequent guests on his weekly variety-cum-game shows (Tesseyre 1993).

Post-colonial minorities are still largely excluded from French-made sitcoms and soaps. To date, the only series in which they have regularly featured are "Sixième gauche," broadcast by FR3 in 1990, the sitcoms "La Famille Ramdam" and "Fruits et légumes," screened respectively by M6 in 1990–1 and F3 in 1994, and two teenage soaps set in multi-ethnic *banlieues*, "Seconde B" and "C'est cool!," aired on F2 in 1993–4 and 1996 respectively. Most of these shows were made with financial assistance from the FAS, and, with the sole exception of "La Famille Ramdam," all were broadcast by public service channels. Preoccupied with audience ratings, commercial stations have been far less willing to consider including minority characters in their programs.

Shows featuring minority characters have been largely written and produced by majority ethnic professionals. Although "La Famille Ramdam" was devised by Aïssa Djabri and Farid Lahoussa, both of whom were brought up in France by Algerian immigrant parents, M6 was unwilling to allow their newly created company, Vertigo Productions, overall control of the production process. As originally conceived, the Ramdam family reflected the humble social origins of Djabri and Lahoussa; as reworked to meet the requirements of M6, the finished version tones down the ethnic specificity of the family and moves them higher up the social scale in a kind of Cosby show *à la française*. "Sixième gauche" (Plate 5.1) and "Fruits et légumes" (Plate 5.2) were both co-written by veteran French

Plate 5.1 The Ben Amar family in "Sixième gauche"

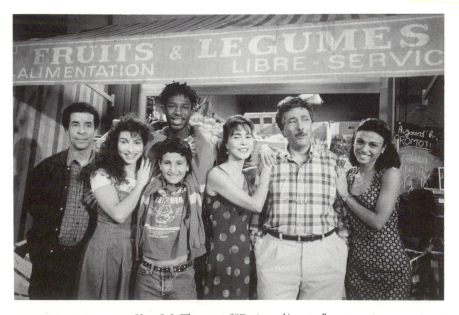

Plate 5.2 The cast of "Fruits et légumes"

program-maker Henri de Turenne and a young second-generation Algerian, Akli Tadjer. Although both shows feature Algerian immigrant families – the Ben Amars in "Sixième gauche" and the Badaouis in "Fruits et légumes" – Turenne and Tadjer worked under the direction of a production team preoccupied with making the characters attractive to majority ethnic viewers. Like other programs supported by the FAS, the series were weighed down by a well-intentioned but heavy-handed concern to convey "positive" images as a corrective to those more commonly seen on French TV,[3] which has often limited the audience appeal of these shows (Hargreaves 1995; Hargreaves and Helcké 1994).

CASSETTES, CABLE, AND SATELLITE

Until quite recently, it was easy for the gatekeepers of French television to assume that the cultural diversity associated with international migration could and should be marginalized or excluded from the programs purveyed by terrestrially based television stations. As a result, minority audiences have been poorly served by program schedules designed to maximize viewing figures among the majority population. In the face of this neglect, minority viewers have been voting increasingly with their feet or, to be more accurate, with their tuning buttons, by turning to alternative sources of programming.

Domestic video cassette recorders (VCRs), which have been widely available in France since the early 1980s, have freed viewers from the monopoly of nationally licensed broadcasters over the supply of television programs. Minorities of recent immigrant origin were quick to spot the potential of the VCR as a gateway to alternative program sources. Although the rest of the population has now caught up, on a per capita basis this was for a considerable period one of the few consumer goods owned more frequently by residents of immigrant origin than by the general population (Tribalat 1996: 213). VCR ownership makes it possible for minority viewers to watch cassettes imported from overseas, significantly widening the choice of programs available to them. In addition, the gradual introduction of cable television since the mid-1980s in major urban areas, substantially increasing the choice of stations beyond the six terrestrially based channels, has considerable potential for minority audiences. The licensing authorities have been very slow to exploit that potential. Cable channels using Arabic, the most widely spoken mother tongue among France's post-colonial minorities, have been licensed in only a handful of localities. The restrictive

licensing policy of the CSA has been driven by a deep reluctance to do anything that might facilitate cultural separatism among minorities of recent immigrant origin, and more particularly by fear of allowing ready access within France to programs originating in Islamic countries (Frachon and Vargaftig 1993: 171–3; *Télé Satellite* 1995).

The policy of attempting to insulate the national territory of France from cultural forces beyond the control of the state has been blown apart by the advent of satellite television. Since the early 1990s, a growing number of channels originating in the Arab world and other parts of the Mediterranean basin has been available in France to viewers making a modest investment in a satellite receiving dish. As with VCRs, immigrant minorities have rapidly seen the advantages of satellite receivers. A survey conducted in 1995 indicated that whereas only 4 percent of households across the country as a whole could receive satellite programs, 21 percent of those headed by Arabic-speakers had installed dishes (*Info câble et satellite* 1995). By the end of 1996, the proportion of Arabic-speaking households equipped with satellite receivers was reported to have leapt to 42 percent (*Le Monde* 1996).

A FAS-financed report spoke in alarmist terms of these developments, warning that if minority ethnic viewers were not to be lost to potentially subversive channels beamed from Islamic countries, cable and terrestrially based stations would have to offer more attractive programs (Bouchera 1995). Panicking at the sight of satellite dishes mushrooming across tower blocks in *banlieues* containing dense concentrations of minority ethnic groups, the authorities also considered other options, such as more restrictive regulations on the installation of satellite receivers, but with little effect. To counter the satellite "threat," the CSA was by all accounts poised in the fall of 1995 to license a substantial expansion of handpicked, Arabic-language channels judged to be safe for cable distribution in France, but these plans were shelved as a result of the Kelkal bombings (*Libération* 1995).

While it is clear that the range of programs available to diasporic groups has expanded considerably with the advent of VCRs and satellite receivers, comparatively little research has so far been conducted into the effects of this on the viewing habits, attitudes, and behavior of those concerned. A few small-scale studies do give some idea of the impact of VCRs on minority ethnic households. A study of fifty Maghrebi families by Chaabaoui (1989) found that video cassettes were used intensively to make up for perceived deficiencies in the programs offered by France's terrestrially based channels. Analyzing the responses of his interviewees, Chaabaoui distinguished three main factors influencing the acquisi-

tion and use of VCRs: devotional concerns led to the purchase or loan of cassettes featuring Islamic teachings and religious history; films of traditional festivals and other folkloric recordings were used for family viewing and other social occasions; instructional cassettes were viewed as an aid to reading and writing or for initiating family members into religious rituals. Arabic-language cassettes came from a range of countries stretching from the Maghreb to the Middle East.

Chaabaoui (1989: 26) also notes briefly, but does not expand on the fact, that most of the feature films viewed on cassette were westerns, karate, crime, or war films. These are genres already catered for in varying degrees on broadcast channels, and are not specifically linked to the ethnic origins of his interviewees. Clearly, therefore, the use of viewing facilities other than those offered by terrestrially based channels does not necessarily equate with immersion in ancestral cultures.

Although Chaabaoui does not indicate this explicitly, it seems likely that there were significant differences in the viewing habits of different age groups in the households which he visited. While the older generation undoubtedly draws on modern technology for nostalgic purposes, using cassettes of a religious and folkloric nature to compensate for gaps in the schedules of broadcast channels, younger family members born in France appear to be more attracted by American-made programs. This was certainly the finding of Diop and Ba (1996) in a study of West African immigrant families, all of them Muslims. As the sample was small (just nine families, with a total of sixty-three interviewees), the data need to be interpreted with care. It is nevertheless striking that whereas West African migrants show a marked preference for cassettes in their mother tongues and/or depicting their home countries and religious traditions, their children are reported to express "a preference for American films (crime films, westerns and spy films), karate and kung fu films and certain made-for-TV films" (Diop and Ba 1996: 51).

These cinematic genres are very similar to those listed by Chaabaoui as being the most popular in the video acquisitions of the households included in his survey. The absence of any additional information on those particular cassettes probably reflects the fact that Chaabaoui's interviews were confined to adults, whereas Diop and Ba interviewed all family members, including the children, most of whom were born in France. Diop and Ba note that, while the cassettes watched by parents related mainly to the home country and its cultural traditions, their children "had greater latitude in their choice and viewing of cassettes: *Rambo*, *Terminator*, *Robocop*, *Rush 3*, etc." (Diop and Ba 1996: 56). A similar generational divide is apparent in the findings of Raulin who, in interviews on video cassette

usage by South-East Asians in France, found that among teenagers "the favourite films are American (*Rocky, Rambo, King-Kong, Terminator, Crocodile Dundee*)" (Raulin 1990: 24).

A similar pattern is visible in the preliminary findings of research in which I am currently engaged on the viewing habits of minority families equipped with satellite TV. Interviews conducted among Maghrebi families show that the older generation tend to use satellite programs beamed from the home country as virtually non-stop televisual wallpaper. By contrast, their children use other sets to watch programs dominated by Western, particularly American, popular culture. Gillespie (1995: 37–40) has found similar generational differences among South Asians in the UK. Thus while enabling the older generation to reassert diasporic links drawing on ancestral connections, television is drawing the children of migrants into American-dominated forms of popular culture that are consumed with equal enthusiasm by majority as well as minority ethnic youths.

CONCLUSION

A prime lever in the structuring of national consciousness, French television, like the state which controls it, has been slow to find anything other than a marginal place for post-colonial minorities. Such images that do feature on screen tend to be neo-colonial in character, presenting migrants and their descendants as alien to the national community and/or as the beneficiaries of paternalistic condescension. With digital technology poised to bring a huge increase in the number of satellite channels available to viewers, the days of monopolistic state control over the flow of television images consumed on French soil are now definitively gone. While the heavy capital costs involved in television production and marketing do not make it easy for minority groups to take an active role as program-makers and suppliers, they at least enjoy greater choice and flexibility as television consumers. Many migrants have used these opportunities to strengthen diasporic links, but among the younger generation television is serving as a gateway to a global youth culture that owes more to American than to Third World models.

NOTES

1 On a brief period during which the minority-run Agence Im'Média supplied regular input to the program "Rencontres," see Abdallah (1993: 86–8).

2 Cf. above, p. 12.

3 This is also true of the FAS-financed weekly magazine program "Saga-cités," which focuses on positive images of the *banlieues*. Broadcast by F3, initially within the Paris region, the show has been screened nationwide since 1994, when it effectively took over from "Premier service" as the FAS's main televisual flagship (*Le Monde* 1995a).

REFERENCES

Abdallah, Mogniss H. (1993) "L'Agence Im'Média met les pieds dans le paysage de l'immigration en Europe," in Claire Frachon and Marion Vargaftig (eds), *Télévisions d'Europe et immigration*, Paris: INA/ADEC, pp. 81–93.

Battegay, Alain, and Ahmed Boubeker (1993) *Les images publiques de l'immigration*, Paris: CIEMI/L'Harmattan.

Bouchera, Leïla (1995) "L'offre de programmes télévisuels diffusés par satellite à destination des populations étrangères en France," unpublished report for the Ministère des Affaires Sociales, de la Santé et de la Ville.

Chaabaoui, Mohammed (1989), "La consommation médiatique des Maghrébins," *Migrations-société*, vol. 1, no. 4, August 1989, pp. 23–40.

Diop, A. Moustapha and Saada Ba (1996) "La consommation médiatique des immigrés ouest-africains," *Migrations-société*, vol. 8, no. 44, March–April, pp. 47–58.

Frachon, Claire, and Marion Vargaftig (eds) (1993) *Télévisions d'Europe et immigration*, Paris: Institut National de l'Audiovisuel/Association Dialogue entre les Cultures.

Gastaut, Yvan (1996) "L'émergence de la question de l'immigration à la télévision française (1970–1983)," unpublished paper, Festival de cinéma de Douarnenez, August 21.

Gillespie, Marie (1995) *Television, Ethnicity and Cultural Change*, London/New York: Routledge.

Hargreaves, Alec G. (1991) "La Famille Ramdam: Un sit-com 'pur beur'?," *Hommes et migrations*, no. 1147, October, pp. 60–6.

——— (1993) "Télévision et intégration: La politique audiovisuelle du FAS," *Migrations-société*, vol. 5, no. 30, November–December, pp. 7–22.

——— (1995) *Immigration, "Race" and Ethnicity in Contemporary France*, London/New York: Routledge.

Hargreaves, Alec G., and Helcké, Joanna (1994) "*Fruits et légumes*: Une recette télévisuelle mixte," *Hommes et migrations*, no. 1182, December, pp. 51–7.

Hargreaves, Alec G. and Perotti, Antonio (1993) "The representation on French television of immigrants and ethnic minorities of Third World origin," *New Community*, vol. 19, no. 2, January, pp. 251–61.

Humblot, Catherine (1989) "Les émissions spécifiques: De 'Mosaïque' à 'Rencontres,'" *Migrations-société*, vol. 1, no. 4, August, pp. 7–14.

Info câble et satellite (1995) "Equipement des foyers français en réception satellite par rapport au câble," November 2, pp. 4–5.

Kepel, Gilles (1987) *Les banlieues de l'Islam: Naissance d'une religion en France*, Paris: Seuil.

Kuhn, Raymond (1995) *The Media in France*, London/New York: Routledge.

Lévy, Françoise (1993) "L'immigration dans la production documentaire, le magazine, la fiction française: Variations autour d'un thème, 1975–1991," in Claire Frachon and Marion Vargaftig (eds), *Télévisions d'Europe et immigration*, Paris: INA/ADEC, pp. 57–65.

Libération (1995) "L'an 1 de la révolution satellitaire," September 2.

Le Monde (1994) "M. Chirac: 'Il y a overdose,'" June 21.

——— (1995a) "'Saga cités,' objet d'intérêt national," September 3–4.

——— (1995b) "Un quotidien suisse accuse M6 d'avoir tronqué un reportage," October 3.

——— (1995c) "L'injonction 'Finis-le!' a bien été enregistrée par M6 lors de la mort de Khaled Kelkal," October 4.

——— (1995d) "Lapsus," October 11.

——— (1996) "Deux chaînes arabophones conventionnées," November 29.

Raulin, Anne (1990) "La consommation médiatique: Une passion des minorités urbaines?," *Migrations-société*, vol. 2, no. 8, March–April, pp. 17–28.

Smaïn (1990) *Sur la vie de ma mère,* Paris: Flammarion.

——— (1992) *Rouge baskets,* Paris: Michel Lafon.

——— (1995) *Ecris-moi,* Paris: NiL Editions.

Télé Satellite (1995) "Le problème de la diffusion des chaînes arabes en France," no. 70, September, p. 147

Tesseyre, Cécile (1993) "Nagui: Les secrets de son enfance," *Télé 7 jours*, November 13, pp. 20–3.

Tribalat, Michèle (1996) *De l'immigration à l'assimilation: Enquête sur les populations d'origine étrangère en France,* Paris: La Découverte/INED.

6

BROADCASTING FROM THE MARGINS

Minority ethnic radio in contemporary France[1]

Richard L. Derderian

INTRODUCTION

The election of the Socialist government in May 1981 opened unprecedented opportunities for minorities in France. After twenty-three years of conservative rule the Socialists introduced a series of measures to promote social justice and to expand participation in French society. Two measures in particular – the end of the state monopoly over radio and television and the right of foreigners to organize associations – empowered minorities to become actors in the public sphere while valorizing and cultivating ethnic, racial, and religious differences. This was a dramatic departure for a nation that has historically espoused universalist ideals and an assimilationist model of citizenship.

This chapter offers an overview of minority radio stations in France. Of particular interest are issues of language, audience, programming, and the relationship between minority broadcasters and the French institutions that regulate and subsidize their activities. The conclusion touches on recent changes in the French audiovisual landscape and on some of the challenges that lie ahead for minority stations. A range of broadcasters is discussed, with detailed case studies drawing on fieldwork relating to the Paris stations Radio Beur and Beur FM.

THE END OF THE STATE MONOPOLY

The end of the state monopoly over radio in 1981 and the expansion of private stations has been one of the most-transformative and least-studied events in the recent cultural history of France. From the establishment of Louis XI's royal postal system in the fifteenth century to the development of the telegraph in the nineteenth century, French governments have historically exercised strict control over all forms of communication.

State control over radio began to tighten during the tumultuous years leading up to and following the Second World War. In September 1939, following the declaration of war against Germany, all private stations were required to relay public broadcasts. At the end of the war, the ordinance of March 23, 1945 revoked the last remaining authorizations held by private stations (Rossinelli 1991: 93–5). From 1945 to 1981 the French government effectively controlled all radio broadcasts within its own borders. As late as 1980, France had only seven legal stations for a population of fifty million – proportionally some twenty-five times fewer than the United States (Cazenave 1984: 8).

The state monopoly was never airtight. For decades, a number of peripheral stations (*radios périphériques*) reached large segments of the French population from border areas of neighboring countries. In fact, between 1948 and 1968, French public radio lost more than half its audience to peripheral stations broadcasting on long wave. Yet even these stations did not escape the grasp of the French state. Through the holding company SOFIRAD, the French government maintained a controlling interest in all of the peripheral stations except Radio Luxembourg – itself subject to state influence through its parent company Havas, then operated by the French government. Until the privatization of the peripheral stations in the mid-1980s, French administrations from de Gaulle to Mitterrand appointed and removed political allies and enemies from key managerial and administrative positions (Kuhn 1995: 92–5).

During the presidency of Valéry Giscard d'Estaing (1974–81), pressure intensified to end the state monopoly. Government control over the airwaves came to be seen less as an effective means of serving the public interest and more as a mechanism for stifling public expression and diffusing official propaganda. The 1970s saw the creation of scores of pirate stations, which challenged the ban on private stations. Socialist presidential candidate François Mitterrand, who viewed the monopoly as a "threat to the freedom of information," used his party's pirate station, Radio Riposte, to argue for the opening of the airwaves (Cazenave 1984: 51–2).

On August 6, 1981, just four months after Mitterrand's election to the presidency, Minister of Communications Georges Fillioud announced government plans to dismantle the state monopoly and to legalize private stations. Fillioud's announcement precipitated a rush by hundreds of stations to stake out a place on the FM dial. As early as September 1981 there were already some 400 private stations on the air – despite the fact that the government did not clearly lay out its requirements for broadcasting rights until the law of July 29, 1982 and the first official authorizations were not issued until 1983 (Rossinelli 1991: 103). By 1985 the number of private radio stations climbed to 1,500 and reached 1,800 by 1990 (Berrahal 1987; Nataf 1990).

RADIOS COMMUNAUTAIRES

Among the hundreds of *radios locales privées* – an expansive term covering many different types of FM broadcasting, ranging from stations that are part of national, general entertainment networks to local, specialized broadcasters – are a relatively small number of stations operated by and targeting France's ethnic, racial, and religious minorities, known as *radios communautaires*. According to a 1991 article in *Télérama* there are roughly thirty minority stations in France – a number that has remained more or less the same since 1981 (Berdah and Bouchez 1991).

In actuality, French universalist traditions make it impossible to arrive at the precise number of minority stations. The Conseil Supérieur de l'Audiovisuel (CSA), responsible since 1989 for the authorization and policing of broadcasting rights in France, does not officially recognize or keep statistics on minority stations. Just as French law prohibits census-takers from revealing the national origins of naturalized citizens, a general classification system applied to all stations in France masks the specificity of minority broadcasters. The principal criteria for this system are geographic and economic, not ethnic, racial, or religious.

In practice, however, the CSA and French lawmakers have singled out minority stations in numerous policy initiatives. For example, the February 1994 Pelchat amendment, which requires all broadcasters in France to devote 40 percent of their music to French artists, excludes minority stations from its provisions (Cauhape 1994). Moreover, the CSA routinely groups together or chooses between broadcasters that target a particular community, regardless of their official status as commercial or nonprofit stations. This tension between

universalist ideals and particularistic practices is part of a complex dynamic at work just below the surface of the French nation-state (Silverman 1992: 5).

Most minority stations are structured as nonprofit associations and staffed by unpaid volunteers. The bulk of their operating costs comes from state and local subsidies, listener donations, membership dues, benefit parties, and concerts. Since 1989, associational stations have the right to collect advertising revenue up to but not exceeding 20 percent of their gross income. The majority of these stations are located in major urban areas such as Paris, Marseilles, and Lyon, with historically high concentrations of immigrant workers. Paris and its suburbs, with at least twelve minority stations, has the largest share of *radios communautaires*.

North Africans, who represent nearly 40 percent of France's four million immigrants (INSEE 1994: 14, 17), have been particularly active in creating radio stations. According to *Télérama*, there were some twelve stations in France broadcasting to the "Arab"[2] community in 1991 – the Paris region accounted for five of these stations while Marseilles had three (Berdah and Bouchez 1991). Journalist Ariane Chemin (1994) added that members of the Arab community are more apt to apply for a frequency than Jewish or Christian groups – Arabic speakers filed twenty-three applications in 1987 and nineteen between 1991 and 1992.

LANGUAGE

French appears to be the language of preference for a large number of Paris-area minority broadcasters. While the music aired by North African stations Beur FM and Radio France-Maghreb is predominantly Arabic or Berber, most of the speech is in French – at least 90 percent, according to Berdah and Bouchez (1991). A similar principle is applied by Radio Judaïque and Radio Communauté Judaïque in broadcasts aimed at the Jewish community. Announcers at both stations offer music in Hebrew but speak to their listeners almost exclusively in French. However, at Radio Orient and Radio Soleil, two additional stations targeting the North African and wider Muslim population, Arabic plays a more prominent role. Announcers at Radio Orient communicate primarily in Arabic, and Radio Soleil's staff uses French only 60 percent of the time. It is important to note, however, that Radio Orient is not a typical minority-run station. Founded in 1982 by Raghid El-Chammah, Radio Orient was rumored to receive much of its resources from Islamic states in the Persian Gulf region, particularly Saudi Arabia, closely

allied with the West. Radio Orient, whose programming is far more religiously oriented than that of other stations targeting similar ethnic groups, operated until 1987 without an official authorization but was tolerated by French authorities (Younès 1994; Cauhape 1996; Sutton 1992: 32–3; Berdah and Bouchez 1991).

In part, language decisions hinge on audience and staff composition. For example, Beur FM claims a special following among second-generation North Africans, popularly known as Beurs,[3] and broadcasts primarily in French because most Beurs have only a rudimentary understanding of Arabic or Berber – the two principal languages in North Africa. Staff members at Beur FM, who are predominantly second-generation North Africans, share these same language difficulties. Houria Bounab, production secretary at Beur FM, explained that she is one of the few station members capable of recording and reading commercials which air in Berber (Interview, February 2, 1994). At Radio Soleil, however, the situation is quite different. Created by North African student-activists as a spin-off of the militant paper *Sans Frontière*,[4] Radio Soleil caters mainly to listeners of Algerian, Moroccan, and Tunisian origin whose first language is Arabic (Polac 1991: 31).

Financial concerns also have a bearing on language choices. Stations structured as nonprofit associations, such as Radio France-Maghreb, rely heavily on state and local subsidies to cover significant portions of their operating costs. The Fonds d'Action Sociale (FAS),[5] responsible for promoting the inclusion of immigrants and their families into French society, is the chief source of subsidies for most minority associations, including radio broadcasters. FAS agent Fernanda da Silva noted that her agency subsidizes about seventy stations – not all of which are minority broadcasters (Interview, December 27, 1993). The chief preoccupation and determining factor for FAS support is the extent to which French or foreign broadcasters promote the integration of immigrants and their families. In making this assessment, the FAS certainly considers French-language programming as an important criterion.

Yet time allotted to French is not the only concern of the FAS. The FAS covers one-third of the operating expenses of Marseilles station Radio Gazelle, which features programs in thirteen different languages. Unique among minority broadcasters, Radio Gazelle divides its airtime and administrative responsibilities among a number of ethnic and racial groups from Marseilles's diverse immigrant population (Berqué *et al.* 1993: 216, 218). Saïd Boukenouche, president of Association Rencontre Amitié, Radio Gazelle's parent organization, remarked that the station's objective was to promote a greater sense of mutual understanding and interaction among immigrant communities in Marseilles

(Contrucci 1984). The ability of Radio Gazelle to bridge group divisions and to serve as a model for interethnic and interracial cooperation is undoubtedly what makes it such a successful recipient of state and local support.

Language preferences can be a contentious and potentially explosive issue for some minority broadcasters. This is particularly true for Algerian-run stations. Most Algerians are descendants of the original Berber tribes who populated western North Africa from the time of antiquity. With the spread of Islam in the seventh century, much of the indigenous population adopted the Arabic language of their conquerors. Today, Berber speakers represent between 20 and 25 percent of the national population, and most are Kabyles, i.e. inhabitants of the mountainous regions of Kabylia, located to the east of the capital, Algiers (Ruedy 1992: 9–10).

During the colonial period the French authorities attempted to secure their rule by dividing the linguistic groups. Through the construction of schools and the creation of language, history, and cultural programs, the French favored the Kabyle minority. Following independence in 1962, successive Algerian governments made life difficult for speakers of Berber and even of Algerian Arabic by imposing classical Arabic – foreign to most of the population – through the educational system. Ironically, this French-style assimilationist policy,[6] promoted through state-controlled schools and cultural institutions, was part of an official plan to break with the colonial past and to invent a national identity (Stora 1994: 53–5).

The now defunct Radio Beur (1981–92), which as late as 1992 claimed the largest following of any minority station in France, was never able to arrive at a balance between Arabic and Berber (CSA 1991a: 84; Derderian 1995: 56–7). Although Radio Beur officially allotted equal time to Arabic and Berber music, listeners complained that the station favored Berber programming. According to his 1988 study, Fattah Allah found that Radio Beur failed to respect its official guidelines: "The particularity of the music broadcast on Radio Beur resides in the central place reserved for Kabyle music." In Fattah Allah's opinion, this tendency resulted from the predominance of Berber-speaking hosts (Fattah Allah 1988: 39–40). Indeed, throughout Radio Beur's eleven-year history Kabyles dominated all levels of administrative and operational positions at the station (Derderian 1995: 56).

Michel Anglade's 1989 study discusses the efforts made by Radio Beur to diversify its personnel and programs:

Moroccan and Tunisian hosts were recruited. *Pied-noir* Jews have been given a music show. Radio Beur has even tried to go beyond Maghrebi boundaries and has opened itself to sub-Saharan Africa and to the Caribbean through a "black" show hosted by a Martiniquan.

(Anglade 1989: 14)

While president of Radio Beur in 1989 and 1990, Mohand Dehmous tried to expand the number of shows in Arabic:

Most of Radio Beur's audience were Berber speakers in the Paris area. But I don't think that you can say it was a Berber station. When I was in the administrative council I looked everywhere for Arabic speakers to host programs in Arabic . . . Our charter stipulated that we expressed ourselves in the three languages, but it was difficult to find people to broadcast shows in Arabic.

(Interview, March 31, 1994)

Many of Radio Beur's founding members felt so uncomfortable about these cultural tensions that they decided to leave the station. This was certainly the case for Youcef Boussaa:

When people started to say that there were too many Berbers and not enough Arabs the conflict became important. Moreover, these problems were formulated by people who couldn't even speak Arabic or Berber. I speak Arabic, Berber, and French and felt that I had no part in this conflict.

(Interview, May 16, 1994)

Boussaa's brother-in-law, Kamel Amara, stayed at Radio Beur for over a year but finally left because of what he described as the "Berberization" of the station:

Most of the programs were in Berber, which the Arabic-speaking listeners didn't necessarily understand. I wanted to play a little of everything: Arabic, Kabyle, and Anglo-Saxon music. Sometimes, by impulse, I only played Arabic music to show that although I'm Kabyle I also listen to Arabic music . . . It was at Radio Beur that I discovered that even within our own community there could be an anti-Arab racism.

(Interview, May 24, 1994)

Other station members rejected the charge that Radio Beur favored Kabyles. For former station president Nacer Kettane this accusation was a reflection of the cultural racism in Algeria, which had been transplanted to France. Kettane noted that before Radio Beur there was very little Berber music on the French airwaves, and insisted that Radio Beur did not practice any form of cultural or linguistic discrimination: "We were a tolerant, not a closed station" (Interview, July 4, 1994).

PROGRAMMING

Minority broadcasters offer a rich selection of programs and services for diverse ethnic, racial, and religious communities that have historically been excluded from the mass media in France. Although the immigrant press has a rich history in France, these publications only reached a small literate segment of the foreign population (Génériques: 1990).[7] Minority broadcasters, who are capable of accessing a much larger audience, act as important cultural outlets, provide innumerable social and religious services, and offer alternative sources of information. Moreover, as powerful intermediaries, they mitigate potentially explosive situations by serving as vectors for constructive debate.

Stations such as Radio Beur filled a cultural void in the Maghrebi community. For over a decade, Radio Beur broadcast scores of native North African performers as well as aspiring Beur artists. Many of these performers took part in live programs that gave listeners the chance to call in and ask direct questions. Several former station members commented that Radio Beur was the driving force behind the success of raï music in France.[8]

Yet the diffusion of music extended beyond the framework of station programs. In 1984, Radio Beur released an album featuring a number of previously unrecorded Beur singers and musical groups. Throughout its history, Radio Beur claimed to be the largest organizer of concerts in the North African community. Its most successful concert, at the Zénith in Paris in 1985, drew some 7,000 people. Concerts brought in much-needed revenue, helped promote North African artists, and provided the Maghrebi community with a wealth of previously unavailable entertainment.

Music was not the only object of cultural promotion at Radio Beur. Scores of North African and French artists and intellectuals from diverse horizons took part in the weekly broadcast "La tribune de Radio Beur." Shows such as "Triptyque" featured literature, and cinema; "Canoun" and "Tafsut" took up Berber language and culture. "Les Beurs et la plume" gave listeners the opportunity to compose and present their own poetry (CSA 1987: 86–8). In addition to these programs, the station created its own literary prize for promising North African novelists and published several volumes of poetry, beginning with *Prise de parole* (1985) as well as an account of the 1988 anti-government demonstrations in Algiers, *Octobre à Alger* (1989).

A great number of Radio Beur's programs depended on listener participation. "Flipper," for example, was a show directed at and run by North African youths.

"Juridiquement vôtre," hosted by two lawyers, helped inform listeners about their rights by discussing pertinent topics and allowing callers to ask specific legal questions (CSA 1991a: 96, 98). Several former station hosts commented that Radio Beur provided a particularly important outlet for women. In 1982, Lila Benbelaïd hosted a show called "Paroles de femmes" in which she invited guests and addressed a host of typically taboo subjects such as marriage, sex, and divorce. It aired in the afternoon, when husbands and fathers were away at work and housewives and daughters were free to listen and call in with questions (Interview, April 20, 1994). Aïcha Benmamar, who joined the station in the mid-1980s, added that women lawyers, writers, sociologists, and doctors who took part in many of these programs helped open a discussion and facilitated a dialogue with female listeners. According to Benmamar, the station encouraged women to express themselves and promoted a better understanding between the sexes (Interview, May 13, 1994).

To varying degrees, minority stations play an active role in the religious life of their respective communities. Secular stations such as Radio France-Maghreb, Radio Soleil, and Beur FM mark the important Islamic holidays with special announcements, music, and thematic shows. Radio Orient, a more confessionally oriented and financially endowed station, airs the Islamic call to prayer five times daily and offers a direct broadcast from Mecca every Friday morning via satellite (Kahn 1989). Some stations, such as Radio Gazelle or Paris's France-Méditerranée, offer programs that promote an exchange between Jews, Muslims, and Christians (Chemin 1994; El Yazami Khammar 1983).

Religion can be a highly contentious issue for minority stations. Malika Ouberzou, long-time administrator at Radio Beur, recalled that there was no consensus on how to approach Islam. Some stations' members were ready to air prayers and daily programs, whereas others felt it was better just to mark the major holidays (Interview, April 28, 1994). At Radio Gazelle, special programs aired during Ramadan disrupted the regular schedule and created feelings of resentment among non-Muslim station members. Only after years of debate did the association's general assembly finally resolve the issue in favor of the Muslim community (Berqué et al. 1993: 217–18).

Minority stations provide listeners with an alternative source of information on pertinent events and issues in France and abroad. It is during extraordinary crisis periods that this role becomes most pronounced. When anti-government demonstrations broke out in Algiers in 1988, Radio Beur interrupted its regular programming with special extended coverage of the events in Algeria. When the Islamic Salvation Front (FIS) won a landslide victory in the 1990 municipal and

regional elections in Algeria, Radio France-Maghreb had already been developing its coverage for months. "We announced this terrible FIS victory at eight in the evening thanks to twenty-eight correspondents and three months of work," commented Brahim Hadj-Smail, one of the founders of Radio France-Maghreb (Berdah and Bouchez 1991).

The Gulf War provides an excellent illustration of the multiple services offered by minority stations. During the war, North African and Jewish stations interrupted their regular programming and opened their telephone lines to anguished listeners. Radio France-Maghreb reached an agreement with Radio France Internationale (RFI) to relay more in-depth RFI news coverage of the war to its audience. Communauté Judaïque-FM contracted with the two most important Israeli stations – Galei tsahal and Khol Israël – to keep its audience abreast of the most recent developments. Through direct connections to Israel, Radio Shalom allowed its listeners to ask questions about unfolding events in the Middle East (Piot 1991; Nataf 1991).

During the war, minority broadcasters helped mitigate escalating tensions by providing a structured, controlled outlet for a wide range of viewpoints. For example, a large segment of France's North African community sympathized with the Iraqi people and opposed the war. North African stations allowed listeners to vent their feelings of anger, frustration, and fear within clearly defined guidelines for constructive dialogue and debate. According to Radio France-Maghreb director Hadj-Smail, calls to his station could go unfiltered because listeners understood and respected France-Maghreb's long-established position against all forms of hatred, insults, and anti-Semitism. Moreover, the station tried to create an atmosphere conducive to reasoned dialogue by avoiding nationalist scores and playing calm, peaceful music (Piot 1991).

Not everyone was in agreement about the beneficial role of minority stations during the Gulf War. On January 29, 1991, the Comité Technique Radiophonique (CTR), an organ of the CSA, met with nine minority broadcasters to express its concerns. The CTR warned that the policy of airing "uncontrolled" viewpoints could seriously damage relations between Muslims and Jews in France. In fact, all of the Jewish stations ended the policy of open telephone lines after the first bombs fell on Iraq on January 17, 1991. Radio Orient was the only station targeting France's Muslim population to shut down its phone lines (Piot and Perez 1991). "Our principal objective," proclaimed Radio Orient founder Raghid El Chammah, "is to adhere to state policy and to convince the Muslim community of its duty to participate in the national consensus" (Cojean 1991).

As mentioned earlier, Radio Orient should not be taken as a typical minority-

run station. Purchased in 1992 by Rafic Hariri, Lebanese Prime Minister and billionaire businessman, its $6 million budget for 1993 dwarfed that of its competitors. In addition to seventy-five full-time employees, forty of whom are journalists, Radio Orient possesses a network of some forty correspondents stationed throughout France, in London, and Switzerland (Younès 1994). Moreover, some French journalists point to Hariri's close ties to Saudi Arabia and argue that Radio Orient is part of a larger Saudi geopolitical strategy to gain influence over Europe's Muslim population (Malaurie and Ploquin 1992).

AUDIENCE

There is considerable confusion surrounding the issue of audience figures. Minority broadcasters often exaggerate their own audience, and professional surveys are unreliable. For example, in its 1991 frequency application, Radio Beur claimed to reach 800,000 listeners. Yet in the very same application an IPSOS survey of Paris-region listeners aged fifteen and older placed the station's audience in June 1991 at 121,500 (CSA 1991a: 86, 121). The problem resides in the fact that most nonprofit minority stations do not have the budget to conduct their own surveys and are naturally inclined to overestimate the importance of their listening audience. Surveys taken by companies such as IPSOS or Médiametrie draw from disparate geographic samplings, which do not reflect the more concentrated demographic reality of minority communities.

Journalists further obscure audience figures by employing unverified numbers. A 1989 article in *Le Point* credited Radio Orient with 1,200,000 listeners. Three years later, a 1991 article in *Le Figaro* placed Radio Orient's audience at only 450,000 (Kahn 1989; Nataf 1991). While *Le Figaro* indicates that its figures came from Radio Orient staff, *Le Point* offers no reference information. It is highly doubtful that Radio Orient lost two-thirds of its audience in the span of three years. It is more likely that the *Le Point* article – which treated the spread of Muslim broadcasters in France and appeared shortly after a sensationalized Paris demonstration by a few hundred, mainly Pakistani, Muslims against Salman Rushdie's *Satanic Verses* – used inflated figures to exaggerate the phenomenon of Islam in France (Hargreaves 1992: 169).

Audience composition is also unclear. Do minority stations appeal to more women than men? Do young people tune in, and are most listeners first-generation members of minority communities? The case of Radio Beur, a station

that claimed a special following among North African youths, reveals the complexity of this problem. Extensive interviews with the majority of the station's former administrators yielded conflicting and contradictory responses regarding audience composition. Some of the administrators claimed that young people took an early interest in Radio Beur and were always present at concerts or benefit parties. Others argued that it was more of a family station. If young people listened, it was because their parents had tuned in. Still others insisted that young people took little or no interest in Radio Beur. It was primarily a station that appealed to the nostalgic inclinations of an older group of immigrant workers. Young people had adopted Western cultural practices and were much more likely to listen to the same stations and music as their French counterparts.

INTEGRATION OVER THE AIRWAVES

To a large extent, the survival of minority stations depends on their ability to adapt to shifting political attitudes toward cultural diversity. By the mid-1980s, the electoral success of the Front National and its anti-immigration rhetoric caused both the Socialists and their conservative rivals to harden their position toward France's foreign population. As early as 1984, the Socialists adopted a tougher stance toward illegal aliens, erected new restrictions to complicate the process of family reunification, and reintroduced financial incentives for the repatriation of foreign residents (Weil 1991: 170–6). An earlier optimism about favoring minority cultural expression and political rights gave way to fears of solidifying ethnic ghettos and the "Lebanonization" of French social relations. The fight against unemployment, drugs, and urban violence – threatening dis-advantaged groups of majority as well as minority origin with social exclusion – now tops the political agenda.

Within this context, agencies such as the FAS have come under increasing pressure to minimize support for cultural activities and to prioritize social and economic initiatives. The 1994 FAS budget for cultural expenditures was slated for a significant reduction, according to FAS agent André Videau (Interview, February 2, 1994). At the Délégation Développement Formations – a division of the Ministry of Culture – which seeks to "democratize" culture by sponsoring a range of initiatives among certain segments of French society (rural inhabitants, low-income urban residents, minorities, prisoners, senior citizens, the physically disabled, etc.), Sylvie Bessenay argued that state support for cultural initiatives is

now directed less at particular minority groups and more at larger spaces, such as the urban suburbs (*banlieues*), which contain disproportionate numbers of people disadvantaged by global economic change (Interview, April 27, 1994). While the *banlieue*, which has a sociological resonance equivalent to that of "inner city" in English, is often equated with North African youth, it also represents a more ethnically diverse urban environment encompassing groups of majority and minority ethnic origin who share similar economic and social hardships.[9]

Minority stations have responded to this new context by redefining themselves in terms of the role they play in the integration process. While still valorizing the expression of cultural diversity, minority stations frame themselves as the promoters of mutual understanding, alternative sources of social and economic assistance, and beacons of republican values. For example, in their competing 1991 applications for a Paris frequency, both Radio Beur and Beur FM depicted themselves as being invaluable to the process of transforming North Africans into French citizens. Radio Beur's application proclaimed that the station's ambition was "to contribute to a better integration of Beurs and to reinforce social cohesion within the framework of an open, plural, and unified society." The station intended to accelerate the inclusion of North Africans, and second-generation members in particular, by allowing minority youths to express their aspirations, including them in pertinent debates, and offering specific programs to facilitate the job search and the creation of new businesses (CSA 1991a: 20, 83). Beur FM's application explained that although North Africans have made considerable strides toward integration, significant challenges still remain. As a "true integration medium," Beur FM proposed to advance the integration process by upholding republican values of tolerance and mutual understanding, treating all cultures equally, and working in close concert with associations and government institutions. In addition, Beur FM planned to favor exchanges and communication between cultures and to improve the diffusion of information about minority life in France. The application contended that, if France is to find its place in a European community, it must first complete the process of inclusion within its own borders (CSA 1991b: 85–8).

CONCLUSION

The liberation of the FM band in 1981 represented a victory for free expression and the opportunity to transform radically the French public sphere. To benefit

from these new possibilities, minority stations must overcome cultural divisions, an increasingly hostile political context, and a host of financial, professional, and administrative weaknesses. Perhaps the most ominous threat to independent broadcasters has been the proliferation of powerful commercial networks over the past decade. In 1991 there were 400 nonprofit stations and 1,200 commercial broadcasters, 900 of which were part of regional or national networks. As Raymond Kuhn (1995: 102) has observed, by conceding to private broadcasters the right to form commercial stations (1984) and national networks (1986), then failing to take timely and assertive measures in defence of independent stations, the French government has been facilitating the emergence of a new commercial oligopoly:

With a few exceptions the era of the small artisanal station of the early 1980s has gone. In its place there is now a system dominated by highly professional companies, targeting listeners on the basis of sophisticated market research and seeking to retain, if not increase, their audience share.

(Kuhn 1995: 107)

Meeting the challenge of this highly competitive environment will require fundamental changes for minority broadcasters. Some stations have already opted for a commercial structure, formed alliances and networks, and modeled their programming on a more standardized music and news format. Yet by making these concessions to market forces, minority stations risk sacrificing their role as powerful and unique agents in the service of their respective communities. Only by maintaining their integrity will minority stations continue to function as vital spaces of free expression.

NOTES

1 I would like to thank Alec G. Hargreaves and Mark McKinney for their helpful comments on this chapter.

2 As commonly used in France, "Arab" denotes primarily people of North African descent.

3 Cf. p. 20.

4 Cf. p. 122.

5 Cf. p. 43.

6 Cf. p. 21.

7 See Driss El Yazami (below, Chapter 7).

8 For a discussionof raï music in France, see Warne (below, Chapter 8).

9 Cf. p. 12.

REFERENCES

Anglade, Michel (1989) "Radio Beur," Mémoire, Institut d'Études Politiques de Paris.

Berdah, Maryse, and Emmanuelle Bouchez (1991) "Radios communautaires: Les voix de la différence," *Télérama*, February 13.

Berqué, Pascal, Evelyne Foy, and Bruce Girard (1993) *La passion radio: Vingt-trois expériences de radio participative et communautaire à travers le monde*, Paris: Syros/Alternatives.

Berrahal, Hamida (1987) "Ces radios qui 'branchent' les jeunes," *Actualité de l'émigration*, vol. 10, October 1–7.

Cauhape, Véronique (1994) "L'application de l'amendement Pelchat promet d'être complexe," *Le Monde*, January 10.

—— (1996) "Le CSA autorise Beur FM à émettre sur 106.7 24 heures sur 24," *Le Monde*, March 26.

Cazenave, François (1984) *Les radios libres*, Paris: Presses universitaires de France.

Chemin, Ariane (1994) "Les muezzins de la radio," *Le Monde*, October 13.

Cojean, Annick (1991) "Les radios communautaires s'efforcent de canaliser les réactions de leurs auditeurs," *Le Monde*, February 6.

Contrucci, Jean (1984) "Une gazelle bilingue," *Le Monde Loisirs*, May 13–15.

CSA (1987) Radio Beur frequency application, no. 3407.

—— (1991a) Radio Beur frequency application, no. 91PA A045.

—— (1991b) Beur FM frequency application.

Derderian, Richard L. (1995) "Radio Beur, 1981–1992: L'échec d'un multiculturalisme à la française?" *Hommes et migrations*, no. 1191, October, pp. 55–9.

El Yazami Khammar, Driss (1983) "Le nouveau Marseille c'est Gazelle," *Sans Frontière*, February.

Fattah Allah, Abdennasser (1988) "L'expression beure en France: Cas de Radio Beur de Paris," Mémoire de DEA: Science de l'information et de la communication, Université de droit, d'économie et de sciences sociales de Paris, Paris II.

Génériques (1990) *Presse et mémoire: France des étrangers, France des libertés*, Paris: Mémoire Génériques/Editions ouvrières.

Hargreaves, Alec G. (1992) "Ethnic minorities and the mass media in France," in Rosemary Chapman and Nicholas Hewitt (eds), *Popular Culture and Mass Communication in France*, Lewiston, NY: Mellen, pp. 165–80.

INSEE (1994) *Les étrangers en France*, Paris: Hachette.

Kahn, Annette (1989) "Les voix d'Islam," *Le Point*, March 6–12.

Kuhn, Raymond (1995) *The Media in France*, London/New York: Routledge.

Lévy, Marie-Françoise (1993) "L'immigration dans la production documentaire, le magazine, la fiction française. Variations autour d'un thème, 1975–1991," in Claire Frachon and Marion Vargaftig (eds), *Télévisions d'Europe et immigration*, Paris: Institut National de l'Audiovisuel/Association Dialogue entre les Cultures, pp. 57–65.

Malaurie, Guillaume, and Frédéric Ploquin (1992) "Quand les Saoudiens font leur guerre sur la FM," *L'Evénement du jeudi*, May 28–June 3.

Nataf, Isabelle (1990) "Les radios associatives en première ligne," *Le Figaro*, June 5.

—— (1991) "Radios communautaires: Risques de dérapages?" *Le Figaro*, January 23.

Octobre à Alger (1989) Paris: Seuil.

Piot, Olivier (1991) "Radio France-Maghreb: L'apprentissage de la démocratie," *Le Quotidien de Paris*, February 5.

Piot, Olivier, and Catherine Perez (1991) "A l'écoute des radios communautaires," *Le Quotidien de Paris*, February 5.

Polac, Catherine (1991) "Quand les immigrés prennent la parole: Histoire sociale du journal *Sans Frontière*, 1979–1985," Mémoire de DEA, Paris: Institut d'Etudes Politiques.

Prise de parole (1985), Les Beurs prennent la plume, no. 1, Paris: Radio Beur/Grenel.

Rossinelli, Michel (1991) *La liberté de la radio-télévision en droit comparé*, Paris: Publisud.

Ruedy, John (1992) *Modern Algeria: The Origins and Development of a Nation*, Bloomington, IN: Indiana University Press.

Silverman, Maxim (1992) *Deconstructing the Nation: Immigration, Racism and Citizenship in Modern France*, London/New York: Routledge.

Stora, Benjamin (1994) *Histoire de l'Algérie depuis l'indépendance*, Paris: La Découverte.

Sutton, Homer B. (1992) "*Radios missionnaires*: religious radio stations on the FM band in France," *Contemporary French Civilization*, vol. 16, no. 1, Winter–Spring, pp. 30–41.

Weil, Patrick (1991) *La France et ses étrangers. L'aventure d'une politique de l'immigration, 1938–1991*, Paris: Calmann-Lévy.

Younès, Monique (1994) "Mobilisation des radios arabes et juives," *Le Figaro*, May 14–15.

Interviews

Kamel Amara, Telephone, May 24, 1994.

Lila Benbelaïd, Aubervilliers, April 20, 1994.

Aïcha Benmamar, Paris, May 13, 1994.

Sylvie Bessenay, Paris, April 27, 1994.

Houria Bounab, Paris, February 2, 1994.

Youcef Boussaa, Paris, May 16, 1994.

Fernanda da Silva, Paris, December 27, 1993.

Mohand Dehmous, Paris, March 31, 1994.

Nacer Kettane, Paris, July 4, 1994.

Malika Ouberzou, Saint-Denis, April 28, 1994.

André Videau, Paris, February 2, 1994.

FRANCE'S ETHNIC MINORITY PRESS

Driss El Yazami[1]

INTRODUCTION

France, with its long history of large migratory inflows (Lequin *et al.* 1988; Noiriel 1988; Weil 1991) has been the birthplace of many hundreds of newspapers and other periodicals created by groups of foreign origin. Almost 2,000 periodicals were listed at the 1989 exhibition "France des étrangers, France des libertés" [France of Foreigners, France of Liberties], and this is certainly an underestimate; the figure will no doubt rise when the findings of research currently in progress are known (Génériques 1990). These publications are a key source for the study of international migration in general, and more particularly for the study of the political and cultural movements that have evolved among minority groups. They also offer many valuable insights into the complex relationships between people of majority and minority ethnic origins. Within this "French melting-pot" (Noiriel 1988), vast areas of which are still largely unexplored, research on post-colonial immigrant minorities is still notably lacking. We cannot understand these diasporic minorities without knowing something of their origins. Yet mainstream French society and, in some cases, minority groups themselves seem to suffer from a form of amnesia about this history, which we can divide into two main periods. The first stretches from the beginning of the century up to 1962, when Algerian independence marked the end of France's colonial empire. The second covers the period from 1962 to the present. This chronological division sets the framework for the present analysis of the periodicals produced by France's post-colonial minorities.

1900—62: "GREATER FRANCE"

The first phase really got underway in the colonial metropolis just after the First World War. As Benjamin Stora (1990: 109) observes:

In Paris, between the two World Wars, Algerian and Moroccan nationalist forces first became manifest in their "modern" forms as independence movements. It is a remarkable paradox that these nationalist movements developed as part of the migratory process outside of the countries that they wished to liberate.

If we study the appearance of Maghrebi publications in France from the 1920s down to the present day, we can see just how mythical it is to imagine that the Maghrebi population in France has only recently arrived, and is still fragile, unstable and lacking in any sense of political direction.

What Stora says here about Maghrebi immigration appears broadly true of other expatriate communities in France. While different in other respects, all these communities have been marked to a greater or lesser extent by the same twin paradox: expatriation in France was the seedbed for nationalist movements seeking independence at home, and in demanding liberation from France those movements drew on Western concepts of human rights, as forged by the French revolution and proletarian internationalism.

Tiny at the beginning of the century, population flows from the colonies, which the authorities liked to call "Greater France," grew markedly during the First World War (Meynier 1981, 1984). During the conflict, 580,000 colonial soldiers were sent to the front and more than 200,000 colonial workers were mobilized to support the industrial war effort. For the Maghrebi, sub-Saharan African, and South-East Asian troops who came to France, fought and, in not a few cases, died for it, the journey to the colonial metropolis had important consequences. When they were demobilized, some of them decided to stay on in France, where, relatively speaking, they found life more egalitarian than in the overseas empire. In France they were exposed to a dynamic labor movement and became active in trade union and political movements. Some took the view that the blood spilled on behalf of France should now be rewarded: the key demands that emerged – equal rights alongside French workers and within the colonies, then national independence – were proclaimed in newspapers and magazines whose titles stated quite directly their editorial policy: *Le Cri des Nègres* [Negros' Voice], *Le Paria* [The Pariah], *El Ouma* [The Islamic Community], *La Nation annamite* [The Annamite Nation], *Maghreb* [The Maghreb], *Résurrection* [Resurrection], and so on.

The movement towards decolonization and changes taking place within what would later be called the South were at the heart of these periodicals, as can be

seen from the political careers of many of those who turned their hands to journalism in their columns. Messali Hadj, the founder of modern Algerian nationalism, established several newspapers in France between the two World Wars. Ho Chi Minh, who was to lead the struggle for Vietnamese independence, edited *Le Paria* while working in France in the early 1920s. During the same period, Chinese revolutionaries such as Deng Xiaoping and Zhou Enlai, who came to France as students, produced various newssheets, often using hand-drawn calligraphy.

The experience of living side by side with French left-wing activists (Communists for the most part) opened up new horizons for these nationalists and for African, Caribbean, and Malagasy friends such as Léopold Sédar Senghor, Aimé Césaire, and Jean Ralaimongo. It also provoked conflicts, which crystallized in broad terms around the questions of autonomy and prioritization: should they focus primarily on the nationalist struggle for decolonization, or should they work first and foremost for proletarian internationalism, by pursuing the class struggle against capitalist exploitation (Dewitte 1985)? For all these different communities and the pioneering nationalist movements running through them, relations with the French labor movement were often stormy. Interrupted to some extent by the Second World War, the debate was taken up again when the war ended and in practically every case led to a parting of ways, which was to leave an enduring imprint on both camps.

The struggle for the independence of colonial territories, which had begun before the war, became central after 1945, as can be seen in the newspapers and magazines that were produced by rapidly growing migrant communities. Maghrebis were particularly active, with Messali Hadj and his followers resuming the fight for Algerian independence in papers such as *L'Emigré algérien* [The Algerian Emigrant], and *L'Etoile algérienne* [The Algerian Star] in the late 1940s, which also saw the birth of *Présence africaine* [African Presence], which brought together black novelists, intellectuals, and political activists. The 1950s and early 1960s brought the liquidation of France's colonial empire, after bloody wars in Indochina and Algeria, or more peacefully, as in Morocco, Tunisia and sub-Saharan Africa. By the early 1960s, this phase was over. The triumph of nationalist movements seemed a very positive development: it was expected to herald an end to outward migration from these territories and to the unhappy features associated with this. Today, we know that exactly the opposite has happened. Continued migration to the ex-colonial metropolis and indeed permanent settlement there have helped reshape the ethnic minority press.

THE PERIOD SINCE 1962: THE BITTER FRUITS OF INDEPENDENCE

Population flows to France since the 1950s have had similar causes to parallel movements in other European countries (Simon 1995). Demographic trends, post-war reconstruction, economic modernization, and the sometimes tragic consequences of decolonization led to increased migratory flows from ex-colonies to the former metropolis. Initially seen as temporary migration by "lone" immigrant workers, these flows gradually changed in complexion with family reunification, despite the tight immigration controls imposed in 1974, which have been steadily tightened ever since then. The settlement of wives and children alongside their menfolk has transformed all of these minority communities. Among Maghrebis, Moroccans and Tunisians have been catching up with Algerians, still the largest national group. Military and political upheavals in South-East Asia have prompted fresh migratory waves, immigration from Turkey has grown markedly, and minorities originating in sub-Saharan Africa are increasingly visible. The expansion of educational systems in newly independent countries resulted in tens of thousands of students coming to France to continue their studies, and was soon followed by waves of political exiles seeking refuge in the former colonial metropolis. Many periodicals have their origins in a mixture of three developments: economic migration, student mobility, and political exile.

In my discussion of these news publications, I will focus essentially on the Maghrebi population and its journalistic initiatives. This is partly because Maghrebis are the largest of France's post-colonial minorities, but also because they typify in many ways the debate surrounding immigration in France. The closeness of the sending countries just across the Mediterranean, the upheavals which they have experienced, and the emotively charged nature of their relations with France – especially where Algeria is concerned – have made the Maghrebi minority particularly important, and this is reflected in the news periodicals that they have produced. Changes in the home countries and the radical transformation of the minority population itself, with the rise of family settlement, have been reflected more or less promptly in the minority ethnic press. Initially focused mainly on the home country, during the transition from colonial domination to domestic authoritarian regimes, minority presses have gradually changed their orientation towards the country of settlement while attempting to retain links, sometimes in a difficult and ambiguous way, with their ancestral origins.

1968 and after

During the mid-1960s, minority ethnic groups, particularly the more politicized elements among them, were affected by a range of events (El Yazami 1990). Israel's victory over its Arab neighbors in the Six-Day War of June 1967 appeared to spell the end of Nasser's dream of pan-Arab unity. This period was also marked by the emergence of the Palestinian resistance movement (seen as an extension into the Arab world of the war in Viet Nam), political fallout from the Sino-Soviet split, and a first wave of repression in the home countries of France's post-colonial migrants.[2] The near-revolution of May 1968 in France fostered the emergence of extreme left-wing groups drawing mainly on high school and university students. There were within France significant numbers of students from all the countries affected by these events, and their numbers were swollen by the arrival of a first wave of post-independence political exiles.

Out of this ferment, traversed by many different ideological currents, came news publications and periodicals such as *El Amel Tounsi* [The Tunisian Worker], published in vernacular Arabic by a group called Perspectives tunisiennes, *Souffles* [Blasts of Wind], and *Anfas*, an Arabic version of the same publication, both based on a review of the same name published in Morocco by the poet Abdellatif Laâbi, *El Massira* [The March], *Maghreb Annidal* [Moroccan Struggle], *23 mars* [23 March], *El Mithaq* [The Charter] – an organ of the "FLN clandestin" [underground FLN][3] – *Al Kadihoun* [The Workers], and *Ac-Charrara* [The Spark]. Many periodicals were brought out in France by political groups who, for obvious reasons, could no longer publish them in their home countries. This was the case, for example, of *El Jarida* [The Newspaper], organ of the Algerian Parti de la Révolution socialiste (PRS), whose leader, Ahmed Boudiaf, was later to serve briefly as President of Algeria before being assassinated.

With only a few exceptions, the editorial material in these publications was almost always devoted to political issues in the home countries. In the eyes of their editors, particularly those linked to particular political groups, migrant workers from those countries in France were to serve as a recruiting ground and launch pad for political reform or revolution back home. The migrant population in France was usually approached within more general analyses underlining the responsibility of the home governments in continued migratory outflows; little attention was given to the concerns of migrants within France. Yet in fact – and this is a major aspect of the situation after the events of May 1968 – major changes were taking place among these minority populations, who were realizing that the "fruits of independence" offered them little, and to whom it was becoming

increasingly evident that their future lay in France. Small groups of activists, mainly Maghrebi students, began a dialogue with economic migrants, who had also been marked by May 1968 and recent upheavals in the Arab world.

Grouped together initially around a newssheet called *Lutte palestinienne* [Palestinian Struggle], which began publication in 1969, they launched a new periodical in November 1970 with the very explicit title *Fedaï*.[4] Although the first issues were entirely devoted to the Middle East and activities organized within France in support of the Palestinians, matters relating to migration gradually came to the fore, dominating the main stories. So issue no. 15, published in February 1972 – the last issue of the series – still carried the subtitle "Supporting the Palestinian revolution" and had a cover photo of young "lion-cubs"[5] marching; but the text accompanying this was an appeal for readers to join in demonstrations against racist crimes, and the rest was in keeping with that: after some short articles on current events in the Maghreb and the Middle East, two pages were given over to the situation at the Renault automobile corporation, where immigrant workers were on strike, and the remaining pages dealt with problems of housing and racism in France.

A decisive step in this new orientation came with the first issue of a new series beginning in July 1972. There was still a Kalashnikov rifle illustrating the Fedaï logo, but now there was a new subtitle: "The newspaper of Arab workers." Meanwhile, in Marseilles, activists involved in similar Palestinian committees had been publishing a like-minded newssheet entitled *Al Assifa* [Tempest],[6] with the subtitle: "Supporting the struggle of the Arab masses." Beneath this explicit reference to the armed wing of Fatah was a much more prosaic set of news stories covering housing campaigns by Maghrebi immigrant workers and their "riposte" [response] to racist crimes. Between 1972 and 1975, the various campaigns of Maghrebi migrants were given extensive coverage in these periodicals, which were published on an irregular basis and distributed by groups of activists. From time to time, the coordinating committee of the Sonacotra hostel[7] rent strikers brought out a bulletin covering the long strike, which began in 1974 and lasted several years. Individual associations also put out their own newssheets. The Comité des Travailleurs Algériens (CTA), for example, published *La Voix des Travailleurs algériens* [The Voice of Algerian Workers], while the Association de Marocains en France (AMF) relaunched *Al Jaliya Al Maghribiya* [The Moroccan Community], the first issue of which had appeared in 1972.

With a few exceptions, the dozens of newspapers and bulletins of this kind seem to have gone through the same process of development. They were written by collectives of amateur journalists, in a very homemade way, and distributed by

activists at weekly working-class street markets or during demonstrations of various kinds, and their circulation was probably less than 1,000 copies. Initially preoccupied with political events in the home countries (political trials, riots, etc.) almost all of them gave more and more space to the experiences of migrants and particularly to campaigns such as the many hunger strikes by undocumented immigrants (1972–5), protests against racist crimes (1973), rent strikes (1974–7), and so on. While cultivating allies within mainstream French society, the people running these periodicals – who were mainly political activists – held the view that minority groups needed their own autonomous organizations and newspapers, despite the fact that foreigners did not at the time enjoy the free right of association.

They were not particularly interested in links with the traditional parties of the left, which at the time were still dominated by the French Communist Party (PCF). The PCF in turn was more interested in its historic links with Communist Party activists in the sending countries or, in the case of Algeria, in that country's "Socialist" government. Instead, these minority publications found support and partners among the New Left, which had emerged in May 1968. These sorts of supporters included extreme-left groups, such as the Gauche Prolétarienne and the Ligue Communiste, certain branches of the Confédération Française Démocratique du Travail (CFDT) labor federation, progressive Christian groups such as Témoignage Chrétien and Vie Nouvelle, various Catholic groups such as Action Catholique Ouvrière, Jeunesse Ouvrière Chrétienne and Mission de France (Verbunt 1980; El Yazami 1992), and a number of leading intellectuals, such as Jean-Paul Sartre, Simone de Beauvoir, Michel Foucault, Jean Genet, Claude Bourdet, and Claude Mauriac. For these supporters, the "immigrant question" was one of a number of issues, alongside the women's movement, gay and lesbian liberation struggles, prisoners' rights, etc., ignored by the traditional left and now brought onto the agenda of the New Left (Mauriac 1975, 1976, 1983, 1986). The immigrant press drew extensively on this network, in particular to find French nationals willing to serve formally as "directeurs de publication" [editorial directors] (thereby covering these periodicals in relation to the then restrictive law on foreigners' rights to organize) without intervening in the content of the papers.

New directions

The late 1970s and the 1980s brought three major developments: the great adventure of *Sans Frontière* [No Border] and *Baraka* [Good Fortune], the emergence of a youth press and the creation of reviews. Styling itself as a "weekly news magazine of immigration," *Sans Frontière* was launched in March 1979. The original idea was conceived by a group of Maghrebis who had been active in various campaigns during the 1970s, in particular through the Mouvement des Travailleurs Arabes (MTA), which had disbanded in 1975 after playing a vigorous role in hunger strikes by illegal immigrants and in labor stoppages protesting against racist killings. Before the first issue appeared, the editorial team had been widened to include journalists and activists from other ethnic groups. This multiethnic dimension was to be a feature of the magazine throughout its existence, and it was extended in *Sans Frontière*'s successor, *Baraka*, which in its inaugural issue, in March 1986, ran the headline: "Ces gens d'en France" [People hailing from France]. Run by a mixed editorial team who tried to blend together journalistic professionalism and political activism, campaign issues and cultural innovations, *Sans Frontière* tried to hold together a range of editorial interests that sometimes proved too disparate for it to be possible to construct a coherent policy line capable of maintaining a stable readership.

The main stories run by *Sans Frontière* reflect and document an important period of change (Plate 7.1). The magazine was closely involved in a whole series of campaigns. In 1980, for example, it supported a petition against a number of Communist mayors who had complained about "excessive" numbers of immigrants and their families within the localities that they governed. During the presidential election campaign of 1981, it ran the main support network for a hunger strike in Lyon protesting against the deportation of young second-generation Maghrebis with criminal records. In 1983, it gave major coverage to the nationwide March for Equality and against Racism, which the mainstream media nicknamed the "Marche des Beurs" [March of the Beurs].[8] Shortly afterwards, *Sans Frontière* reported on the strike by migrant workers protesting against layoffs of workers by an automobile manufacturer, Talbot. It also campaigned for the release of the journalist Jean-Paul Kaufman, held with other French hostages by pro-Palestinian militants in Lebanon, and helped the Collectif des Droits Civiques [Collective for Civil Rights] in its campaign for voting rights for immigrants and the electoral registration of young citizens of foreign origin.

Launched with a grant of four million francs from the Fonds d'Action Sociale pour les travailleurs immigrés et leurs familles (FAS),[9] *Baraka* was relatively well

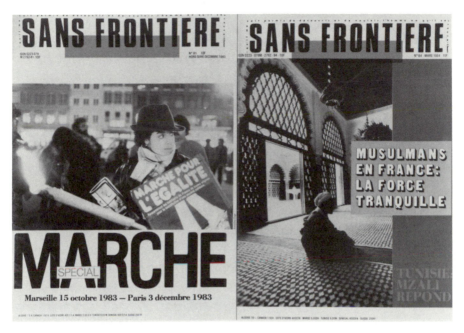

Plate 7.1 Sans Frontière in monthly format, 1983–4

financed and benefited from considerable professional expertise, but it was soon
weakened by internal divisions. The first issue had scarcely hit the newsstands with
a print run of 100,000 when a serious dispute broke out within the core group
of Maghrebis who had set up the magazine. Some of them wanted to broaden the
editorial team and form a private corporation within which the *Sans Frontière*
association would retain formal ownership of the title and be the channel for the
FAS funding, but in other respects would become just one shareholder alongside
others, with input from various journalists and media specialists outside the initial
core. A second faction was opposed both to broadening out the magazine and to
the idea of making it a weekly, all of which seemed too risky. At the time, very
little leaked out about this fierce struggle between the members of the editorial
team, who had been involved in a variety of shared activities over the previous
fifteen years. The outcome was that the first eight issues of *Baraka* were brought
out on a weekly basis by the first faction, who then left the magazine. The second
group edited nos 9–16 on a monthly basis, and then the magazine folded.

Having been a participant in the events, I am not in a position to take a wholly
detached view of them.[10] However, a number of points do stand out. First, this
eight-year-long experience, forged by a core of Maghrebis in collaboration with

sub-Saharan Africans, Caribbeans, native French, Latin Americans, etc., was quite unusual in that it sought to professionalize minority ethnic journalism, distributing the product via regular newsstands, and above all, in the case of *Baraka*, by hiring permanent staff.

A second feature was the diversity of those involved, embracing political activists from the 1970s, young second-generation activists, professional journalists, publicists and designers, as well as intellectuals such as Abdelmalek Sayad, Leïla Sebbar, Driss Chraïbi, Abdellatif Laâbi and Miguel Benassayig. The editorial teams of *Sans Frontière* and *Baraka* were therefore unusually diverse, indeed heterogeneous, compared with much of the ethnic minority press. This hybridity was by no means unproblematic or lacking in tensions. The fact is that there were many different visions of the kind of periodical that was needed, just as there were diverse, sometimes antagonistic expectations and perceptions of the journalists themselves and of "immigration" as a field of coverage. As Catherine Polac (1991: 75) has observed, the coexistence and combination of people who were extremely diverse socially, culturally and ethnically led to conflicts that could only be resolved by setting a fluid, not to say vague, editorial line on *Sans Frontière* first of all and later on *Baraka*.

A third point to note is the fact that these two magazines enabled numerous contributors to gain on-the-job training, opening up or furthering journalistic careers that are now being pursued in a variety of mainstream media. In the print media this applies, for example, to Farid Aïchoune, who is now with *Le Nouvel Observateur*, Nidam Abdi and Bouziane Daoudi who work for *Libération*, and Marc Weitzman, at *Sept à Paris*. Mohamed Nemmiche moved on to television, while Magid Daboussi moved into commercial radio broadcasting.

Yet having "made it possible for countless immigrant communities and amateur journalists to find a public voice, saying things that had previously been left unspoken" (Polac 1991: 89), these magazines disappeared at a time when issues relating to immigration and minorities of recent immigrant origin were ever more prominent in French public debate, without any comparable publications emerging to fill the gap. In Polac's view, this "partial failure" was inevitable because the people running these magazines were

dissenters *vis-à-vis* conventional ideas of emigration and immigration, engaged in subverting established concepts of nationhood, blurring the boundaries between nationals and non-nationals, demanding the same rights for all. Typical of this was the very fact of producing their own magazine as immigrants, which ran counter to existing laws limiting the rights of foreigners . . . They were also dissenters by virtue of their political activism and protest campaigns in favor of political rights

(Polac 1991: 89–90)

Most of the leading figures in *Sans Frontière* and *Baraka* had emigrated to France as students. Simultaneously with those activities, second-generation Maghrebis raised and, in many cases, born in France were developing their own publications. These were of two main types (Delorme 1985; Jazouli 1986). Some bulletins or magazines set up in a particular town or locality remained within those limits (examples include *Rencar, Mercure, Jeune Arabe*). Others, while starting out as local publications, sought to establish themselves nationally. As with *Sans Frontière*, there were tensions in the editorial lines of all these publications between political activism and more narrowly journalistic approaches.

Typical were *Za'ama de Banlieue* and more particularly *Rock against Police*. Led by Djida Tazdaït, *Za'ama de Banlieue* functioned initially as a pressure group-cum-bulletin before giving birth to a formal association called Jeunes Arabes de Lyon et sa Banlieue (JALB). Among the actions pursued by JALB was a hunger-strike by Tazdaït in 1986 against the Chirac government's first, unsuccessful attempt to introduce more restrictive French nationality laws. Elected in 1989 as a Member of the European Parliament (MEP) on a list of candidates put forward by the Greens, Tazdaït has more recently refocused her activities on the city of Lyon, where new organizations have been developing, particularly among young Muslims.

Like *Za'ama de Banlieue*, *Rock against Police* was both a bulletin and a youth movement, which in particular organized rock concerts against police brutality and racist crimes (Dazi and Polac 1990). The Im'Média news agency, which developed out of *Rock against Police* under the leadership of Mogniss Abdallah, published at irregular intervals various magazines and reviews highlighting youth initiatives and changing urban milieux, before focusing mainly on the production of documentary films. *L'yeux ouverts*, run by another founder-member of *Rock against Police*, Samir Abdallah, followed a similar trajectory. Im'Média has developed an increasingly strong European dimension to its activities. Its relatively long and continuing lifespan has made it a significant actor and witness in the development of minority youth movements during the last decade.

Reviews

Despite the longevity of Im'Média, for reasons which are not entirely clear minority youth magazines more generally seem to have been running out of steam. At the same time, new Maghrebi initiatives have been evident in a different sphere, that of scholarly reviews. These have been developed since the beginning

of the 1980s by the first generation of wholly post-independence intellectuals and researchers against a socio-economic and political background in the Maghreb that has been generating new questions and demands while reactivating issues, such as Islam, that seemed to be in abeyance and others, such as Berber minorities, francophonie, and so on, that seemed doomed to extinction by the power of nationalism and the nation-state. Reviews of this kind that could not be published in the Maghreb but which found a home in France include *Tafsut* [Spring], *Awal* [The Word], *Etudes et documents berbères* [Berber Studies and Documents], *Sou'al* [Question mark], and *Horizons maghrébins* [Maghrebi horizons].

Horizons maghrébins has been edited in Toulouse since November 1984 by a small team of students originating in the Maghreb, and draws on a wider network of tens of thousands of Algerian, Moroccan, and Tunisian students living in France. Directed initially by Abdelhake Serhane, who has since returned to Morocco, the review aims to be an outlet for the numerous unpublished dissertations by Maghrebi students. It also reviews cultural events and conferences and publishes new work by francophone Maghrebi authors.

The pan-Maghrebi dream behind *Horizons maghrébins* was also a driving force behind *Sou'al*, produced in Paris by the historian Mohamed Harbi, who was a senior figure in the Front de Libération Nationale (FLN) during the Algerian war of independence, and Sami Nair, a university researcher of Algerian origin. "Maghrebi unity is a necessity, not just a duty," wrote Nair in the second issue of the review. "It is not a question of reconstructing some lost power or of renewing some old myth," he added. "Maghrebi unity is, rather, a factual, objective reality, which is being stifled instead of fostered by the political forces that are dominant in North Africa today" (Naïr 1982). This set the tone for the review as a whole. In contrast with *Horizons maghrébins*, *Sou'al* tackles political issues head-on through interviews with exiled political leaders, eyewitness accounts of repressive regimes in the home countries, and special issues devoted to themes such as Islamic fundamentalism (April 1985) and "Algeria, 25 years after independence" (September 1987). The field of interest embraced by *Sou'al* goes beyond the Maghreb, covering the Arab world as a whole, understood not as a uniform, homogeneous entity in search of some impossible unity, but as a collection of ethnic, linguistic, and religious entities, which must together seek to build a pluralist, democratic society.

This commitment to and exemplification of pluralism is at the heart of the many Berber reviews and bulletins published in France, marking the ever-stronger assertion of Berber identity in countries right the way through from Libya to Mali and Niger. This trend began in 1972 with the pioneering work of the Groupe

d'Etudes Berbères, set up at the University of Paris VIII-Vincennes, which brought out a dozen issues of its *Bulletin d'études berbères* [Bulletin of Berber Studies] up to 1977. This was followed by the review *Tisuraf* [Small Leaps], which was more than just a campaigning bulletin. The emphasis was more academic, although this did not prevent lively debates from taking place within and around the editorial team. The wave of enthusiasm, writing, and analysis generated by the spring of Tizi-Ouzou in 1980, when pro-Berber demonstrations in Kabylia were vigorously repressed by the ruling FLN, found an outlet in France in the review *Tafsut* [Spring], which circulated, among the Maghrebi community, texts and information that could not be published in Algeria. *Tafsut* published a dozen regular numbers plus four special issues in a collection entitled "Etudes et débats" and three numbers of a pedagogic-cum-scholarly series. Contributors from Morocco and Niger worked alongside the Algerian core team.

The review *Awal* [The Word], also established in Paris, focuses on a "transnational" research field – that of popular culture – which has been looked down upon for too long, and either neglected accordingly or analyzed purely within "national" boundaries. *Awal* emphasizes the multiple aspects of the phenomena with which it is concerned, acknowledging that "these may result in real divergence" (*Awal* 1985). This is one of the most original and distinctive features of the new Berber movement, which has found in *Awal* a scholarly review of true quality. Created and directed by the Algerian novelist and scholar Mouloud Mammeri with the support of French intellectual Pierre Bourdieu, *Awal* is published by the Editions de la Maison des Sciences de l'Homme. Since the death of its founder, it has appeared at irregular intervals. Another quality review, *Etudes et documents berbères* [Berber Studies and Documents] was founded by Ouahmi Ould Braham in 1986 and published by the association La Boîte à documents. It disappeared after bringing out a few issues dedicated to the diffusion of "old, previously unpublished or inaccessible documents" (*Etudes et documents berbères* 1986) together with up-to-date studies.

This Berber upsurge seems past its peak now, at any rate in France, despite the existence of a rich range of associations and a few publications such as *Tiddukla* [Union], published by the Paris-based Association de Culture Berbère, and local bulletins produced in a number of provincial towns. With the focus of debate increasingly on the permanent settlement of Maghrebis in France and their position within the so-called "French model of integration," with particular reference to Islam, the Maghrebi press in France today consists of a few modest bulletins published by Islamic associations, newsletters of around a dozen pages such as *Jossour* [Bridges] or *Machmoum* [Bouquet] published by more secularly

minded associations, and two high-quality reviews: *Intersignes* [Intersigns], directed by the psychoanalyst Fethi Benslama, and *Dédales* [Labyrinth], created by the writer Abdelwahab Meddeb.

CONCLUSION

Since 1992, the arrival in France of a large number of Algerian exiles has given rise to numerous bulletins reflecting a wide spectrum of political opinion on the state of near civil war that has broken out in Algeria. Produced for the most part on an amateur basis and distributed among activists, with a circulation of probably only a few hundred, these publications may appear quite minor, but in the longer term they could turn out to be of greater significance. Like earlier waves of refugees, the exiles producing these bulletins see themselves as temporary residents. They are following the pattern set by the Maghrebi press in France since the early 1960s. Practically all political and cultural movements in the Maghreb, including those of Islamic fundamentalists, have used France at one time or another as a base and a platform upon which to communicate messages that could not be voiced on the other side of the Mediterranean. The periodicals produced in this way, not uncommonly at irregular intervals and unimpressive in appearance, have often had more influence than might be imagined purely on the basis of their immediate readership.

That is also true of the periodicals produced by other minorities, for whom France, and more specifically Paris, has been a real place of refuge. This is apparent from the rare studies so far devoted to the periodicals produced in France by members of the Turkish (Guzel and Malzac 1990), Chinese (Yu-Sion 1990, 1994: 9–20) and Vietnamese (Le Van-Ho 1990) populations. The minority ethnic press has generally gone through two main phases: first, an anti-colonial phase drawing on the ideas of the Enlightenment and of Communism, and then, after independence, a second wave attacking despotic post-colonial regimes and addressing the needs arising from diasporic settlement within the former colonial metropolis. This press is mainly the work of exiles, intellectuals and students writing in the context of minority communities that are heavily working class in character. While most of the periodicals produced in this way may appear marginal in terms of their production, print-runs and distribution networks, at a deeper level they offer invaluable insights into the history of post-colonial diasporas and the complexities of their settlement within French society.

NOTES

1 Translated by Alec G. Hargreaves and Mark McKinney.

2 Morocco's first post-independence riots took place in March 1965 and were bloodily repressed. In the same year, the Moroccan opposition politician Mehdi Ben Barka was kidnapped in Paris, and Houari Boumedienne seized power in a *coup d'état* in Algeria.

3 The FLN clandestin brought together in Algeria, but more particularly in France, supporters of Algeria's first post-independence President, Ahmed Ben Bella, who had been overthrown by Boumedienne in 1965.

4 *Fedaï* (plural: *fidayin*) was the name used by Palestinian activists; it can be translated as "fighter," "resister," "guerrilla."

5 A nickname given to young people in Palestine Liberation Organization (PLO) camps, who were often shown engaged in military training.

6 This was the name of the military wing of Fatah, founded by Yasser Arafat, and by far the most important component of the PLO.

7 Sonacotra hostels were set up to provide state-run accomodation for migrant workers.

8 Cf. p. 20.

9 Cf. p. 23, n. 11.

10 The author was one of the cofounders of *Sans Frontière*, and worked on it from 1979 to 1986, before serving as editor-in-chief of *Baraka* during its first eight issues.

REFERENCES

Awal (1985) "Présentation", no. 1, pp. 1–6.

Dazi, Fouzia, and Catherine Polac (1990) "Chroniques de 'la vraie base': La constitution et les transformations du réseau associatif 'immigré' à Nanterre," *Politix*, no. 12, pp. 54–69.

Delorme, Christian (1985) *Par amour et par colère*, Paris: Centurion.

Dewitte, Philippe (1985) *Les mouvements nègres en France, 1919–39*, Paris: L'Harmattan.

El Yazami, Driss (1990) "Du fidayin au beur," in Génériques, *Presse et mémoire: France des étrangers, France des libertés*, Paris: Mémoire-Génériques/Editions Ouvrières, pp. 113–15.

———— (1992) "Chrétiens et immigrés maghrébins, esquisse d'une histoire," *Hommes et migrations*, no. 1150, January, pp. 8–12.

Etudes et documents berbères (1986) "Editorial", no. 1, pp. 3–4.

Génériques (1990) *Presse et mémoire: France des étrangers, France des libertés*, Paris: Mémoire-Génériques/Editions Ouvrières.

Guzel, Mehmet Sehmus, and Michèle Malzac (1990) "C'est un dur métier que l'exil," in Génériques, *Presse et mémoire: France des étrangers, France des libertés*, Paris: Mémoire-Génériques/Editions Ouvrières, pp. 169–71.

Jazouli, Adil (1986) *L'action collective des jeunes maghrébins de France*, Paris: CIEMI/L'Harmattan.

Lequin, Yves *et al.* (1988) *La mosaïque France: Histoire des étrangers et de l'immigration*, Paris: Larousse.

Le Van-Ho, Mireille (1990) "Les débuts de la presse vietnamienne en France," in Génériques, *Presse et mémoire: France des étrangers, France des libertés*, Paris: Mémoire-Génériques/Editions Ouvrières, pp. 69–73.

Mauriac, Claude (1975) *Les espaces imaginaires*, vol. 2 of *Le temps immobile*, Paris: Bernard Grasset.

———— (1976) *Et comme l'espérance est violente*, vol. 3 of *Le temps immobile*, Paris: Bernard Grasset.

———— (1983) *Signes, rencontres et rendez-vous*, vol. 7 of *Le temps immobile*, Paris: Bernard Grasset.

———— (1986) *Mauriac et fils*, vol. 9 of *Le temps immobile*, Paris: Bernard Grasset.

Meynier, Gilbert (1981) *L'Algérie révélée*, Geneva: Droz.

——— (1984) *L'Algérie révélée. La guerre de 1914–1918 et le premier quart du XXe siècle*, Lille: Presses de l'Université de Lille-III.

Naïr, Sami (1982) "Sept thèses sur le Maghreb", *Sou'al*, no. 2, June, pp. 1–11.

Noiriel, Gérard (1988) *Le creuset français: Histoire de l'immigration, XIXe–XXe siècles*, Paris: Seuil.

Polac, Catherine (1991) "Quand les immigrés prennent la parole: Histoire sociale du journal *Sans Frontière*, 1979–1985," Mémoire de DEA, Paris: Institut d'Etudes Politiques.

Simon, Gildas (1995) *Géodynamique des migrations internationales*, Paris: Presses universitaires de France.

Stora, Benjamin (1985) *Dictionnaire biographique de militants nationalistes algériens: ENA, PPA, MTLD, 1926–54*, Paris: L'Harmattan.

——— (1986) *Messali Hadj: Pionnier du nationalisme algérien (1898–1974)*, Paris: L'Harmattan.

——— (1990) "La presse maghrébine dans les luttes d'indépendance," in Génériques, *Presse et mémoire: France des étrangers, France des libertés*, Paris: Mémoire-Génériques/Editions Ouvrières, pp. 109–12.

Verbunt, Gilles (1980) *L'intégration par l'autonomie: La CFDT, l'Eglise catholique, la FASTI face aux revendications d'autonomie des travailleurs immigrés*, Paris: CIEMM.

Weil, Patrick (1991) *La France et ses étrangers: L'aventure d'une politique de l'immigration, 1938–1991*, Paris: Calmann-Lévy.

Yu-Sion, Live (1990) "Du Quartier latin à Billancourt, une école de la politique," in Génériques, *Presse et mémoire: France des étrangers, France des libertés*, Paris: Mémoire-Génériques/Editions Ouvrières, pp. 62–7.

——— (1994)*Chinois de France, un siècle de présences, de 1900 à nos jours*, Paris: Mémoire Collective.

PART III
MUSIC

8

THE IMPACT OF WORLD MUSIC
IN FRANCE

Chris Warne

INTRODUCTION

A consideration of the place of "world music" within contemporary French culture requires some introductory remarks to set the discussion in context. It is important to stress the ambiguities inherent in the term: while obviously Anglo-American in origin, it circulates widely in France, though duplicated by expressions like *musiques du monde* or *musique(s) mondiale(s)*. French use of this Anglo-American term and French-language expressions deriving from it illustrate the complexities involved in categorizing and appreciating forms of music when they travel from a local to a global setting. If we follow Martin Roberts and take world music as "simply the music sold in the world-music sections of major record stores throughout the Western (and partly non-Western) capitalist world" (Roberts 1992: 231), it becomes clear that it is not a stable category: in Paris, francophone African and Caribbean artists are included, but not the French rock and *variétés* [popular music] that are found in the world music section of a New York store. Overall, the principle of differentiation from existing categories of music (rock, jazz, and dance music) flows not so much from linguistic or musical otherness as from racial and ethnic differences.

It cannot, however, be assumed from this that the world-music category was simply evolved by the major record companies in order to extend their control over the global music economy. Its appearance in the 1980s was initially thanks to certain influential musicians, artists and music fans aiming to bring to a wider audience "discoveries" that they had made of vibrant musical genres emerging from non-Western sites.[1] When considering the "world music" label it is therefore

essential ask who is using it and for what ends. In France, most individual forms of world music have an audience that covers three distinct, but fluid, groupings, each of which derives from a different relationship to the music and for each of which the term "world music" carries different associations. The first is made up of those members of France's ethnic minority populations for whom the music has a direct ethnic connection. The second is a niche audience drawn primarily from the majority ethnic population, but which would include members of ethnic minorities who come into contact with music not from their country of origin (e.g. fans of Algerian raï from West African communities in France). This second, niche audience at times overlaps with the first group of listeners, but also with a third grouping, made up of ethnic majority individuals who eclectically consume both the world music that is disseminated by the transnational music industry, and other types of music (rock, jazz, etc.).

In each context, the label has a different performative function. For the audiences for world music among France's ethnic minority populations, the national specificity of the music and the fact that it allows strong identification with the cultures of the country of origin precede attempts to categorize it as a global phenomenon, and indeed members of this audience often resist such attempts (see Mézouane 1992: 68; and below, pp. 142–3). On the other hand, the use of the term may be welcomed as part of a process of acknowledging affinities across different ethnic minority groupings, both in terms of the common problems of exclusion and discrimination experienced in the host country, and of valorizing the cultures of the non-Western world (cf. the statement by Hijaz Mustapha of British-Turkish group 3 Mustaphas 3: "four-fifths of the world cannot be wrong," quoted in Broughton *et al.* 1994: v). For members of the niche audience described above, and for many of the pioneers who introduced world music to these audiences, appreciation of and interest in world music can signify identification with non-Western cultures (1) against perceived cultural and economic imperialism, (2) as part of an anti-racist stance, or (3) because of the desire to create an ethnically and culturally plural society (see the strong presence of world music at concerts organized by human-rights groups like Amnesty International and SOS-Racisme). Finally, when used in conjunction with the third, "mainstream" audience, the term frequently enables the convenient regrouping of heterogeneous music into an understandable, homogeneous category that is neatly juxtaposed to existing forms of Western music.

Clearly, in all these respects, the use of the term has both positive and negative aspects. However, in France, the category of world music has recently been most widely employed in such a way as to facilitate the commercial operations of the

globally dominant Western music industry by familiarizing exotic and unclassifiable musical forms for the convenience of the consumer. In this respect, the category can be justifiably criticized as a perpetuation of colonial-era relationships, whereby non-Western music is marketed indiscriminately and indistinctively as an exotic "other," in contrast to existing pop music. Consequently, two distinct but intertwined dynamics dominate the appreciation of world music in the Western context. The first stresses those features that can be presented as curious, quaint, or strange. The second depends on characterizing "tribal" cultures as reservoirs of authentic humanity, lost to Western societies through the processes of industrialization. Evidently, the term contains within it an ideological maneuver. In the first place, its use conceals the very processes of Western popular music's evolution, which are primarily the result of encounters with the cultures of the African diaspora in America, the Caribbean, and Britain. It enables Westerners fearing "contamination" from "native" cultures in the global economy to draw demarcation lines between popular cultures in the North/West and those in the South/East. It enables the paradox whereby the hybrid culture of rock music is used by white supremacists to articulate cultural purity and separateness.[2]

By contrast, a recourse to the category of "world music" often occurs in the context of a search by well-meaning cultural tourists for pre-capitalist authenticity, for signifiers of rootedness. "World music" then becomes a projection screen for the anxieties and neuroses of ethnic majority Westerners dealing with the guilt of a colonial past. It disguises both the effects of Western capitalism's globalization, where Western forms of mass popular culture become the worldwide currency of cultures undergoing urbanization, and the fact that the origins of much of the music included in the term lie in encounters with Western pop music as *the* international musical form. This is why resultant new musical forms are often denigrated by intellectuals and cultural activists in the developing world as signs of neo-colonial deculturation.[3] Finally, the use of the term denotes the safe assimilation of otherwise challenging forms of culture within a predetermined category that acts to contain them. By tracing the history of forms in the category and by providing an account of their passage to France in the 1980s and 1990s, I will make clear that this has indeed been one of the effects of the term's use. However, as will be seen, one particularity of the French context is that a younger generation of musicians and groups has begun to elaborate a response to the world-music industry's ghettoizing and exoticizing tendencies. Although this new initiative is in its early stages, it might well constitute a new phase in the development of world music in France. The dynamics of this new phase flow from socio-generational distinctions, rather than ethnic ones. A second

set of introductory remarks is needed to explain why this is so.

The notion of post-coloniality is seldom applied by analysts to the music scene within France. The French commonly perceive themselves as being among the colonized: as victims of American neo-imperialism, rather than as colonizers. A somewhat defensive conception of French culture emerges in consequence. France's stand on the cultural sections of the GATT treaties, and attempts to encourage musically conservative versions of *la chanson française* [the French popular song] via the imposition of radio quotas are symptomatic of this reflex (cf. Assemblée nationale 1994). It extends further than this, however. At the national level, debates on French identity have been dominated by the Front National, with its monocultural conceptions of "Frenchness." Consequently, the vision of a *France pluriculturelle* [multicultural France], so prominent in the emergence of the so-called Beur[4] movement in the early 1980s and apparently reinforced by Socialist cultural policy at the time, emphasizing plurality and difference, seems to be waning for lack of clear national advocacy (Bouamama *et al*. 1994: 95–105), and there is now a reluctance among sympathetic social commentators (François Dubet and Adil Jazouli, *inter alia*) to "ethnicize" the question of marginalized popular culture in France. This does not mean that themes germane to the post-colonial debate are not woven through any consideration of the place of "world music" in contemporary French society. Disillusionment with traditional militant politics among France's marginalized youth has favored the emergence of more culturally based formers of political and social world views, among which music is particularly significant. Younger participants in the associative movements emerging from France's marginalized outer-city suburbs over the last decade frequently express empathy with the experience of the African diaspora, and with the musical traditions in America and the Caribbean that have emerged from it (soul, funk, hip-hop, reggae). This empathy extends to the civil rights struggles of the black Atlantic and the East/South (Bouamama *et al*. 1994: 108, 158–9; Leclercq 1989: 287-9). Therefore, world music should not be seen in isolation in France, but rather as part of a wider continuum of resurgent marginalized cultural practices engaged in by a young, ethnically diverse and socially excluded sector of the population that is embarking on the process of articulating French post-colonial identities.

If the categorization of music often takes place for no more than the convenience of the multinational music industry, in the interests of targeting audiences more efficiently with ever more products, then in the case of world music, such categorization can be seen as a function of a dominant neo-colonial ideology inscribed on the social practices of the former colonies: raï in the French

setting becomes just another form of "world music," and the specific context of its emergence within a volatile, alienated young section of the Algerian population is concealed. More importantly, the possibility that raï as a social force might highlight the existence of analogous social groupings within France itself is also contained. Consequently, the categorization of music can be seen as the function of a dominant ideology active within France itself, which is inscribed on the social practices of those subject to it. Therefore, when a new generation of French-based groups deliberately foregrounds the blurring and even transgressing of previously distinct musical categories – not after the fashion of the globally dominant Western music industry by evolving a functional catch-all definition that fails to recognize the specificity of the music involved, but in a way that articulates new and equal relationships between particular musical forms not seen previously as compatible (funk-raï, soul-raï, etc.) – it might be regarded as being in defiance, however limited, of this dominant ideology.

A comprehensive survey of the world-music scene in France is beyond the scope of this chapter. Instead, I intend to examine in a general fashion how various forms commonly bracketed within the term "world music" have emerged in the French context, the role that French sites have played in their development, and the dynamics of their reception by both ethnic minority and majority populations. I will then provide a post-colonial focus by examining the history of raï, which was the result of the encounter between popular Algerian forms of music and the production values of Western popular music. The general context of its passage to France is obviously provided by the shared colonial history of the two countries. Overall, its ambiguous crossover to the mainstream culture of the majority population, plus the role that it plays within ethnic minority communities indicate that the challenge of fostering post-colonial cultural plurality in France is not being met. Although the *banlieues*[5] may be the privileged site of France's cultural melting pot, their marginal status means that the social practices that they produce are not having the impact they might have had on the cultural mainstream. Thus, the implantation of world music in France can only be very tentatively read as the first fruits of a putatively multicultural society.

FRANCE AS A CROSSROADS

It is now commonplace to describe Paris as the world-music capital of Europe.[6] There is little doubt that the city has served as a meeting point for musicians from

many parts of the globe, and has consequently been important in the cross-fertilization of musical styles and forms that is one of world music's most characteristic features (Seck and Clerfeuille 1993: 21). The following artists, all conventionally categorized as world music and all based and produced in France, provide an indication of this diversity: Gipsy Kings, Roé (sing in Spanish), Mory Kanté, Salif Keita, Alpha Blondy, Youssou N'Dour, Touré Kunda, Ismael Lô, Rakoto (in various African languages), Khaled, Cheb Mami, Fadéla, Sahraoui (in Arabic), Oio (in Basque), Polyphonies (Corsican), Kassav, Malavoi (French Creole), Boukman Eksperyans (Haitian French). The development of zouk is in many ways exemplary: although its emergence is usually credited to a single Caribbean group (Kassav), it is now ranked alongside reggae and salsa as a Caribbean musical form of worldwide influence. Zouk could only have emerged in the way that it did through the intermediary presence of Paris as a crossroads of the international music scene. It was in France, where they were part of the migrant population originating in the Caribbean Départements d'Outre Mer (DOM),[7] that Kassav made their name. As a musical form, zouk combines the rhythms of Guadeloupean beguine with those of Haitian and Latin American dance music, melodic forms derived from American funk and jazz with those taken from the waltzes of the French *grands bals* and West African pop music. The putative alliance of previously disparate Martiniquan and Guadeloupean cultures represented in the music was seen by some militants of the French Antilles associative movement as having political significance, both in terms of uniting the islands' search for independence from France and in terms of zouk's deliberate hybridity, although Kassav themselves subsequently played down this political aspect (Ledesma 1994).

In general, "French" production constitutes the largest part of what is internationally perceived as world music, although the majority of such artists, while overwhelmingly francophone, prefer to sing in another language (generally their mother tongue), or even in English. However, the reception accorded in France to music originating in the Caribbean, in Africa, and in Latin America has undoubtedly greatly facilitated its wider global transmission, and ethnic minority populations who trace their ancestry back to countries where the music originates have played a vital role in its initial mediation into the French context. Music provides channels for maintaining contact with the homeland. Indeed, parallel economies of musical production and marketing (usually of cassettes) have grown up within concentrations of ethnic minorities, linking them closely to their countries of origin. Some have taken their sense of cultural identity developed as part of an ethnic minority group in metropolitan France back to their country of

origin, and have thereby played a role in its cultural renewal.[8] However, interest in world music has not been confined to post-colonial minority populations in France.

An idea of world music's ethnic majority audience can be gained from the fact that out of all of France's national newspapers, only the left-of-center *Libération* has a designated world-music section in its events guide. It also devotes space to reviews of recorded world music. Other publications have played an important role in promoting world music to a majority audience, notably the re-launched *Actuel*, and more recently *L'Affiche*, committed to covering new musics. Both of these magazines have a younger, eclectically minded readership. Similarly, certain popular French musicians (Higelin, Lavilliers) have introduced world-music artists to their audiences by inviting them to make guest appearances at concerts and on record. Finally, the succession of anti-racist concerts promoted by SOS-Racisme and Amnesty International in the mid- to late-1980s increasingly featured non-European musicians and effectively launched the European careers of, among others, Youssou N'Dour, Mory Kanté, and Khaled. The extent of world music's implantation is seen in the fact that it now constitutes a separate section at the round of music festivals in France: Africa fête, Printemps de Bourges, Francofolies de La Rochelle, Banlieues Bleues de Saint-Denis, and so on. A plethora of independent record companies founded in France have given to some musicians their first opportunity to record and have brought them to wider attention. Overall, such activity indicates the existence of a niche audience for world music drawn primarily from France's ethnic majority.

Without a serious sociological study of this audience for world music in France, any generalization about its nature is speculative. However, a fair comparison can be drawn with the audience for jazz: both rely on a national network of festivals, journalistic coverage, and retail outlets. Profiles of audiences at France's music festivals reveal characteristics that imply a shared set of liberal social values, an eclectic attitude towards music, and a willingness to overcome apparent barriers of culture and of language.[9] In the crossing of cultural boundaries, the interaction between this niche audience and the ethnic minority audience is centrally important. Cheb Mami, the raï artist, noted the intermediary role of ethnic Algerians among the audiences for his European concerts in "demonstrating" an appropriate response to the music (Hazera 1990).

World music's niche audience undoubtedly overlaps in turn with the French cultural mainstream: the festivals, magazines, and independent record labels that constitute its economic and social parameters enjoy a national reputation and distribution, and are occasionally accorded space in the national media. Moreover,

French divisions of the multinational recording companies, and in particular Barclay, the predominantly French-owned subsidiary of Virgin, which with the other big five recording companies (BMG, EMI, PolyGram, Sony, Warner Music) accounts for 83 percent of the French market share (Gross *et al*. 1994: 21), were among the first to sign recording contracts at an international level with world-music artists, hitherto reliant on independent circuits of production and distribution, and on promotion via community-based or local radio stations (Radio Beur, Radio Nova). For a select few artists, major-label interest has procured airplay on the national FM radio stations, and secured the attention of sections of the televisual media.

This story of apparently continuous progression is not without its ambiguities. As in all popular music production, disentangling the purely artistic or cultural from the purely commercial is impossible, and some musicians complain about the exploitation, recuperation, and bastardization of world music in France. In this regard, specific examination of the French experience provides an opportunity to delineate some of the complex processes that see musical forms move from a local to a global setting.

RAÏ: FROM ALGERIA TO FRANCE AND BEYOND

Such processes are evident in the development of raï, a musical form that emerged in a specific local context (Algeria), but which has now moved to the global setting. In tracing the Algerian origins of raï, most writers draw lines of continuity between it and long-running popular oral traditions of song and poetry, but its emergence stems more immediately from various rural influxes into Algeria's western cities (and Oran in particular), the most recent having occurred in the years following independence. By the 1960s, a form of music now known as acoustic raï was the mainstay of popular celebration, whether in the more formal setting of the wedding or the less formal context of the bar, cabaret, or brothel.

This form remains simple and strongly repetitive: against a consistent rhythm, short phrases are intoned by a singer, and duplicated by melodic instruments or by a responsive choir. Textual content depends on improvisation inspired by verbal interaction with the audience and is structured by repeated lyrics. Content is non-linear, apparently non-narrative, but hints at circumstances deriving from misery, thwarted sexual desire, and loss, with which members of the audience can easily

identify from their own experience. Indeed, the singer's central preoccupation is to connect with the audience: emotionally, physically (it is primarily dance music), and also financially (the singer depends on audience contributions for a living) (Daoudi and Miliani 1996: 37–85; Virolle 1995: 41–55).

The international form of raï emerged from this musical tradition. Three factors were important: the first was the influx to Algeria in the years following independence of Western popular music. The second was the appearance of a new generation of raï singers, born in this era, who knew nothing other than independence. This generation of performers – commonly referred to with the prefix Cheb (male) or Cheba (female), meaning "young one" – combined knowledge of Western music with traditional raï and integrated new instruments and processes. The result is a form (described globally as pop-raï) that adds to the basic dance rhythm and melodic formulae more complex rhythmic conventions, musical phrases, sound ideas or motifs borrowed from the global circulation of popular music. The third factor was the development of technologies (portable recording studios and the cassette) that enabled massive and artisanal diffusion of pop-raï, both in the Maghreb and among post-colonial minority communities in Europe. Pop-raï enjoyed phenomenal success in Algeria, particularly in the early 1980s among the mass of urban youths who, despite constituting the majority in Algeria, were socially, politically and economically marginalized. The music's explosion indicates that it had succeeded in articulating the concerns of this group (Daoudi and Miliani 1996: 87–118; Virolle 1995: 57–76; Schade-Poulsen 1995: 83–5).

Its success also provoked controversy. Due to its perceived immoral textual content, the fact that it offended accepted standards for poetic production, and because of its associations with mixed-company dancing, raï was for a long time banned from Algerian state radio and television (Gross *et al*. 1994: 7–8). Opponents saw it as symptomatic of continuing destructive colonial influences and of the failure of post-colonial society to socialize its young. Others, however, have seen in raï a form of cultural resistance by disaffected youths that is indicative of widespread disillusionment with the official politics and culture of the Algerian post-colonial state (Mézouane 1992). Still others have felt that the disjointed narratives of raï's texts, and the ambivalent emotions they articulate, express the duality of Algerian youths, caught between the aspirations and frustrations of post-colonial modernity and the revolutionary monism of Islamic fundamentalism, and signify a blocked desire for change, ultimately expressed as social explosion (Virolle 1995: 173–4). It is easy to characterize this debate, which has occurred mainly among social commentators in Algeria, as a rerun of an age-old conflict

between competing claims for legitimacy made by popular and elite cultures (Schade-Poulsen 1995: 85). Recent events in Algeria, including the assassination of stars such as Cheb Hasni, Rachid Ahmed Baba and Cheb Aziz, along with raï's expansion as part of world music's globalization, have moved this debate outside of the original Algerian context. Several writers agree that as a specifically Algerian form of music, raï has reached a decisive, perhaps ultimate, point in its development (Morgan and Kidel 1994: 133; Virolle 1995: 175). In this respect, the civil war in Algeria undoubtedly accelerated a process already underway: raï had become an international art form.

The movement of raï into France can be seen as occurring in roughly three phases: the first saw its adoption by young descendants of immigrants from the Maghreb. From as early as 1981, community-based radio stations in France (Radio Beur and Radio Soleil in Paris; Radio Galère and Radio Gazelle in Marseilles) were broadcasting raï. Contact with musical developments in the homeland was reinforced by the growing trade in cassettes, and retailers in the Barbès district of Paris, the place du Pont in Lyon, or the cours Belzunce in Marseilles found a particularly receptive market among the young second- and third-generation members of post-colonial ethnic minority groups (Gross *et al*. 1994: 9–11; Daoudi and Miliani 1996: 217). Meanwhile, newspapers and magazines such as *Libération* and *Actuel* were paying attention to raï. However, it wasn't until the mid-1980s, and the first official raï festivals organized by the Algerian Culture Ministry (in particular in Oran in August 1985), to which Western music journalists were invited, that raï came to widespread French attention. For some commentators close to the music, this first contact was thus with a sanitized form that was acceptable to the Algerian authorities but not truly representative of raï's raw, explosive tendencies (Daoudi and Miliani 1996: 218–19). Further, less-sanitized contact – via the first exclusively raï festival to take place in France (and the first outside Algeria), at Bobigny in January 1986 – did not necessarily facilitate a truer appreciation.

Both at the time in the official Algerian press and more recently by writers claiming a better knowledge of the music (Virolle 1995: 30–2; Daoudi and Miliani 1996: 212), French coverage was criticized for presenting a distorted assessment, by stressing the music as resistance to the Algerian state and to Islamic values. By concentrating on a form produced by the latest stars, whose progressive outlook was more acceptable to its readership, the French press was held to have overstated the distinction between raï and the radical Islamic politics of the Front Islamique du Salut (FIS): both emerged from the same social milieu, and it is not certain that attachment to raï guarantees a stance of overt resistance to the rise

of Islamic fundamentalism (Virolle 1995: 131–50). The glossing over of otherwise uncomfortable facts regarding Islam's social significance replicated a concurrent dynamic in French press coverage of the Beur movement. The latter's emergence was greeted with universal relief in progressive circles: young descendants of immigrants had definitively turned their back on their ethnic origin, but more specifically on the dreaded Islam, and were now confidently embracing Western liberal values. What was missing in this portrayal was an awareness that the people involved were rejecting not just monolithic Algerian or Arab identities, but also monolithic versions of French identity, or indeed any other monocultural tradition (including the liberal progressive one). For those self-consciously adopting it, "Beur" signified passionate commitment to multicultural identities (Bouamama *et al.* 1994: 98–100). Similarly, it was comforting to read raï as a sign of the successful implantation of progressive values among Algeria's youth, but to do so conveniently overlooked the more complex nature of raï's challenge. It equally obscured the music's potential as a focal point for disaffected members of ethnic minority populations in France itself (a role it was increasingly coming to play: Daoudi and Miliani 1996: 221). In projecting onto the raï phenomenon anxieties over the rise of Islamic influence both in the Maghreb and in France, French journalists were painting a distorted picture of its significance.

However, the increasing attention given to raï signified that it had entered a second phase of its movement into France, that of extending its audience beyond the Maghrebi communities there, so that it was incorporated into the now-solidifying world-music category, with its niche audience. Yet raï's increasing importance on the international circuits of world music, and its subsequent presence from 1990 onwards at French festivals devoted to such music (Virolle 1995: 156–7), was felt by some of its Franco-Algerian proponents to only reinforce a certain ghettoization. Raï was still subject to ethnic marginalization as part of the world-music category, a fact explained by latent racism and a fear of "Arabs" (Mézouane 1992: 68, but writing in 1989). Although these reservations should be acknowledged, other factors were important. As noted above, the major distribution of raï had been massively by cassette, a form of production slanted towards the financial benefit of the producer and not particularly favoring the artist, who had little control over the product or its quality. In 1993, Bensignor saw this as the main cause of raï's failure to penetrate the mainstream market, now dominated by compact discs. As events would have it, raï's first appearance on CD was not produced in France, but London.[10] Its foothold on the international world-music scene was thus extending beyond France and Algeria, and the interest accorded by a major record label helped in turn to move raï into

a third phase within France, taking it beyond the world-music niche audience into the mainstream.

Khaled's itinerary is exemplary. For a long time the most popular of Algerian artists, he signed with Barclay in 1991, bringing out an album in February 1992 (*Khaled*). Produced by the Americans Don Was and Michael Brook (experienced producers of world music), the album quickly impressed: 20,000 copies sold immediately, and by June it was in the top fifty album chart, eventually going gold (over 100,000 sales). A single, "Didi," became only the third song in Arabic to enter the French charts, eventually reaching the top ten. It was also a worldwide smash, charting heavily throughout Europe, Asia, and Africa. A second album *N'ssi n'ssi* (February 1993), while less successful commercially, won a *César* for best film soundtrack (to Bertrand Blier's *1-2-3 Soleil*). An illustration of Khaled's acceptance within the French cultural mainstream comes from the fact that in 1994 and in common with all rising music stars, an obligatory passage via the Paris Zénith sold out and he has been invited more than once to the televised variety show "Taratata." His crossover from the world-music niche has also assured recording deals with the majors and commercial success for others (Mami, Hasni, Zahouinia). It has similarly provoked the compact disc release of backcatalog cassette material previously circulating only in the Franco-Maghrebi parallel music economy.

This success has not been uncontroversial. Some feel that it has been at the cost of diluting Algerian raï with Western production values and instrumentation, such that Khaled's music no longer qualifies as raï (cf. Bensignor 1993: 28; Virolle 1995: 163; Gross *et al*. 1994: 21). Others see it as provoking a split in Algerian production, between a rich and poor raï, where the success of a few superstars purveying bland, acceptable pop-raï masks difficulties confronting marginalized and increasingly politicized grass-roots artists in Algeria, under pressure from the social dictums of the FIS, and prey to a cutthroat cassette industry struggling to adapt to harsh economic circumstances and the changing expectations of an increasingly sophisticated domestic and international audience (Morgan and Kidel 1994: 133; Virolle 1995: 9).

Controversy surrounded the promotion of Khaled's first album for Barclay, which was advertised with posters proclaiming "Ceci n'est pas un disque arabe" [This is not an Arab record]. It is true that the slogan apparently encourages us to reexamine our notions of just what really is Arab, but was this simply pandering to neo-colonial cultural relations? The promotional campaign suggests that the cliché of an unspecified, backward Arab nation (Khaled's *Algerian* origins were obscured) unable to foster anything as modernist and progressive as popular dance

music has to be evoked before it can be discarded. Moreover, why is this new presentation of Arab-ness more acceptable? Is it because it displays features that are comfortingly familiar and reassuringly "Western"? In spite of the fact that Khaled himself stressed the campaign's humorous elements and that it fore-grounded raï's hybridity, the record company's slogan indicates an awareness from those marketing the record that a certain "disassociation" is required to introduce certain artists to a mainstream audience.

The promotion was evidently effective: Khaled was received coldly by an unfamiliar audience while supporting British band Dire Straits at the Zénith in early 1992, and yet that summer, "Didi" became the biggest hit of the year in Paris nightclubs. However, the relative lack of success of the follow-up album may be explained by Khaled's return to traditional forms of raï (partly at Blier's request), which were less to the taste of a mainstream Western audience. Such ambiguities indicate that it would be naïve to assume an unreserved acceptance within the French mainstream for a culture often viewed as suspect due to its Islamic connections.

Other distinctions explain raï's failure to decisively enter the mainstream. Mainstream musical practices are distinguished from those of the world-music niche audience and the largely marginalized youths of the *banlieues*, not only by language, but also by the conditions in which musical forms are produced and consumed. Most music in the world-music category (raï, zouk, high-life, soukous), and also the music of the black Atlantic (funk, rap, ragga, jungle) is primarily collectively produced and consumed *dance* music. Consequently, textual content is foregrounded to the extent that it expresses emotional explosion, but decentered in terms of the specifically linear narratives more common to rock music, or the traditions of *la chanson française* [the French popular song]. Comprehension of words is not necessarily decisive in the collective act of receiving the music as socially significant practice. Much world music is only meaningful either in the context of the live event (festival), or when the recorded product, which on its own signifies the *absence* of the collective that spawned it, becomes integrated by the selector or DJ into the experience of a locally based social gathering (jam, sound system, party), who in so doing proclaims the shared history of that gathering. Raï's future in France seems viable only as part of this spectrum (Gross *et al.* 1994: 17–18), rather than as a product marketed for individualized consumption within the cultural mainstream.

RAÏ AT THE CROSSROADS

Today, raï stands in many ways at a new crossroads. On the one hand, Algerian raï seems to be having difficulties in renewing itself, as the late 1970s' generation of singers runs out of ideas. With its artisanal methods of production, it is facing stiff competition from more sophisticated Western-originated products. On the other hand, performers born in France – such as Cheb Malik, pioneer of a strand of dance music significantly labelled *l'after-raï*, or techno-house-raï – signal new developments. The traditional circuit for Maghrebi music in France has been revitalized by a dynamic associative movement at the grassroots level and the creation of raï-based cabarets and discos (Daoudi and Miliani 1996: 221). Members of the new generation of bands now emerging from France's *banlieues* would have been only about ten years old at the time of the Bobigny festival (the occasion of the first all-raï concert in France, in 1986). Zebda, from Toulouse, now a fixture on the round of France's music festivals, mixes raï with funk, rock and rap. Kafia, from Paris, with members of Algerian, Moroccan, Zaïrian, Guadeloupean and French descent, combines raï with reggae, soul, and salsa, and sings mainly in French, focusing on the problems faced by a young, marginalized generation from the *banlieues*.[11] It is too early to generalize about attitudes demonstrated by these groups: some proclaim their loyalty to raï via their name, indicating that origins are not unimportant for this generation. However, raï remains only one part of their makeup. A recent survey found rap, funk, and reggae to be the most popular musical forms among a range of young people in the *banlieues*; raï had a narrower resonance, being associated most often with a nostalgic or wistful mood (Matheron and Subileau 1994: 66).

Within these milieux, raï is just one of a range of elements being blended into new formations. The rap music produced by Marseilles group IAM is typical in the way in which it brings together signs of a North African identity (musical samples from raï artists and other Arabic sources; references to Egyptian mythology) and an explicit identification with their hometown of Marseilles, which they feel is often despised by others and subjected to the internal colonialism of Paris. The Parisian group Jungle Hala mixes funk, jazz, and oriental music to form a background against which the rapper Hakim raps in French or in Arabic. Raï's specific contribution to this hybrid material has to do with signifying origins, or with expressing the more wistful or sentimental moods that act as a counterpoint to the anger that rap articulates so effectively. For Gross, *et al.* (1994: 29), it fulfills a defensive function in that it helps to foster a wider social space within which new identities can then be articulated (1994: 29). Its

particular ethnic significance is therefore tempered by a deliberate espousal of plurality and by the making of new forms of musical hybridity. Concepts of plural social identity now seem so firmly implanted in significant sections of the youths of the *banlieues* that the latter's already severe marginalization can only be compounded by the continued assertion of unitary notions of identity within and by educational, political, and cultural institutions. A desire to escape ghettoization in any form remains a central dynamic for these youths, and is expressed through the tactic of deliberately and provocatively disrupting the commercial compartmentalizing that, in the long run, has seen world music confined to a musical and ethnic ghetto.

CONCLUSION

Algerian raï and other forms of world music face an uncertain future (Virolle 1995: 175). In the French context, they take their place alongside numerous other musical and cultural influences, and are framed by overt articulations of identity and affiliation that are firmly based in the local and the particular, but also connected to the universal and the global. This dynamic owes as much to social and generational motivations as to ethnic ones. Any folkloric or archaic aspect in the presentation of cultural origins is undoubtedly offensive to ethnic minority youths (Jazouli 1989: 282); rather, they respond to analogies between such origins and their lived experience in France.

Until recently, rap was not included in world-music festival programs. This exclusion was partly a reflection of the music industry's arbitrary categorization, and also the festival organizers' view that rap's American origins minimized its significance for the ethnic minority communities that form a major part of their constituencies. The long-running Africolor festival, held annually in Saint-Denis and co-founder of the European Forum of Worldwide Music Festivals, owes its success to close links with local members of various ethnic minority groups (notably the Malian community). In 1995, for the first time, Africolor devoted an evening to "cette nouvelle génération qui a choisi le hip-hop comme expression de sa spécificité africaine et de sa modernité" [this new generation, which has chosen hip-hop as a means to express both its African specificity and its modernity], and programmed other, more eclectic groups from the Parisian suburbs. Such developments might prove distasteful to those who are committed to notions of cultural authenticity and fear that this apparent eclecticism will

produce a meaningless mishmash of neo-culture. If such attempts to redefine the parameters of world music can counter the dynamics of closure and ghettoization afoot in France, I would view them as more of a positive than a negative development.

NOTES

1 For an account of this movement in the Anglo-American context, see Roberts (1992: 231–2).

2 An obvious example of this paradox is "oi," the extreme right-wing political rock of the skinhead subculture, which has developed a following among some skinhead groups in France's northern industrial cities.

3 Such a reaction was a key feature of raï's reception among Algeria's artistic and cultural elites during the late 1970s and early 1980s (Virolle 1995: 30–6).

4 On the origins of this term, see above, p. 20.

5 Cf. above, p. 12.

6 Central Paris alone contains more than fifty clubs and concert halls regularly programming world music nights (Virolle 1995: 156).

7 Cf. above, p. 8.

8 For a case analysis of the *Antillais* [Caribbeans] in France that explores the relationship between immigrant population and country of origin, see Giraud and Marie (1987: 41–3).

9 On the music festival as an environment where "risks" are more likely to be taken by the (young) audience, see Pame and Halley des Fontaines (1994). This is not to say that misapprehension is not possible within this well-meaning cultural exchange: Virolle (1995: 167) reports a common misinterpretation of the Arabic phrase *serbi serbi*, sung by the raï artist Khaled, taken by some to refer to the former Yugoslavia, but which in fact means "give me a drink."

10 *Raï Rebels*, vol. I (Earthworks/Virgin 1990); *Raï Rebels*, vol. II: *Pop-raï and Rachid Style* (Earthworks/Virgin 1990).

11 Other names included in this wave: Raï Kum, Nemla, Melaz, Sawt el Atlas, Momo Roots, Ouled el Raï, Les Vagabonds du Raï.

REFERENCES

Assemblée nationale, Commission des Affaires culturelles (1994) *La chanson française: Rapport d'information*, no. 1006, Paris: La Documentation française.

Benoit, Edouard (1990) *Musique populaire de la Guadeloupe: De la biguine au zouk 1940–1980*, Basse-Terre, Guadeloupe: Office régional du Patrimoine guadeloupéen/Agence guadeloupéenne de l'Environnement, du Tourisme et des Loisirs.

Bensignor, François (1993) "Le raï, entre Oran, Marseille et Paris," *Hommes et Migrations*, no. 1170, November, pp. 25–9.

Bouamama, Saïd (1993) *De la galère à la citoyenneté: Les jeunes, la cité, la société*, Paris: Desclée de Brouwer.

Bouamama, Saïd, Mokhtar Djerdoubi, and Hadjila Sad-Saoud (1994) *Contribution à la mémoire des banlieues*, Paris: Edition du Volga.

Broughton, Simon, Mark Ellingham, David Muddyman, and Richard Trillo (eds) (1994) *World Music: The Rough Guide*, London: Rough Guides.

Daoudi, Bouziane, and N. Abdi (1994) "Deviens muezzin," *Libération*, September 30.

Daoudi, Bouziane, and Hadj Miliani (1996) *L'aventure du raï: Musique et société*, Paris: Seuil.

Dubet, François (1987) *La galère, jeunes en survie*, Paris: Fayard.

Frith, Simon (ed.) (1989) *World Music, Politics and Social Change*, Manchester/New York: Manchester University Press.

Garofalo, Reebee (ed.) (1992) *Rockin' the Boat: Mass Music and Mass Movements*, Boston, MA: South End Press.

Giraud, Michel, and Claude-Valentin Marie (1987) "Insertion et gestion socio-politique de l'identité culturelle: Le cas des Antillais en France," *Revue européenne des migrations internationales*, vol. 3, no. 3, 4th trimester, pp. 31–47.

Gross, Joan, David McMurray and Ted Swedenburg (1994) "Arab noise and Ramadan nights: raï, rap, and Franco-Maghrebi identity," *Diaspora*, vol. 3, no. 1, Spring, pp. 3–39.

Hazera, Hélène (1990) "Musique: Saïda–Paris–New York: Du retour du service militaire, Cheb Mami, petit prince du raï fait le tour du monde," *Rolling Stone* (French edition), no. 28, May 3–June 5, p. 26.

Jazouli, Adil (1989) "Les dynamiques autonomes d'intégration des jeunes d'origine immigrée: exposé introductif," in Bernard Lorreyte (ed.), *Les politiques d'intégration des jeunes issus de l'immigration*, Paris: CIEMI/L'Harmattan, pp. 280–3.

Leclercq, Robert-Jean (1989) "Nature des revendications et des enjeux culturels portés par les minorités actives issues de l'immigration maghrébine en France pour la période 1978–1987," in Bernard Lorreyte (ed.), *Les politiques d'intégration des jeunes issus de l'immigration*, Paris: CIEMI/L'Harmattan, pp. 284–92.

Ledesma, Charles de (1994) "Zouk takeover: the music of the French Antilles," in Simon Broughton, Mark Ellingham, David Muddyman, and Richard Trillo (eds), *World Music: The Rough Guide*, London: Rough Guides, pp. 514–20.

Matheron, Corinne, and Jacques Subileau (1994) *Jeunes, musiques et médiation*, Paris: Villes et Miroirs des Villes.

Mézouane, Rabah (1992) "Génération raï," in Merzak Allouage and Vincent Colonna (eds), *Algérie, 30 ans: Les enfants de l'indépendance*, special issue of *Autrement*, no. 60, pp. 64–70.

Morgan, Andy, and Mark Kidel (1994) "Thursday night fever: Algeria's happiest hour," in Simon Broughton, Mark Ellingham, David Muddyman, and Richard Trillo (eds), *World Music: The Rough Guide*, London: Rough Guides, pp. 126–33.

Pame, Patricia, and Virginie Halley des Fontaines (1994) "Les jeunes au Printemps de Bourges 92: Étude de la prise de risques dans les situations de grand regroupement," in Alain Vulbeau and Jean-Yves Barreyre (eds), *La jeunesse et la rue*, Paris: Desclée de Brouwer, pp. 119–28.

Rigby, Brian (1991) *Popular Culture in Modern France*, London/New York: Routledge.

Rigoulet, Laurence (1992) "Raïled," *Libération*, November 16.

Roberts, Martin (1992) "'World music' and the global cultural economy," *Diaspora*, vol. 2, no. 2, Fall, pp. 229–42.

Schade-Poulsen, Marc (1995) "The power of love: raï music and youth in Algeria," in Vered Amit-Talai and Helena Wulff (eds), *Youth Cultures: A Cross-cultural Perspective*, London/New York: Routledge, pp. 81–113.

Seck, Nago, and Sylvie Clerfeuille (1993) *Les musiciens du beat africain*, Paris: Bordas.

Shusterman, Robert (1992) *L'art à l'état vif: La pensée pragmatiste et l'esthétique populaire*, Paris: Editions de Minuit.

Virolle, Marie (1995) *La chanson raï*, Paris: Karthala.

Warne, Christopher (forthcoming) "Articulating identity from the margins: Le Mouv' and the rise of hip-hop and ragga in France," in Sheila Perry and Máire Cross (eds), *France, Populations and Peoples*, vol. II: *Voices of France*, London: Cassell Academic.

PANAME CITY RAPPING

B-boys in the *banlieues* and beyond [1]

Steve Cannon

INTRODUCTION

"Le hip-hop" and "le rap" are terms both of which have taken up residence in the French language due to the development of a dynamic and flourishing hip-hop movement in France over the last twelve years or so. Broadly speaking, "le hip-hop," as used in French, embraces a wide spread of interconnected street arts which originated in the urban projects of New York in the late 1970s, including graffiti and dance as well as the specifically musical form known as "le rap," which Tricia Rose (1994: 2) succinctly defines as "rhymed storytelling accompanied by highly rhythmic, electronically-based music." The present chapter focuses on the specifically musical aspects of hip-hop in France. It begins with a brief outline of rap's development in the USA, introducing some of the basic techniques and terminology and also giving a sense of the complex web of connections at the origin of this hybrid cultural form. The connections that young people in France have made with this urban American cultural phenomenon are explored in the second section of this chapter, where I examine the character of the hip-hop audience in France, the position of people of minority ethnic origin in its production, dissemination, and consumption within the post-colonial context of contemporary France, and the nature of the ideas and images of resistance it has generated in the process of gaining growing commercial success.

"ADVENTURES ON THE WHEELS OF STEEL":[2] DEEJAYS, RAPPERS, AND THE BIRTH OF HIP-HOP

In both France and the USA, hip-hop is indissociable from its urban context. The south Bronx, where hip-hop developed in the mid- to late-1970s, was a particular kind of crucible, a post-slum clearance public housing development that was predominantly populated by "relocated" black and Hispanic (Puerto Rican) families and by newer immigrants. One such was Clive Campbell (better known as Kool DJ Herc), who came to New York from Kingston, Jamaica, in the late 1960s, bringing with him a love of the giant outdoor reggae "sound systems." Herc therefore built the biggest (and loudest) mobile disco in the Bronx, popular at house parties, school gyms, and outdoors at summer "block" sessions or in the parks. More importantly, perhaps, Herc also imported Jamaican deejay "toasting," the calling out to the crowd through a microphone over the top of the record of catchphrases or appeals to known faces in the crowd to keep dancing (e.g. "Rock the house!" "Wallace Dee is in the house!" (Hager 1984: 32). Finding his audience resistant to reggae rhythms, he played faster latin funk, and in response to the dancers' desire to go faster and harder, Herc and other deejays such as Grandmaster Flash (Joseph Saddler) and Afrika Bambaataa began to extend the "breaks" in popular records (those sections most popular with the dancers, where the beat and the instruments take precedence over the vocals) by cutting back and forth between two copies of the same cued and re-cued twelve-inch disc (see Toop 1991; Hager 1984; Hebdige 1987: 136–48).

The speed and dexterity of the deejays became a matter of rivalry, as did their attempts to employ more and more obscure records, to outfox the competition, as suppliers of breakbeats, while beats from several different records began to be mixed together using twin turntables and sound faders. The more complex the deejaying task became, with Flash in particular developing the technique of "scratching" (manipulating the disc under the stylus in a staccato rhythm in time to the underlying beat), the more "rapping," as it was now known, over the top of these beats devolved to sidekicks, masters of ceremonies (MCs) who would vaunt the prowess of their particular deejay, or of themselves as part of his "crew," while acrobatic dancers would add to the spectacle and give a lead to the crowd.

This tripartite division of labor (deejay, rapper(s), dancers), originally part of the natural development of deejaying technique, has become the established pattern for hip-hop shows and hip-hop bands, both in the United States (Public Enemy) and in France (IAM), and has also contributed to the foregrounding of

the rapper (Chuck D and Chill/Akhenaton respectively), rather than the deejay, as the "leader" or personality of the group when the music and the bands who record it are marketed.

A further technical or formal shift in the development of hip-hop came somewhat later with the advent of the sampler, which isolates and digitally stores sound components. It allowed the mixing of sounds in hip-hop production to move beyond the vinyl-and-tape pirating of beats from dance records to encompass TV and radio jingles and theme tunes, speech, sirens, and other "found" sounds, and enabled deejays and producers to reduce records to their tiniest component parts and then reassemble or reorder them, or utilize some mere fragment to add the desired quality to their own sampled stew, a process of complex montage that Greg Tate describes as "micro-surgery" (Tate 1992: 121).

THE IMPORTING OF RAP TO FRANCE

Fanzines and sympathetic radio stations celebrated the "tenth anniversary" of hip-hop in France in May 1994; this might surprise those record label executives only recently awakening to rap's market potential, but it also gives some indication of the complexity of the relationship between US import and French audience response. The first appearance of rap in France came in 1982, when *Actuel* journalist Bernard Zekri brought news from New York of this latest music craze and persuaded the radio station Europe 1 to finance a tour in the autumn of that year (Zekri 1994: 87), featuring the three elements of the new hip-hop culture: rapping/deejaying (Fab 5 Freddy, Afrika Bambaataa, DST) and also graffiti art (Futura 2000, Dondi), and breakdancing (the Rock Steady Crew, the Double Dutch Girls). This tour, combined with images of breakdancing in films like *Flashdance*, *Footloose*, and the less mainstream *Beatstreet*, helped create a short-lived vogue beginning around 1984 for dancing that became known in France as "le smurf," at the expense of the music itself.

This "occultation du rap par le smurf" [overshadowing of rap by breakdancing] (Lapassade and Rousselot 1990: 11) was perpetuated on television in the weekly "Hip-Hop" program broadcast on TF1, presented by Sidney, where the dancers were always foregrounded even when performers were appearing in the studio. But whether due to marketing priorities or simply linguistic barriers, this prominence afforded to the acrobatic gyrations of "smurfeurs" means that we can only agree with Lapassade and Rousselot's comment that "contrairement aux

Etats-Unis, le rap français n'a pas commencé dans la rue" [unlike in the USA, French rap was not born on the streets] (ibid.: 10).

Zekri's account of his involvement in the development of rap in France notes that by late 1985 and the end of Sidney's broadcasts: "le Paris qui bouge enterre le rap" but, he continues, "c'était compter sans la banlieue" [trendy Paris was burying rap . . . but no one told the *banlieues*] (Zekri 1994: 88).

Fans who had witnessed the American hip-hop tours, who had simply glimpsed the new styles of dance and dress on TF1, or who were tuning in to broadcasts on independent radio stations saw and heard in hip-hop styles and forms, in the fan culture of tagging, graffiti art, breakdancing, and dressing in the now-recognizable hip-hop styles (of which the baseball cap, basketball boots and tracksuits have become the archetypal elements) a range of cultural practices to be involved in, attempted, copied, and mastered. It is this openness and accessibility which is characteristic of hip-hop practice, seldom involving a substantial outlay of cash on equipment, instead reappropriating "the simplest and most widely-available devices in the recording chain (turntables and microphones) and transform[ing] them into musical instruments in their own right" (Chambers 1985: 190) or, in the case of the even more readily copied tagging, requiring only spray can and cardboard stencil, or just a cheap marker-pen. We will return later to the ways in which the images and ideas of US hip-hop have been appropriated and made relevant to the social context of post-colonial France, but first: who were these suburban hip-hop fans and would-be practitioners?

Early descriptions of breakdance and rap festivals indicate that while the spectators represented a mixed ethnic cross-section, the dancers and rappers themselves were mainly "des jeunes issus de l'immigration" [youngsters of immigrant origin] (Bachmann and Basier 1985: 59). Similarly, describing hip-hop devotees in his own *banlieue* of Villeneuve-St Georges, rap star MC Solaar states: "A l'époque il y avait 95% de Mélanos-Antillais ou Africains, maintenant il y a encore 90%" [At the time there were 95% black West Indians or (black) Africans, and there are still 90% now] (Desse and SBG 1993: 105). Further anecdotal descriptions from rap interviewees underline the "public très black" [very black audience] of early club nights (ibid.: 147).

The participants in that fan culture were also learning their own apprenticeship as rappers and deejays, and the compilation *Rapattitude*, the first major record release of rap in French, in 1990, seems to offer a representative snapshot of the early practitioners of rap in the Paris region. If we leave aside the two "ragga" artists included on the album,[3] the eight remaining artists or groups offer the following breakdown: Assassin (from the *18e arrondissement* in Paris, "[c]omposé

de membres dont les origines vont du Maghreb à l'Afrique noire, en passant par la Corse, les Antilles et l'Irlande" [made up of members whose origins range from the Maghreb to black Africa, via Corsica, the West Indies and Ireland] (*On a faim!* 1994: 16); Dee Nasty (a white deejay from the Cité de la Pierre-Plate in Bagneux); EJM (mother from Martinique, father from Cameroon); Lionel D (from Vitry-sur-Seine; white mother, black father); Les Little MC (also from Vitry, all "Mélanos-Antillais ou Africains," to reuse Solaar's phrase); New Generation MCs (same ethnic background); Saliha (a *rappeuse* [female rapper] from Bagneux; Maghrebi father, Italian mother) and Suprême NTM (from St Denis; their two permanent members are white rapper Kool Shen and West Indian Joey Starr).

There are a few notable exceptions who do not feature on the album but who can safely be added to this survey of the first wave of rap in France: MC Solaar, whose first single "Bouge de là" came out that year (he was born in Senegal of parents from Chad, and was brought up in Villeneuve-St Georges, via Cairo; his principal musical collaborator is white deejay Jimmy Jay); Jhony Go and Destroyman ("un tandem de jeunes noirs" [a young black duo]: Bachmann and Basier 1985: 59), who released a little-known single "On l'balance/Egoïste" in the late 1980s; and Nec Plus Ultra (three white rappers from the *19e arrondissement*), who performed at Le Bataclan around 1987.

If that was the picture in Paris's suburbs, what about the provinces? Certainly hip-hop posses[4] were less numerous outside Paris, but examples exist: for example, in Marseilles we find the six members of B-Boy Stance, who later became IAM: sons of immigrants from Italy, Mali, Algeria, and Spain. For the Lille–Roubaix–Tourcoing conurbation we have a document that presents photos and lyrics from a range of rap outfits (and one dance crew) that existed until the early 1990s (Cissé and Callens 1992). From that source we can detect a similar mix: three of the eleven groups pictured personify the "Black, Blanc, Beur" [black, white, Beur] slogan of the annual anti-racist festival (also the title of France's first daily rap broadcast, which began in September 1991, on a Lille radio station: ibid.: 5]); over half of the artists' photos (eight out of thirteen) show white participants; seven feature black members, and Maghrebi youth are present in six illustrations.

So, in spite of the fact that our information is incomplete and varied in form, we can nonetheless draw from it the following points:

(1) If we approach the French scene with the dominant images and discourse of US hip-hop in mind, the visible presence of credible, authentic "white" rappers

and deejays might be the most striking feature. Yet although there is a significant white presence in hip-hop in France, and perhaps more so among the provincial representatives, it is only the sharply polarized "racialization" of cultural debate in the USA that makes this presence stand out.

(2) Approached within its own post-colonial context, where the population in France resulting from non-European immigration represents only around 6 percent, the ethnic contours of hip-hop there become more properly appreciable. Even though our evidence may be drawn from less reliable sources than INSEE (the French census bureau), statistically speaking, the disparate testimonies, documents, and studies of hip-hop in France in the 1980s and 1990s suggest that not only is the most significant numerical participation in both production and consumption of hip-hop "products" among people of minority ethnic origin, but also that hip-hop in France is characterized to a great extent by its role as a cultural expression of resistance by young people of minority ethnic origin to the racism, oppression, and social marginalization they experience within France's *banlieues* and in its major towns and cities.

(3) Within that broad category of people "issus de l'immigration" [of (recent) immigrant origin], whether personally or as second-generation offspring, we can also discern a significantly greater presence and involvement of "Mélanos-Antillais ou Africains" than of other minority ethnic groups.

(4) Notable absentees are South-East Asian youths, but this leaves the potential enigma of the relatively lower visibility of Maghrebi youths, particularly in the 1990s, when rap has become commercially successful. Members of the IZB posse, who produce the fanzine *Get Busy*, have bemoaned the fact that "Les rebeux n'ont pas la place qu'ils devraient y avoir dans le hip-hop en France" [Second-generation Maghrebi youth are not represented as they should be in hip-hop in France] (Desse and SBG 1993: 136), and point to the predominance of soul and funk, hip-hop's obvious precursors, in "rebeu" (i.e. Beur) clubs – whereas reggae dominated the West Indian equivalents (ibid.: 136) – indicating, as do Bachmann and Basier's (1985) observations and the representations in *Rap en Nord*, that Maghrebi youth were a significant component in *banlieue* b-boy activity. The era of commercial success for rap in France has so far seen only one significant Maghrebi rapper receiving credit and material reward: K-Mel of Alliance Ethnik, so striking in his isolation as to be featured on page one of *Le Monde* (Cachin 1996: 77).

(5) The other important observation that may be made, given the solitary presence of Saliha on *Rapattitude*, is the rarity of women in hip-hop in France.

Saliha is not completely alone, but Melaaz (of Kabyle origin), part of Solaar's 500 One posse, and Princesse Erika (another Vitry pioneer, whose parents are from Cameroon) have lately had to diversify (into soul and ragga) to establish recording careers, as if record companies found the presence of females in the aggressive, potentially macho world of rap difficult to stomach, or to market.

Some light may now be shed on these absences or exclusions (i.e. of women and Beur rappers) in our discussion of the tensions between mainstream and minority activities and agencies in the journey of hip-hop in France to commercial respectability. While it is relatively easy to establish the "pioneer" status of individuals like Dee Nasty, it is less straightforward to chart the often complex overlapping paths of those individuals in their relationships with networks or organizations within the hip-hop scene and in their contacts with "outsiders." First of all, I will attempt to describe the ways in which hip-hop has organized itself in France, before I offer some examples of its relationships with wider, commercial structures in French society.

The basic unit of organization of hip-hop is the "posse," a notion clearly imported and adopted from the USA, generally a loosely defined group or "crew" of friends and contacts from the same housing project whose collective identity and solidarity, usually expressed by a collective "tag" (e.g. NTM 93), derives from that geographical link and a shared love of hip-hop (Bazin 1995: 97–105). The tag is then liberally sprayed wherever the posse finds itself. Tagging, the creation of graffiti murals, and breakdance sessions constitute the main activities of the posse, and offer a kind of apprenticeship in hip-hop culture that usually precedes any musical activity: for example, Kool Shen, one of the two rappers in Suprême NTM, was a dancer in the well-known Paris City Breakers crew, while Fabe, now a rapper with a growing reputation, was a renowned *taggeur* [graffiti artist] captured on film by an FR3 TV documentary team in 1990. Although there are certainly local and inter-*banlieue* rivalries, these posses also share a collective sense of belonging to the hip-hop "*mouvement*" [movement], whose values and ideas are preserved and expounded by fanzines, collectively written and illustrated and often very well produced.

One important source of collective values and provider of a form of collective identity was the Zulu Nation, founded by Afrika Bambaataa in New York precisely to overcome inter-project rivalries and gang wars. In 1984 after a visit by Bambaataa a branch was established in France, with its own "King and Queen." It had its own fanzine, *The Zulus' Letter*, and *soirées* called "Zulu's Party" (*sic*), and was one of the first organizations that attempted to rally the disparate forces of

hip-hop in France during the late 1980s. However, despite this desire for unity, the relatively prescriptive "charter" regulating behaviour of official members of the Nation – for example, it forbade tagging as a form of delinquency – was unlikely in the end to make possible the sought-after cohesion.[5]

More loose-knit networks involving several posses began to organize events and club nights at Le Bataclan, Le Globo (1987), and La 5e Dimension in Montreuil. Nevertheless, management concerns about the type of clientele attracted by hip-hop *soirées*, confirmed by violence at a Run DMC tour date at the Rex (Paris) in 1987, led to periods of exclusion from clubs. As an alternative, open-air events modeled on Bronx block parties would be arranged, on *terrains vagues* [wasteland] such as one at La Chapelle, where the "mike," the floor, or the wallspace necessary for the practice of the various hip-hop arts was made available to anyone willing to have a go, for a token entry fee of Fr5. Another unlikely location was "chez Paco Rabanne" [at Paco Rabanne's place], since the fashion magnate opened up rehearsal space for youngsters to practice breakdancing to their own "ghetto-blaster" tape players.

Alongside these events, rapping was gaining access to the airwaves of pirate stations or independent local or Paris stations, which began to schedule rap slots, most notably Dee Nasty's on Radio Nova every Sunday, with Lionel D as MC. Independent stations such as Nova were the lifeline of hip-hop in late 1980s' France, and today's rappers pay tribute in interviews to Dee Nasty and Lionel D, who acted as keepers of the flame (Desse and SBG 1993), by broadcasting the latest sounds from abroad, but also by opening up their microphone to the unofficial "champions" of each *banlieue* who would "freestyle" over Dee Nasty's mixes. Les Little MC, Saliha, Suprême NTM, Ministère Amer, and MC Solaar all made their debuts on this show.

If the rap developments maturing in the Paris suburbs remained relatively hidden from the cultural mainstream, this was not the case of that other element of the hip-hop trio: graffiti. "Tagging" was extremely visible in Paris, particularly on the subway system, and led to some sensationalist reporting about mass "vandalism" (even *Le Monde*, May 4, 1989, referred to France as suffering from "the contagion" of this previously exclusively American problem), as well as another kind of increased (media) visibility: a fictional made-for-TV movie by Cyril Collard (*Taggers* 1988).

Rap's regular (re-)appearance on television in 1990, with Olivier Cachin's weekly *Rapline* show on M6, opened up the beginnings of a debate around "external" involvement in and/or exploitation of rap. Cachin, a music journalist and editor of *L'Affiche*, an alternative music magazine, shares with Georges

Lapassade, an academic from the University of Paris VIII, the dubious privilege of being most frequently named in denunciations of "outsiders" who meddle in rap (for example, for a comment about Lapassade, see Saliha interview in Desse and SBG 1993: 147; see ibid.: 196, for a remark by Lionel D about Cachin).

Lapassade's "crime" of opening the doors of his department to local youths around the university, which is in St Denis (he established contacts between rappers and students while doing research on urban youth culture), has been frequently repeated, particularly by local authorities in the *banlieues*, where as early as 1982's "anti-été chaud" [anti-long hot summer] campaign, festivals and concerts were set up along the lines described above (Bachmann and Basier 1985). Chill exaggerates only partially in asserting that "[a]ujourd'hui, les trois quarts des maisons de quartier, des centres sociaux, ont des samplers" [today, three-quarters of youth clubs and social centers have their own samplers] (Narlian 1995: 20; see also Bédarida 1995).

While municipalities were seeking to absorb and "integrate" the potentially destructive energies of young *banlieusards*, Cachin, and more especially major record labels, stand accused of commercial exploitation and of tarnishing the authentic values of hip-hop. The 1980s had already seen the appearance of the first mini-album of hip-hop in France – *Paname City rapping* – self-produced and financed on his own "Funkzilla" label by Dee Nasty, and Jhony Go and Destroyman's single ("On l'balance/Egoïste") also came out towards the end of the decade. However, the first rap hits in France were, perhaps inevitably, caricatures: Benny B, often called the French Vanilla Ice (the American "original" is a white pop-rapper who invented a personal background as a young urban tough to lend himself authenticity), had a hit with "Mais vous êtes fou" in 1990. This was followed by comedy trio les Inconnus' "yuppie" parody (1990) of a *banlieue* rap, which recited "*Auteuil, Neuilly, Passy* . . ." (rather posh western suburbs of Paris) instead of the usual litany of danger zones, and at least had the merit of being mildly funny.

"L'ARGENT POURRIT LES GENS, J'EN AI LE SENTIMENT":[6] CROSSING OVER OR SELLING OUT?

By this time, the major record labels had been convinced that there might be a market for French hip-hop and rushed to get themselves a rapper on the books.

While this has led to the successful careers of MC Solaar, IAM, and Alliance Ethnik, it has also produced victims: Lionel D in particular, for some the "pionnier du rap français" [pioneer of French rap] (Lapassade and Rousselot 1990: 12; Prévos 1992), was dropped by CBS after one hastily produced album. Saliha, perhaps equally promising when featured on the *Rapattitude* compilation, has suffered the fate of many female rappers at the hands of the record companies in being promoted either as a sex object or not at all.

Newer groups observing this, and others having experienced it firsthand, became part of a growing trend towards self-produced material, independent labels, and a turn inwards towards a self-consciously defensive "underground" movement (*L'Affiche* 1994). The fanzines that sustain this hardcore tendency (*Yours, From Da Underground, Down With This*) and some of the rappers themselves have turned on MC Solaar and IAM, because of their success, and have accused them of "selling out." Moreover, they have denounced the "programmation abusive" [excessive playlisting] of IAM's "Je danse le Mia" (1993) and the "attitude commerciale" [commercial bent] shown by their "enchaînement de passages télé" [string of TV appearances] (*Down With This* 1994: 11). The criticism of MC Solaar even takes a "racial" form: ragga band le TRIBU claimed that "MC Solaar correspond au fantasme du Black intégré que les médias ont envie de voir . . . ils avaient besoin d'un noir, ça y est, ils l'ont" [MC Solaar corresponds to the fantasy of the integrated black desired by the media . . . they needed a token black face, now they've got one] (*Black News* 1994: 7).

Whether or not the most successful rappers have sold out, they have certainly *sold*: leading exponents of francophone[7] rap can be expected to "move" upwards of 300,000 units and, in the case of MC Solaar (whose second album has now sold 900,000 copies worldwide) or IAM, the right album or single tops half a million sales, as was the case with "Je danse le Mia," *the* hit single of summer 1994. Figures available for 1993 show that even before the major success of IAM began to catch up with that of Solaar, rap represented a multimillion franc sector of the French recording industry (Blanchet and Plougastel 1993: 83). Successful nationwide tours undertaken by the top acts in 1994–5 filled larger and larger venues. Solaar's tour – sponsored by Pepsi, the radio station NRJ, and the television channel TF1 – featured a full-scale stage show choreographed by theater director Serge Aubry (but, showing touching faith in the origins of hip-hop, deejay Jimmy Jay stood placidly center-stage behind his twin turntables, getting records out of album sleeves), and filled the Zénith (Paris), which holds roughly 7,000 spectators, for three nights running. It attracted (at least on the night I attended in Pau) an incredibly young audience who chanted along with every word and

clearly idolized France's first black superstar. Both Solaar's and IAM's tours featured local rappers and hip-hop crews as supporting acts, indicating clearly that hip-hop had by now moved from the *banlieues* of Paris and the other major centers to practically every corner of France.

Thanks to its obvious profitability and growing mass appeal, hip-hop became the sound track to ads for products as varied as Pépito biscuits and the Renault Clio. Commodities more directly associated with hip-hop have seen their sales grow significantly, particularly sportswear, leading to advertising deals between bands and manufacturers such as Reebok (IAM) and Adidas (Suprême NTM). Commodification takes a further form: the "star quality" of MC Solaar has seen attempts to market his image in the cinema, with over fifty offers of film roles, and the cinematic success of Kassovitz's *La Haine* (1995), with an accompanying album of rap, further cemented hip-hop's presence in the mainstream cultural domain. Does the mass "crossover" audience now consuming the work of IAM and co. necessarily signify betrayal? Certainly it is a different audience, in terms of scale and ethnic composition, than that which purchases the fanzines and the self-produced, often vinyl (preserving the deejay's role) recordings of Da Lausz or Démocrates D. But it would be too simplistic to divide rap artists along a clear "authentic"/sellout line on the basis of sales or even presence on a major label.

Suprême NTM and Assassin, whose image or musical style have retained "hardcore" connotations, have nonetheless begun to sell around the 100,000 mark; Suprême NTM have been with Epic/Sony since 1990 and indeed their latest release – a 1996 single entitled "Est-ce la vie ou moi?" – received the kind of rotation on FM stations like NRJ that first launched IAM to prominence. Similarly, while "*autoproduction*" [independent production] has developed as a response to majors' attempts to package bands in a particular way or to add choruses to "uncommercial" tracks (as was the case with Da Lausz in their days as Les Little), it could hardly be argued to be somehow outside the commercial domain, either objectively (the independents do place commodities on the cultural market) or subjectively (Ménélik has complained vehemently that his hit "Quelle aventure," on the independent label Big Cheese, which is linked to Da Lausz's Mafia Underground, has been sold to any and every dance compilation that wanted it, and there has been a very clear attempt by that label to push Sté on the market as the first big female rapper).

IAM and Solaar seem to have developed a greater diversity in the musical style of French hip-hop, which in part explains their success: they sample a greater variety of artists and musics (jazz, Maghrebi instruments), rapping in a more flowing, less staccato style (perhaps more suited to the French language), and their

inventive wordplays have increasingly made cultural references to francophone musical sources – such as Boby Lapointe, Jacques Dutronc, Gainsbourg, and Renaud – rather than mimicking US styles and sounds. And while the fanzines and pioneers like Dee Nasty are perceived as the guardians of hip-hop values, successful rappers have used their influence and developed the notion of the posse in setting up their own labels or imprints (Jimmy Jay's Sentinelle Nord and IAM's Côté Obscur), which encourage other hip-hop talents to emerge.

So it seems that both the early pioneers and the recent successful artists show a desire to be defenders of hip-hop's values and to become "parrains" [godfathers] to the next generation of rappers. But what kind of values does hip-hop promote among youth in France? Can we begin to assess its impact in the *banlieues* and beyond? What are the meanings that young people of both minority and majority ethnic origin have found in its sounds and images?

"PROSE COMBAT":[8] RAP IDEOLOGY IN 1990s FRANCE

One important facet of any explanation is that rap represented the *"prise de parole"* [having your say] of submerged or repressed voices. Its very wordiness plus its immediacy and accessibility as a musical style meant that, as in New York in the 1980s, French *banlieusards* "seized and used microphones as if amplification was a life-giving source" (Rose 1994: 22). We can view rap in this sense as the oral equivalent of tagging's aggressive displays: the visual "I was here" of the *banlieusard* in transit through Paris is matched by the loud, gesticulating demands for attention of live rap performance.

The energy, anger, and resistance of US rap was certainly attractive to hip-hop fans in France, but it is important also to recognize the specific character of their appropriation of it. Resistance to racism's direct effects, to discriminatory policing, and to the problems of the "ghetto" are aspects of rap in France that have most closely drawn inspiration from US models and attention from the French media. Examples are drugs and delinquency (IAM's "L'aimant" 1993) or hostility to the police (Suprême NTM's "Nick la Police", a 1992 single), Ministère Amer's "Garde à vue" and "Brigitte, femme de flic" (1992), or Assassin's "L'état assassine" (*La haine* 1995).[9]

But it should also be pointed out that rap in France has, on the whole, picked up from the likes of Bambaataa a message of "positivity": the need for hip-hop to

encourage self-awareness and education as an alternative route to that of the "gangsta's" celebration of gang-on-gang violence. The prevalence of racist ideas in France and the impact of Le Pen, who is their most flagrant promoter in political life, have also attracted the fire of rappers: IAM refer to their shame at the "collaboration" of 25 percent of their fellow *Marseillais* with "l'envahisseur" [the (racist) invader] ("Mars contre-attaque" 1993); while Suprême NTM target the Front National on "Plus jamais ça" (1994), taking up the slogan of the Ligue Anti-Nazie, "Never Again."

But the ideological underpinnings of racism in France are also dissected and rejected: there is a vehement anti-nationalism, an explicit rejection of the integrationist "republican" model of "race relations" in France and of colonialist and imperialist attitudes, which shape French education, distort African and Maghrebi history, and reinforce economic domination. The following selections of lyrics are indicative of rappers' stances: "Ma seule patrie est mon posse" [My only nation is my posse] ("Kique ta merde": Assassin 1993); "Brûle l'état policier en premier / Et envoie la République brûler au même bûcher, ouais!" [Set the police state on fire / Dump the Republic on the same funeral pyre, yeah!] ("Qu'est-ce qu'on attend pour foutre le feu?": Suprême NTM 1994); "La CEE organise à travers l'application de ses institutions / L'appauvrissement des pays en voie de développement," [Implementing its institutions / The European Union / Condemns to poverty / All developing countries] ("Le futur que nous réserve-t-il?": Assassin 1993); "J'aurais pu croire en l'Occident, si / Tous ces pays n'avaient pas eu de colonies / Et lors de l'indépendance ne les avaient pas découpées comme des tartes / Aujourd'hui il y a des guerres à cause de problèmes de cartes" [I could've backed the line of the West / If their colonies and empires hadn't been oppressed / If independence hadn't meant being sliced up to order / Wars go on today over disputed borders] ("J'aurais pu croire": IAM 1993).

The rejection of colonialist narratives of history is accompanied by a revalorization of African civilization. In its most common version, IAM stands for "Imperial Asiatic Men," and refers to the origins of humanity in Africa and of "civilization" in both African and Asiatic empires. Whereas IAM's "concept" revolves to a significant extent around ancient Egypt, they are far from alone in deriving inspiration from the "terre-mère" [motherland]. This certainly parallels afrocentric tendencies in US rap, but it is also important to recognize the closer physical and therefore less mythical relationship of (black) rappers in France to the "pays d'origine" [homeland].

More importantly, the social situation of the *banlieues* in France today means that the solutions sought or offered by rappers are not the black nationalist or

separatist certainties of hip-hop's most radical elements in the USA. As we noted earlier, hip-hop in France is very clearly pluriethnic, reflecting the fact that the *banlieues* are "loin d'avoir l'homogenéité des ghettos américains" [far from having the homogeneity of US ghettos] (Blanchet and Plougastel 1993: 84), and although the term "ghetto" is employed in hip-hop circles in France, it is a social ghettoization to which it refers, since the *banlieues* contain plenty of poor whites.

Discussions of identification along class lines among youth in France traditionally involve electoral or opinion poll statistics concerning voting for the French Communist Party (PCF). Such analyses (for example, one by sociologist François Dubet 1990: 11) usually postulate that hitherto "integration" of immigrant working-class youth was achieved via the workplace, trade unions, and the PCF. It is therefore assumed that in today's supposedly "post-industrial" *banlieues*, the atomized "underclass" remnants of the once-mighty French proletariat have dissolved into ethnic factions very much approximating US ghettoized divisions.

Hip-hop's openly celebrated unity, its "Alliance Ethnik," almost automatically calls into question such notions. Certainly, among rappers there is no love for the traditional political forces of the left, its fourteen years in office (1981–95) having proven rather disappointing: "Nous, la gauche, on l'a vue à l'oeuvre" [We've seen the left at work] (Suprême NTM, quoted in Piot 1993: 61). Nevertheless, representatives of hip-hop in France have adopted increasingly militant stances, which range from Solaar's casual denunciations – "Ce monde est caca, pipi, cacapipitaliste / Ils augmentent les prix, en tirent les bénéfices" [What is this world? This capisstalist shitstem / They raise the prices, reap the benefits] ("Matière grasse contre matière grise" 1994) – to Suprême NTM's increasingly enraged calls for righteous violence against oppression, and to the openly revolutionary approach of Assassin (they were recently featured on the cover of the fanzine *Down With This* (1995) brandishing Marx's *Civil War in France*): "Le drapeau de l'unité est planté dans le 18e / Emportant dans son flot des posse par centaines . . . Alliance d'idées, alliance de cultures / Le métissage est notre force, cette force le futur" [The flag of unity is planted in the 18th *arrondissement* / In its wake leading posses by the hundred . . . Alliance of ideas, alliance of cultures / This mixing is our strength, our strength is the future] ("Kique ta merde," "Peur d'une race" 1993).

These expressions of collective identity and resistance transcend the divisions that are ever more openly fostered by the French state (as in the hardline attitude and violent repression adopted towards the "sans-papiers," a group of undocumented immigrants on a hunger strike in summer 1996) and place French hip-hop

well in advance of the forces of the official left, which have traditionally been seen as the yardstick of class identification. While it would be foolish to overestimate the impact of this youth movement on France, given the persistent vote of 15 percent and more for Le Pen, clearly it does represent a significant potential barrier to further inroads by the forces of the fascist extreme right among a consequential proportion of disenfranchised youths of majority ethnic origin. Hip-hop's increasing presence in mainstream cultural life in France means that it clearly represents far more than the dismissive tag of "sous-culture ethnique" [ethnic subculture] placed on it in Dubet's (1987) work, and has the potential to raise the colors of the "flag of unity" way beyond its initial audience in the *banlieues*.

NOTES

1 In Dee Nasty's album, *Paname City rapping* (1984), "Paname" is a slang term for Paris. "B-boys" is a commonly used name for (male) fans of hip-hop, both in France and the United States. I am retaining the French terms "*banlieues*" and "*banlieusards*" in this chapter, since they clearly have directly opposed connotations to their literal translations in English, "suburbs" and "suburbanites": see above, p. 12. Thanks to Eliane Meyer for her assistance with the translations from the French.

2 *Adventures on the wheels of steel*, by Grandmaster Flash and the Furious Five (1982). The wheels of steel are the twin turntables central to the deejay's art of mixing and scratching.

3 Ragga, which is a contemporary Jamaican cousin of rap, is an evolved, faster form of reggae; its development lies outside the scope of this chapter.

4 For a definition of this term, see below, p. 156.

5 By the early 1990s, "zoulou" was merely a media euphemism for black gangs, indicating the declining influence of the Nation "proper." Recently, Dee Nasty and DJ LBR have proposed refounding the Nation on a less "dictatorial" footing.

6 [Money corrupts people, that's my feeling], from Suprême NTM's rap "L'argent pourrit les gens" (1991).

7 The word "francophone" is often used to distinguish French-speakers originating outside France from those of majority French descent. In this chapter, "francophone" is to be understood as embracing any expressive use of French, regardless of the performer's origins, as distinct from usage of other languages.

8 MC Solaar, *Prose combat* (1994).

9 The state has responded to these assaults: at the time of writing, legal proceedings against Ministère Amer are pending over their song "Sacrifice de poulets" on the soundtrack of *La haine*, while in November 1996 prison sentences of six months and fines of Fr50,000 were handed out to Kool Shen and Joey Starr of NTM by a court in Toulon for "outrages par paroles à l'égard de l'autorité publique" [verbal defamation of representatives of the state], in insulting police at a concert in La-Seyne-sur-Mer in the Var in 1995. It is no accident that this savage sentence was meted out in Toulon. The concert at which the offending words were uttered had been organized to protest the election of a Front National candidate as mayor of the city. The FN has vigorously attacked hip-hop in France and the mayor was instrumental in banning NTM from a summer festival in Toulon (*Le Monde* 1996).

REFERENCES

Printed sources

L'Affiche (1994) Two-part dossier on "Rap français: la revanche de l'underground," no. 19, November, pp. 16–21; no. 20, December, pp. 20–5.

Bachmann, Christian, and Luc Basier (1985) "Junior s'entraîne très fort, ou le smurf comme mobilisation symbolique," *Langage et société*, no. 34, December, pp. 57–68.

Bazin, Hugues (1995) *La culture hip-hop*, Paris: Desclée de Brouwer.

Bédarida, Catherine (1995) "Une 'culture des cités' se développe contre l'exclusion," *Le Monde*, May 11.

Black News (1994) Interview with Le TRIBU, no. 11, October.

Blanchet, Philippe, and Yann Plougastel (1993) "Y-a-t-il en France un effet Malcolm X?/Le Rap en France à l'heure de X," *L'Evénement du jeudi*, February 18–24, pp. 82–6.

Cachin, Olivier (1996) *L'offensive rap*, Paris: Gallimard.

Chambers, Ian (1985) *Urban Rhythms: Popular Music and Popular Culture*, London: Macmillan.

Cissé, Sylvère Henri, and Jean Callens (1992) *Rap en Nord*, Lille: Miroirs Nord/Pas-de-Calais.

Desse [Bardin, Desdémone] and SBG [Bardin-Greenberg, Sébastien] (1993) *Freestyle*, Paris: Massot & Millet.

Down With This: fanzine hip-hop français (1994) no. 4.

────── (1995) no. 6.

Dubet, François (1987) *La galère: les jeunes en survie*, Paris: Fayard.

────── (1990) "Le virus américain," part of a special dossier entitled "Faut-il avoir peur des bandes?" in *Le nouvel observateur*, August 9–15, pp. 10–11.

Hager, Steven (1984) *Hip Hop: The Illustrated History of Breakdancing, Rap Music and Graffiti*, New York: St Martin's Press.

Hebdige, Dick (1987) *Cut 'n' Mix Culture: Identity and Carribean Music*, London: Methuen.

Lapassade, Georges, and Philippe Rousselot (1990) *Le rap, ou la fureur de dire*, Paris: Loris Talmart.

Le Monde (1996) "Les chanteurs de NTM condamnés à la prison ferme pour outrage à la police," November 16.

Narlian, Laure (1995) "Face à face: IAM/NTM," *Les Inrockuptibles*, no. 7, April 26–May 2: pp. 18–23.

On a faim! (1994) anarchist fanzine accompanying the compact disc *Rhythms against Racism*, no. 18, Winter.

Piot, Olivier (1993) "La rébellion du rap," *Le monde de l'éducation*, September, pp. 58–61.

Prévos, André J. M. (1992) "Transferts populaires entre la France et les Etats-Unis: Le cas de la musique rap," *Contemporary French Civilization*, vol. 16, no. 1, Winter–Spring, pp. 16–29.

Rose, Tricia (1994) *Black Noise: Rap Music and Black Culture in Contemporary America*, Hanover, NH: Wesleyan University Press.

Tate, Greg (1992) *Flyboy in the Buttermilk*, New York: Simon & Schuster.

Toop, David (1991) *Rap Attack 2: From African Rap to Global Hip Hop*, London: Serpent's Tail.

Zekri, Bernard (1994) "Quand un journal visite l'histoire: 15 ans de rap . . . ," *Actuel*, no. 48, December, pp. 87–8.

Selected discography

Assassin (1993) *Le futur que nous réserve-t-il?*, Delabel.

Compilations: *Rapattitude* (1990) Virgin, *La haine: musiques inspirées du film* (1995), Delabel.

Dee Nasty (1984) *Paname City rapping*, Funkzilla (deleted).

IAM (1993) *Ombre est lumière*, Delabel.

Lionel D (1991) *Y a pas de problème*, CBS/Squatt (deleted).

MC Solaar (1991) *Qui sème le vent récolte le tempo*, Polydor.

────── (1994) *Prose combat*, Polydor.

Ministère Amer (1992) *Pourquoi tant de haine?*, Musidisc.
Suprême NTM (1991) *Authentik*, Epic/Sony.
———— (1994) *Paris sous les bombes*, Epic/Sony.

PART IV
VISUAL ARTS

MÉTISSAGE IN POST-COLONIAL COMICS[1]

Mark McKinney

INTRODUCTION: POST-COLONIAL COMICS IN FRANCE

In the late 1970s and early 1980s, a new force emerged on the French-language comics scene. Maghrebi-French cartoonists raised in France by immigrant parents – cartoonists such as Farid Boudjellal, Larbi Mechkour (Mechkour and Boudjellal 1985), Rachid N'Haoua, Rasheed and Sabeur D. (also known as Sabeurdet) (*El building* 1994) – began to bring a distinctively post-colonial voice to this popular cultural form. In March 1985, the Centre Culturel Algérien (1992) in Paris held an exhibition on comics that brought together these new artists alongside well-known Algerian cartoonists such as Kaci (1994), Saladin (1979) and Slim (1995, 1996).[2] The new Maghrebi-French artists' talent gained recognition in main-stream French society: for example, in 1987 Boudjellal was featured on the cover of *Le Point* – along with other rising Beur[3] stars – and his comic book *Ramadân* (Boudjellal 1996b) won the "Résistances" prize (sponsored by *Témoignage Chrétien*; the jury was presided over by Danielle Mitterrand) at the Angoulême national comics festival in 1989. The post-colonial tide in comics also included the Caribbean artist Roland Monpierre who has published comics on Caribbean-related themes (Monpierre 1986, 1988).[4] Monpierre was a member of the ground-breaking comics-producing trio known as Anita Comix, whose other members were Farid Boudjellal and José Jover (Anita Comix 1984).

Certain key groups and ideological currents in France have been especially stamped by colonialism, the resistance to it, and its aftermath: *pieds-noirs*, *harkis*, people of majority ethnicity who actively oppose(d) racism and colonialism, as

well as Third World immigrants from France's (ex-)colonies and their offspring.[5] There are now actively publishing cartoonists from almost all these groups. In fact, a great many comic books are available in France today that could fall under the category of "post-colonial comics" (authored mostly by ethnic majority authors, but also by minority artists, such as those mentioned above). Rather than attempting to provide a general survey of them, I will restrict my analysis to one particularly revealing aspect: *métissage*, which is to say ethnic, "racial", and cultural mixing or hybridity. Mixed couples and *métis/ses* as characters, and interethnic friendships between characters are significant post-colonial tropes and motifs found in many comic books. They are often inflected differently according to the perspective of the cartoonist(s) on France's colonial history and its current post-colonial hybridity. In turn, this outlook often varies according to the cartoonist's general political, philosophical or social outlook, which may be influenced by his or her ethnic identification.

I analyze here five important approaches to *métissage* in post-colonial comics: (1) as (neo-)colonial erotic encounter between dominant First-World and subaltern Third-World characters; (2) as nostalgic *pied-noir* foundation myth; (3) as a trope for representing anti-colonialism during the wars of decolonization, and then post-colonial reconciliation between former enemies; (4) as an unattainable dream for certain marginalized groups of post-colonial immigrants or ethnic minorities in contemporary France; (5) as the normal but conflictual process of cultural integration for France's post-colonial minority ethnic communities. The ability of *métissage* to figure all of these different neo- and post-colonial perspectives says something about its malleability and current importance as a trope to signify intercultural relations and a perspective on colonialism. This polyvalence of *métissage*, or hybridity, was also observed by Ella Shohat and Robert Stam (1994: 41–6), who have argued that it is power-laden, asymmetrical, and cooptable, that it can be conscious or unconscious, and that its agency today is problematic to the extent that its contemporary forms are indebted to colonial violence.

Contemporary French discourses on *métissage* have their roots in colonial violence and ideology, specifically French ideologies of assimilation and racial separation.[6] Acrimonious debates about French national identity and the far right's related successful efforts to propagate and give credibility to racist notions in public and private discourse have meant that various issues related to *métissage* remain at the forefront of current concerns, politicking, and legislation: the integration of Third World minorities whose original cultures are thought to be incompatible with "French" culture, so-called "mariages blancs" [marriages of

convenience] between French nationals and foreigners, sexualized racial panic about males of color, and so on. One minority activist has even argued that French discourse in the 1980s about *métissage* was calculated to dilute demands for greater minority rights and a recognition of the already existing multicultural reality of France (Bouamama 1994: 118–24).

COLONIAL ENCOUNTERS: THE "EROTICIZATION OF THE EXOTIC"[7]

In an article on colonial and post-colonial French cinema, Dina Sherzer argues that a "double standard" was at work in cultural forms and works in metropolitan France during the colonial era: "They presented negative images of interracial relationships while at the same time suggesting the attractiveness of exotic sexual encounters." Today it is still "possible and desirable for financial reasons to titillate spectators with old taboos," including the one against mixed-race couples (Sherzer 1996: 230–8). Another critic, Rachel A.D. Bloul, analyzed – in political cartoons and discourse about young Maghrebi-French women – the "phallic strategies of the eroticization of difference which transform French colonial desire into an enterprise of postcolonial seduction" (Bloul 1994: 122). Comics are thus a field of contemporary cultural production in which old colonial taboos coexist alongside new forms of "postcolonial seduction."

In most French-language comics where romantic or sexual liaisons occur between European characters and (post-)colonial others, the foreign partner is generally a woman serving as an exotic/erotic partner destined to be unthinkingly cast off by the male protagonist when wanderlust seizes him or when he must return to the (ex-)colonial center.[8] In such comics there is an "eroticization of the exotic" (ibid.) that "does not shift frontiers in inter-ethnic image-making, but merely recycles them" (Nederveen Pieterse 1992: 209). By contrast, the most innovative comics are those that attempt to read the colonial past, decolonization, and the history of immigration against the grain.

Even in comic books that attempt to critique (neo-)colonialism and racism, women of color seem to serve principally as the white male protagonist's sexual partner, and to titillate the male reader/voyeur. This is the case in Jean-Louis Tripp's *Zoulou Blues* (1987), an otherwise interesting story that links anti-Arab racism in Toulouse with apartheid in South Africa. It is also true in Warnauts and Raives's *Lettres d'outremer* (Warnauts and Raives 1996), where a denunciation of

(neo-)colonialism in Guadeloupe plays second fiddle to the French protagonist's erotic adventures with a black West Indian woman. On the other hand, despite a certain voyeurism of its own, Pierre Christin and Annie Goetzinger's *La voyageuse de petite ceinture* (1985) furnishes a biting critique of *métissage* as an "eroticization of the exotic" and "an enterprise of post-colonial seduction." In it, Naïma, a young woman of Algerian heritage, is reduced to working as a prostitute for one night. She finds herself in a (post-)colonial bordello, adorned with colonial-era posters, staffed by women of color (Maghrebi, Asian, black) and run by white Frenchmen who spout a cynical discourse about *métissage* (Plate 10.1).

FOUNDING THE NATION THROUGH MÉTISSAGE: "FRENCH ALGERIA"

In an insightful article on French comics set in the Maghreb, Kacem Basfao wonders if one should see in them a neutral "representation of colonialism" that simply results from an attempt to accurately depict the colonial period, or if they might be characterized as presenting a "neo-colonial vision." He draws the conclusion that in these books there is no clear break between a colonial and a post-colonial representation of France's conquest of the Maghreb (Basfao 1990: 231). The representation of the colonial period is the main subject of several of Jacques Ferrandez's comics (1994a, b, c, d, 1995), which have been widely celebrated for providing a complex vision of France's colonial history in Algeria (e.g. Khamès 1995). Ferrandez is a *pied-noir* in the sense that he was born in Algiers in 1955, although he grew up in Nice (Gaumer and Moliterni 1994: 243). He based his five-volume series "Carnets d'Orient" on a wealth of historical and artistic sources, including his own family history. In a very tangible way, Ferrandez's work is aimed at preserving his family's memory and a *pied-noir* ethnic heritage, as he states in one of his comic books: "Tout cela, je ne voulais pas le laisser perdre" [I did not want all of that to be lost] (Ferrandez 1994c: 14–15).

In the final analysis, Ferrandez's project consists of attempting to represent moments when, for him, a genuinely coequal relationship between European colonizers and Algerians was possible and might have allowed for the creation of an egalitarian multicultural society, and thereby the perpetuation of the French presence in Algeria. *Carnets d'Orient*, the first volume of Ferrandez's comic book saga – an epic history of "French Algeria" – is clearly based on Eugène Delacroix's visit to Algiers in 1832. Various textual elements recall this event, but key among

Plate 10.1 Multiculturalism in a neo-colonial optic: women of color work as prostitutes in a Parisian bordello

From Pierre Christin and Annie Goetzinger, *La voyageuse de petite ceinture*, 1985, p. 40. © Humano SA, Genève – Les Humanoïdes Associés

them is the visit that Joseph Constant, the painter protagonist, pays to the same harem that Delacroix is supposed to have visited in Algiers (Ferrandez 1994a: 18). There Joseph becomes instantly infatuated with Djemilah, an Algerian woman. This inaugural moment, when Joseph virtually ravishes an Algerian woman right under the nose of the Algerian port master, is later memorialized by Joseph in an orientalist painting.

In Djemilah, we can recognize one of those historical and literary women who mediated between invading European colonizers and the colonized: figures such as Pocahontas or Malinche (Malintzin) in the Americas who often play strikingly different roles for different "interpretive communities." Such racial mixing can be read in radically divergent ways: by the (ex-)colonizers as a romantic "Westerniz-ing narrative" – as a national foundation myth – or by the (ex-)colonized as "a strategy for survival" (Shohat and Stam 1994: 43–4). In "Carnets d'Orient," Djemilah and Joseph's romance attains the status of foundation myth, anchors the rest of the five-volume epic, and legitimates the presence of the French in Algeria. However, Ferrandez's portrayal of colonialism is more complex than this might suggest. In his effort to find Djemilah, Joseph becomes a renegade: he immerses himself in Algerian culture and joins up with Abdelkader's resisting forces for a time. Although Ferrandez's revisionist approach to the French conquest of Algeria was generally very well received in the press, it apparently scandalized some readers: *Carnets d'Orient* was panned in the far-right newspaper *Présent* as a comic book that "insults French Algeria," and Ferrandez himself was labeled a "renegade" by the outraged reviewer (Elbe 1987).

At the end of "Carnets d'Orient," we know that despite Joseph's "constancy" his union with the lovely Djemilah is sterile and cannot redeem colonial society. The series ends with *Le cimetière des princesses* [The Princesses' Cemetery] (Ferrandez 1995),[9] in which a cemetery (where Joseph and Djemilah are said to have been buried) and an earthquake allegorically refer to the impending traumatic death of the settler colony in the coming war of independence, which is not directly portrayed. Ferrandez's placing of his fictive mixed couple at the conquest of Algeria is significant, for it allows him to found his epic on a mythical union of two peoples, the French and the Algerians. At the same time, the absence of a mixed couple at the end of the series points to that myth's implausibility in the light of the approaching Algerian war.

TRAITORS TO THE NATION

In the comic books studied in this section, the decision to situate the mixed couple, not at the conquest, but rather during the war of liberation signals a different viewpoint on history: not that of the colonial settlers who have now assimilated in France and look back with nostalgia to a bygone era, but rather a leftist majority viewpoint or a post-colonial minority one. From these alternative perspectives, the emphasis is less on the mourning or commemoration of colonial society, than on exploring the reasons for the (incomplete) break with the colonial era and its sequels today (such as the continuation of the Algerian war through racist attacks on Maghrebis in France). In the relatively rare French comic book stories that do look unflinchingly at the Algerian war, the mixed French-Algerian couple's difficulties in remaining together symbolize the conflict between national communities. For example, there is an open recognition of the rupture in French and Algerian relations in Farid Boudjellal's "Amour d'Alger" (1984), a four-page comic that shows the immense pressure on individuals, even children, to take sides in the Algerian war. In it, Ramdane, a young Algerian boy, is the friend of Mireille, a French girl. Although the two children would like to remain together, they are surrounded by forces that conspire to keep them apart.

A similar situation exists in a comic book by Baru (art) and Jean-Marc Thévenet (scenario), entitled *Le chemin de l'Amérique* (published in translation as "The road to America" 1995, 1996), which shows the difficulties of its main character, an Algerian boxer named Saïd Boudiaf, who wishes to fight only "on the side of boxing" (1995: 14). However, it becomes extremely difficult for him to maintain his position of neutrality when he starts to date a Frenchwoman who is secretly helping the Algerian Front de Libération Nationale (FLN). Boudiaf must finally choose sides at the end of the story, when he is a witness to the organized police killings of October 17, 1961, in which over 200 Algerians are believed to have died.

If we turn now from Algeria to South-East Asia, the site of other French colonies and a colonial war in which France was defeated, we find some compelling comic books that use mixed couples and *métis/se* characters to examine the colonial past and the (post-)colonial present. Such is Marcelino Truong and Francis Leroi's *Le dragon de bambou* (1991), which plots the coordinates of a nascent power struggle for the control of Vietnam: the French colonial administration, assisted by Vietnamese organized crime, is pitted against Nguyen Ai Quoc (i.e. Ho Chi Minh) and his followers. The book's "retro" atmosphere and its images of 1920s French Indochina – for example, exploitative rubber plantations, decadent French colonial society, and Vietnamese anti-

colonial fighters disguised as a traveling theater troupe – found an echo in Régis Wargnier's subsequently released film, *Indochine* (1992). However, a significant difference between the comic book and the film is the book's more critical take on French colonial society. This discrepancy is evident in the different treatments by film and comic book of the *métis* offspring of a French soldier father and a Vietnamese mother. In *Le dragon de bambou* Marcel Clément-Rivière is a young *métis* artist living in Saigon. He joins up with some aristocratic French dissidents attempting to launch *Combat Indochinois*, an anti-colonialist newspaper. Yet although his anti-colonial sentiments are fueled by French racism directed against him as a *métis*, his loyalties are divided beween the political struggle and an attachment to French ways. Marcel's bicultural dilemma is figured through his attraction to Yvonne, a rich French woman who alternately entices and rejects him, and his conflicting prior attachment to Liên, a young Vietnamese peasant woman who still loves him. Yvonne's eventual marriage to a gold-digging French soldier seals Clément-Rivière's commitment to the nationalist struggle and frees him to rejoin Liên.

Viet Nam's separation from France is also the subject of the two-volume *Les oubliés d'Annam*, by Lax (art) and history teacher-turned-cartoonist, Frank Giroud (scenario) (1990, 1991), in which the return to the colonial period takes the form of a quest for truth about an important aspect of France's colonial history that is suppressed today: the fact that some French soldiers deserted the French army in order to collaborate with the Vietnamese liberation forces, led by Ho Chi Minh. Lax and Giroud's approach to the historical record resembles that of the American cartoonist Jack Jackson, whose comics depict the history of Texas and Native Americans in a new way, by "tell[ing] stories left out of the officially approved consensus versions of America's history" (Witek 1989: 61). Lax and Giroud's artistic treatment of France's troubled memory was remarkably prescient: less than six months after the first volume's publication, the "Boudarel Affair"[10] made headlines and provoked much debate and soul-searching about the colonial past (Personal interview 1996; Dupuis n.d.).

In *Les oubliés d'Annam*, French soldier Henri Joubert deserts and joins the Viet Minh liberation forces; he then marries a Vietnamese woman, who gives birth to a girl, Kim-Chi. The latter is a *métisse*, whose very existence suggests a fragile but real, anti-hegemonic union of the two peoples during and beyond the colonial period, and is tangible proof in the present that a suppressed history of French anti-colonialism existed. Henri Joubert is a figure of redemption: his treason to France and the fact that he is part of a mixed couple allow for a positive link to the (ex-)colonized. He differs from Ferrandez's Joseph Constant because he does

not represent the justification of France's presence in the colonies, but instead a legacy of resistance – which is continued by Nico Valone, the journalist who unearths this history of anti-colonialism, keeps its memory alive, and continues the struggle in the present. Moreover, Valone renews a connection with Viet Nam, in part by bringing the *métisse* Kim-Chi to France, where she meets her French grandmother (Plate 10.2). Their encounter symbolizes the reconciliation of the former colonizers and colonized.

Another French look at the West's colonial wars against the Vietnamese is to

Plate 10.2 The *métisse* as a figure of post-colonial reconciliation: Kim-Chi meets her French grandmother
From Lax and Giroud, *Les oubliés d'Annam*, vol. 2, Marcinelle: Dupuis, 1991, p. 37. ©
Lax & Giroud/Editions Dupuis, 1991

be found in "The murderer of Hung" (1991), a short comic by Dominique Grange (scenario) and Jacques Tardi (art). Here, the protagonists are Nguyen Thi Loan, a Vietnamese woman, and Jerzy Kupinsky, a Polish immigrant friend. The pair search New York City for Cliff Brixton, a former Marine, who had raped Nguyen in front of Hung, her four-year-old son, and then murdered the boy. Now, years after the Vietnamese war, Nguyen seeks to kill Brixton in revenge. However, when they finally track down Brixton in the Bowery, Kupinsky convinces Nguyen to let him go, because as an amputee and an alcoholic, "the swaggering Marine was now a total wreck" (Grange and Tardi 1991: 215). In both *Les oubliés d'Annam* and "The murderer of Hung" there is an attempt made to avoid "imprisonment within colonial dreams," and instead to replace imperialist nostalgia with "a growing recognition of the death of empire" (Stora 1993: 101). Moreover, the colonial past is finally brought home, as it were, through the presence of post-colonial minorities within the former colonizer's countries: Nguyen Thi Loan lives in New York City, and Kim-Chi goes to France.

BARRIERS TO *MÉTISSAGE*: "ABDULAH'S EVENINGS"[11]

Immigrants may be characterized as "socio-cultural voyagers caught in situations of transit" (Certeau 1986: 12). Single male immigrant workers are often depicted as an "enjeu sexuel" [sexual stake] of French society (Jay 1988: 4): as sexual menace, the hapless prey of sexual predators, or lonely and sexually deprived. The latter is the case of Abdulah, in Farid Boudjellal's early "Les soirées d'Abdulah" (first published in 1979; reprinted in 1996b; cf. Douglas and Malti-Douglas 1994: 201). A prostitute is the only person to offer any substantial sign of friendship to Abdulah, who wanders in the margins of French society. In two other comic book stories, *harkis* are represented as occupying the margins of French society alongside solitary immigrant workers. In the recent *Nègres jaunes* (Alagbé 1995) the sequels of the Algerian War are apparent in a *harki*'s loneliness and (sexual) alienation, which leads him to prey on two undocumented West African workers, Martine and Alain. Just after Alain reluctantly decides to marry his French girlfriend, Claire, to obtain French nationality papers, he is arrested and, we surmise, risks being deported. A different type of mixed couple may be found in "Vengeance harki," by Denis Merezette (art) and Boudjellal (scenario) (1994),

where a man whose family was massacred by *harkis* takes vengeance against the murderers by seducing the daughter of one of the *harkis*, who had moved to France. In these comics, social and historical pressures such as racism, socio-economic exploitation, and colonial violence conspire to reify relationships, break up mixed couples, and render *métissage* impossible.

In *L'autoroute du soleil* (1995), an award-winning comic book (it received the Alph'art prize for the best French-language comic book at the 1996 Angoulême festival) first published in Japan, Baru manipulates the "eroticization of the exotic" Maghrebi male. Baru, a cartoonist whose full name is Hervé Barulea, was born in 1947 to a Breton mother and an Italian father in a Lorraine working-class town. In an interview (Personal interview 1996), he said that for a long time his Breton mother was the victim of vicious prejudice because she had married an Italian, a foreigner. With that in mind, he described the "integration" of minorities as "une violence faite à quelqu'un" [violence done to someone]. His personal history informs his philosophical outlook on life, as well as his comics: "On est condamné au métissage, et je pense que ça devrait être le but de l'humanité. Mais en tout cas, tous mes bouquins font l'éloge du métissage" [We are condemned to *métissage*, and I think that it should be the goal of humanity. But in any case, all my books are in praise of *métissage*]. Although Baru's mixed ethnic origins are not directly linked to the former empire, he feels considerable empathy for France's post-colonial minorities and many of his comic books portray French characters of Algerian heritage.

In *L'autoroute du soleil*, the Maghrebi-French character Karim Kemal and his admiring teenage sidekick, Alexandre Barbiéri (Plate 10.3), are ruthlessly pursued by Dr Raoul Faurissier, the sadistic and increasingly deranged local leader of a fascistic political party, the Elan National Français. Faurissier's name no doubt alludes to the revisionist French historian Robert Faurisson, as some reviewers observed (e.g. Delcroix 1995), just as the Elan National Français corresponds to the Front National (FN). In his working-class Lorraine neighborhood, Kemal has a bad reputation as a gambler, an AIDS-infected seducer of women, a gigolo and a drug-dealer (Baru 1995: 6–7), which gives him an aura as a romantic outlaw. This erotic charge comes mainly from Kemal's marginal position in French society. Faurissier begins to chase Kemal after he catches the young man having sex with his own wife, whom Faurissier later kills because of her infidelity. The transgression of the taboo against miscegenation triggers Faurissier's descent into a murderous and suicidal insanity, and the young men's flight.

Plate 10.3 Fleeing from racists after breaking the taboo against miscegenation: Karim Kemal on the road, with Alexandre Barbiéri riding behind
From Baru, *L'autoroute du soleil*, Tournai: Casterman, 1995, p. 19. © Baru/Kodansha Ltd, Tokyo

THE DILEMMA OF CULTURAL MIXING: FARID BOUDJELLAL'S COMICS

As we have seen, mixed couples, *métis/se* figures, and interethnic friendships are recurrent tropes in post-colonial comics in France. They occupy a central place in Boudjellal's comics; for this reason, and because Boudjellal is the most published French cartoonist of post-colonial minority origin, I devote the last section of this chapter to a discussion of his comics. His books are now published by his brother Mourad, who estimated in 1996 that his Toulon-based comics publishing house, Soleil Productions, was the fifth largest in France (Dassonville

1996).[12] Boudjellal was born in Toulon in 1953 of Algerian parents. His father, whose own mother was Armenian, grew up in a Christian tradition; on the other hand, Boudjellal's mother was raised a Muslim (Personal interview 1995; Gaumer and Moliterni 1994: 86). Boudjellal himself married a Frenchwoman of Italian heritage. This personal experience of *métissage* no doubt helps to inform his treatment of it in his art.

In Boudjellal's comics, *métis/se* figures – Linda (1996b: 153), Charlotte-Badia (1995), Moussa and Mathieu (1995), and Djilali (1996b: 80) – help to mark the boundaries of community. Chronologically within the story time, the first *métis* child in Boudjellal's comic book Slimani family would have been that of Latifa (1996b: 86, 91, 103, 147), the eldest daughter, who committed suicide rather than face her father's anger over her illegitimate pregnancy by a French boyfriend. She symbolizes a tragic first attempt by a member of the second generation – and, significantly, by a woman – to negotiate between two ethnic communities, and the fact that at least some degree of *métissage* is unavoidable, despite all attempts to maintain "racial," cultural, or ethnic homogeneity. It is significant that Latifa's death occurred prior to the beginning of Boudjellal's narrative (1996b), because it founded, for her younger sisters, possibilities of greater freedom from parental control, of cultural *métissage*, and of mixed relationships (although these three things are not necessarily linked).

Djilali, the son of an Arabic father and a French mother, is another key *métis* figure in Boudjellal's work (Plate 10.4). His ethnic and sexual/gender ambiguity, drug use, irresponsibility, and anti-conformist friends (1996b: 79–81, 101, 108, 120–1, 137) all mark Djilali as an example of ethnic and cultural *métissage* as alienation and troubling indistinction. Nevertheless, through his liminal position he plays a key part in signaling the boundaries of family and thereby the limits of ethnic identity and of the Maghrebi-French community, from which he is ultimately excluded (1996b: 154).

The oscillation between the positive and negative poles of *métissage* is apparent in Boudjellal's *Jambon-Beur: Les couples mixtes* (1995). There, two mixed couples give birth to a total of three *métis* children. Djamila and René's twin sons, Moussa and Mathieu, are mirror opposites of one another: Moussa is white (he looks like his Algerian-French mother) and plays with black children, while Mathieu is black (he looks like his Senegalese(-French?) father) and plays with white children. Although cultural, racial, and ethnic mixing pose no difficulties to the twins, who represent Boudjellal's playful configuration of what are often considered to be the opposite terms of a binary pair, a much more painful dimension of the overdetermination of *métissage* (Taguieff 1987: 343) is represented by Charlotte-

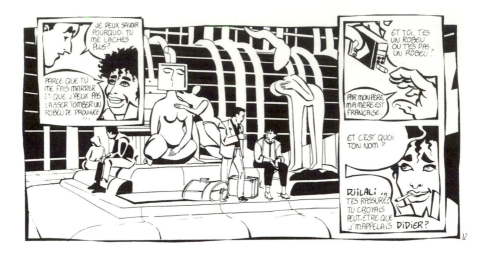

Plate 10.4 Testing the contours of Beur identity through the figure of the *métis*:
Nourredine meets Djilali
From Farid Boudjellal, *L'oud: La trilogie*, Toulon: Soleil Productions, 1996, p. 80. © Soleil
Productions

Badia, the child of Patricia Barto and Mahmoud Slimani. Unresolved memories
of the Algerian war lie behind Charlotte-Badia's identity crisis: Fabien, her French
maternal grandfather, was killed in Algeria shortly after her mother's birth, and
her Algerian paternal grandfather was wounded in the war. The result is that the
three surviving grandparents still harbor pain and resentment.

Faced with the double burden of cultural mixing and family animosities
deriving from the Algerian war, nine-year-old Charlotte-Badia splits into two
separate characters, Charlotte and Badia (Plate 10.5) (1995: 27). The cultural and

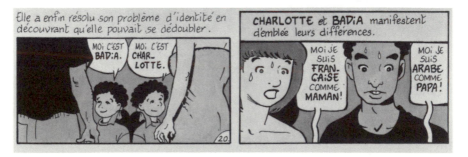

Plate 10.5 The Algerian war wreaks havoc on the *métisse* and her parents: Charlotte-Badia
splits in two
From Farid Boudjellal, *Jambon-Beur: Les couples mixtes*, Toulon: Soleil Productions, 1995,
p. 28. © Soleil Productions

ethnic mixing symbolized by Charlotte-Badia's hyphenated name, chosen by her parents as a compromise designed to placate the grandparents (1995: 15), suddenly decomposes into an irreconcilable "schizoid" pair (Shohat and Stam 1994: 43). *Jambon-Beur: Les couples mixtes* suggests that cultural difference is not an obstacle in itself to *métissage*, as cultural essentialists would argue. Rather, the difference between *métissage*'s positive pole, represented by Moussa and Mathieu (in Taguieff's terms, "the one and the other"), and its negative pole, in the form of Charlotte and Badia ("neither the one nor the other", Taguieff 1987: 345) should be attributed to concrete social conditions, informed by historically derived antagonisms between the French and the Algerians.

In order for Charlotte-Badia to piece together her two halves, her grandparents must be reconciled and their differences laid to rest. This occurs at a birthday party, where the bickering family members finally discuss the Algerian war and the traumatic experiences engendered by immigration, especially Latifa's death (1995: 53). We understand that Charlotte-Badia can once again become whole when we see her two selves looking on at her/their grandmothers, who are embracing for the first time ever (1995: 54).

Métissage's positive pole is illustrated by the front cover and title page of *Jambon-Beur: Les couples mixtes*. There, in a happy family portrait, Patricia and Mahmoud are shown holding hands, with Charlotte and Badia in front of them: Badia, wearing a Muslim headscarf, stands before Patricia, while Charlotte, in her Catholic communion gown, is in front of her father. This harmonious vision of *métissage* is duplicated by the title, which is a pun on food and identity, since "Jambon" means "ham" – a food that Muslims are forbidden to eat – and by extension refers to the mainstream French, a great many of whom do eat ham, for as Catholics they do not have this dietary restriction; on the other hand, "Beur" alludes to "butter" ("beurre" in French) and is a term often used to refer to a French Arab.[13] The hyphenated union of the two terms is both a "ham and butter" sandwich and the joining of an ethnic majority French person and a Beur: Patricia and Mahmoud. The title's typographical presentation, as "**JAMBON**-BEUR: *LES COUƊLES ⊙I𝒳TES*," is in the same playful vein: "Jambon" is colored black and in one type-face, "Beur" is red and in another one, and four letters in "couples mixtes" are in an altogether different font.[14] However, on the back cover we find a sad-looking Charlotte-Badia wearing a hand of Fatima and a cross – both were presents from her grandmothers (1995: 12).

CONCLUSION

In an interview (Personal interview 1996), Boudjellal said that this image of Charlotte-Badia wearing her two medallions originally was to have appeared on the front cover, as it did on the prospectus that he prepared for the publisher ("Couple mixte" n.d.). It finally did not occupy that position because the people to whom he showed it did not immediately perceive the symbolism of the medallions. The picture that finally did appear on the cover of the book is much more immediately "readable," in terms of cultural identity, no doubt largely due to the French media's stereotyped fixation on young women's headscarves as perhaps the most provocative sign of Muslim difference within France, of ethnic minority endogamy (that is, of the *absence* of mixed couples), and of women's oppression in Islam.[15] Charlotte-Badia never dons a headscarf within the comic book, though in order to provoke her French grandmother's family, Badia does say that she will wear one next year (1995: 36). The back of the author's prospectus shows an adolescent Charlotte-Badia, bare-headed, but in the published book the author apparently did not dare to look so far ahead into the girl's future. In this comic book it would appear that although the longing and hope for post/colonial vistas[16] no longer plagued by the weight of the colonial past exist and are symbolized by the possibility of Charlotte-Badia's regained wholeness, the latter is by no means a foregone conclusion. The comic book's front cover suggests at least one more reading of the story's ambiguous conclusion: in the future, Charlotte-Badia will remain split into her two halves (a Christian Charlotte in her communion garb and a Muslim Badia, veiled and wearing an Algerian dress), but they and their parents are smiling, implying acceptance of the two girls as members of one happy family. In fact, Boudjellal leaves the comic book's reader to choose between three portraits and their distinct implied (non-)resolutions of history's weight and *métissage*'s tensions: (1) the smiling and separated Charlotte and Badia on the front cover; (2) the single, unhappy Charlotte-Badia on the back one; and (3) the image of a single, smiling Charlotte-Badia attached to a family tree at which Patricia and Mahmoud are gazing at the comic book's conclusion (60–1). By leaving the narrative's outcome in his readers' hands, Boudjellal appears to suggest that the future shape of Maghrebi–French relations will also depend on them and what they make of a conflictual, but somehow shared, colonial past that exists still in the post-colonial present.

NOTES

1 I wish to thank especially Farid Boudjellal for his generous welcome and willingness to share his great knowledge of comics. My warm thanks also to the following artists who kindly agreed to be interviewed, share their insights, and show me their art work: Baru, Pierre Christin, Jacques Ferrandez, Annie Goetzinger, Frank Giroud, Kamel Khelif, Lax, Amine Medjdoub, Séra, Slim, Jean-Philippe Stassen. For their help I also thank all those who assisted me at Casterman, the Centre Culturel Algérien, Dargaud, Dupuis, Rackham, Z'éditions, Soleil Productions. Crucial research on this article was funded in part by an award from the Philip and Elaina Hampton Fund for Faculty International Initiatives and an Alumni Travel Grant (Miami University). Thanks to Valérie Dhalenne and to Alec G. Hargreaves for their careful readings of this chapter and their helpful feedback on it.

2 The bloody civil war in Algeria has driven Slim, "Algeria's best-known comic strip artist" (Douglas and Malti-Douglas 1994: 188) and political caricaturist, to exile in France. There he started drawing a daily political cartoon in *L'Humanité*, the French Communist Party's (PCF) newspaper, in January 1995 (Ibrahim 1995), and has published two comic books that address Algeria's current crisis (Slim 1995, 1996).

3 For an explanation of this term, see above, p. 20.

4 There are many other Caribbean cartoonists – including Patrick Chamoiseau! However, I will not discuss their work here, in part because it is not readily available in mainland France, and in part because much of it is in Creole, in which I am not conversant. For an introduction to the work of these artists, see *Kreyon noir* (n.d.).

5 For a discussion of these groups, see above, pp. 7–10, 18–20.

6 See above, p. 21.

7 Bloul (1994: 122).

8 Cf. Pierre (1988: 118), with respect to Africa in comics: "Il est convenu que la Blanche est une proie pour le Noir et la Noire un cadeau pour le Blanc" [It is understood that the white woman is the black man's prey and the black woman is a gift offered to the white man].

9 This ending may only be provisional. Ferrandez told me (Personal interview 1996) that one of his future projects was to continue his series, starting with the Algerian war.

10 Georges Boudarel, a French Communist, served from 1952 to 1954 as a re-education officer of French prisoners of war in a Viet Minh prison camp. In 1991, long after he had returned to France and had become a professor of history, Boudarel was accused of crimes against humanity for his past actions in Viet Nam. He was later cleared of legal charges.

11 Translation of the first part of the title: *Les soirées d'Abdulah. Ratonnades* (in Boudjellal 1996b).

12 Boudjellal's comics include: (1) a collection of strips entitled *Les soirées d'Abdulah. Ratonnade* (first published separately in comic magazines *Circus* and *Charlie Mensuel* in 1978–9, then in book form by Futuropolis in 1985, and most recently in Boudjellal 1996b: inside cover, 4–21); (2) five books on the adventures of the Slimani family: *L'oud, Le gourbi: L'oud II, Ramadân: L'oud III* (now collected together in Boudjellal 1996b, but previously published individually by Futuropolis in 1983, 1985, 1988, respectively; before *Ramadân* was first issued in book form, it was published serially in *Actualité de l'émigration* (a magazine directed at the Algerian community in France), *Jambon-Beur: Les couples mixtes* (1995), and a collection of short stories, *Gags à l'harissa* (1989). For ease of reference in this chapter, I will refer to the collections: Boudjellal (1996a; see below) and (1996b); (3) a four-volume "Juif–Arabe" [Jew–Arab] series (*Juif–Arabe, Juif–Arabe: Intégristes, Juif–Arabe: Conférence internationale, Juif–Arabe: Français* – the unfolding of the titles tells a story in itself) issued individually by Soleil Productions 1990–2, and then collected together (Boudjellal 1996a); (4) a series now in progress, in the vein of the Arabian Nights, of which the first volume is *Djinn* (1992); (5) various collaborative works, including *Les Beurs* (Mechkour and Boudjellal 1985), *Ethnik ta mère* (Boudjellal and Jollet 1996), and a recent work with Soraya Nini. Boudjellal has also published comics in a Japanese magazine and written the scenario for five episodes of the television sitcom "La famille Ramdam."

Besides Soleil Productions, Mourad Boudjellal also runs Plein Sud, a brand-new independent publishing firm, which has put out books that attack the far right and the Front National (FN). An FN mayor was recently elected to run Toulon, where Plein Sud and Soleil Productions are headquartered and where the Boudjellals grew up (see Dassonville 1996).

13 See above, p. 20.

14 When the publisher's designer first presented his layout for the cover and title page lettering, with some letters turned upside down and backwards, Boudjellal insisted that, while incorporating diversity in the typography, the designer should put some order back into it, and told him: "On dirait que tu veux montrer que le couple mixte c'est le bordel" [It looks as though you want to show that mixed couples are a mess] (Personal interview 1996).

For a reading of a similar type of transgressive visual play with the notion of difference, in anti-racist posters, see Lionnet (1995: 101–3).

15 Cf. Bloul (1994: 114) on the distinction made in France between hand of Fatima medallion and Muslim headscarf.

16 For a definition of this term, see above, p. 22.

REFERENCES

Comics

Alagbé, Yvan (1995) *Nègres jaunes*, Wissous [France]: Amok.

Anita Comix (1984) *Anita comix*, Paris: Arcantère.

Baru [Hervé Barulea] (1995) *L'autoroute du soleil*, Tournai: Casterman.

Baru [Hervé Barulea] (art and scenario) and Jean-Marc Thévenet (scenario) (1995) "The road to America, part 1," trans. Helge Dascher, in *Drawn and Quarterly*, vol. 2, no. 4, December, pp. 2–19.

———— (1996) "The road to America, part 2," trans. Helge Dascher, in *Drawn and Quarterly*, vol. 2, no. 5, April, pp. 30–43.

Boudjellal, Farid (1984) "Amour d'Alger," *Révolution*, no. 244, November 2–8, pp. 38–41.

———— (1989) *Gags à l'harissa*, Geneva: Humano, SA–Les Humanoïdes Associés.

———— (1992) *Djinn*, colors by Farid Boudjellal and Sophie Mondésir, Toulon: MC Productions.

———— (1995) *Jambon-Beur: Les couples mixtes*, articles by Martine Lagardette, colors by Sophie Balland, Toulon: Soleil Productions.

———— (1996a) *Juif–Arabe: L'intégrale*, Toulon: Soleil Productions.

———— (1996b) *L'oud: La trilogie*, Toulon: Soleil Productions.

———— (n.d.) "Couple mixte," artist's proposal, with Martine Lagardette, Paris.

Boudjellal, Farid (scenario) and Thierry Jollet (art) (1996) *Ethnik ta mère*, Toulon: Soleil Productions.

Christin, Pierre (scenario) and Annie Goetzinger (art) (1985) *La voyageuse de petite ceinture*, Paris: Dargaud.

El building (1994) no. 1, January, and no. 2, December. Includes comics by Anita Comix, Farid Boudjellal, Larbi Mechkour, Rasheed [Rachid Chebli], Sabeurdet [Drissi Sabeur].

Ferrandez, Jacques (1994a) *Carnets d'Orient*, Tournai: Casterman.

———— (1994b) *L'année de feu*: *Carnets d'Orient*, vol. 2, pref. Jean-Claude Carrière, Tournai: Casterman.

———— (1994c) *Les fils du sud*: *Carnets d'Orient*, vol. 3, pref. Jules Roy, Tournai: Casterman.

———— (1994d) *Le centenaire*: *Carnets d'Orient*, vol. 4, pref. Benjamin Stora, Tournai: Casterman.

———— (1995) *Le cimetière des princesses*: *Carnets d'Orient*, vol. 5, pref. Louis Gardel, Tournai: Casterman.

Grange, Dominique (scenario) and Jacques Tardi (art) (1991) "The murderer of Hung," trans. Matthew Screech, in Bob Callahan (ed.), *The New Comics Anthology*, New York: Collier Books, pp. 208–15.

Kaci (1994) *Bas les voiles!* (first edition 1984) n.p.: Edifra [Edition française pour le Monde Arabe].

Kreyon noir (n.d.) no. 1.

Lax [Christian Lacroix] (art) and [Frank] Giroud (scenario) (1990) *Les oubliés d'Annam 1*, Marcinelle [Belgium]: Dupuis.

———— (1991) *Les oubliés d'Annam 2*, Marcinelle [Belgium]: Dupuis.

Mechkour, Larbi (art) and Farid Boudjellal (scenario) (1985) *Les Beurs*, Paris: L'Echo des Savanes/Albin Michel.

Merezette, Denis (art) and Farid Boudjellal (scenario) (1994) "Vengeance harkie," *El building*, no. 2, December, pp. 76–106.

Monpierre, Roland (1986) *Le diable blanc*, Paris: Futuropolis.

——— (1988) *Reggae rebel: La vie de Bob Marley*, Paris: Edition Caribéennes.

Saladin [S. Zeghidour] (1979) *Les migrations de Djeha: Les nouveaux immigrés*, pref. Guy Bedos, Claix [France]: La Pensée sauvage.

Slim [Menouar Merabtene] (1995) *Le monde merveilleux des barbus*, Toulon: Soleil.

——— (1996) *Aïnterdit*, Toulouse: Editions de la Salamandre.

Tripp, Jean-Louis (1987) *Zoulou blues: Une aventure de Jacques Gallard*, colors by Anne Clément, text in Afrikaans by Georges Lory, Toulouse: Milan.

Truong, Marcelino, and Francis Leroi (1991) *Le dragon de bambou*, Paris: Albin Michel.

Warnauts [Eric] and Raives [Guy Servais] (1996) *Lettres d'outremer*, Tournai: Casterman.

Other sources

Barulea, Hervé (1996) Personal interview, Nancy, July 25.

Basfao, Kacem (1990) "Arrêt sur images: Les rapports franco-maghrébins au miroir de la bande dessinée," *Annuaire de l'Afrique du Nord*, no. 29, pp. 225–35.

Bloul, Rachel A.D. (1994) "Veiled objects of (post-)colonial desire: forbidden women disrupt the republican fraternal sphere," *Australian Journal of Anthropology*, vol. 5, nos 1–2, pp. 113–23.

Bouamama, Saïd (1994) *Dix ans de marche des Beurs: Chronique d'un mouvement avorté*, pref. Mogniss H. Abdallah, Paris: Desclée de Brouwer.

Boudjellal, Farid (1995) Personal interview, Paris, August 4.

——— (1996) Personal interview, Paris, January 5.

Centre Culturel Algérien (1992) Dossier on "Bande dessinée," Paris.

Certeau, Michel de (1986) "Diversité culturelle: Conclusions d'un colloque," *Hommes et migrations*, no. 1089, February 15, pp. 11–17.

Dassonville, Aude (1996) "Les publications pugnaces de l'ambitieux 'Monsieur Mourad,'" *Le Monde*, January 26.

Delcroix, Olivier (1995) "L'actualité par la bande," review of *L'autoroute du soleil*, by Baru, supplement on "Grandes écoles," in *Le Figaro*, November 6.

Douglas, Allen, and Fedwa Malti-Douglas (1994) *Arab Comic Strips: Politics of an Emerging Mass Culture*, Bloomington, IN: Indiana University Press.

Dupuis (n.d.) "Quand la BD précède l'histoire . . . ," publisher's publicity flyer for *Les oubliés d'Annam*, by Lax and Giroud.

Elbe, Eric d' (1987) "Ferrandez: 'Carnets d'Orient.' Un album qui insulte l'Algérie française," *Présent*, February 5.

Ferrandez, Jacques (1996) Personal interview, Nice, July 30.

Gaumer, Patrick, and Claude Moliterni (1994) *Dictionnaire mondial de la bande dessinée*, Paris: Larousse.

Ibrahim, Youssef M. (1995) "Algerian-in-exile's pen wielded for home front," *New York Times*, March 19.

Jay, Salim (1988) "L'imaginaire, d'Elise à Idriss," *Le livre et l'immigration*, special issue of *Hommes et migrations*, no. 1112, April, pp. 3–6.

Khamès, Djamel (1995) "L'Algérie fait des bulles," review of the series "Carnets d'Orient," by Jacques Ferrandez, *Arabies*, no. 99, March, pp. 70–1.

Lacroix, Christian, and Frank Giroud (1996) Personal interview, Saint Didier de Formans, July 26.

Lionnet, Françoise (1995) "Immigration, poster art, and transgressive citizenship: France 1968–1988," in Lawrence D. Kritzman (ed.), *France's Identity Crises*, special issue of *SubStance*, nos 76–7, pp. 93–108.

Nederveen Pieterse, Jan (1992) *White on Black: Images of Africa and Blacks in Western Popular Culture*, New Haven, CT: Yale University Press.

Pierre, Michel (1988) "La B.D., terre des grands fantasmes," *Notre librairie*, no. 91, January–February, pp. 116–19.

Le Point (1987) "La poussée des 'Beurs'," February 16–22.

Sherzer, Dina (1996) "Race matters and matters of race," in Dina Sherzer (ed.), *Cinema, Colonialism, Postcolonialism: Perspectives from the French and Francophone World*, Austin, TX: University of Texas Press, pp. 229–48.

Shohat, Ella, and Robert Stam (1994) *Unthinking Eurocentrism: Multiculturalism and the Media*, London/New York: Routledge.

Stora, Benjamin (1993) "France and the Algerian War: memory regained? An interview with Benjamin Stora," trans. Dan Cianfarini, *Journal of Maghrebi Studies*, vol. 1, no. 2, Fall, pp. 95–102.

Taguieff, Pierre-André (1987) *La force du préjugé: Essai sur le racisme et ses doubles*, Paris: La Découverte.

Witek, Joseph (1989) *Comic Books as History: The Narrative Art of Jack Jackson, Art Spiegelman and Harvey Pekar*, Jackson, MS: University Press of Mississippi.

ARTISTIC GAPS IN THE ETHNIC CIRCLE

Dalila Mahdjoub[1]

INTRODUCTION

In writing a chapter about the works of creative artists labelled as being "of Maghrebi immigrant origin," I find myself taking as an initial starting point a criterion of ethnicity that in many ways runs counter to my main line of argument. In the first part of this chapter, I will sketch out a range of individual artistic paths, basing my discussion on specific examples of works chosen to reflect five major criteria:

1 Ethnicity: the authors or artists of these works are all of Maghrebi immigrant origin, i.e. they were born and/or raised in France;
2 Recognition by French cultural institutions;
3 Diversity of artistic forms: the works discussed come from a variety of different creative fields (design, painting, sculpture);
4 Personal choice;
5 Possible unintentional omissions, to the extent that I may be ignorant of certain works.

Woven into the fabric of all this will be a hint of cynicism, best expressed in the following quotation: "I do not like to write about artists. I do not know what to write. I find describing a work of art ridiculous, a photograph does it better" (Vautier 1989). I leave to art critics the serious business of artistic analysis. The first section leads me to raise the question of the pertinence or sterility of ethnicity as a criterion for classifying artistic approaches. In the second half of my analysis I explore how this same ethnic criterion can serve as a basis for allocating

funds to artistic projects supported by public institutions, and I consider some of the disturbing effects this can have. To illustrate my argument, I will draw on various examples, some of which are anecdotal. This is not a scientific treatise!

First of all, I wish to underline two givens which, taken together, threaten to subvert the task that I have taken on:

1 the ethnic criterion – in practice, does not any attempt at analyzing works by artists whose only common denominator lies in their ethnic origin run the risk of giving credibility to the idea of them forming part of a distinct community, placing them in a kind of ghetto?
2 my personal background – in positioning myself as author, does not the fact that I am of Algerian origin, born in France, and schooled in a French academic program at the Ecole Nationale des Beaux-Arts de Lyon trap me in the same ethnic ghetto?

This reminds me of a statement made by Ouali Chekour while he was commissioner and initiator of the exhibition entitled "Peintres et sculpteurs algériens de France: La nouvelle génération 1989" [Algerian Sculptors and Painters in France: The New Generation 1989], organized in Grenoble in 1989, which brought together twenty-two artists of Algerian origin:[2] "I only bring them together the better to break them apart" (Chekour 1989b: 30). This is a possible answer to the question raised under my first point above, but nevertheless includes a certain margin of ambiguity . . . or perhaps of Utopia? In any event, I should like to state at the outset that I am neither a "Docteur-ès-artistes d'origine maghrébine" [Doctor of Maghrebi artists], nor a "community spokesperson"; I alone bear the full responsibility for the comments made here.

DIVERSE PATHS

What is important to me is to exist, as long as there is the joy of poetry . . . that firefly of the mind dancing on human history.

(Mohamed El-Guettaa, quoted in Farès, 1995: 329)

"Ex-nihilo, nihil" [from nothing comes nothing] (Quilichini 1993) – this aphorism, followed by a reference to the Bauhaus school, opens the text of the catalog of an exhibition in honor of the Finnish designer Alvar Aalto conceived and mounted by Chérif Medjeber, a designer born in 1962 in Médéa, Algeria. Chérif – which

is how he signs his name – attended the Ecole Nationale Supérieure des Beaux-Arts d'Alger and the Ecole Nationale des Arts Décoratifs de Paris, where he specialized in design. He lives and works in the Paris suburb of Asnières. Through this aphorism, Chérif inscribes his work within the history of design and its international dimensions. The art objects produced by Chérif – such as "Le berceau de Lilia" [Lilia's cradle] (beech, 1.10 × 0.52 × 2.20 meters), the sofa entitled "Inari" (ash, 1.70 × 0.84 × 1.00 meters), or the bench entitled "Carnet de voyage" [Travel notebook] (ash, 1.70 × 0.60 × 0.72 meters) – seem to emanate from a subtle dosage of material, form, and function. Whether a single object or serial production, the insistence on quality is always present. "Sopi" (curved wood, 1.65 × 0.50 × 0.66 meters) and "Spigo" (curved wood, 0.50 × 0.46 × 0.66 meters), respectively a bench and a small armchair, use the technique of curved wood, a Nordic tradition bequeathed by Alvar Aalto, who elevated this skill to an extremely high degree of perfection. The fact that he has worked within this tradition takes nothing away from the specificity of Chérif's work. At one and the same time an invitation to sit down and an invitation to travel, the bench "Carnet de voyage" is a canvas for the artist's sketches. As though taken from a travel notebook, perhaps the one that accompanied Chérif during his visit to Lapland, there are sketches printed on the white cloth of the seat, representing long lines of reindeer pulling sleighs against a background of snow-covered countryside, suggesting an invitation to the beyond, as if the object itself were participating in an adventure of the mind.

"Haunted by the continuous cycle of life and death" (Des photographes en Méditerranée 1987: 42), a comment made about "Pompeï," the work of Touhami Ennadre (a photographer, born in 1953 in Casablanca, Morocco, who lives and works in Paris), seems to set forth a universal, existential problematic, through its "obsessive journey to the deepest parts of man, to the sources of life" (Alaoui 1993: 37). "Pompeï" (1986, a series of black and white photographic prints mounted on aluminum, 1.50 × 1.22 meters) groups together a series of images that present a focal point, often at the center of the photograph, created by a concentration of light. The lit space seems to rise up out of a black mass situated on the circumference of the photograph, thereby creating a dramatic effect on what seems to be a piling up, an intertwining of human skeletons. The scenic space, a truly morbid, macabre vision, where the skeletons seem to be buried under layers of cinders and lava, undeniably makes reference to the idea of death, violent death, an observation that does not necessarily apply in general to this photographer's work.

Referring to Rachid Khimoune (a sculptor born in 1953 in Decazeville, France,

whose professional schooling was at the Ecole Nationale Supérieure des Beaux-Arts de Paris, where he specialized in painting), Chouteau (1993) says that "he is a storyteller of the present, of the passage of time." We read elsewhere: "Rachid Khimoune works on human memory" (D.S. 1991). Rachid K. (which is how he signs his name) recounts the following short anecdote about "La tortue" [The Tortoise] (1992, iron and copper) (Plate 11.1), which is part of his bestiary: "Among the Berbers of Kabylia, the land of my ancestors, the tortoise is an emblematic figure . . . It protects one from bad luck and bad spirits . . . My mother has four of them at home. The tortoise is like a parody of time and of history" (Khimoune, quoted in Chancel 1995: 106). This strange terrestrial reptile, outfitted with a helmet from the Wehrmacht – an object conjuring up the Second World War, from which it seems to have been lifted to serve as a protective shell – has traded the flaccidity of its limbs for the rigidity of iron and copper, essential components made of recuperated objects, recycled marks of the decadence of industrial society. Allusions to time, which passes and fixes all,

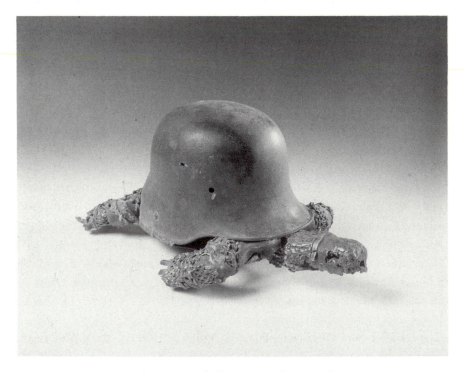

Plate 11.1 Rachid Khimoune, "La tortue"
Photograph: Pierre Terrasson

allusions also to memory and to history, Rachid Khimoune's embalmed tortoises move in another mode of temporality, rather as if time had been suspended.

Yet under this apparent state of immobility, there is life in "this skin that has crossed the centuries," (Khimoune 1991: 52) notably in the work entitled "Les oeufs et les carapaces de tortues" [Tortoise eggs and shells] (1990, plaster). With reference to skin, Rachid Khimoune quotes Paul Valéry – "skin is the deepest organ" – and continues in his own words: "under the skin there are all of these ramifications, these veins, these nerves . . . under the city's skin there are all these symbols of life and communication: water, gas, electricity" (Khimoune 1991: 51). It is this frontier, between that which is underneath and that which is on top, that fascinates Rachid Khimoune. The notion of frontiers, associated with the concept of skin, is particularly visible in the work entitled "Les enfants du monde" [The children of the world] (a monumental sculpture in the town of Blanc-Mesnil), where each character is the result of a cunning and playful assemblage of road surface objects, sewer covers, tar, grills, and cobblestones, all molded in elastomer, then cast in resin strengthened with fiberglass.[3] "Le scorpion chef d'orchestre" [The scorpion orchestra conductor] (1993, iron and copper) (Plate 11.2) and the "Poisson hache" [Fish hatchet] (1993, iron and copper),[4] which have escaped from one knows not what arid desert or ocean, realizing that they are able to change their color like a chameleon does, have – as it were – elected to dress themselves up in this apparatus made of disparate objects: springs, pliers, nuts, bolts, fencing, bicycle chain, tubing, and various other bits of metal rubbish thrown up by industry, in order to join in the long procession that makes up Rachid Khimoune's bestiary, which is in the image of our post-industrial society.

The "Untitled" works (Plate 11.3) by Ghada Amer (a painter born in 1963 in Cairo, who now lives and works in Paris), which are embroidered and scrambled images that she initially takes from men's pornographic magazines, raise questions about the representation of women, the nature of sex (between eroticism and pornography), and about love relations. In them, Amer underlines the thematics of the vulgar and the obscene through a plastic procedure that moves around the relationship between the hidden and the exposed. The fact that Amer's works incorporate embroidery, an artistic technique based on a traditionally feminine skill, can only add to these semantic connotations, however subjective they may be.

Djamel Tatah (a painter born in 1959 in Saint-Chamond, who lives and works in Apremont-Perdreaux-Ville) cites Francis Bacon in the catalog of an exhibition: "I think that art is an obsession with life and, after all, since we are human beings our greatest obsession is with ourselves" (quoted in Mozziconacci 1992: 3).

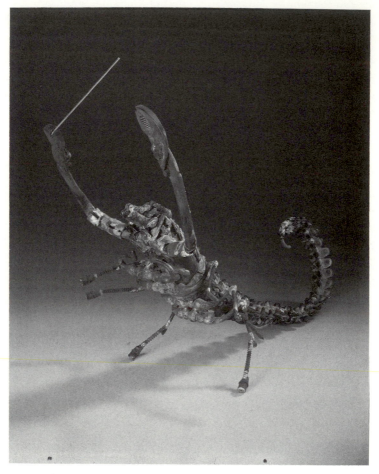

Plate 11.2 Rachid Kimoune, "Le scorpion chef d'orchestre"
Photograph: Pierre Terrasson

"Autoportrait à la stèle" [Self-portrait with stela] (1990, oil on canvas and wood, tryptich, 2 × 7 meters), "Autoportrait à la Mansoura" [Self-portrait with Mansoura] (1990, oil and wax on canvas and wood, 0.80 × 1.60 meters), are paintings by Tatah that give a figurative representation of people (himself or others, as though repeating infinitely the representation of a single person), pale and immobilized on monochromatic, unsaturated backgrounds. The precision of the delineation and contours isolates the figurative elements in a strange muteness. The work "Autoportrait à la stèle" (Plate 11.4) is composed of three panels laid out horizontally, one beside the other, representing respectively two-fifths, one-fifth and two-fifths of the total length of the rectangle that they make up. A figure

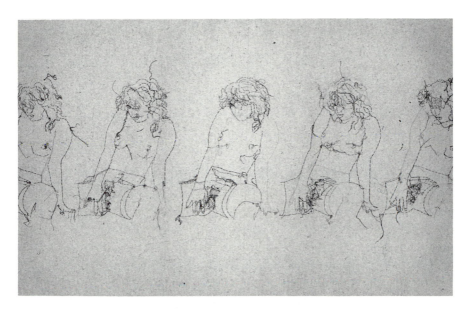

Plate 11.3 Ghada Amer, "Untitled"

— a self-portrait of the artist — is symmetrically represented on the two extremities of the work. This symmetry around the central axis creates a focal point that is accentuated by the blue-colored frame within the painting, on the central panel (the complementarity between the blue of the frame and the orange color of the background increases the color contrast of the painting). Engraved in the center of this panel, by scraping away paint, are the following words: "I understand here that which is called glory. The right to love without measure. Albert Camus." These words are almost undecipherable, rather as though they had been effaced by time and the weather. In fact, this is a quotation taken from a poem engraved on a concrete stela, erected close to Tipaza, Algeria, in memory of Albert Camus. The semantic allusion to Tatah's homeland and its relationship

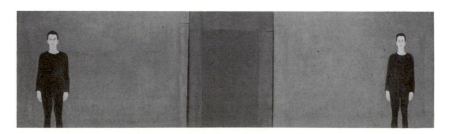

Plate 11.4 Djamal Tatah, "Autoportrait à la stèle"

with France attains a universal dimension through the choice of the verse. The plastic codes used by the artist bear no specific marks of the artist's ethnic origins.

To this list of artists and their works one could add the round figures of Mohand Amara's sculptures (the sculptor was born in 1952 in Béjaïa, Algeria, and lives and works in the Paris suburb of Aubervilliers), the lithography-paintings of Djâafer (born in Algeria, he acquired his professional skills at the Ecole Nationale des Beaux-Arts d'Alger and the Ecole Nationale Supérieure des Arts Décoratifs de Paris), the paintings of Kadid Djilali (born in Sfisef, Algeria), those of Fatiha Rahou (a painter born in 1949, in Hennaya, Algeria, who lives and works in Genevilliers, another Paris suburb), those of Meriem Bouderbala (painter), the massive silhouette-like sculptures of Salima Zerrouki (a sculptress born in 1961 in Burnoy, France), the tortured bronzes of Hadji Béchir (a sculptor born in 1956 in Constantine, Algeria, who went to the Ecole Nationale des Beaux-Arts de Lyon), the harmony emanating from the paintings of Sid Ali Hams, the work in bronze, ebony or basalt of Kaci Chaouch (a sculptor who attended the Ecole Nationale Supérieure des Beaux-Arts de Paris and Oslo University in Norway), the geometry of the paintings of Meziani (a painter born in Batna, Algeria, who attended the Université de Nice), the dynamism in those of Racheed (an illustrator, cartoonist and painter born in 1962 in Paris, who lives and works in Asnières), or the ethno-design of Yamo (a designer born in Algeria) . . . Rather than attempt some exhaustive litany, I will end this list here.

One single point unites these artists: all were born of parents from (ex-)colonies, in this case the countries of the Maghreb (Algeria, Tunisia, Morocco) colonized by France, and all live and work today in France. Their careers have followed very different trajectories. Some of these artists, such as Meriem Bouderbala, Chérif, Rachid Khimoune and Kacem Noua, have earned something of a reputation; others are less well-known. Some are self-taught: Salima Zerrouki, Fatiha Rahou, Mohamed El-Guettaa (a sculptor, born in 1961 in Rognac, France, who lives and works in Aix-en-Provence), Mohand Amara, Melik Ouzani (a painter born in 1942 in Vichy, France, now based in Aubervilliers), Tibouchi (a painter born in 1951 in Tibane, Algeria, who lives and works in Monsoult), Khaldi Messaoud (a painter born in 1953 in Bordj-Bou-Aréridj, Algeria, now living in Paris), and graffiti artists given institutional recognition as creative artists by Jack Lang, who served as Minister of Culture under François Mitterrand. Others have an academic background: Chérif, Rachid Khimoune, Kaci Chaouch, El Kouaghet (a painter, born in Algeria, who was schooled at the Ecole Communale des Beaux-Arts de Constantine in Algeria, the

Ecole Nationale des Beaux-Arts d'Alger, the Ecole des Arts Appliqués de Metz in France, the Ecole Nationale Supérieure des Arts Décoratifs de Paris, the Ecole Nationale Supérieure des Beaux-Arts de Paris and the Université de Paris VIII), Meziani, Kacem Noua (a painter born in 1952 in Lyon, France, who attended the Ecole Nationale des Beaux-Arts de Lyon and now lives and works in Lyon), Ould Mohand (a painter born in 1960 in Algiers who attended the Ecole Nationale des Beaux-Arts d'Alger and the Ecole Nationale Supérieure des Beaux-Arts de Paris), Mohamed Ounouh (a painter born in 1964 in Tizi-Ouzou, Algeria, who attended the Ecole des Beaux-Arts d'Alger and the Ecole Supérieure des Arts Modernes de Paris). . .

If we compare the works of these artists – for example, "Chauffeuse grenade," [Pomegranate armchair], a work by Chérif (Plate 11.5), "Icône Famille El-Guettaa" [El-Guettaa family icon] (1991),[5] which is a piece by Mohamed El-Guettaa (Plate 11.6), and "Le scorpion chef d'orchestre" [The scorpion orchestra conductor] by Rachid Khimoune (Plate 11.2) – we can see that it is futile to look for any convergences in their art, whether plastic, semantic, or more generally aesthetic, indicating the ethnic origins of the artists. Even if some more or less implicit formal influences do exist, reflecting a specific ancestry, these are by no means systemic; there is no consensus around them. "There is no 'Beur' culture, nor even a 'Beur' community!" is the stinging response given by Doukhar

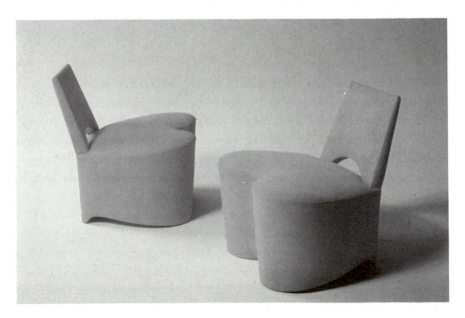

Plate 11.5 Chérif [Medjeber], "Chauffeuse grenade"

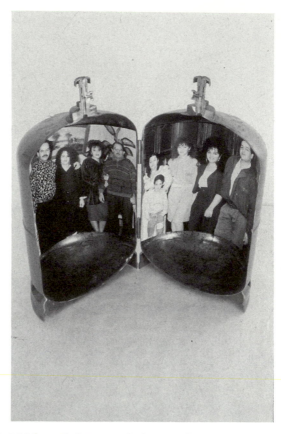

Plate 11.6 Mohamed El-Guettaa, "Icône Famille El-Guettaa" (June 1991)

(1993: 14) to the question: "is there a Beur culture?" (Reynaert 1993).[6] This is a question that Azouz Begag has answered in the following manner: "As I see it, this is not a culture, it is a temporary social phenomenon in which people describe where they come from so that they can subsequently put this behind them" (quoted in Reynaert 1993). The ethnicization of culture, the trap of communitarian closure, trying to see a common aesthetic or school in the works of these artists — all of this would be fundamentally misconceived. As Alaoui (1993: 35) observes, "there is no pictorial determinism"; the work of these artists "is not enclosed in some empty shell, they are not 'artists-of-Maghrebi-immigrant-origin,' they are quite simply 'artists'" (Dewitte 1993). Their diverse itineraries, which Philippe Dewitte (ibid.) describes as "proliferating" and "bubbling over," bring crashing down "any attempt at aesthetic categorization based exclusively on the fallacious criterion of some sort of bedrock identity as the origin of these works" (Chekour 1989a). Without cynicism, Kamel Khélif (a cartoonist and

painter) affirms that "the artist has no nationality" (Khélif 1995). This *prise de position* reminds me of Derek Walcott's remark: "my only nation is the imagination" (quoted in Jouffroy 1993).

FUNDING GHETTOS

I painted and I sold paintings for fifty or one hundred francs. Curiously, I painted at night. With the kids from the neighborhood, we talked about paintings, about Van Gogh and Gauguin . . . But there was an incident during the exhibitions . . . instead of putting my name, the social center put another signature, that of the "Social Center."

(Kamel Khélif, quoted in Farès 1995: 331)

In 1993 Philippe Dewitte hailed the end of an era in which artists of Maghrebi origin had set themselves up as "flag-bearers of an ethnic identity" (Dewitte 1993).[7] Yet the same year, Malik Chibane made the movie *Hexagone*, with the objective of "fighting against cultural invisibility, that of the Beurs in the *banlieues*" (Chibane 1994).[8] Similar thoughts had been expressed a few years earlier, in a document outlining the basic conception of the exhibition set up on the initiative of Ouali Chekour:

This is the first time that artists of Algerian origin in France have together "occupied" the artistic heights of a major city . . . it is a project whose objective is to reveal to the general public the creative genius of a community often seen in a negative light . . . to show another face – the true one . . .

(Chekour 1989b: 30)

This had a pretty assertive ring to it.

Financed to the order of Fr 1.2 million by public institutions – the Ministry of Urban Affairs, then headed by Bernard Tapie, the Caisse des Dépôts et Consignations (a public investment agency), the Ministry of Youth and Sports, and the Fonds d'Action Sociale pour les travailleurs immigrés et leurs familles (FAS) – the film *Hexagone* is the result of institutional do-gooding. I am reminded of the following criticism of Mehdi Charef's first film (*Le thé au harem d'Archimède* [Tea in the harem of Archimedes]), shortly after its release: "Its success is not yet shorn of the equivocal condescension of those who like to display their concern for . . . in this case, the exoticism of the urban periphery" (Sadoul 1990). Must a repressive context exist for certain kinds of cultural demands to emerge? Today, "the empire of compassionate frivolity" (Finkielkraut 1995)[9] is such that those circumstances cannot be said to exist. The fact is that "the sphere of [institutional]

kind-heartedness" (Hegel, quoted in Delacampagne 1985: xx) is concerned to "give the right to speak" to those poor oppressed people, otherwise known as "youths of immigrant origin." The ways of naming them are multiple, all the better to ghettoize them. "In texts published between the two World Wars or during the 1950s I have never read that, with regard to the '*babi*' (one of several names given to Italians in Marseilles), people ever talked about a second or even a third generation, or that they thought it necessary to make up words or various metaphors to designate succeeding generations," remarks Mireille Meyer (1991: 14–15). Without attempting to be exhaustive, let us take a look at some examples of these defenders of the moral order.

First, the FAS, through its paternalistic "Gattien"[10] policies, has set itself the goal (among others) of "valorizing the potential of immigrants" (FAS 1992a). "It fosters, in particular, the opening of cultural facilities to the works of creative artists who hail from socially disadvantaged neighborhoods" (FAS 1992b), so long as they are members of a neighborhood association, for the FAS does not finance individual projects, but only group ones and, as a result, does not finance artists' projects unless the artists are backed by an association. The FAS openly declares its attachment to ethnic criteria; things could not be otherwise, since those criteria legitimate its existence. As I mentioned above, *Hexagone* is one such project and was financed in part by the FAS, through the Idriss association of Goussainville. In this case, it would seem that more attention was given to the fact that the director is a young Maghrebi from a socially disadvantaged neighborhood than to the artistic merits of the project. One of the objectives of the FAS is to "facilitate the integration" of immigrant workers and their families (FAS 1992a). Yet paradoxically, when we read the following statement by Malik Chibane, we seem instead to be confronted with a nationalistic, exclusionary, separatist, even tribal discourse which, rather than promoting dialogue, honors autarky:

The film draws its identity from the specific locality of the *banlieue* . . . If I work with the same partners, I can make more films with them, digging deeper into my *banlieue* roots . . . I want to get out in one sense while remaining in the *banlieue* . . . thus countering the brain drain . . .

(Chibane 1994).

On this obsession with roots, I cannot but quote the words of Christian Poitevin (1995): "Human beings are not vegetables; they aren't rooted to the spot."

Chibane's attitude is paralleled by Ouali Chekour's language, even though he qualifies his discourse with the following disclaimer: "it was not at all out of a spirit

of sectarianism [that artists from the 'Algerian community' were brought together for an artistic project], but rather as a way of believing in one's own capacities, in one's own creative genius" (Chekour 1989b: 31). The act of identifying with a certain group of individuals can provide more power but it entails the risk of sealing oneself off inside the group's identity. In the words of Kamel Khélif (1995): "the group is a blind alley."

The sculpture "Don Quichotte et Sancho Pança" [Don Quixote and Sancho Panza] (1991) by Rachid Khimoune, situated in the Visitation housing project in Marseilles, also received financial support from the FAS, through the association Tout Horizon (three other partners contributed as well: the Direction Régionale des Affaires Culturelles, the Conseil Général, and the city of Marseilles, respectively the regional, departmental, and municipal levels of local government). This work again used the technique of casting urban materials through the use of resin – a procedure that the artist had already mastered – which were then assembled in order to recreate Cervantes' heroes. The result is full of poetry and fits perfectly into the urban landscape, since it is the street itself that generates its forms. One of the positive qualities of this project lies in the fact that it brings together perfectly the artist's plastic preoccupations and those of the inhabitants, because of the project's capacity to let itself be appropriated by the gaze and spirit of each and every person. Thus, I am not seeking to demonize, on the artistic level, everything that the FAS supports, but rather to highlight through my other examples the risks involved in using ethnic and/or geographic (i.e. neighborhood-based) criteria when allocating funding.

Second, the government-run Développement Social Urbain (DSU) scheme proposes, among other things, to finance artistic projects that target a certain segment of the population. In the words of Gilbert Ceccaldi (1995) (the DSU's cultural delegate at the Direction Générale des Affaires Culturelles in Marseilles): "the DSU population is defined, at least in general, as disfavored and excluded . . . the projects financed by the DSU must primarily reach these groups."

As an example of a project financed by the DSU, let us take a work initially entitled "La DS des lieux" [The Goddess of the Place],[11] by Malik Ben Messaoud, a young artist from the Bassens neighborhood of Marseilles. Let us consider the various elements involved in this enterprise. First of all: Bassens. The area has been described as follows: "Since its demolition was announced, Bassens, officially classified as a chronically disadvantaged neighborhood, where the majority of the population is of Algerian origin, is today in a state of limbo" (C.D. 1995). Next, demolition. This is what the DSU has to say on the subject:

To destroy a building where families have lived for five, ten, twenty or thirty years is to destroy places where people grew up and lived. The things they lived were not necessarily solely moments of misfortune. They lived their lives here, including moments of happiness, and other people are wrong to think they have the right to destroy that without preserving the memory of it.

(Ceccaldi 1995)

Of memory, we may say: "(Silence): Suffering. Speech, speak" (Bourdieu 1993).[12] The preservation of memory, more particularly via a child of the neighborhood (in which we may see conscience-salving or perhaps a Gattien operation), is one of the reasons that explain the support of the DSU for the project of Malik Ben Messaoud. Of the project itself, we are told that "'La DS des lieux' [is . . .] the mark of a child of the neighborhood" (C.D. 1995). Messaoud describes it in the following terms: "I am doing this project for the people in the neighborhood, to show that we are all together, that we are in solidarity (it is not a personal project), and to show people outside that we are capable of producing beautiful things" (quoted in Lobstein 1995).

Regarding the artist: at the outset we should be aware that the first criterion that must be satisfied for the DSU to give its approval to a project concerns the "professionalism of the artistic activity, to be guaranteed either by the presence of an artist already recognized by the cultural establishment or by the management of the project by a recognized cultural institution" (Ceccaldi 1995). In the case of Malik Ben Messaoud, the second condition was fulfilled: in requiring that the project be managed by a recognized cultural institution, the DSU implicitly refused to recognize Ben Messaoud as a genuine artist in his own right. The DSU appeared interested in Ben Messaoud only to the extent that he was a disadvantaged youth of Maghrebi origin from a neighborhood destined to be demolished, a standard-bearer of ethnic identity or a token "immigrant artist" papering over the planned demolition of the neighborhood, guaranteeing the public a guilt-free conscience.

Two organizations initially selected to manage the project – Lieux Publics (a national center for street arts located in the Friche de la Belle de Mai, an artists' complex in Marseilles) and Le Château de Servières (a contemporary art exhibition center close to Bassens) – pulled out at an early stage. In a revealing statement, the Director of Le Château de Servières, Régine Dottori, referred to Ben Messaoud as a "self-proclaimed artist" (Dottori 1995). The project was eventually managed by Système Friche Théâtre with the support of the architect Jean Nouvel, President of the Friche de la Belle Mai, and the participation of recognized artists such as the video filmmaker Pierre Lobstein, the poet Joe Dale Tate Nevaquaya and the photographer Richard Ray Whitman (the latter two are Native Americans).

With support from a wide array of central, regional, departmental, and local government agencies and a large budget, the project, renamed "Bassens-Support Cité 1" was inaugurated in September 1996 (Plate 11.7). The finished product consisted of some five latex mock-up luxury cars affixed vertically to the exterior walls of HLM apartment blocks, three papier mâché ones, and a two-story replica of the Statue of Liberty's head, made from iron tubing and set on top of one of the buildings. The art installation was inaugurated on September 6, 1996 at a gala event that was attended by the project's sponsors, and the latex cars and metal sculpture were still in place two months later.[13] At a meeting of officials organized shortly afterwards to review this and similar projects, I heard one of those present comment: "We've used Culture in Bassens to say 'Look, there *is* life, there are things holding the place together, now get on with living there!'" There was no mention at all of the artist who had initiated the project. Bassens remains in a state of limbo. With no precise date set for demolition, residents remain in their apartment blocks, now with a growing number of windows boarded up and walls festooned with state-sponsored bread and circuses.

A third case concerns the creation of the Ministry of Urban Affairs, at the time of Bernard Tapie. It was created for propaganda reasons and was aimed essentially at the youths in the *banlieues*, who were a potential part of the electorate. As Hédi Doukhar (1993) put it: "Was it not indeed for them [the 'Beurs'] that the Ministry . . . of Urban Affairs was created?" The Ministry therefore had a reason for financing projects like *Hexagone*.

Other groups also have a vested interest in maintaining this paternalistic climate since it can, in certain cases, legitimate their existence. For instance, social welfare centers, funded on condition that they address the needs of particular neighborhoods, often take on a paternalistic role. See, for example, Kamel Khélif's anecdote, quoted earlier. These centers justify their existence through the good work that they undertake; it is as though they were saying, with much humility, "Look at what WE bring to these poor youths!" In addition certain associations operate as cultural charities. Take, for example, the Association Arts et Développement, which is backed by the DSU and funded as follows: 30 percent from the central state, the city authorities and the FAS; 10 percent from the Conseil Régional; 30 percent from the departmental Conseil Général (two-thirds of this comes from state-backed minimum wage funds); 20 percent from housing organizations; and 10 percent from the Fondation de France. This organization, whose cultural missionaries are sent to the northern neighborhoods of Marseilles, asks the following question: "Is there not an urgent need to give to excluded people the possibility to create, and by creating, the means to progress?"

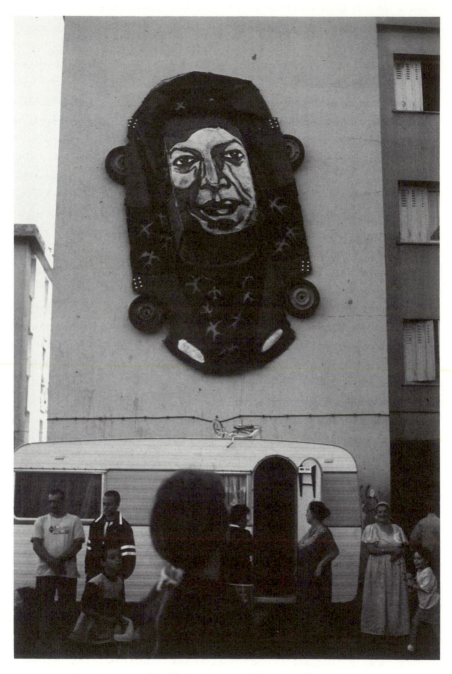

Plate 11.7 Part of Malik Ben Messaoud's art installation in Bassens

(Association Arts et Développement 1995). Even if all of that comes from good intentions, this is no excuse for so much paternalism.

And finally, a certain misplaced indulgence on the part of some intellectuals contributes to this mindset. See, for instance, the following comment, laced with euphemisms, made by Cécile Mury (1995): "despite a certain clumsiness in this [Chibane's] first film, I am eager to see a follow-up made with equal intelligence and generosity." Or again, Pierre Murat's (1995) remark: "his [Chibane's] first film was praised in certain quarters." These comments about Chibane's film bracket off the demand for quality that would have been made in relation to other artists from less disadvantaged backgrounds. Quite simply, this is the discourse of political correctness.

To the humanitarian and semantically obscure formula "donner droit à la parole" [let us give them the right to speak], which implies a relationship between dominator and dominated, we might oppose the expression "la parole se prend" [let us speak when we wish], pointing towards an assertion of cultural autonomy, which cannot be accomplished without economic autonomy. However, the economic dependency that characterizes most of the projects undertaken by "youths of immigrant origin" rules out the notion of autonomous cultural demands.[14] Rather, the general situation is one in which an institutional initiative gives voice only to what it wants to hear. Thus, to counter media coverage suggesting the opposite, publicly funded institutional initiatives are encouraging a discourse to the effect that things are not quite so bad in disadvantaged neighborhoods, that life there is . . . well, politically correct.

CONCLUSION

Faced with all these factors, would we not do better to speak simply of "artists," instead of attaching labels to them? Even if there sometimes exists a more or less apparent semantic and/or plastic connection between artist and country of origin, this is not at all systemic either within the works of an individual artist or across the works of artists grouped together on the basis of ethnic criteria, in spite of themselves. I propose therefore to speak neither of a school nor of a movement in connection with the artists' works that I have discussed here. Financial support based on ethnic and neighborhood criteria carries a double risk: on the one hand, that of creating ghettos and, on the other, that of funding projects made up of "shoddy exotic merchandise" (Finkielkraut 1995),[15] thereby leading to a

"subculture of the poor" (Certeau 1980), or what one might perhaps call "Social-ass/cult" [Socio-Cul] by opposition to Culture. But to this paternalistic, Gattien politics of culture, would it not be preferable to seek a *color-blind* politics (blind to skin color)? And should we not meditate on the call made by Cécile Zervudacki (1995): "It is time to leave our tribes!"

NOTES

1 Translated by Mark McKinney and Alec G. Hargreaves.

2 Amara, Hadji Béchir, Nacer Bouzid, Kaci Chaouch, Djâafer, Kadid Djilali, Mohamed El Guettaa, El Kouaghet, Dias Ferhat, Sid Ali Hams, Noua Kacem, Rachid Khimoune, Nadia Khouni, Khaldi Messaoud, Meziani, Ould Mohand, Ounouh, Melik Ouzani, Racheed, Fatiha Rahou, Tibouchi, Salima Zerrouki.

3 *Translators' note*: Khimoune is perhaps best known for these sculptures. They are described in François Maspero's travelogue (1994), which contains a picture of one of them taken by Anaïk Frantz (p. 202).

4 *Translators' note*: *Poisson hache* is the French name for a type of fish. Khimoune's sculpture plays on this name, by using a hatchet head as the body of the fish.

5 This mixed-media sculpture, created in 1991, features photographs of El-Guettaa's family framed within a dissected gas cylinder, which the artist saw as a symbol of energy. Similar gas cylinders later acquired entirely separate connotations when they were packed with explosives by Islamist terrorists during the bombing campaign of 1995: see above, pp. 88–9.

6 On the origins of the word "Beur," see above, p. 20.

7 The comics of Farid Boudjellal (see McKinney, above, Chapter 10) illustrate this approach. Most of Boudjellal's comic books were first published and/or later reissued by Soleil Productions, which belongs to the artist's brother, Mourad Boudjellal. They are examples of artistic works, still produced today, where the emphasis is on the ethnic particularities of Maghrebis in France. Another example is the photographer Hocine Berrada's work entitled "Le respect des pères" ["Respect of/for the fathers"] whose guiding principle is the parallel that it draws between two series of men's portraits: a first sequence photographed in the Flamants district of Marseilles (the artist's birthplace), and a second in Algeria.

8 For an explanation of the word *banlieue*, see above, p. 12.

9 It is Finkielkraut's phrase that interests me, not the context in which he used it.

10 *Translators' note*: This is a reference to the filmmaker and playwright Armand Gatti, who has sought to help disempowered groups find a public voice. See Dort (1990) and Gatti (1991).

11 *Translators' note*: This title, later superseded, contains a pun, referring both to a goddess ("*déesse*" in French) and to a now-classic Citroën car model ("DS").

12 These words feature on the jacket of a French edition of this work. Again, it is the phrase, not the context in which it was used, that interests me.

13 The event was later mentioned in *Le Monde* as an example of a successful project by unemployed youths, channelling pent-up energies that might otherwise lead to outbreaks of violence (Bonnet 1996).

14 One counter-example might be Farid Boudjellal's comic books, which are published by his brother. Could this be an example of an autonomous cultural project?

15 It is again Finkielkraut's turn of phrase that interests me, not its original context.

REFERENCES

Alaoui, Brahim (1993) "Et les arts plastiques . . .," interview by Philippe Dewitte, *Arts du Maghreb, artistes de France*, special issue of *Hommes et migrations*, no. 1170, November, pp. 35–8.

Association Arts et Développement (1995) "Naissance," *Association Arts et Développement: Bilan et perspective*, Corenc: Éditions de la Dilbona, p. 1.

Bonnet, François (1996) "Jean-Claude Izzo: Le rêve de Le Pen est de faire exploser cette ville," *Le Monde*, September 16.

Bourdieu, Pierre (ed.) (1993) *La misère du monde*, Paris: Seuil.

C.D. (1995) "L'empreinte d'un enfant de la cité," *Le Provençal*, July 31.

Ceccaldi, Gilbert (1995) Personal interview, Marseilles, October 5.

Certeau, Michel de (1980) "Minorités," in *La culture au pluriel*, Paris: Christian Bourgois, pp. 139–53.

Chancel, Jacques (1995) "Au rythme des tortues de Rachid Khimoune. Une philosophie de la sagesse," *Les écrits de l'image. Les saisons de la télévision*, no. 7, Summer, pp. 106–7.

Chekour, Ouali (1989a) "La nouvelle génération 1989," in *Peintres et sculpteurs algériens de France. La nouvelle génération 1989*, exhibition catalog, Paris: Association Singulier-Pluriel, p. 3.

———— (1989b) "Autour de créateurs algériens de France. La nouvelle génération," interview by Kadid Djilali, in *Peintres et sculpteurs algériens de France. La nouvelle génération 1989*, exhibition catalog, Paris: Association Singulier-Pluriel, pp. 30–1.

Chibane, Malik (1994) "Interview de Malik Chibane," by Florence Maignan, *Macadam Journal*, June, p. 6.

Chouteau, C. (1993) "Il fallait que les choses prennent un sens," *Rachid K: Les enfants du monde*, Aubervilliers: Rachid Khimoune.

Delacampagne, Christian (1985) "Préface. Jean-Jacques Rousseau: Une relecture interminable," in Jean-Jacques Rousseau, *Discours sur l'origine et les fondements de l'inégalité parmi les hommes*, Paris: Gallimard, pp. vii–xxi.

Des photographes en Méditerranée (1987) *Mémoires de l'origine*, exhibition catalog, Marseilles: Des photographes en Méditerranée.

Dewitte, Philippe (1993) "Supplément d'âme," *Arts du Maghreb, artistes de France*, special issue of *Hommes et migrations*, no. 1170, November, p. 2.

Dort, Bernard (1990) "Il leur [aux exclus du langage] donne la parole. . .," *Libération*, July 13.

Dottori, Régine (1995) Personal interview, Marseilles, July 3.

Doukhar, Hédi (1993) "Quels 'beurs,' quel cinéma?" *Arts du Maghreb, artistes de France*, special issue of *Hommes et migrations* no. 1170, November, pp. 14–18.

D.S. (1991) "Rachid K(OOL . . .!)," *Taktik* no. 156.

Farès, Nabil (1995) "Creusé dans le noir," *Penser l'Algérie*, issue of *Intersignes*, no. 10, Spring, pp. 323–33.

FAS [Fonds d'Action Sociale pour les travailleurs immigrés et leurs familles] (1992a) "Quelques enseignements tirés de la période récente," *Supplément à la lettre du FAS*, no. 30, p. 3.

———— (1992b) "Les actions sociales et culturelles," *Supplément à la lettre du FAS*, no. 30, p. 9.

Finkielkraut, Alain (1995) "La propagande onirique d'Emir Kusturica," *Libération*, October 30.

Gatti, Armand (1991) *Armand Gatti: Les films 1960–1991*, Paris: Arcanal.

Jouffroy, Alain (1993) "Derek Walcott, vagabond des Antilles," *L'agonie de la culture?*, special issue of *Manière de voir*, no. 19, Paris: Le Monde diplomatique, p. 91.

Khélif, Kamel (1995) Personal interview, Marseilles, September 7.

Khimoune, Rachid (1991) Interview by Bernard Rousseaux, *Rachid Khimoune: Futur composé*, exhibition catalog, Paris, pp. 51–3.

Lobstein, Pierre (director) (1995) *Parole d'humanité! Marseilles*, documentary film.

Maspero, François (1994) *Roissy Express: A Journey Through the Paris Suburbs*, trans. Paul Jones, London/New York: Verso.

Meyer, Mireille (1991) "Emigré héréditaire," *Couches populaires et pratiques sociales*, Aix-en-Provence: Université d'Aix-Marseilles, pp. 13–17.

Mozziconacci, Jean-François (1992) "La peinture comme moyen," *Djamel Tatah*, exhibition catalog, Montbéliard: Musée et Centre d'Art contemporain de Montbéliard, pp. 2–3.

Murat, Pierre (1995) Film review of *Douce France*, *Télérama*, no. 2393.

Mury, Cécile (1995) Film review of *Hexagone*, *Télérama*, no. 2362.

Poitevin, Christian (1995) "Ben, mon vieux Ben," *Al Dante*, no. 8, p. 21.

Quilichini, Michel Etienne (1993) "L'arche de Chérif," *Hommage à Alvar Aalto*, exhibition catalog, Asnières: Chérif, n.p.

Reynaert, François (1993) "Y a-t-il une culture beur?" *Le Nouvel Observateur*, no. 1517, December 2.

Sadoul, Georges (1990) "Mehdi Charef," *Dictionnaire des cinéastes*, rev. ed. by Emile Breton, Paris: Seuil, p. 62.

Vautier, Ben (1989) "Meziani," in *Peintres et sculpteurs algériens de France. La nouvelle génération 1989*, exhibition catalog, Paris: Association Singulier-Pluriel, p. 19.

Zervudacki, Cécile (1995) "Sortons de nos tribus!" *Libération, October 30.*

PART V
LITERATURE

CALIXTHE BEYALA AND THE POST-COLONIAL WOMAN

Nicki Hitchcott

INTRODUCTION

The theorization of post-colonial femininity is an area fraught with difficulty, particularly as post-coloniality is rejected by critics such as Carole Boyce Davies as yet another master narrative which elides both race and gender (Boyce Davies 1994: 85). Such difficulties are compounded by the ambiguous status of feminism in writing by and about women from the so-called Third World. Feminism has been condemned for its conflation with imperialism (Mohanty 1988: 64; Amos and Parmar 1984), and for producing what Mohanty describes as a monolithic notion of the "Third World woman" (Mohanty 1988: 61). While such critics are right to draw our attention to the ideological holes in our critical frameworks, Spivak offers a more forward-looking perspective with what she describes as "the careful project of un-learning our [academic feminists'] privilege as our loss" (Spivak 1990a: 9–10). Such a self-conscious process should allow the feminist critic to speak with and about other women without erasing either their differences or her own. In a similar way, Sara Suleri stresses the importance of dialogue between feminism and the "Third World Woman," identifying the intersections between gender and race as sites with wider discursive possibilities for the politically loaded category of the "post-colonial woman" (Suleri 1992: 765).

This chapter interrogates the figure of the post-colonial woman through the writing of Calixthe Beyala, a Cameroonian novelist living in Paris, whose seven novels and one essay, along with numerous television appearances and literary prizes, make her the most famous African woman writer in France today.[1]

Recently, Beyala's public profile has become increasingly tainted by controversy over allegations of plagiarism. In May 1996, a Paris court found her guilty of having partially plagiarized the American writer Howard Buten in her novel, *Le petit prince de Belleville*. Later that year, she was accused of plagiarizing the Nigerian author Ben Okri in her most recent award-winning novel, *Les honneurs perdus*. A further twist in what has become known as "l'affaire Beyala" [the Beyala affair] came early in 1997 with new allegations of plagiarism brought against her in the literary review, *Lire* (Assouline 1997). In rejecting these charges, Beyala has presented herself as a victim of racism and misogyny. Although the controversy has placed Beyala's critical reputation in a state of flux, the "Beyala affair" has also helped to hold this African woman writer at the centre of the French literary scene and has challenged the role of both the media and the academy in the creation of the post-colonial writer's reputation. Considering Beyala's status as an emblem of post-colonial writing in France will lead to a discussion of the role of the French literary establishment in the promotion of authors whom Elleke Boehmer has described as "'not quite' and 'in-between'" (Boehmer 1995: 232). Moreover, Beyala's rise to fame in France raises important questions about the incorporation of minority artists into majority French culture. Such incorporation begins to blur the distinction between post-coloniality and neo-colonialism, if we understand post-coloniality as emerging from the experience of colonial oppression, and neo-colonialism as the reworking of that oppression in a post-colonial context.

As well as considering the usefulness of classifying this author as a "post-colonial woman writer," this chapter seeks to map the construction of the post-colonial woman in Beyala's novel, *Maman a un amant* (1993). Like *Le petit prince de Belleville* (1992), the text is narrated by Loukoum, a second-generation Malian boy who lives with his parents in the Belleville district of Paris. However, unlike the first Loukoum novel, *Maman a un amant* gives the post-colonial woman a voice through the presentation of the memoirs of Loukoum's adoptive mother, M'am (short for M'ammaryam). These italicized memoirs take the form of thoughts and feelings addressed to an anonymous friend. They interrupt and fragment the narrative, ultimately setting up a dialogue with the first novel, *Le petit prince de Belleville*, in which similar italicized musings are attributed to Loukoum's father, Abdou.

THE POST-COLONIAL WOMAN WRITER

The fact that Beyala's novels are produced by three prominent French publishers (Stock, Le Pré aux Clercs, and Albin Michel) immediately distinguishes her from other francophone African women writers who are published either in African publishing houses such as Les Nouvelles Editions Africaines, with short print-runs and limited marketing, or with specialist publishers in Paris, like L'Harmattan and Présence Africaine. Indigenous African editions are generally expensive to buy and reinforce the French readership's perception of African women's writing as marginal and foreign. Metropolitan African editions such as L'Harmattan are also more expensive than mass-produced paperbacks and suffer from low prestige and a lack of distribution networks. By contrast, four of Beyala's six novels are now available in a low-priced *livre de poche* [small paperback] format produced by Editions J'ai Lu. These include both *Le petit prince de Belleville* and *Maman a un amant*, demonstrating the popularity of these works with the metropolitan French readership. It is also worth noting that *Le petit prince de Belleville* is the first of Beyala's novels to be translated into English as *Loukoum, the Little Prince of Belleville*, published by Heinemann in 1995.

In 1994, Beyala's novel, *Assèze, l'Africaine*, appeared in bookshops with the red and white *bande de lancement* [publicity wrapper] connoting a best-selling or canonical author in France. Following the success of the two Loukoum novels, Calixthe Beyala had apparently become a name that sells. Indeed, she is one of the few francophone African authors to make her living from writing fiction (Volet 1993: 314). She is also one of the few African authors to employ a literary agent. While the demarginalization of an author like Beyala can be read as a positive indicator of a more global definition of literature in French, the promotion of Beyala as a marketable commodity bears traces of what was the old French colonial policy of assimilation.

It is not without significance that the promotion of Beyala's fiction is marked by an attempt to situate the author in relation to metropolitan France. On the back of the J'ai Lu editions of her novels, Beyala's personal itinerary and her novels are described in the following terms: "Née au Cameroun, elle a fait ses études en Afrique et en Europe, puis s'est installée à Paris. Ses romans nous racontent avec brio le continent africain et la France" [Born in Cameroon, she studied in Africa and in Europe before settling in Paris. Her novels brilliantly describe the African continent and France]. By initially referring to her birthplace in Africa, the publishers seem to be emphasizing the exoticism of the migrant writer. Furthermore, the juxtaposition of Africa and France in the final sentence stresses

the geographical separation of the two locations rather than focusing on their interpenetration, which the Loukoum novels describe. A similiar distinction is made in the title of Jean-Marie Volet's article, in which Calixthe Beyala is identified as "a Cameroonian woman living in Paris" (Volet 1993). The reception and promotion of Beyala's writing point to the dichotomous position of the post-colonial writer in France, since she is simultaneously located inside and outside French national culture. Whereas her publishers, and critics like Volet, highlight her African roots, other French readers de-emphasize these roots, focusing instead on the fact that Beyala is now living in their capital. A glaring example of this emerges when Sylvie Genevoix, writing for *Madame Figaro*, describes Beyala as "Parisienne jusqu'au bout des ongles" [Parisian right down to her fingertips] (Genevoix 1993). Whether she is located inside or outside the national culture of France, Calixthe Beyala has been incorporated into the literary world of Paris and is now identified primarily in relation to it. This kind of identification is ideologically problematic in a post-colonial context, since Beyala represents a minority francophone artist who has been incorporated into mainstream French culture. Recalling the French colonial mission to create French Africans through a policy of assimilation, literary incorporation denies cultural difference and suggests a neo-colonization of post-colonial writing. In the case of Calixthe Beyala, this neo-colonial incorporation is symbolized not only in her packaging but also in the prize she was recently awarded by the Académie française, the self-appointed bastion of high culture in metropolitan France.

What is most fascinating about the French academy's decision to award Beyala the prestigious Grand prix du roman de l'Académie française is the debate which ensued in the French and British media. On November 24, 1996, exactly one month after the award, Pierre Assouline, editor of the French literary magazine, *Lire*, not only accused Beyala on national television of plagiarism, but also accused the academy for endorsing a writer known to be a plagiarist. Moreover, as the alleged victim, Nigerian-born writer, Ben Okri, has pointed out, "If the academicians were really aware of what was going on in the world of literature, they would not have stumbled into this embarrassment" (Seaton *et al*. 1996). Okri's comment makes reference to the fact that the members of the academy's prize jury were evidently not familiar with his novel, *The Famished Road*, which won the Booker prize in 1991. He therefore calls into question the academy's knowledge of post-colonial literature outside France. Whereas Beyala claims that she has been treated with racism and misogyny at the hands of the French press, the "Beyala affair" suggests tokenism and incorporation on the part of the Académie française.

The incorporation of Beyala into the French literary canon leads us to wonder whether the French success of the two Loukoum novels does not rely rather heavily on their classification by French readers as what Boehmer terms "migrant texts." Migrant writers, Boehmer argues, are especially popular with readers and critics in the (ex-)colonial metropolis because "although bearing all the attractions of the exotic, the magical, the Other, they also participate reassuringly in [familiar] aesthetic languages" (Boehmer 1995: 236). In other words, the migrant text combines "new orientalism" (Spivak 1990b: 228) with an appeal to what Gilroy describes as "cultural insiderism" (Gilroy 1993: 3).[2] Like its author, the migrant text is simultaneously inside and outside the majority culture of, in this case, metropolitan France. Indeed, these two novels are far more explicitly francocentric than Beyala's other four texts as the narrative development never leaves French soil: the story unfolds in the eponymous neighborhood of the twentieth *arrondissement* of Paris in *Le petit prince de Belleville*, and in the southern French village of Pompidou – where M'am had gone on holiday – and back to her home in Belleville in *Maman a un amant*. Africa is portrayed as a far-off continent where Malian immigrants have left their wives and where exiles go to die (Beyala 1993: 13, 80). France, on the other hand, is cited by Loukoum's sister, Fatima, as the symbol of personal freedom, where women can swear and sunbathe topless, and daughters are no longer forced to obey their fathers (Beyala 1992: 121; 1993: 55). That is not to say that France is portrayed as a promised land. On the contrary, M'am describes it as a place of suffering and solitude (Beyala 1993: 62). In fact, through the polarization of Africa and France, the text highlights the distance of the Malian immigrants from their roots (both geographical and cultural) as well as the seemingly irreconcilable systems of values in their native and adopted homes.

If we follow Boehmer's succinct definition of the post-colonial writer, then Calixthe Beyala undoubtedly fits the bill:

In the 1990s the generic postcolonial writer is more likely to be a cultural traveller, or an "extra-territorial," than a national. Ex-colonial by birth, "Third World" in cultural interest, cosmopolitan in almost every other way, he or she works within the precincts of the western metropolis while at the same time retaining thematic and/or political connections with a national background.

(Boehmer 1995: 233)

However, the notion of a generic post-colonial writer needs sharpening if we are to apply it more specifically to the post-colonial woman. Drawing on Spivak's concept of a "frontier style" (Spivak 1988: 13), Boehmer describes the distinctive feature of post-colonial women's writing as its "mosaic or composite quality"

(Boehmer 1995: 227). The figure of the mosaic can usefully be applied to Calixthe Beyala's writings which are characterized by a nexus of different cultural contexts, writing styles and speaking positions. On the other hand, whereas critics like Spivak and Boehmer point to the mosaic as a unique feature of the post-colonial text, allegations of plagiarism in the "Beyala affair" have cast doubt on the composite nature of her writings, interpreting them rather as a dislocated patchwork (Assouline 1997). Paradoxically, in this case, the "frontier style" of Beyala's novels has now been used as evidence for challenging the legitimacy of her status as a post-colonial writer. However, specificity is not only found on the level of form: Boehmer also stresses women's focus on the specific features of their existence, a point echoed by Ketu H. Katrak who emphasizes the dual nature of the oppression examined in post-colonial women's texts: "women writers are presenting a new kind of content in their writings – issues which challenge patriarchy and capitalism – and new forms that carry the weight of these concerns" (Katrak 1989: 173).

THE POST-COLONIAL WOMAN'S WRITING

From the outset of *Maman a un amant*, M'am's story is described as "un chemin dont on ignore l'itinéraire" [a journey with an unknown itinerary] (Beyala 1993: 7). In a post-colonial context, this familiar metaphor of the journey connects with what Gilroy has presented as the routes versus roots debate in racial ontology:

Marked by its European origins, modern black political culture has always been more interested in the relationship of identity to roots and rootedness than in seeing identity as a process of movement and mediation that is more appropriately approached via the homonym routes.

(Gilroy 1993: 19)

As an African immigrant woman living in France, M'am's identity is constructed both in terms of her culture of origin in West Africa (roots) and the adopted culture to which she has travelled and through which she is still travelling (routes). Although initially the two poles are diametrically opposed, M'am's sexual infidelity with the white Frenchman, Etienne Tichit, generates a dialogue between these two perspectives, destabilizing the central dichotomy and beginning to create a space for the post-colonial woman.

The identity that M'am assumes in relationship to her roots is initially

constructed according to the patriarchal ideal of what a woman should be, but is gradually reconstructed as a reaction to this ideological construct. Her childhood was infused with the notion that a woman is born kneeling at man's feet, her behavior governed by the belief that women must obey. However, what is striking about M'am's memoirs is that they openly condemn the imposed identity of the African woman as that of a prisoner or slave of a patriarchal system of beliefs (Beyala 1993: 48). On first reading, this condemnation of traditional gender roles seems to contradict the image of traditional wife and mother that M'am initially presents. However, the decision to present M'am's observations as memoirs suggests that they are in fact formulated with hindsight – the holiday and the affair with Tichit are over – and so suggest that M'am's critical awareness of the construction of gender roles is partly a result of her experiences in the southern French village of Pompidou. Yet the use of the present tense also implies that M'am's memoirs are a contemporaneous commentary on Loukoum's narrative – which refers to the same events – producing an intriguing tension between the different voicings of M'am's experiences and views. Ultimately, the contradiction between the two levels of narrative suggests that her identity has been mediated through her physical and emotional journeys. It also emphasizes the degree to which her self-image becomes fragmented and transformed.

Moreover, the metamorphosis of M'am does not surprise the reader as the foundations are already laid in *le petit prince de Belleville* through Abdou's comments on women's evolution and through the French feminist figure of Madame Saddock. Although eventually banished from the Traoré family home, Madame Saddock symbolizes the infiltration of Western ideologies into the once closed communities of African immigrants in France. Abdou explains:

Depuis que les femmes servent de longues rasades d'indépendance dans ma maison, depuis qu'elles boivent de cette sève, j'apprends à ne plus être un homme. Qui suis-je? Un immigré. . . . Je n'ai plus de repère.

Since the women in my house have been serving themselves large measures of independence, since they've been drinking from that sap, I've been learning how not to be a man. Who am I then? An immigrant. . . . I've lost my point of reference.

(Beyala 1992: 169)

Clearly, the metamorphosis of the post-colonial woman has implications for post-colonial masculinity. The exposure of M'am and her co-wife, Soumana, to alternative femininities causes Abdou's masculinity to fall into crisis because it relies on the maintenance of patriarchal definitions of gender identities. Since femininity is no longer fixed, then masculinity is destabilized. Thus, Abdou has

to learn how not to be a man because if woman is no longer defined in relation to man, then the reverse is also true. Abdou needs another Other against which to identify himself. He therefore turns to France and defines himself as an immigrant.

For the women of the house, Madame Saddock's influence is ambiguous. Her decision to report Abdou to the authorities once she learns that he has been illegally claiming child allowances leaves the family in severe financial hardship. However, while Abdou is detained in prison for defrauding the social security system, M'am decides to expand the business of making leather jewelry that Loukoum had started in order to impress his friends at school. M'am develops Loukoum's initiative into a full-scale jewelry company, demonstrating both her business acumen and her financial independence. Thus, on the one hand, the Madame Saddock encounter demonstrates the apparent incompatibility of Western feminism and post-colonial women, in this case because the feminist is blind to the notion of cultural difference and to the economic hardships and legal difficulties faced by African working-class immigrant women in France. While Madame Saddock is informing M'am and her co-wife, Soumana, about women's groups and women's rights, she learns that Soumana is an illegal immigrant and that she and Abdou are not officially married. As far as the French authorities are concerned, M'am is the mother of all Abdou's children.[3] M'am, however, is sterile and simply lent Soumana her papers when the children were born. Madame Saddock's denunciation of Abdou is based on a Eurocentric concept of maternity which privileges the biological mother. Moreover, in spite of her claim to be acting in the two women's best interests, Madame Saddock fails to consider the financial repercussions for both of the wives and for M'am in particular. On the other hand, M'am is presented as empowered by this experience: she throws Madame Saddock out of the family home and challenges her own husband's authority, which she had never before questioned. Furthermore, the conjugal power relationship is ultimately reconfigured when Abdou, finally released from custody, is employed by M'am in her expanded and successful jewelry business.

Thus, the first part of this diptych ends with a mutation of M'am's identity generated by exposure to certain aspects of French culture (in this case, feminism and racism) inside a cultural "contact zone" (Pratt 1992: 6–7). Indeed, the degree of M'am's transformation is emphasized when Abdou asks her to marry him again, suggesting that she has, in fact, become another woman. The marriage proposal is an attempt to fix M'am's new identity. M'am, however, does not accept, thereby resisting fixity and making space for other metamorphoses.

In the second novel, *Maman a un amant*, the juxtaposition of "mother" and

"lover" in the title immediately points to the further transformation of the identity of M'am, a metamorphosis that, if it does not surprise the reader, certainly surprises the African inhabitants of Belleville. The outrage of the African immigrant community when they discover M'am's infidelity is generated by the orthodox view dominant among Muslims that women should remain faithful to their husbands. It is therefore significant that M'am's affair should begin in the southern French village of Pompidou, away from the people of Belleville who tie her to her African roots. It is also no coincidence that her lover is not a Muslim. Indeed, M'am's affair with Etienne is doubly inappropriate for a Muslim woman in that she not only commits adultery, but does so with a non-Muslim man. Thus, through sexual infidelity, Beyala's post-colonial heroine becomes a symbol of roots in crisis as her new routes lead to a shedding of traditional values and the acceptance of new and foreign values on the way.

As her inner self mutates, M'am's external appearance also changes:

Elle va chercher son indépendance jusque dans sa façon de s'habiller, des petites culottes courtes et des robes à fleurs qu'elle exhibe. Mais malgré les apparences, si tu cherches sa personnalité, tu ne la trouveras pas, vu qu'elle se cherche.

She's trying to find her independence, even in the way she dresses, flaunting her skimpy panties and floral dresses. But in spite of her appearance, if you try to find her personality, you won't find it. She's trying to find herself.

(Beyala 1993: 88–9)

To the uninformed observer, M'am's appearance signifies a certain degree of cultural synthesis: a black African woman speaking French and wearing European dress. However, both Loukoum's narration and M'am's memoirs describe M'am's experience of hybridity not as synthesis but as loss of self, as a sense of un-belonging. As she becomes increasingly distanced from her roots, M'am begins to internalize the negative identity of the immigrant woman she had learned from Abdou. In a Fanonian moment of racial/gender alienation (Fanon 1952), she tells Etienne she knows he will never marry her because she is black, ugly, illiterate, and sterile (Beyala 1993: 157), repeating, almost verbatim, the words of her husband (117, 175). Etienne makes no attempt to challenge her, thereby tacitly reinforcing her negative self-image.

For Loukoum, the transformation of M'am's sexuality is expressed as a kind of schizophrenia. She can no longer be reduced to the singular identity of mother and oscillates instead between identities of mother and lover. When M'am laughs with her husband, Abdou, Loukoum describes it as "telle une bonne Négresse" [laughing like a good Negro woman]. When he hears her laughing with her lover,

Loukoum wants to strangle her (81). As she becomes more and more involved with Etienne, M'am gradually begins to mimic Aminata, Loukoum's biological mother, who is a singer and a prostitute. At the birthday party for Madame Trauchessec, the owner of their holiday home in Pompidou, M'am, wearing a sexy dress, sings one of Aminata's songs. The title of the song, "Pas facile d'oublier" [It isn't easy to forget] (83) expresses the permanence of roots, which cannot be replaced by the adopted culture but are mediated through it.

The textual link with Aminata, Loukoum's biological mother, also recalls the fact that M'am is sterile, an issue that resurfaced when Aminata arrived in Belleville to reunite with her son. This link therefore implies that M'am's affair with Etienne is in part a compensation for that aspect of female sexuality which M'am has been denied. The African stigma of the childless woman has followed M'am to France, leading her to identify herself as some kind of androgynous monster: "J'étais un arbre desséché, ou un animal inconnu mi-homme mi femme" [I was a dried-up tree or an unknown creature, half man, half woman] (92). Desexualized, M'am is also defeminized and dehumanized since, according to patriarchal conventions, a desexualized woman is not a woman at all. Etienne's desire for M'am recreates her as a sexualized self but this resexualized identity is subsequently problematized in the text. When the French police arrive at the holiday home to look for M'am who has gone missing, they assume that she is fat with large breasts and is wearing a boubou. In other words, the police categorize her as the Western stereotype of the black African woman. When Abdou then refutes this assumption, he also describes her in terms of her sexual characteristics (her slim waist and small breasts). The police, unable to reduce M'am to a racial stereotype, revert instead to a sexual one, commenting: "Elle doit être bien bonne à croquer, celle-là" [She sounds good to get stuck into] (132). Here the racism and sexism of the police challenge the inference that M'am's resexualization is empowering, since it now denies her autonomous self and allows her to be objectified. This is undoubtedly one of the reasons why the affair with Etienne comes to an end: sexual infidelity is simply one route in M'am's quest for her post-colonial identity. Thus, although the objectification that results from her extra-marital affair can be read as a dead end, M'am's decision to end the affair demonstrates that her identity is not ultimately fixed by this objectification; rather, the experience of it has transformed her. The further she travels away from her roots, the more her traditional identity is challenged and reformulated and the more polyvalent the concept of post-colonial femininity becomes.

As a consequence of her infidelity, M'am decides that she wants to learn to

read and write. Etienne Tichit whets M'am's appetite for learning so that she begins to view her illiteracy as a failing. Although, on the one hand, M'am's decision to learn to read is undermined in the text when it emerges that the literacy classes are partly a ruse for continuing the affair with Etienne, at the same time a link is established between education and sexual freedom. This link is reinforced by the fact that M'am announces her decision while she is preparing the family meal, dressed, in Loukoum's words "comme une vieille pute" [like an old whore] (173). When she eventually goes out, ostensibly to her class, dressed in latex trousers, red nail varnish, and dripping in jewelry, Loukoum declares in a fit of pique that she is not his mother (219). Her identity as mother is temporarily rejected by Loukoum as incompatible with her new behavior. M'am, however, ignoring Loukoum's remark, behaves in a quintessentially maternal way, cleaning Loukoum's wounds and kissing him on the cheek. Here, then, the text contests the essentialism of Loukoum's narration in that M'am is able to combine both maternal and non-maternal codes of behavior. Hence M'am is restored to her position as mother without the loss of her personal space.

Yet, in her own commentary, M'am describes herself as no longer the same nor completely another. She writes:

Il me faut me dépouiller du passé, retourner à l'enfance et récrire l'histoire. Que faire, l'Amie? Ces voies du praticable me sont interdites. J'ai des responsabilités. J'ai des enfants.

I need to rid myself of the past, go back to my childhood and rewrite the story (history). What should I do, woman friend? I'm not allowed to travel down those roads of possibility. I have responsibilities. I have children.

(224)

At this point in the text, M'am is questioning the compatibility of maternity with her personal journey as her children and her responsibilities seem to tie her to her roots. Patriarchy declares that women's routes are mapped out for them in advance. This is why the affair is so attractive: it gives M'am an impression of rootlessness. With her lover, M'am becomes "sans généalogie d'aucune sorte" [without any kind of family tree] (224). However, this rootlessness is only temporary and does not equip her with the tools she needs to assert her own identity.

Reading, on the other hand, offers a route into self-awareness. Notably, it is through an exchange of reading and writing that M'am eventually persuades her son to recognize her autonomous identity. When Loukoum and M'am go to the Chinese restaurant together, M'am reads first the restaurant sign and then the menu:

M'am a lu le nom du restaurant à haute voix avant. Et elle s'est souri et tout lui a souri, et la vie entière entrait par ses yeux, sur un mot prononcé à haute voix. . . . La lecture l'emporte sur le terre à terre digestif. Acte éblouissant. Dépassement de soi.

M'am read the name of the restaurant out loud. And she smiled to herself, everything smiled at her, and the whole of life entered through her eyes with a single word spoken out loud. . . . Reading has the edge over the mundane question of food. It was a dazzling act in which she surpassed herself.

(271)

Here, reading becomes an act of existential transcendence, and the text suggests that, through reading, M'am's identity is once again transformed. Inside the restaurant, Loukoum, refusing to speak to M'am, communicates with her in writing. This scene signifies the renegotiation of M'am's identity in the eyes of Loukoum who, adhering to patriarchal criteria, indirectly condemns her as a non-person, describing her as: "Femme de personne. Mère de personne" [Nobody's wife. Nobody's mother] (271). Since Loukoum initially limits M'am's identity to these two roles, the fact that she no longer consents to play them means that she no longer has an identity. Only after the written exchange does Loukoum finally begin to "la regarder avec les yeux du coeur" [look at her with heartwarmed eyes] (271). From then on, his gaze is no longer the appropriating gaze of the "seeing-man" (Pratt 1992: 7) but the generous gaze of reciprocity and recognition.

What is also interesting about the restaurant scene is that, whereas Loukoum writes notes to M'am, she replies with spoken words. In other words, although M'am is empowered by her literacy, she chooses to articulate her experience through speech and not through writing. Even her memoirs are presented as oral musings inside M'am's head, which somehow become magically translated into French and transposed into written words on the novel's pages. By addressing the memoirs to M'am's anonymous woman friend, the text stresses the need for an interlocutor. Moreover, the use of oral elements such as repetition, exclamations, and constant questioning emphasizes the importance of dialogue, not only with "l'Amie" [the woman friend], but also with M'am herself. Whereas orality can be read as an exotic marker of otherness, Beyala's decision to combine the oral elements of M'am's discourse with an emphasis on the acquisition of literacy suggests a more positive connection between the construction of post-colonial femininity and the oral tradition, which Katrak has identified as one of the "many empowering elements of culture." In her article, Katrak writes that post-colonial women writers use these elements as "effective tools of resistance against neocolonial tendencies and against women's particular oppressions" (Katrak 1989: 178). Katrak's equation of the oral tradition with resistance explains the fact that,

in Beyala's text, M'am formulates her memoirs in Bambara. If, as the reader infers, the friend to whom the memoirs are addressed is a feminist, then she must also either be a Bambara or at least able to communicate in that language.

The language of the memoirs raises another important question in that they are presented in French as translated by Loukoum (Beyala 1993: 8). Given the emphasis on M'am's literacy, the decision to present her words as a translation could be read as the appropriation of her discourse by both patriarchy (represented by Loukoum) and by the majority culture (France). Such a reading follows the line that Beyala's texts are mediated through the language of the French majority. However, the translation also emphasizes resistance, as M'am's musings and memories are not initially formulated in French. This question of choice of language also points to the issue of mediation, a key component in the construction of post-colonial femininity. Just as Beyala's own Frenchification creates a new, post-colonial space, so the translation of M'am's thoughts represents a "border crossing" (Humm 1991: 2), which facilitates dialogue between cultures.

Mediation inevitably involves compromise. Not only is M'am's discourse mediated through her son's translation, but also her sexual identity is mediated through compromise and conformity. On one level, the return to the family home seems to imply a denial of the self in that M'am appears simply to rejoin the ranks of the socially acceptable. The final scene presents a silent, guilty woman who falls into her husband's arms and is welcomed back into the community. However, this scene is prefaced by M'am's final memoir in which she explains that she has returned for the sake of the children and that she has decided to remain silent. M'am's routes are no longer prescribed; they are freely chosen. Paradoxically, a compromised self-image allows her to assume an autonomous identity. She explains: "C'est pour mieux être moi que j'ai accepté cet ultime rôle. Une armure qui devrait désormais s'adapter aux êtres et aux circonstances" [It's so that I can better be myself that I've accepted this final role. It's an armor, which from now on should adapt to people and to circumstances] (Beyala 1993: 281). Here the image of a mutating outer shell expresses the constant shifts and adaptations of the post-colonial self and stresses the need for immigrant women to protect themselves from the compound nature of their oppression.

There is, then, an illusion of synthesis in the novel, demonstrated by M'am's reintegration into family and community, and emphasized by her metaphorical rebirthing as "Maryam" rather than "M'ammaryam." Superficially, it appears that, for the post-colonial woman, European routes are not incompatible with African roots if they are reconciled through compromise. However, M'am's constant

interrogation of her identity expressed as the repetition of "Qui suis-je?" [Who am I?] throughout her memoirs connotes an identity that remains unresolved and is constantly mediated and transformed through the nature of the post-colonial experience. Like Loukoum's friend, Alex, M'am becomes "sans provenance ni étiquette" [with neither country of origin nor label] (Beyala 1993: 12), demonstrating that post-colonial femininity is not singular but plural and in a constant state of flux.

Whilst the author's own reputation has been called into question by the "Beyala affair," the Loukoum novels stand as revealing products of post-colonial France. This context is portrayed as a world in which boundaries are constantly shifting and women continuously required to renegotiate their identities. M'am is forever repositioning herself in order to resist fixity. In this way she becomes a "migrating subject," which "asserts agency as it crosses borders, journeys, migrates and so re-claims as it re-asserts" (Boyce Davies 1994: 37). M'am's experience is not a celebration of hybridity; rather, it is a strategy for coping with the omnipresent forces of (neo-)colonialism and patriarchy. In this respect, Beyala's text connects with Spivak's view of post-coloniality as "a crisis-managing ensemble of cultural explanations" (Winant 1990: 95), a definition that can incorporate an infinite number of migrating agents, including the gendered and historicized subject that is the post-colonial woman.

NOTES

1 For example, in May 1993, following the publication of *Maman a un amant*, Beyala appeared twice on France 2 in "Matin bonheur" and "Le journal de 20 heures." The book was also reviewed in *Amina*, *Bonne Soirée*, *Elle*, *Jeune Afrique*, *Le Parisien*, *Madame Figaro* and *Télé 7 Jours*.

Calixthe Beyala's first novel, *C'est le soleil qui m'a brûlée* was awarded the Prix du roman africain. She won the Grand prix littéraire de l'Afrique noire for *Maman a un amant*, and both the Prix François Mauriac de l'Académie française and the Prix Tropiques de la Caisse Française de Développement for *Assèze l'Africaine*. In 1994 Beyala was awarded the Prix du meilleur auteur africain, and in 1996 received the Grand prix du roman de l'Académie française for her most recent novel, *Les honneurs perdus*.

2 Gilroy takes the term "cultural insiderism" from Werner Sollors's *Beyond Ethnicity* (Gilroy 1993: 225 n. 1).

3 Since the reform of French nationality laws in 1993, reunification of immigrant families in France has been restricted to only one spouse and one set of directly dependent children. Before 1993, however, co-wives of immigrants from former French colonies were permitted to stay with their husbands, provided that they bore children while in France (Hargreaves 1995: 114–16).

REFERENCES

Amos, Valerie, and Pratibha Parmar (1984) "Challenging imperial feminism," *Feminist Review*, no. 17, pp. 3–19.

Assouline, Pierre (1997) "L'affaire Beyala rebondit,"*Lire*, February.

Beyala, Calixthe (1987) *C'est le soleil qui m'a brûlée*, Paris: Stock.

——— (1988) *Tu t'appelleras Tanga*, Paris: Stock.

——— (1990) *Seul le diable le savait*, Paris: Le Pré aux Clercs.

——— (1992) *Le petit prince de Belleville*, Paris: Albin Michel.

——— (1993) *Maman a un amant*, Paris: Albin Michel.

——— (1994) *Assèze, l'Africaine*, Paris: Albin Michel.

——— (1995) *Lettre d'une Africaine à ses soeurs occidentales*, Paris: Spengler.

——— (1996) *Les honneurs perdus*, Paris: Albin Michel.

Boehmer, Elleke (1995) *Colonial and Postcolonial Literature*, Oxford: Oxford University Press.

Boyce Davies, Carole (1994) *Black Women, Writing and Identity: Migrations of the Subject*, London/New York: Routledge.

Fanon, Frantz (1952) *Peau noire, masques blancs*, Paris: Seuil.

Genevoix, Florence (1993) "Portrait: Calixthe Beyala," *Madame Figaro*, July 22.

Gilroy, Paul (1993) *The Black Atlantic: Modernity and Double Consciousness*, London: Verso.

Hargreaves, Alec G. (1995) *Immigration, "Race" and Ethnicity in Contemporary France*, London/New York: Routledge.

Humm, Maggie (1991) *Border Traffic: Strategies of Contemporary Women Writers*, Manchester/New York: Manchester University Press.

Katrak, Ketu H. (1989) "Decolonizing culture: toward a theory for postcolonial women's texts," *Modern Fiction Studies*, vol. 35, no. 1, pp. 157–79.

Mohanty, Chandra (1988) "Under western eyes: feminist scholarship and colonial discourse," *Feminist Review*, no. 30, pp. 61–88.

Pratt, Mary Louise (1992) *Imperial Eyes: Travel Writing and Transculturation*, London/New York: Routledge.

Seaton, Max, Dan Glaister and Alex Duval Smith (1996) "Famished Road feeds French book fever," *Guardian*, November 26.

Spivak, Gayatri Chakravorty (1988) *In Other Worlds: Essays in Cultural Politics*, London/New York: Routledge.

——— (1990a) *The Post-Colonial Critic: Interviews, Strategies, Dialogues*, ed. Sarah Harasym, New York/London: Routledge.

——— (1990b) "Poststructuralism, marginality, postcoloniality and value," in Peter Collier and Helga Geyer-Ryan (eds), *Literary Theory Today*, Ithaca, NY: Cornell University Press, pp. 219–44.

Suleri, Sara (1992) "Woman skin deep: feminism and the postcolonial condition," *Critical Inquiry*, no. 18, pp. 756–69.

Volet, Jean-Marie (1993) "Calixthe Beyala, or the literary success of a Cameroonian woman living in Paris," *World Literature Today*, vol. 67, no. 2, pp. 309–14.

Winant, Howard (1990) "Gayatri Spivak on the politics of the subaltern," *Socialist Review*, vol. 20, no. 3, pp. 81–97.

RESISTANCE AT THE MARGINS

Writers of Maghrebi immigrant origin in France

Alec G. Hargreaves

INTRODUCTION

Post-colonial literature is widely perceived to have entered a new phase during the last twenty years. Dominated in earlier decades by anti-colonial imperatives closely allied with the struggle for national independence, post-colonial writing is today more commonly associated with conditions of exile, migration, and nomadism (cf. Lionnet and Scharfman 1993). The exemplary figures of both waves spent their formative years in (ex-)colonial territories, often traveling to the (ex-)metropolis for the first time as young adults, in many cases as students.[1] Second-generation Maghrebis in contemporary France, commonly referred to as "Beurs,"[2] do not fit neatly into either of these categories. Raised and in most cases born in France when formal decolonization was already largely complete, they are generally far removed from the nationalist climate in which early post-colonial writing was forged. Neither can they be described in any literal sense as exiles, migrants, or nomads. Far from being expatriates, they live and write primarily within the country where they were born and brought up. As the children of international migrants (mainly Algerians), they are, of course, heavily marked by the legacy of migration. Their marginalization by powerful forces within French society sometimes induces feelings of exile, and their textual explorations of personal and collective identities often display strategies of displacement which in some ways resemble nomadism. Yet at root, as Mehrez (1993) has argued, most of these writers feel an intuitive sense of belonging in France — though not, it

should be said, of belonging with hegemonic notions of Frenchness – which sets them apart from expatriate authors. Unlike exiled or nomadic writers, for whom France is a second or sometimes a third home, most second-generation Maghrebi authors see France as their primary territorial attachment, even when – as is often the case – exclusionary obstacles rooted in memories and attitudes inherited from the colonial period are placed in their way.

The marks of this movement towards incorporation are visible in three key locations: the diegetic "content" of these narratives (i.e. the events which they recount), the positions from which they are narrated, and the audience which they address. In theory, while writing in French, authors of immigrant origin might represent events, adopt narrative positions, and address readers entirely disconnected from mainstream French society, thus producing what Deleuze and Guattari (1975) call a "minor" literature. In practice, their writings are far removed from this separatist model.

At the level of diegesis, most of the writings produced by authors of immigrant origin chart the itineraries of young people moving between the different cultural fields brought into contact by international migration. Tensions and contradictions between these fields frequently give rise to difficult choices, which are sometimes dramatized in the form of full-scale identity crises. However, the frequency and extent of these crises should not be exaggerated. For most young Maghrebis, the two most difficult moments come when they are young children, with their entry into the French school system, and during adolescence, when they seek to exercise personal freedom and to prepare a place for themselves within adult society. During infancy, the children of immigrants are exposed primarily to the culture of their parents. When they begin school, it often comes as a shock to find that the language and traditions which they have learned within the family home have no purchase outside its walls.[3] They rapidly acculturate, however, to the point where French generally displaces Arabic or Berber as their "natural" everyday tongue; the Islamic teachings of their parents are also displaced in many cases by the more secular values dominant in France. Unlike the trauma of school entry, characterized by inner cultural confusion, the crises of adolescence are more likely to arise from contradictions between the positions adopted by young Maghrebis on the one hand and the attitudes of their parents and/or members of the majority French population on the other. More often than not, the conflicts stem from their desire to establish personal relationships without regard for ethnic differences, a desire which is perceived as threatening by adults on both sides of the ethnic divide.[4]

In the writings of second-generation Maghrebis, the position from which the

narrator speaks is seldom defined explicitly. Not uncommonly, it shifts at different points in the text. At times, the narrator appears to speak from within the minority community; elsewhere, he or she looks upon it from the outside. Almost always, however, his or her vision is informed by the underlying conviction that the dividing line between "inside" and "outside" is specious.[5] Exclusionary reflexes among the majority French population undoubtedly marginalize Maghrebis, and some migrants long for enclosure within their ancestral culture, but most of their descendants see the minority and majority populations as inextricably inter-twined. For them, the Maghrebi presence in France has to be seen as part of, rather than apart from, the rest of French society.

Their bi-cultural condition enables the narrators of these texts to traverse the ethnic divide, serving as interpreters between the minority and majority populations. While raised as children in cultural traditions transplanted from the other side of the Mediterranean, as adults they see themselves as speaking not only from within but also to French society in the widest sense. Numerous descriptions or explanations are furnished for the benefit of readers unfamiliar with the experiences of the Maghrebi population in France. Explanations of everyday French customs are extremely rare; in most texts it is assumed that the reader is already fully conversant with them. Thus almost without exception, the primary readership addressed by these texts is implicitly located within French society. Although this may include acculturated readers of minority ethnic origin, the majority population is clearly dominant among the target readership.[6]

This triple movement towards a French cultural orbit, visible at the levels of diegesis, narration, and reception, carries an obvious danger of recreating the hegemonic relationships characteristic of the colonial period. The remainder of this chapter explores some of the strategies employed by writers of immigrant origin in seeking to resist this outcome. I will begin by discussing some common strategies for asserting the dual legitimacy of distant origins along with the right to participate in French society, and will then go on to discuss some rare cases of outright resistance to incorporation.

TOWARD INCORPORATION

A recent autobiographical essay by the rock-singer and novelist Mounsi, who joined his immigrant father in France at the age of eight, undoubtedly displays elements of a migrant or nomadic consciousness:

Je repousse ceux qui veulent faire de moi un Français de France ou un Algérien d'Algérie. Elevé dans un monde bigarré, tissé d'influences kabyles et imprégné de culture française, je revendique aujourd'hui une conscience cosmopolite, celle des immigrés du monde.

L'immigration constitue à mes yeux un ensemble de pères, de mères, de frères, de soeurs pour qui j'éprouve une tendresse mêlée de respect. Mais j'ai aussi besoin de violer ce respect au travers de mots, fussent-ils scandaleux, et je refuse toute appartenance si le débat restreint l'exigence fondamentale de ma réalité humaine.

I refuse to accept it when people try to label me as either purely French or purely Algerian. I was brought up in a hybrid world, impregnated with Kabyle influences and French culture, and now I stand for a cosmopolitan way of thinking, which is that of immigrants the world over.

In my mind, immigration means a multiplicity of fathers, mothers, brothers and sisters for whom I feel affection and respect. But I also need to transgress that respect through words, even if they are regarded as scandalous, and I refuse any form of belonging that limits the reality of my needs as a human being.

(Mounsi 1995: 39)

Like most second-generation Maghrebis, Mounsi rejects simplistic binary choices according to which he must be *either* French *or* Algerian.[7] He is culturally hybrid, and sees himself as part of a global network of relationships stretching far beyond the political boundaries of individual states. Black and Native Americans are regarded as natural reference points alongside the Maghreb and the Middle East (Mounsi 1995: 85). Yet the balance between these different elements is by no means equal. Mounsi's humanist values owe more to France, and in a wider sense to the West/North, than to Algeria and the East/South. While respecting his Muslim forebears, Mounsi casts off their religion, declaring himself an atheist (Mounsi 1995: 35). It is true that he describes the act of writing as "le seul acte de résistance capable d'affirmer mon identité: celle d'un enfant du 'Maghreb périphérique'" [the only act of resistance through which I can assert my identity, that of a child of the "Maghrebi periphery"] (Mounsi 1995: 42). But the periphery from which he writes is located on French soil, in the sprawling *banlieues*[8] where Maghrebi and other minorities are concentrated. He writes in French, and while vigorously asserting his "légitime différence" [legitimate difference] (Mounsi 1995: 38), consciously addresses a French audience (Mounsi 1995: 12, 98). Though tempted by separatist impulses, this self-declared atheist asserts the right of Muslims to a legitimate place *within* French society (Mounsi 1995: 115), and implicitly stakes a similar claim for himself.

If Mounsi is reluctant to formulate that claim explicitly, this is in part because, unlike most second-generation Maghrebis, he has direct memories of a childhood home across the Mediterranean, and no less importantly because, as a politically bounded space, France is marked by a long history of overseas colonization and

state-sponsored myths of cultural homogeneity. Most Algerian immigrant workers supported the struggle against colonial rule, and their children too are generally reluctant to identify with the French state, which for over a century sought to deny Algerian nationhood. But the corrupt, authoritarian regime which has ruled post-independence Algeria is also felt to hold few attractions. Deeply alienated from both the French and Algerian states, Mounsi and other young Maghrebis nevertheless have no practical alternative but to live in one or other national territory. Most choose to live in France. While determined to make their future there, they remain suspicious of the French state (though they often take French nationality for practical purposes such as travel) and are deeply resistant to mono-cultural concepts of national identity. Averse to national boundaries while inevitably residing within them, they cultivate supra- and sub-national identities: diasporic and global on the one hand (exemplified in Mounsi's "cosmopolitan way of thinking"), local on the other (seen most obviously in his identification with the *banlieues*) (cf. Hargreaves 1993; Rosello 1993).

The positions from which their texts are narrated are often elusive, deliberately playing on ambiguity and imprecision. Irony and humor are among the most characteristic features of these works (Achour 1990; Delvaux 1995). They draw their effects from the juxtaposition of ordinarily distinct or opposed positions, often by combining them within the discourse of a single but multivoiced narrator. The opening lines of Azouz Begag's second novel, narrated by his slightly fictionalized alter ego, Béni, typify this dynamic:

Noël et son père barbu ne sont jamais rentrés chez nous, et pourtant Dieu sait si nous sommes hospitaliers! . . . Et tout ça parce que notre chef à nous c'est Mohamed. Dans son bouquin, il n'avait pas prévu le coup du sapin et des cadeaux du 25 décembre. Un oubli comme celui-là ne se pardonne pas facilement. On aurait presque envie de changer de chef, du coup, pour faute professionnelle!

Alors, oubligi, pour faire comme tout le monde, mon père ne voulait pas entendre parler du Noël des chrétiens. . . .

Heureusement, il y avait le comité d'entreprise de mon père qui pensait à nous chaque année. . . .

Quelques jours avant le grand gala, mon père ramenait à la maison les bons de jouets à échanger pendant la fête. Il y en avait un pour chacun. C'était le plus grand moment de l'année, celui où, avec mes frères et mes soeurs, nous nous sentions vraiment proches des Français. De leurs bons côtés.

The bearded wonder, old Father Christmas and co., never visited us, and Lord knows, we're a hospitable lot! . . . All because our boss is Mohammed. There's nothing in his little book about Christmas trees and presents on December 25. An oversight like that isn't easy to forgive. It makes you feel like finding a new boss, one who's more on top of his job.

So, not wanting to stand out from his friends – doasyertold – my father refused to have anything to do with Christmas. . . .

Fortunately, the works committee in the factory where my father worked remembered us each year. . . .

A few days before the big event, my father would bring home the vouchers which were to be exchanged for toys during the works party. There was one for each of us. It was the highlight of the year, the moment when my brothers and sisters and I felt really close to the French – or, at any rate, close to the right side of them.

(Begag 1989: 7–8)

While identifying himself at one level as belonging to a Muslim immigrant family (through the repeated use of the "nous" form), the narrator-protagonist at the same time distances himself from the Islamic heritage of his father not only by stating his frustration at being excluded from Christmas celebrations but also by the deeply secular and highly ironic tone in which he speaks of Mohammed ("notre chef à nous"), the Koran ("son bouquin"), and the Prophet's alleged shortcomings (his "faute professionnelle"). Béni stands both within the Maghrebi minority, exposing it to the gaze of the majority population, and at the same time outside, observing it from a vantage point close if not identical to that of the implied reader.

For the young Béni, the French-dominated world outside the family home holds greater attractions than can be found within its walls. At the works Christmas party, handicapped in a children's quiz by his parents' ignorance of French popular songs, Béni wins a prize by appropriating an answer whispered to another boy by his French mother. Later, as a teenager, Béni has his sister take a flat iron to his hair to remove his natural dark curls in the hope of concealing his Maghrebi origins from a beautiful blonde girl with whom he has fallen in love. Her name, highly symbolically, is France. The climax of the novel comes when he is barred from entry by the racist operators of a night club in which France has promised to meet him. In his anger, Béni rubs his hair in a carpet of snow lying out the street, seeking thus to restore his curls, and imagines himself beckoned into the heavens by a ghostly figure who calls: "Béni ! Béni ! Allez, viens. Résiste" [Béni! Béni! Come with me. Resist] (Begag 1989: 173). This call to resistance apparently signals the possibility of Béni reverting to his Maghrebi roots in order to find therein the sense of dignity and social inclusion denied to him by widespread racism among the French population. Yet such a reversion would be far from simple, for Béni has internalized French cultural norms to the point where they are not simply borrowed as instrumental means to an end – as during the children's quiz several years earlier – but to a large extent embraced as core values in their own right.

The desire to make France his girlfriend is emblematic of a wider desire on

Béni's part to achieve personal success within mainstream French society. This does not, however, imply any ideological or political commitment to hegemonic notions of the French nation-state. Even while speaking in a voice imbued with French secularism, Béni makes an ironic allusion to the darker, racist side of French society at the end of the opening passage quoted above, when he talks about wanting to get close to the French – or at rate, close to the "right side" of them. Like the narrators and protagonists of other novels by young Maghrebi authors, Béni knows full well that France has a history of colonial oppression and remains deeply impregnated by racist attitudes which threaten to block his personal advancement. If, in his desire for incorporation, Béni is at times prepared to conceal his Maghrebi origins, the text as a whole engages in a more subtle and less self-effacing game. While we see in the opening pages, quoted above, a greater identification with the values of French secularism than with those of Islamic Algeria, the cultural baggage brought to France by Maghrebi immigrants is established from the outset as a constituent element of Béni's background. The voices of those immigrants are heard directly in scattered transliterations of their accent (in the opening passage, "oubligi" in place of "obligé"), which are incorporated into Béni's polyphonic discourse. To the extent that Béni penetrates and becomes part of French society, he does not simply internalize and reinforce pre-existing norms (though he undoubtedly does this to a considerable degree), but also adds to them – even if only at a secondary level – markers which are drawn from his Maghrebi heritage. In staking a claim for themselves within France, second-generation Maghrebis are thus engaged in subtly modifying the constituent elements of France itself.

Though relatively secondary in most of these texts, memories of the colonial period play a significant role in signaling the roots of the Maghrebi presence in French history, which go back to the nineteenth century and beyond. A few of these authors spent their early childhood in North Africa before emigrating to France with their parents in the late 1950s or early 1960s, when the Algerian war of independence was in its final phase. Childhood memories of Algeria during this period are briefly drawn on by writers such as Charef (1983: 112), Kenzi (1984: 11–20), and Kettane (1985: 21, 47, 83), and more substantively by Arriz Tamza (1993). Nationalist forces fighting in Algeria drew strong support from migrants in France, who by the same token were regarded with deep distrust by French officials and the public at large. A considerable number of narratives by second-generation Maghrebis briefly recall this aspect of the conflict. A recurrent reference point is the night of October 17, 1961, when thousands of unarmed Algerian migrants marched through the streets of Paris in defiance of a curfew

imposed on them by the chief of police. The march was repressed with savage brutality. Dozens of Algerians (the precise number is not known) are believed to have died at the hands of the police, who threw some of their victims into the river Seine. These and related events involving the migrant population during the war of independence are alluded to in works such as those of Kettane (1985: 9–23), Mehdi Lallaoui (1986: 158–60) and Mounsi (1995: 21–33), and are given more substantive treatment by Kamal Zemouri (1986), Tassadit Imache (1989) and Jean-Luc Yacine (1995).

Information about the killings of October 1961 was systematically censored by the French authorities, and it is only very recently that French historians have begun to explore what was previously a taboo subject (Einaudi 1991). In voicing memories habitually repressed by the former colonial power, textual representations of these events constitute an act of resistance to the discourses of (neo-) colonialism. At the same time, they draw attention to the fact that Algerian settlement in France has a history stretching back far beyond its emergence into the political and journalistic limelight during the 1980s. No less importantly, they remind the reader of a time when French statesmen and army officers (among them Jean-Marie Le Pen) were fighting to keep Algeria and its inhabitants French. These references serve therefore not only to recall aspects of the French national experience that are customarily papered over but also to de-exoticize the Maghrebi Other. If France wanted to keep North Africa French, can its inhabitants really have been as fundamentally alien as is frequently supposed?

The *harkis*, Muslim auxiliaries who fought in support of the French against the nationalist insurgents in Algeria, are a living embodiment of this historical irony. Many *harkis* were massacred by triumphant nationalists when independence came in 1962. Those who were able fled the country, resettling in France. Today, they and their descendants are an embarrassing reminder of the war of independence, and often fall victim to the same racist attitudes that are turned against economic migrants and their families, with whom they are not infrequently confused. This irony is explored at length by Mehdi Charef in his second novel, *Le Harki de Meriem* (1989), which turns on the racist killing of Sélim, the son of a *harki*, in the mid-1980s. Born in France, Sélim has topped the list in national examination results for the French language, holds French nationality and has a father who a quarter of a century earlier lost his home in Algeria because he had fought unsuccessfully to keep the country French. Had he been foreign, Sélim's assailants would have merely roughed him up. As one of them explains, it is his claim to French identity that leads them to kill him: "On te fait la peau, on ne veut pas de basanés dans les mêmes registres que nous, Bicot tu es, Bicot tu resteras" [We're going to do

you in. We don't want any darkies on our membership list. You're a bloody Arab, and always will be] (Charef 1989: 28).

Charef's novel, like those of other second-generation Maghrebis, amply demonstrates the absurd and unjust nature of this exclusionary concept of Frenchness. Selim is French in everything except his ethnic origins. Those origins lend an additional dimension to conventional notions of Frenchness without in any way subtracting from them. In incorporating this dimension in their works, authors of immigrant origin seek to widen the space of French identity and to locate themselves within it. This is not to say that they identify solely with this widened concept of Frenchness. They are aware of also belonging in part to diasporic communities whose centers are located outside France, and at the same time they participate through the mass media in increasingly global forms of American-dominated popular culture (cf. above, Hargreaves, Chapter 5). While their cultural hybridity cannnot be reduced to any simplistic notion of national identity, there is nevertheless a clear realization among most of these writers that they have to work within, rather than outside, the complex dynamics that are reshaping the cultural contours of France.

RESISTANCE TO INCORPORATION

A few narratives by writers of Maghrebi immigrant origin seek to take an alternative, nationalist route. The clearest instance is Zemouri's *Le jardin de l'intrus* (1986). Like the author, the narrator-protagonist, Lamine, was born of Algerian immigrant parents in the northern suburbs of Paris in 1941. The bulk of the narrative describes his adolescence and early adulthood, which are contemporaneous with the Algerian war of independence, in which the family vigorously supports the nationalist Front de Libération Nationale (FLN). At the end of the novel, following his father's death, Lamine sees in Algerian independence an opportunity to flee the animosity surrounding North Africans in France by resettling in Algeria. The text itself was written by Zemouri after settling in Algeria, where it was published in 1986. Unlike the vast majority of narratives by authors of immigrant origin, which are written and published in France, Zemouri's novel clearly targets an Algerian readership, to whom it serves up stereotyped nationalist rhetoric of a kind that fits readily with the party line of the state-owned publishing house on whose presses it was produced. In moving from the hostile gaze of French society to the glazed clichés of post-independence

Algeria, Zemouri's textual practices accrue few benefits.

It was not until the 1950s that significant numbers of North African immigrant families began to settle in France. Most second-generation Maghrebis were therefore born at least ten or fifteen years later than Zemouri. By the time they reached adulthood, the high hopes of material improvement and social justice which had accompanied the Algerian revolution had turned to bitter disillusion in the face of the discredited regime which has held a monopoly of power since independence. Whatever their tribulations in France, most young Maghrebis are now far more cautious than was Zemouri in contemplating resettlement. Stories of failed attempts at resettling in the Maghreb are legion (see, for example, Tadjer 1984; Bouzid 1984: 35–6; Kettane 1985: 93–121). Even Sakinna Boukhedenna, who cultivates a vigorously nationalist discourse while in France, changes her tune when she sets foot in Algeria. The narrative form – that of a private journal – chosen by Boukhedenna appears to extricate her from serving the needs of a French audience, for private journals are, in principle, written for oneself, rather than for others. In places Boukhedenna's thoughts are addressed to an unnamed narratee, whom the author privately envisaged as an "homme arabe idéal" [idealized Arab man],[9] thus indicating that if her words were to be shared with others, her preference would be for Arab rather than French readers. Similarly, at the levels of diegesis and narration she vigorously asserts her Arab and Algerian identity as part of a continuing struggle against French colonization:

Je suis Algérienne, colonisée culturellement, mais je ferai tout pour retrouver mes racines. Si je les appelle, elles m'appelleront. Je cherche des vraies racines, pas celles que me proposent les Arabes. Ils veulent que je prouve mon arabité en me cloîtrant. Jamais. Je cherche la vraie culture arabe qu'eux-mêmes ne connaissent pas. Je ne veux pas respecter l'honneur du père, ni du frère. Je suis Arabe.

I am an Algerian. I'm a victim of cultural colonialism, but I'll do everything in my power to get back to my roots. I want real roots, not the ones offered by Arabs who want me to prove my Arabness by locking myself away. I want authentic Arab culture, and they know nothing about it. I'm not here to uphold my father's or my brother's honor. I am an Arab.

(Boukhedenna 1987: 71)

This seemingly uncompromising assertion of Arab identity is implicitly disrupted by Boukhedenna's denunciation of France for imposing a different culture upon her, enunciated simultaneously with her refusal to accept the models of Arab tradition proposed by Arab men. Like most second-generation Maghrebis, Boukhedenna speaks and writes only in French, and her fiery blend of feminism and Marxism is difficult to reconcile with mainstream Islamic teachings. Born in

France, she learns some basic Arabic at the age of twenty by attending extra-mural classes in preparation for her first trip to Algeria, but feels deeply out of place during the visit, refusing to accept the subordinate role traditionally expected of Muslim women. Impatient to leave Algeria, she dreams of building an island in the middle of the Mediterranean where second-generation Maghrebis might at last find peace (Boukhedenna 1987: 103), but in the real world she settles for France as the lesser of two evils:

La France est raciste, mais en France je peux vivre seule sans mari, sans père, mère, et la police ne m'épie pas tous les jours. Je peux crier, "non" au racisme, "non" à l'exploitation de la femme, je me sens un peu plus libre que sur ma terre.

France is racist, but at least in France I can live alone without a husband, father or mother, and the police aren't spying on me every day. I can shout "no" to racism, "no" to the exploitation of women; I feel more free in France than in my home country.

<div align="right">(Boukhedenna 1987: 100–1)</div>

Thus even nationalistically minded young Maghrebis appear condemned to seek their future in France.

This tragic paradox has been brilliantly – and humorously – explored by Farida Belghoul in what to date remains one of the finest pieces of writing by a second-generation Maghrebi. Anxious to resist the erosion of her Maghrebi heritage, Belghoul is deeply conscious of the dangers inherent in writing for a French audience:

L'audience, en soi, est une victoire mais j'ai le sentiment que la définition à l'égard du milieu d'adoption l'emporte et que dans ce rapport à l'extérieur, les choses se perdent. . . . Mon problème est de maintenir les relations avec ce milieu d'adoption, tout en lui opposant un milieu de contre-référence. Ce milieu d'adoption est conscient comme nous du "choix": céder ou pas. Ça sonne guerrier, puisque le milieu d'adoption exprime le désir de nous digérer et la résistance à cette voracité prend parfois les allures d'une guerre.

Getting a hearing is a kind of victory in itself, but I can't help feeling that too many things are defined in terms that suit that outside audience, losing a great deal of our own inner experience. . . . The problem I face is how to relate to the outside while at the same time maintaining the integrity of my countervision. The outside knows what is at stake: capitulation or resistance. It sounds warlike. The outside wants to swallow us up, and resisting that voracity is sometimes like fighting a war.

<div align="right">(Belghoul 1985: 19)</div>

In her novel, *Georgette!* (1986), Belghoul presents the experiences of a seven-year-old girl, born in France to Algerian immigrant parents, as she learns to write at

school. To comply with the instructions of her teacher, the girl is obliged to jettison the teachings of her father, and she comes to see in the schoolmistress "une cannibale [qui] mange les grenouilles et me bouffe jusqu'à la moelle" [a frog-eating cannibal gobbling me up] (Belghoul 1986: 130). In a literary *tour de force*, the text traces the girl's schizophrenia as her mind shifts backwards and forwards between the competing cultures of France and Algeria.

Although the girl is too young to understand the concept of nationalism, this is implicitly attached to the struggle in which she is engaged through the figure of her father, for whom she feels an affection that is never present in her dealings with the teacher. A veteran of the struggle for Algerian independence, the father is deeply distrustful of the French state, and sees in its educational system a means of expropriating him of his own daughter. In writing *for* the French teacher, she is felt in effect to write *against* her Algerian father. By writing in French, the author herself is exposed to a parallel risk. Belghoul seeks to counter this by casting the text in the form of stream-of-consciousness narration. The text is thus presented as a transcription of the girl's inner thoughts, which have no narratee other than the girl herself, still less any implied audience. In reality, the author skillfully allows the (essentially French) audience to experience the illusion of sharing the girl's inner thoughts by subtly ensuring that these are verbalized in a form accessible to French readers. This implies a process of authorial modeling and control far removed from the spontaneous thought processes of a confused seven-year-old. Paradoxically, the very success of Belghoul's literary enterprise, reformulating the girl's resistance so as to make it intelligible to a majority French readership, seems to confirm that such resistance is ultimately doomed to failure. Significantly, the girl does not survive the trauma of the schoolmistress's demands. While attempting to return home after running away from school, she is knocked down and killed by a car apparently driven by the teacher. Although her counter-culture remains in one sense unbroken at the moment of her death, it is perhaps only by stopping the clock at that point that the author saves the girl from being "gobbled up" by France.

CONCLUSION

The narratives of Zemouri, Boukhedenna, and Belghoul are haunted by a nostalgic longing to protect or return to a pre-colonial or pre-migratory cultural condition free from the contaminating influences of France. As Hall (1989) has argued in

connection with the work of black British filmmakers, it is impossible to stop or turn back the clock in this way. International migration carries within itself a relentless dynamic of cultural change, leading to new formations that bear the indelible marks of hybridity. For all their monocultural nostalgia, the works of Boukhedenna and Belghoul are themselves profoundly hybrid in character. While relegated in many ways to the margins of French society, minorities of immigrant origin are deeply impregnated with cultural practices and aspirations derived from the majority population. Most second-generation Maghrebis are indeed more in tune with those aspirations than with projects of cultural purity or separatism. To the extent that they seek at the same time to assert a distinct identity, this can only be done by working in every sense at the margins. Forbidding to the external eye, the *bidonvilles* (shantytowns) where early migrants settled, like the *banlieues* in which today's minorities are concentrated, are crucibles of cultural exchange. They draw in practices from the dominant culture of the surrounding society and at the same time send out new elements derived from the migrant diaspora which are destined to become part of the French cultural space. While a radical transformation of that space appears unlikely, young Maghrebis are busy renewing it at least at the margins.

NOTES

1 Early post-colonial writers of Maghrebi origin include Kateb Yacine and Mouloud Mammeri; the newer generation is typified by Tahar Ben Jelloun and Leïla Sebbar. Some first-wave writers, such as Driss Chraïbi and Assia Djebar, now feature among the second, more nomadic tendency.

2 On the origins and problematic status of this term, see above, p. 20.

3 Narratives focusing on this childhood culture shock include those of Begag (1986) and Belghoul (1986).

4 Examples of novels dealing with such tensions are those of Begag (1989) and Kessas (1990).

5 For a fuller discussion of narrative viewpoints, see Hargreaves (1997: 88–115).

6 The relationship between these writers and their audience is discussed at greater length in Hargreaves (1997: 127–143).

7 This rejection of binary logic is explored more fully by Laronde (1993: 144–9).

8 Cf. above, p. 12.

9 Interview with Alec G. Hargreaves, April 21, 1988.

REFERENCES

Achour, Christiane (1990) "Ancrage, identité et dérision: L'humour dans le récit 'beur,'" in *L'Humour d'expression française,* Nice: Z'Editions, pp. 202–8.

Arriz Tamza, Maya [pseud., Messaoud Bousselmania] (1993) Quelque part en Barbarie, Paris: L'Harmattan.

Begag, Azouz (1986) Le Gone du Chaâba, Paris: Seuil.

——— (1989) Béni ou le paradis privé, Paris: Seuil.

Belghoul, Farida (1985) Interview with Gilles Horvilleur, Cinématographe, no. 112, July, pp. 18–19.

——— (1986) Georgette! Paris: Barrault.

Boukhedenna, Sakinna (1987) Journal : "Nationalité: immigré(e)," Paris: L'Harmattan.

Bouzid [pseud., Bouzid Kara] (1984) La marche: Traversée de la France profonde, Paris: Sindbad.

Charef, Mehdi (1983) Le thé au harem d'Archi Ahmed, Paris: Mercure de France.

——— (1989) Le Harki de Meriem, Paris: Mercure de France.

Deleuze, Gilles, and Félix Guattari, (1975) Kafka: Pour une littérature mineure, Paris: Minuit.

Delvaux, Martine (1995) "L'ironie du sort: Le tiers espace dans la littérature beure," French Review, vol. 68, no. 4, March, pp. 681–93.

Einaudi, Jean-Luc (1991) La Bataille de Paris, 17 octobre 1961, Paris: Seuil.

Hall, Stuart (1989) "New ethnicities," in Black Film, British Cinema, ICA Documents 7, London: Institute of Contemporary Arts.

Hargreaves, Alec G. (1993) "Figuring out their place: post-colonial writers of Algerian origin in France," Forum for Modern Language Studies, vol. 29, no. 4, October, pp. 335–45.

——— (1997) Immigration and Identity in Beur Fiction: Voices from the North African Immigrant Community in France, second, expanded edition, Oxford/New York: Berg (first edition 1991).

Imache, Tassadit (1989) Une fille sans histoire, Paris: Calmann-Lévy.

Kenzi, Mohammed (1984) La menthe sauvage, Lutry: Bouchain.

Kessas, Ferrudja (1990) Beur's Story, Paris: L'Harmattan.

Kettane, Nacer (1985) Le sourire de Brahim, Paris: Denoël.

Lallaoui, Mehdi (1986) Les Beurs de Seine, Paris: Arcantère.

Laronde, Michel (1993) Autour du roman beur: Immigration et identité, Paris: L'Harmattan.

Lionnet, Françoise, and Ronnie Scharfman, (eds) (1993) Yale French Studies, no. 82: "Post/colonial conditions: exiles, migrations and nomadisms."

Mehrez, Samia (1993) "Azouz Begag: Un di Zafas di Bidoufile (Azouz Begag: Un des enfants du bidonville)," in Lionnet and Scharfman, pp. 25-42.

Mounsi [pseud., Mohand Nafaa Mounsi] (1995) Territoire d'outre-ville, Paris: Stock.

Rosello, Mireille (1993) "The 'Beur nation': toward a theory of 'departenance,'" Research in African Literatures, vol. 24, no. 3, Autumn, pp. 13–24.

Tadjer, Akli (1984) Les ANI du "Tassili", Paris: Seuil.

Yacine, Jean-Luc (1995) Amghrar, la vérité voilée, Paris: L'Harmattan.

Zemouri, Kamal (1986) Le jardin de l'intrus, Algiers: Entreprise Nationale du Livre.

NORTH AFRICAN WOMEN AND THE IDEOLOGY OF MODERNIZATION

From *bidonvilles* to *cités de transit* and HLM

Mireille Rosello

INTRODUCTION

French *banlieues* have become a cultural cliché, a metaphor, a shortcut for a vaguely formulated yet deeply seated malaise.[1] Today, "*banlieues*" is often used in the plural, as if all *banlieues* were the same, and the word had lost most of its semantic territory. "*Banlieues*" now evokes one single type of urban landscape: dilapidated areas of social housing populated by a fantasized majority of "foreigners" and especially of "*Arabes*."[2] Those demonized *cités* are the symbolic crossroads where anti-Arab feelings crystallize around issues of housing: images of drug-ridden basements and of vandalized letter-boxes are often ethnically encoded. Gradually, amalgams permeate French culture, certain types of housing are equated with violence or even terrorism, and immigration is reduced to a gendered caricature: to the menacing silhouette of armed young male delinquents.

It was not always possible to treat issues of housing, gender and immigration as if they were inseparable. In a study of the so-called *seuil de tolérance* [threshold of tolerance], Neil MacMaster (1991: 18) points out that "prior to the 1960s, when immigrants were concentrated in the private housing sector, there may well have been populist anti-immigrant feelings at the local level, but on the whole these were not expressed around the issue of housing." As long as single male

workers had no choice but to fall prey to infamous *marchands de sommeil* [sleep-merchants], who demanded exorbitant rents for filthy rooms or shared garages and basements, right-wing discourses did not identify housing as an immigration-related issue.

Naturally, the ways in which cultural or racial others occupy space is always the object of much speculation and criticism: working classes, or the poor in general, have long borne the brunt of such discriminatory thinking. As François Maspero's narrator ironically reminds us in *Les passagers du Roissy-Express*, it was long assumed that attempts at modernizing working-class housing would be a waste of time: "à quoi bon, les ouvriers stock[ent] leur charbon dans la baignoire. Alors les Turcs, vous pensez" (Maspero 1990: 53–4) [the working classes still keep their coal in the bathtub – so you can imagine what the Turks are like (Maspero 1994: 37-8)].[3] Blacks and Arabs have now replaced Turks and (white) workers as the victims of silly cultural clichés. Widespread stereotypes portray the typical inhabitants of *cités-HLM* (low-rent social housing similar to US housing projects and British council estates) as uncivilized Muslims who actively refuse to "integrate" into French society: they slaughter sheep in the bathtub,[4] they are noisy, their cuisine smells,[5] and most recently, they are all suspected of being dangerous Islamist (i.e. Islamic fundamentalist) terrorists hoarding arms and ammunition.

However, Maghrebi women do not seem to satisfy basic sensationalist requirements; instead, they enjoy the ambiguous privilege of being consistently omitted from such stereotypical pictures, as if the fact that they are not caught by cameras hurling stones at buses or fighting with the police means that *banlieues* are good enough for them. And yet the very logic of stereotypical assumptions should make the media worry about the role played by women in *cités-HLM*. After all, even if we are completely ignorant of what constitutes a Berber, or Arab, or Beur,[6] or Muslim way of life, even when we do not tap old-fashioned orientalist myths, we usually know something about the fact that Maghrebi immigrants maintain a "strict spatial division of male and female spheres" (Geesey 1995: 142) and we would probably agree that "the interior of the home and its management is the domain of women" (ibid.: 143). Then why is the specificity of Maghrebi experience not more often interrogated by all the cultural, social and political agents who clamor for changes in the French *banlieues*? Maghrebi women are certainly never represented as the experts one should consult before implementing any change.

Their absence from the debate is all the more surprising as everyone seems to agree that their lives should change. The conviction that something must be done about the *banlieues* is shared by all constituencies: politicians, journalists, and

sociologists, as well as by the inhabitants of the housing projects. But this
consensus about the urgent necessity to address the issue of the *"banlieues"* is no
guarantee that changes will be synonymous with solutions or improvement for
those women whose voices we never hear. Until now, national and local policies
have regularly resulted in highly publicized "improvement projects," which have
just as regularly failed. Sometimes, "doing something" was constructed as a
mythically cathartic spectacle of destruction: the fear of social apocalypse *à la Los
Angeles* was exorcised by images of technologically controlled destruction.[7] This
type of change implicitly blames the architects of the post-war period and insists
on the past errors of urban developers but completely ignores the specific
problems of North African populations and the implications of anti-Arab feelings.
Other types of change, although they do take on board the cultural linkage
between housing and immigration, are even more undesirable and they
particularly affect women and children: their objective is to police the definition
of "normal housing" and to use prescriptive norms to exclude immigrants.
According to such interpretations, architects and planners were never guilty,
housing projects are acceptable, but the way in which immigrants occupy them
is not: Rosemary Scullion points out that we should not assume that the laws
governing family reunification are automatically humane or culturally informed.
The "Pasqua laws" of 1993 sneakily suggest, for example, that immigrants are
responsible for living in sub-standard housing. Quoting an analysis of the new laws
printed in *Le Monde*, Scullion notes that, at present, "immigrant workers wishing
to reunite with their families may do so only if they prove, if need be through
on-site inspections, that they meet the vaguely formulated requirement of
'hav[ing] at [their] disposal housing considered normal for a comparable family
living in France'" (Scullion 1995: 39). Scullion highlights the risks involved in
allowing bureaucrats to determine the "normalcy of their [i.e. immigrant
families'] living conditions" (ibid.). When will bureaucrats find the time to
question the vagueness of their mission, and what critical tools will middle-class
inspectors use to question the necessarily arbitrary and culturally relative
definition of "normal housing"? If housework remains a feminized activity, will the
responsibility of achieving "normal" housing conditions fall on immigrant
women's shoulders? Will inspectors automatically deny entry to families if they
intend to live in one of the *banlieues* constantly splashed over the front pages of
the press?

 The "Pasqua laws" are all the more ironic because HLM apartments were once
hailed as the long-awaited solution to another, just as scandalous, housing
situation: when the structure of migration shifted to permanent settlement and

families of North African immigrants were gradually reunited, shantytowns started sprawling in the middle of cities, or on their edges. At that point in history, too, North African women played a largely ignored role, but many of the women now living in *banlieues* still remember how they left their country of origin to join the rapidly growing population living in rat-infested, dangerously insalubrious "*bidonvilles*," as shantytowns were called. Until the late 1970s, thousands and thousands of mothers saw their young children grow up in the mud, carrying buckets of water between a pump and their shacks. Twenty years later, we have all but forgotten that for a whole generation of North African women the *trente glorieuses* [thirty roaring years of prosperity] did not mean much. Not only did they experience poverty in the midst of economic prosperity but they also had no say in the narrative of evolution, progress and assimilation that urban planners, architects and politicians designed and forced on them. And yet I can't help thinking that if those women had been able to contribute to the myth of modernization that underpinned the passage from *bidonvilles* to HLM, *banlieues* would be significantly different from what they are now. Unfortunately, when critics look back on that moment of transition, they soon realize that very few texts take the trouble to document it in all its complexity and ambiguity.

One work of fiction immediately comes to mind as an exception to the rule: Azouz Begag's *Le gone du Chaâba* (1986), the first of a series of more or less autobiographical novels, written by one of the best-known Beur writers, one who is also a sociologist.[8] As the author puts it in the title of one of his articles, his own trajectory took him out of the ghetto and into print.[9] Nonetheless, the female characters in his novels are no great advocates of myths of assimilation into the middle-class way of life, perhaps because their destiny is both parallel to and significantly less glamorous than his own: when Begag's fictional women leave the *bidonvilles*, they eventually end up in the kitchens of HLM apartments. Besides, Begag's texts present us with feminine characters who are not willing simply to forget the past as the bad old days and whose perception of change and evolution is a lot more sophisticated than linear, hegemonic narratives of integration and modernization.

MYTHS OF MODERNIZATION

When Emma, one of the heroines of *Le gone du Chaâba*, leaves the Chaâba (a *bidonville* located in the suburbs of Lyon) to move into a rented apartment close

to the city center from which the family will eventually move on to a *cité-HLM*, the novel presents us with a living picture of ambivalence: "Emma pleurait en souriant, le revers de son binouar [i.e. peignoir] entre les doigts" [Emma was crying and smiling at the same time, clutching the edge of her dressingowna between her fingers] (Begag 1986: 164). This moment in 1966, when the young hero Azouz, his siblings and his Algerian immigrant parents finally leave a *bidonville*, is unexpectedly described as an extremely tense and conflictual scene. At a practical level, the relocation means that the family will finally have access to the basic necessities: decent accommodation, electricity and running water. But what *Le gone du Chaâba* powerfully suggests is that, at a symbolic, social and emotional level, leaving the *bidonville* was not an unmitigated triumph and unambiguous liberation from poverty and deprivation. Emma's desperate smile and her hopeful tears remind us that the ideology of assimilation had specific implications for women. On the one hand, *bidonvilles* are the perfect counter-example to be offered to those who plead nostalgically for a return to the good old days. On the other hand, why was Emma crying in 1966? Or to put it differently, how can a fictional female character invite us to pay attention to the contradictions of current hegemonic narratives about *banlieues*, immigrants and ethnic minorities?

Le gone du Chaâba brings us back to a time when *cités-HLM* stood for upward mobility and social respectability, a form of success that remained out of reach for the stigmatized inhabitants of *bidonvilles*. For politicians, *bidonvilles* and *cités de transit* were a temporary solution. *Cités-HLM* were viewed as the most logical remedy to a clearly identified problem. They represented abstract progress and supposedly non-gendered social values (Bachmann and Basier 1989: 39). The construction of HLM was greeted with much enthusiasm. The ideological premises of architectural and urban projects were not open to debate and skeptics were systematically ignored. At the time, *cités-HLM* were seen as futuristic dreams and were not yet plagued with nightmarish visions and catastrophic predictions.

The untidy, muddy, and chaotic network of paths and alleys winding between the shacks of *bidonvilles* was indeed the opposite of those geometric *cités* advocated by the architect who dominated the discipline at the time, the unanimously admired Le Corbusier. Yet in a sense, the cluttered environment of the *bidonvilles* was at the same time a justification for Le Corbusier's visions and also evidence of something that recalls the social theorist Georges Bataille's *part maudite* [accursed share]: at that moment in history, *bidonvilles* embodied the repressed facet of a fantasy of generic purity that had somewhat sinister undertones. Looking back on Le Corbusier's rather condescending tirades against those lazy, ignorant

and blind contemporaries who might object to his ideas of progress, we may feel that what was frightening about his declarations was not so much the content of the myth as the tone of his declarations: for example, the cocksureness with which he sought to discredit some people's desire for their own *maison individuelle* [individual home] left no room for contradiction, doubt or cultural diversity.[10] Typical statements – such as "A bas les taudis, les rues étroites . . .; le logement moderne, c'est la santé, la lumière, la science et la raison" [Out with slums and narrow streets . . . ; modern housing means health, light, science and reason] (Bachmann and Basier 1989: 39) – were a recipe for disaster because they failed to distinguish between health as a fetishized desire to cleanse and organize society and the context-specific problems of immigrants living literally in mud for whom the implications of cleanliness were translatable in terms of intensive labor and painful physical exertion. The dream of modernization was written like a series of slogans; it sounded like propaganda. And yet, it is easy to see why no articulated critique of such projects had a chance of being taken seriously, as long as the only imagined alternative was the *bidonville*.

The attempt at repressing the *bidonville* as a whole was also a desire to cleanse the world of the type of ambiguity felt by people like Emma. This obsession with cleansing is precisely best analyzed and criticized through an exploration of the way in which imagined, symbolic and political purity differed from a practical, daily and often feminine-coded preoccupation with hygiene, and with the activity of cleaning. For two of the keywords of the new dream-world collective habitat were "hygiene" and "cleanliness," which were simplistically equated with health and happiness. The shame of living in a *bidonville* was literally and symbolically represented by the presence of mud and filth, and all autobiographical accounts document the constant quest for water and the long hours spent by children carrying buckets of water, which was the precious element that could never quite dissolve the shameful traces of life in a *bidonville*.[11]

Insofar as the myth of modernization, in the 1950s and 1960s, was inseparable from an idealized definition of cleanliness, it tended to make transparent the work involved in reaching that goal (Maspero 1990: 122). Just as *bidonvilles* were completely destroyed by bulldozers, the story of how women experienced the mandatory advent of modernization has not been recorded. The passage from shacks, mud and painful chores to kitchen cabinets made of Formica – the shiny, tasteless symbol of modernity – presents a literary challenge to post-colonial writers in France: unlike nineteenth-century novelists, they usually display an acute sensitivity to self-contradictory situations that do not lend themselves easily to traditional realistic or naturalistic techniques of narration. Begag's texts show

a deep suspicion towards pathos. The point is not to present Maghrebi women as pathetic figures eventually rescued by better and more modern times, but to analyze the moment of encounter, on the same territory, between *bidonvilles* and *cités radieuses* [cities of light]. If the story did not take place in France itself, on the outskirts of triumphantly proliferating *grands ensembles* [large-scale social housing projects], the complex negotiation between modernization and women's bodies would not produce such an ambivalent text. Here is the opening of the novel:

Zidouma fait une lessive ce matin. Elle s'est levée tôt pour occuper le seul point d'eau du bidonville: une pompe manuelle qui tire de l'eau potable du Rhône, l'bomba (la pompe). Dans le petit bassin de briques rouges que Berthier avait conçu pour arroser son jardin, elle tord, frotte et frappe sur le ciment de lourds draps gonflés d'eau.

Courbée à quatre-vingt-dix degrés, elle savonne avec son saboune d'Marsaille, puis actionne une fois, deux fois la pompe pour tirer de l'eau. Elle frotte à nouveau, rince, tire l'eau, essore le linge de ses deux bras musclés . . .

Zidouma is doing her washing this morning. She has got up early so that she can have the only water-point in the shantytown to herself. This is a manual pump drawing up water from the Rhône: the bumba (pump). By the little red-brick pool built by Berthier to water his garden, she wrings, scrubs and slaps heavy, water-soaked sheets against the cement.

Bending over at a right angle, she rubs her Marsailla soapa, then pulls the bumba handle a couple of times to get some water. She rubs again, pumps up some water, rinses and wrings out the washing with her muscular arms . . .

(Begag 1986: 7)

The passage starts as a detailed description that could very easily become pathetic. But the allusion to "bras musclés" [muscular arms] is a first indication that the author does not wish to tap one traditional type of French literary imagery found in Victor Hugo's *Les misérables*, for example. Clearly, Zidouma's body is neither frail nor unhealthy. Her strong arms are those of a fighter, not of a hapless victim. And as if the author wanted to confirm this impression immediately, the first portrait of Zidouma as washerwoman is followed by an unexpectedly comic depiction of a physical fight between all the women who have gathered at the "bumba" (which is their way of pronouncing the French word "pompe" [pump]). Strangely violent and ritualistic at the same time, the confrontation between the women makes it clear that they are quite capable of defending themselves against other enemies, if need be. The implicit warning that institutional violence may

not always be forgiven is part of another long literary tradition that now includes the first scene in *Le gone du Chaâba* as well as famous passages from Zola's novels.[12]

It is true that, at a diegetic level, the women of Begag's novel turn against themselves the violence that is being done to them, but textual elements of the description add an important element to the history of how women coped with *bidonvilles*: Begag's text shatters a nostalgic image of the *bidonville* as a happy family which now-dispersed inhabitants of the old shantytowns may harbor, but his text also paints a very ambiguous picture of what is desirable and undesirable. Zidouma is happy as well as unhappy, and the fight between the women is both a manifestation of violent conflicts between members of the *bidonville* and a demonstration of their courage and physical strength (i.e. they are not simply French society's victims).

Similarly, Begag makes the point that women's voices can be at the same time heard and rather summarily dismissed by those who will take claims seriously only if they are made in standard French. Zidouma's pronunciation is reproduced when the narrator describes the "saboune d'Marsaille" ("savon de Marseille" [Marseilla soapa]) and the imitation of mispronounced French words functions as an ambiguous form of homage or listening: on the one hand, it could definitely be argued that the text seeks to achieve a comic effect by making fun of the characters' hybrid French in places. On the other hand, Zidouma's voice is neither completely recuperated nor erased.

A conservative reading of the passage would argue that the unladylike fight can be perceived as a grotesque and burlesque struggle, and that Begag is playing into the hands of those who would argue that the inhabitants of the *bidonvilles* are uncivilized to begin with. The women's accent can make them the laughing stock of people who speak standard French. But the text implicitly challenges that reading, by turning the fight into a comic moment of intense verbal and physical energy, which refuses either to idealize life in the *bidonvilles* (Begag does not romanticize Zidouma's thoroughness and skillfulness), or to present the women as miserable waifs or hapless victims.

I suspect that one of the problems here is that women's liberation from painful chores is never the subject of heroic tales, because what puts an end to the epic battle against mud and filth is a form of *confort moderne* [modern comfort] that thinkers and artists who despised the pursuit of crass material gain were quick to mock and ridicule. At one end of the political spectrum, immigrants were considered too backward to properly enjoy the benefits of modernization; on the other hand, some discourses made fun of what modernization meant. Jacques

Tati's film *Mon oncle* (1958) belongs to a satirical tradition that could put the immigrants living in *bidonvilles* in a double-bind: in *Mon oncle*, the object of satire is not the HLM but the conventional middle-class dream of a detached house. Consequently, when Tati makes fun of the monstrous proliferation of modernization, he presents us with a nightmare that is already beyond the wildest dreams of Maghrebi women in the *bidonvilles*. Surely, his irony would be lost on women whose life changed when they discovered running water. For Tati's housewife, the dream verges on the nightmarish. But for the woman stuck in a *cité de transit* or later in an HLM, the nightmarish dream of Tati's films remains unattainable. Even much more modest aspirations could never be fulfilled, and had those women actually been able to imitate the bourgeois housewife caricatured in *Mon oncle*, their achievement would have fallen into the category of what is despised and deemed tasteless. The fact that "modern comfort" was so difficult to obtain in the first place made it impossible to wish for more than the bare necessities: a social and spiritual dimension to modernization. This is one of modernization's essential contradictions.

Tati's critique of modernization happens to coincide with the portrait of an affected and spiritually empty woman. The housewife in Tati's *Mon oncle* is both a slave to and a master of a monstrous cohort of dangerously autonomous and anthropomorphous kitchen appliances. She is so ridiculous that her own image of her success is disqualified in our eyes; no endearing female role model is available in her mechanized world. Only the uncle challenges the rationale of modernization, through his relentless, poetic and unrealistic refusal of any industrialized environment. However, in this context although Tati's critique is hilarious, it is also cruel because it makes fun of things that the women of the *bidonvilles* were not given a choice to refuse. It is not so much that they were stuck between modernization and squalor (the spatial metaphor would imply that their positioning was the problem); rather, they were the embodiment of modernization's contradictions. Whereas Tati seemingly conflates women and a love of modernization, Begag explores the gender implications of the different expectations of happiness constructed for (immigrant) men and women. In *Le gone du Chaâba*, the fault line of modernization's contradictions is overtly expressed as a conflict between genders: modernization becomes a challenge to the father's authority over the tightly knit community of the *bidonville*. In the novel, the community explodes because the women crave a change that Bouzid, the patriarch, despises and refuses.

AN AMBIVALENT TRANSITION

When Bouzid's family is about to leave the Chaâba to be relocated to the HLM, the only character who ferociously resists the move is the father. Because he had successfully recreated a community that gave him a position of authority, he perceives the Chaâba as a home from which evil forces wish to expel him, and he accuses his wife and children of being in cahoots with the enemy. The members of Bouzid's family are victims in scenes of domestic violence that materialize a moment of revolt against the inhumane choice that he must make: a departure from the *bidonville* would mean leaving a sort of home, but it is a necessary move for the woman who wants to have a proper kitchen in which to work. The distressful incompatibility between home and housing suggests the limits of a narrative of urban mobility, but the women have obviously made up their minds: there is no stopping them. This is a point in the novel where they are willing to transgress all the rules to have their own way and escape from the *bidonville*. And as is often the case, their resistance to an internal cultural logic is interpreted as a form of treason, a way of siding with assimilationist Western forces.

By showing the complex issues at stake in the decision to get out, Begag's fictionalization of the moment when the father refuses to leave the Chaâba shatters the pervasive stereotype that is used to accuse "ces gens-là" [those people] of choosing to live in the *bidonville*, i.e. in the dirt and the mud. *Le gone du Chaâba* suggests that the community of immigrants about to be relocated undergoes painful scissions and that the fault line operates within the constraints of gender-specific tasks. When a cousin who is already enjoying the "modern comfort" of an HLM tries to persuade Bouzid that he will greatly appreciate his new accommodation, the father replies:

— Alors, toi aussi, tu es comme eux. Tu ne penses pas qu'ici je suis chez moi, je ne dérange personne, je ne dois rien à personne. Je suis bien ici. Tu crois que je vais retrouver ça ailleurs?

Cette fois, mon père a pu placer son argumentation.

— C'est vrai, Bouzid, je mentirais si je disais le contraire, mais rends-toi compte que tu n'as rien ici, pas d'litriziti.

— Je la ferai mettre!

— Avec quel argent?

— J'en trouverai!

— Tu n'as même pas d'eau dans le robinet. Viens voir chez moi et tu comprendras ce que c'est de tourner un bouton, d'avoir de l'eau chaude. Le confort!

Les oreilles dressées telles des antennes télescopiques, les femmes écoutent, muettes.

– So you too are just like them. You don't understand that I feel at home here, I'm not disturbing anyone, I don't owe anyone anything. I'm fine here. Do you think it will be the same for me if we move?

This time, my father had gotten his point across.

– Yes, Bouzid, it's true. I can't deny it. But don't forget: you haven't got anything here, you've no ilicricitya.

– I'll get it put in!

– How could you afford it?

– I'll find the money!

– You haven't even got running water. Come home with me and see what it's like having hot water at the turn of a tap. That's comfort for you!

Their ears pricked up like telescopic antennae, the women listen in silence.

(Begag 1986: 157)

When Bouzid talks about feelings and relationships with others ("je *suis* chez moi, je ne *dérange* personne, je ne *dois* rien à personne. Je *suis* bien" [I *feel* at home here, I'm not *disturbing* anyone, I don't *owe* anyone anything. I'm *fine*]), his cousin describes his situation in terms of what he "has," instead of talking about what he is or how he feels. The cousin's keyword is the verb "to have," which forces a reluctant Bouzid into the realm of consumption, into the purchase of material objects and utilities. Bouzid "has nothing": neither running water nor electricity.

Common sense forces the reader to admit that the absence of running water can no longer be perceived as an acceptable difference and that Bouzid's family would benefit from electricity. Having said that, I am aware that common sense is not a very useful value when one is talking about encounters between cultures, since what is "common" is precisely being negotiated. Satirical discourses are healthy precisely when they remind us that sometimes "common sense" is the product of the latest ideological fad and that there is no direct correlation between social well-being and technology. So, in a sense, even common sense is not an adequate response to Bouzid's arguments: his reasons for staying are much stronger and convincing than his cousin's list of material benefits. If Bouzid claims "je suis bien ici" [I'm fine here], what can one say that would not be paternalistic?

But like most of our contemporary analyses of what must change in French *banlieues*, Bouzid's description leaves out an important part of the overall picture: his rational dialogue about what he has and who he is relegates all the women in the family to the background. Their disagreement cannot be voiced in the passage, but Begag's narration is careful to inscribe their silent disapproval. If the father's argument is unanswerable, so is the women's silent determination to leave the Chaâba. Their ears are comically compared to "antennes téléscopiques" [telescopic antennae] and in this way their bodies become instruments of communication;

they blend with technology, equipped as they are with antennae that presumably allow them to both emit and receive the gist of the cultural encounter. They bear witness to and participate in the divisions and conflicts that mark the transition from *bidonvilles* to HLM.

When Bouzid finally agrees to leave the *bidonville*, his wife connects with the objects of modernization. Yet although Begag had not thought it necessary to use pathos when representing the laundry scene and the fight between the women at the *bomba*, when the narrator describes the kind of admiration that Emma develops for the fridge, it is obvious that *confort moderne* involves a degree of dehumanized sentimentality. Emma becomes slightly ridiculous in her new kitchen. Her awe when confronted with modern technology in the home becomes a silly form of worship, not the emotional consequence of her previous state of deprivation:

Tous les matins, Emma fait du rangement dans son nouveau bart'mâ. On dirait qu'elle prend du plaisir à astiquer le sol carrelé, aussi lisse que les vitres des fenêtres. Pendant des heures, elle fait briller la table, les chaises et les blocs muraux en formica. Tous ces objets qui l'entourent la fascinent. Il suffit de l'observer caresser le frigo lorsqu'elle le nettoie. Elle craint de l'écorcher.

Every morning, Emma tidies up her new 'partmunt. She seems to enjoy polishing the floor until it's as smooth as the windowpanes. She spends hours putting a shine on the formica table, chairs and cupboard doors. She's fascinated by all the objects around her. Just look at how she caresses the fridge when she cleans it. She's afraid of scratching it.

(Begag 1986: 173)

Emma's attention to the fridge is both amusing and moving. We are obviously supposed to laugh at this woman's fussy regard for what is, after all, only a thing, an object, but the intensity of her feelings also commands our respect. The historical moment of the passage from the *bidonville* to the HLM is perhaps best recorded in such passages, because they encapsulate the ambivalence of the transition. While Bouzid's critique of modernization does not seem to provide an alternative dream, Emma's position embraces change without erasing all trace of the past. Bouzid's reaction is to turn institutional violence against himself and his family, and beat up Azouz whose daily refrain – "j'veux déménager, j'veux déménager" [I wanna move, I wanna move] (Begag 1986: 152) – undermines his authority. Emma and the narrator, as well as the author, could be seen as ridiculous and naive. Emma "caresses" the fridge in a gesture of tenderness that links the past and the present, and the caress may well be read as a rather pathetically materialistic gesture. Yet the overall logic of the text suggests that Emma's silent respect for the fridge is also powerfully meaningful because it represents an alternative reaction to the physical violence generated

by the conflict between Bouzid, who tries to act as a guardian of the past, and his family.

CONCLUSION

I am suggesting here that the construction of a fictional character such as Emma embodies the search for what Paul Gilroy calls "a changing same," which I interpret here to mean not only "the relationship between ethnic sameness and differentiation" (Gilroy 1993: xi), but also the articulation of the rapidly changing relationships within immigrant families, and between them and a quickly evolving "French" society. As Jean-Pierre Besombes-Vailhé (1993: 13) puts it:

Agissant comme un élément d'exclusion et/ou comme un moyen de socialisation, voire de promotion sociale, le logement et les pratiques urbaines jouent un rôle déterminant dans la relation qu'établissent les migrants avec la société d'accueil, et dans les interactions qu'ils [sic] développent au sein de leur groupe familial.

Serving as a factor of exclusion and/or socialization and in some cases of upwards social mobility, housing and urban experiences play a crucial role in shaping relations between migrants and the receiving society and patterns of interaction within migrant families.

Begag invents a female figure whose willingness to change is founded neither on a universalist or Western narrative of progress (narrowly conceived as upward social mobility) nor on some sort of ultra-relativism (all differences have to be embraced *qua* differences). Both universalist and relativist meta-narratives have been easily co-opted by distinctly racist discourses that are powerfully and unambiguously criticized by Emma's apparently ambiguous smiling tears: her tenderness for the new fridge implicitly critiques a universalist tolerance for "difference" resulting in *laissez-faire* policies based on the stereotypical assumption that immigrants are essentially or naturally destined to live in *bidonvilles*. But her tears also critique the ruthlessness of a discourse of urban mobility that the novel cleverly represents through its mirror image: when we close the book, it is clear that both the potentially violent and tyrannical demand for "normalcy" and the powerless father's brutality are two inseparable faces of some social Janus.

NOTES

1 In the body of the chapter I use the words *"bidonville"* [shantytown, ghetto], *"cité de transit"* [transition housing blocks] and *"cité"* [housing complex or project] without translating them, treating them as coinages and verbal commemorative monuments of a specific moment in French history. The *cité-HLM*, which stands for *cité d'habitations à loyer modéré* [low-rent housing complex or project] and is now often abbreviated as *cité*, became a familiar topos at the end of the 1950s, having displaced the earlier *HBM* (*habitations à bon marché* [low-rent homes]), which our cultural memory has not retained. The *cités de transit* were hastily built and extremely cheap rows of concrete boxes that were meant to accommodate the former inhabitants of the *bidonville* for a supposedly very short time while they were waiting for a proper apartment in an HLM. Part of the rhetoric of a 1971 government circular formulating this rationale was overtly racist. The idea was that families leaving the *bidonvilles* would be unable to adapt to modern accommodation and would therefore benefit from "une action socio-éducative s'exerçant au premier chef dans cet habitat provisoire" [socio-educational action conducted initially within this temporary housing] (Lallaoui 1993: 78). Some families were not rehoused for more than twenty years. By then, the *cités de transit* were falling apart and had become death traps for their inhabitants. As for *bidonvilles*, we still know what the word means; yet we sometimes forget that they did not disappear from the French landscape until the 1970s and we tend to look to the so-called Third World to conjure up a mental picture of crumbling shacks, vermin-infested passages and malnourished children.

2 For a discussion of this term's connotations in today's France, see above, pp. 18–20.

3 In *Les passagers du Roissy-Express*, François Maspero (1990) tells the story of a rather surrealistic trip through the Parisian *banlieues*. Accompanied by photographer Anaïk Frantz, he made a point of stopping overnight in each of the *banlieues* scattered along line B of the Paris RER (the urban rapid rail system), the unglamorous diagonal route that stretches from Roissy-Charles de Gaulle airport, 30 kilometers north of Paris, to Saint Rémy-les-Chevreuses, the southernmost tip of the line.

4 See, for example, Serge Meynard's film *L'oeil au beurre noir* (1987).

5 Cf. the June 1994 speech of Jacques Chirac, sympathizing with those who disliked the "noise and the smell" of immigrants (Guyotat 1994).

6 For an explanation of this term, see above, p. 20.

7 Starting in 1985, the highly publicized destruction of enormous high-rise buildings in famous *cités* – for example, in the Val-Fourré *cité* of Mantes-la-Jolie and in the 4000 de La Courneuve *cité* of Vénissieux – were also symbolic gestures. This is because by then *bidonvilles* had disappeared and it seems that *cités* had gradually replaced them as the object of respectable people's curious and frightened gaze (on this, see Lallaoui 1993). Maspero (1994: 157) also suggests that the destruction of high-rises at La Courneuve was orchestrated as a typically Bakhtinian moment of carnival: it both displaced and replaced the risk of social explosion with a moment of spectacle in which everyone was invited to participate, but only as passive observer:

And as there was a risk of social discontent boiling over, they decided to dynamite the biggest "wall," in Cité des 4000 Sud. . . . Scaffolding was specially erected to give the press and television crew a good view. Naturally, there were also large numbers of police and firemen. In this atmosphere of much rejoicing, the French people were able to follow the show on TV in amazement. The big "wall" needed only ten seconds to fall elegantly down. An on-site reception followed.

8 Published in 1986, *Le gone du Chaâba* was followed, in 1989, by *Béni ou le paradis privé*, a sequel of sorts, and more recently by *Les chiens aussi*, published in 1995. In the first page of *Les chiens aussi*, Begag mentions that he was a writer-in-residence in Nanterre when he wrote that novel. And I can't help wondering if the atypically violent, bleak tone of the novel is haunted by the uncommemorated presence of one of the largest *bidonvilles* around Paris. See Lallaoui's map (1993: 44), according to which 9,937 people still lived in the Nanterre *bidonville* in 1966.

9 See Begag (1988).

10 This emerged clearly from a recorded interview with Le Corbusier in a special issue of the program *La marche du siècle* entitled: "Banlieues, état d'urgence," presented by Jean-Marie Cavada on French TV in 1993.

11 See Benaïcha (1994).

12 See especially the passage in *Germinal* (Zola 1957: 350–1) where the women castrate the *épicier* and

also the fight at the washhouse in *L'assommoir* (Zola 1983: 36-40). I am grateful to Nelly Furman for suggesting that there is a sexual aspect to the washhouse scenes (wet blouses; women washing bedsheets). Doing the laundry in public would thus entail the appeal to voyeuristic tendencies that are frustrated when women use washing machines inside, in the privacy of their new apartments.

REFERENCES

Bachmann, Christian, and Luc Basier (1989) *Mise en images d'une banlieue ordinaire*, Paris: Syros.

Begag, Azouz (1986) *Le gone du Chaâba*, Paris: Seuil.

——— (1988) "Du bidonville à l'édition," *Hommes et migrations*, no. 1112, April–May, pp. 15–18.

——— (1989) *Béni ou le paradis privé*, Paris: Seuil.

——— (1995) *Les chiens aussi*, Paris: Seuil.

Benaïcha, Brahim (1994) *Vivre au paradis: D'une oasis à un bidonville*, Paris: Desclée de Brouwer.

Besombes-Vailhé, Jean-Pierre (1993) "Itinéraire urbain d'une famille algérienne," *Hommes et migrations*, no. 1169, October, pp. 13–18.

Geesey, Patricia (1995) "North African women immigrants in France: integration and change," in Lawrence D. Kritzman (ed.), *France's Identity Crises*, special issue of *SubStance*, nos 76–7, pp. 137–53.

Gilroy, Paul (1993) *The Black Atlantic*, Cambridge, MA / London: Harvard University Press.

Guyotat, Régis (1994) "M. Chirac: 'Il y a overdose,'" *Le Monde*, June 21.

Lallaoui, Medhi (1993) *Du bidonville aux HLM*, Paris: Syros.

MacMaster, Neil (1991) "The 'seuil de tolérance': the uses of a 'scientific' racist concept," in Maxim Silverman (ed.), *Race, Discourse and Power in France*, Aldershot, Hants.: Avebury, pp. 14–28.

Maspero, François (with photographs by Anaïk Frantz) (1990) *Les passagers du Roissy-Express*, Paris: Seuil.

——— (1994) *Roissy-Express: A Journey Through the Paris Suburbs*, trans. Paul Jones, London / New York: Verso.

Scullion, Rosemary (1995) "Vicious circles: immigration and national identity in twentieth-century France," in Lawrence D. Kritzman (ed.), *France's Identity Crises*, special issue of *SubStance*, nos 76–7, pp. 30–48.

Zola, Emile (1957) *Germinal*, Paris: Fasquelle (first edition 1885).

——— (1983) *L'assommoir*, Paris: Livre de poche (first edition 1877).

CULTURE, CITIZENSHIP, NATION

The narrative texts of Linda Lê[1]

Jack A. Yeager

"Citoyenne de la langue française"

Citizen of the French language[2]

INTRODUCTION: A VIETNAMESE LITERATURE IN FRENCH

With no new texts having appeared for some fifteen years, I concluded in the mid-1980s that the moment of Vietnamese literature in French had passed (Yeager 1987). The literary voices that had sprung directly from the colonial period in South-East Asia had fallen silent, following the gradual dismantling of the French educational system after the official end of the French colonial period in 1954 and with a new emphasis on Vietnamese institutions, culture, and language (Bandon 1979; Nguyen Tran Huan 1975). Established francophone writers such as Pham Van Ky, Cung Giu Nguyen, Tran Van Tung, and Ly Thu Ho continued to produce but their work did not find its way into print.[3] Publishers and editors, influenced perhaps by their assessments of the market, chose not to print and disseminate the work of these novelists. Simultaneous with my conclusion, however, a new group of Vietnamese who write in French began to emerge, justifying Thuong

Vuong-Riddick's (1978: 152) prediction of a "new effervescence" of Vietnamese literature in French. The resettlement of Vietnamese nationals in France, Quebec, Belgium, and Switzerland in the 1970s – a second wave of overseas immigration triggered by the reunification of Viet Nam – provoked these new voices to present fresh perspectives in extended narratives from the Vietnamese diaspora. Works by Kim Lefèvre, Bach Mai, Nguyen Huu Khoa, and Linda Lê go beyond the central themes of their literary ancestors. In many ways, they strike out in entirely new directions, challenging categories and traditions that defined literature in French from Viet Nam. Bach Mai's and Kim Lefèvre's works signal the appearance of a new Eurasian voice in French. Nguyen Huu Khoa's novels invent a distant Asian past, challenging earlier narratives tied so consciously to colonialism and the violent struggles for independence. Linda Lê sets herself apart by eliminating all but vague references to historical events. These relatively recent narratives, like their predecessors, are written in the language of the (former) colonizers; however, the new, post-colonial authors' relationship to their language of literary expression may be conceived in terms of a strongly made claim on "linguistic citizenship" within French, to use the bold expression attributed to Linda Lê (Hage 1995).

It is true that much of this new work by writers born in Viet Nam recalls in some ways Vietnamese literary traditions of writing in French, a literature emerging from the trauma of over a hundred years of colonialism and war in South-East Asia. Older narratives were often first-person, quasi-autobiographical novels centering on education ("traditional" or "modern") and on adolescence, the future and the choices it held. The presentation and explanation of Vietnamese culture identified these novels as destined for a French readership. The links to colonialism, war, and the tragedy of a people often manifested themselves as a family history in which women played important roles dramatizing the cultural and social upheaval of traditional society (for an extended analysis of this body of fiction, see Yeager 1987).

These traits distinguished a production in which Vietnamese and French traditions collided and blended. All the texts implicitly raised questions about the use of the French language and the cultural imprint of France. Choosing to write in prose in Viet Nam meant turning one's back on a deep cultural heritage that defined literature solely in terms of poetry. These novels carried within them constant reminders of their origins: writing in the language of the colonizer; rejection of one's native traditions, culture, and language; betrayal of a homeland.

THE CHALLENGE OF LINDA LÊ:
IDENTITY AND FICTION

In a move that extends these previous rejections, Linda Lê, a writer born in Viet Nam, said in a conversation in Paris (1992b) and reaffirmed at a lecture in Boston (1995e) that she does not consider herself a Vietnamese francophone writer. The astonishing originality of her writing captures the imagination for its clear challenges to the work of her compatriots who also wrote in French and for her resistance to being categorized with them.

A "post-colonial" writer, born of Vietnamese parents in Dalat in 1963, nine years after the official end of the French colonial period, Lê has lived in France since her arrival there at age fourteen. She studied in a *lycée* [French high school], received her *baccalauréat* [high school diploma], then pursued university-level studies, eventually working on a doctoral thesis in French literature. Finally, she turned from writing about Amiel, the nineteenth-century francophone Swiss writer, to the creation of her own literary texts. Described as a "survivor of the Viet Nam war,"[4] Lê was also said to feel "French" and "Western" by a journalist who interviewed her in the late 1980s.[5]

Let us consider *Un si tendre vampire* [Such a Tender Vampire], Lê's first novel (1987).[6] A photograph (Matzneff 1987) taken at the time her novel appeared locates her in relation to this tradition: draped across an armchair in blue jeans with her hands clasped around her knee in a pose vaguely reminiscent of Balthus, Lê stares directly and even defiantly into the camera lens, thus announcing a major departure from the formally dressed portraits of her literary ancestors. The photograph and *Un si tendre vampire* are distancing gestures and indicate her resistance to writing what one had come to expect from Vietnamese writers in French. In the text, Lê suppresses all references to Viet Nam and the Vietnamese experience so prevalent in earlier French-language Vietnamese texts. Gone are the Vietnamese child educated in French schools, life as a foreigner in France (or feeling like a foreigner in Viet Nam), the struggles for independence, and explanations of Vietnamese culture which in other texts point to an implied reader who is clearly French.

In *Un si tendre vampire*, Lê problematizes the relationship between post-colonial author and mainstream French reader in two related ways. By casting her main characters as ethnic majority French, she keeps her writing from being immediately pigeonholed as yet another novelized ethnological description of Vietnamese experience. In a conversation in Paris Lê (1990) said that she had deliberately waited until her second novel to cast a Vietnamese character,

confirming my suspicions that the general suppression of Vietnamese references had been deliberate in her novel.[7] Moreover, Lê thematizes her entry into authorship as literary theft. Louis, the "vampire" of the title, succeeds in convincing Philippe, an aspiring novelist, to surrender his completed manuscript so that Louis might have it published under his own name. In this way, Philippe loses the status of a genuine writer: he becomes Louis's "nègre" [ghostwriter] (Lê 1987: 89).[8] The exploited "nègre imbécile" (93) thereby loses his identity and his soul, recalling the exploitative dynamics of colonialism itself and setting up the post-colonial problematic that Lê has continued to explore in her subsequent writings.

In her second novel, *Fuir* [To Flee] (1988), Lê examines questions of post-colonial exile and alienation in a somewhat less allusive way. Although the unnamed narrator is never identified in the novel as Vietnamese, he was referred to by Lê as "le Vietnamien" [the Vietnamese man] in an interview (Mermoud 1988: 60), and his story leads the reader to identify Viet Nam as his homeland. In *Fuir*, he tells his tale of degradation, recounting his life and flight from Viet Nam as a flashback. Now he is cut off from traditional collectivities: "Rien à moi, ni patrie ni famille" [I have nothing, neither homeland nor family] (Lê 1988: 148–9).

After a foray into the short story (*Solo* 1989) and a subsequent three-year silence, Lê published her most experimental text to date, *Les évangiles du crime* [The Gospels of Crime] (1992a). Vinh L., the title character of the last of its four interrelated novellas, escapes from "[l]e pays" [the country] (190) – never named – by boat across the sea. With the passengers dying of hunger, Vinh becomes the executioner of one of them, whose body will serve to feed the others. Vinh L.'s story is enclosed by that of a narrator-writer who exploits the crimes/texts of others, such as Vinh, to find topics about which to write. His crime is obviously that of plagiarism (falseness, "simulacra"), but he also recognizes Vinh as his double: "Mon livre, pour exister, avait mangé d'autres livres. Vinh L., pour survivre, avait mangé de la chair humaine. En ouvrant mon livre. . . il s'était vu" [In order to exist, my book had devoured other books. In order to survive, Vinh L. had eaten human flesh. Upon opening my book, he had seen himself] (Lê 1992a: 176–7). The Vinh-narrator pair here recalls *Un si tendre vampire*'s Louis and Philippe, Lê's first examples of textual appropriation or literary cannibalism. This necessary promethean gesture – stealing the language and the texts, or eating the body of the other in order to survive – suggests the hybrid nature of Lê's texts, and reveals the transgressive nature of the act of writing for Lê, a post-colonial author writing in French for the French (as I argue at greater length below).[9]

Lê continued her radical interrogation of national, ethnic, and authorial identities in *Calomnies* (1993). The text is set in motion when the first narrator, a double exile (in France and in an asylum), receives a letter from his niece, the second narrator, who requests information from him about her father. Her mother had revealed that her husband, a character we assume to be Vietnamese, is not the narrator's real father, and that he had claimed her at birth, knowing that she was really the child of his wife's love affair with a foreign soldier.[10]

Calomnies appears to be Lê's most autobiographical novel to date, though indications are vague and imprecise; it is up to the reader to assemble the clues that seem to point to Lê herself.[11] The niece is a writer of Asian origin living in Paris, an "écrivain originaire des anciennes colonies" [writer from the former colonies] (1993: 37). Her unnamed country of birth was taken over by "[l]es hommes en noir" [the men in black] (57) after years of war. Subsequent to this radical shift of power, people began to escape by sea aboard fragile boats (43). The niece is a naturalized "immigrée modèle" [model immigrant] (71) and carries the family name of her Asian father and the "international first name" given to her by the foreign lover of her mother (165–6).

This circumstantial evidence seems to add up to Viet Nam and perhaps the writer herself, but at the same time suggests a deception, if only through the title of the text. Clearly, "calomnie" [slander] refers not only to the libelous stories one might tell about others — those that the family tells about the uncle in order to have him exiled and committed, or the one that the mother tells her daughter to make her question her own paternity — but also includes the arrangements one makes with oneself. Lê seems both to force and to prevent an autobiographical reading of her novel. This concurrent creation and destruction exemplifies the paradoxical position in which she finds herself: compelled to invent a new, composite identity, but with materials that bear the stigmata of the colonial past.

In *Calomnies*, the attempt to reclaim a stolen identity first appears to lie in an originary quest. The niece is seeking her personal history, and thus her true identity, from the uncle, who is the family "historian." He is suspicious of her motives for wanting to rewrite her past (65) and reinvent her genealogy (20). Yet at the end of *Calomnies*, he sends her a notebook which, we can only surmise, answers her questions. He then commits ritualized suicide in the library where he works: a lighted cigarette ignites the books he has arranged around himself. His suicidal act will destroy the past, the patrimony. The niece receives the package from her uncle but refuses to read it, leaves her apartment and neighborhood, and has the last word in the novel: "*Je m'en vais*" [I am leaving] (181).[12] The novel's conclusion avoids the facile illusion of a fixed family/ethnic/national identity that

the notebook would have provided to the narrator by revealing her true paternal lineage.

WRITING IN FRENCH BETWEEN WORLDS

The problematic of language lies at the heart of all colonial and post-colonial narrative texts in French. Not surprisingly, then, the language issue surfaces in Lê's work, sometimes very explicitly as in *Calomnies*. Both uncle and niece have the French language (and books) in common; she has, in fact, written to him in French. He has learned it in the asylum, "parmi les fous" [among the mad] (9) in order to communicate with the nurses. By contrast, the niece (like Lê herself) has received formal education in French (67). Both have learned French for what they perceive to be more legitimate reasons than their relatives, who learned French only for its snob appeal (80), to serve those in power (56).[13]

The niece tries to deploy her new language to free herself. The uncle writes that, for her, French has become the only means of communication, but also a weapon that she aims at her own family and country (though the latter is never named in the novel): "Elle est métèque écrivant en français" [She's an interloper who writes in French] (12). If rejecting the language means rejecting the family, it also goes against culture, country, the past, and the ancestors. This rejection does not come without its costs. The uncle and niece sense that they do not fit in anywhere. The niece questions her heritage, encapsulated in her two fathers, and wonders if her mother is not trying to drive her mad through a questioning of her identity and filiation (34). The uncle and niece live in exile, on the margins: in an asylum (the uncle) or as a psychological nomad (the niece).

The words of a song quoted by the niece suggest that she is condemned to live out her life as a foreigner: "*Je suis un étranger ici, / Je suis un étranger partout, / Je rentrerais bien à la maison, mais / Je suis un étranger là-bas*" [I'm a foreigner here / I'm a foreigner everywhere / I would like to go home / But I'm a foreigner there too] (32). In a passage that resounds with the overtones of the novel's title, the uncle demonstrates the impossibility of getting at a single truth in his correcting the portrait of his sister's lover, the alleged father of his niece. The mother's discourse alternates with the uncle's commentary (46–7): for example, she calls her lover a man of pride and courage while the uncle undercuts the bravery with sarcasm and irony. The attractiveness of re-inventing one's personal history and changing identities, the uncle points out, could lead the niece to forget the

essential, to deceive herself into believing her new father was anything but a murderer (55). The uncle will thus prevent her ignoring the only truth as he perceives it: they are both essentially homeless ("de Nulle Part" [from Nowhere]: 173).

Their drama resonates with other familial pairings in Lê's writing and reveals the trope of filiation as a leitmotif in her texts: mothers and daughters in *Un si tendre vampire* (1987) and *Calomnies* (1993); fathers and daughters in *Fuir* (1988) and *Calomnies*; the "foreign" father and daughter in the latter. In *Les dits d'un idiot* (1995a) Lê presents a mother–son relationship through the symbols and language of rootedness ("racines" [roots]: 15, 203; "terre" [earth]: 15, 73: "patrimoine" [patrimony]: 70, 72), contamination and disguise (the mother's fake English accent: 15, and her pretensions: 33–4, 73), and uprooting (the symbolism of a mandrake that is pulled up by its roots: 15, 203; the wheelchair-bound narrator's useless legs: 21–2, passim). In Viet Nam, Confucianism and the cult of the ancestors emphasize deep roots, groundedness, familial blood lines, and long histories. Thus, uprootedness has serious repercussions, leading to the rantings of this text, and madness caused by the deracination of a human-shaped mandrake. A rootless presence in France destabilizes national identities, whether Vietnamese or French, which are based on inclusion and exclusion. The post-colonial writer, whose "importune" texts lay claim to their place on the French literary landscape and challenge the very definitions of what it means to be French, may thereby represent the demands of post-colonial populations in France.

The dilemmas of being between cultures and of not belonging are familiar themes in colonial and post-colonial literatures. Le Huu Khoa aptly poses the question: "Les Vietnamiens en France: Une Population *en* France ou *de* France" [The Vietnamese in France: A population *in* France or *of* France] (Le Huu Khoa 1985: 9; his emphasis).[14] Studies of Vietnamese immigrant communities in France (Bousquet 1991; Le Huu Khoa 1985; McConnell 1989; Simon 1981; Simon-Barouh 1981) confirm the sense of never being able to belong, of the same problematic of assimilation and exile that is expressed in the post-colonial literary texts analyzed here.

This tension provided the driving force behind several decades of narrative literature in French by Vietnamese writers. Likewise, at a colloquium at New York University in 1995, Lê (1995d) spoke of feeling like a foreigner in France as well as in Viet Nam on her first return there since leaving in the late 1970s. In a lecture the following week (Lê 1995e) she expressed the guilt and betrayal of a writer who rejects her heritage. In *Calomnies* (1993), the cultural conflict and resultant emotions create a desire to rewrite history and genealogy.

However, Lê reinforces and complicates this predicament of being caught in the middle through the use of sexual ambiguity and homosexual characters, examples of what Marjorie Garber (1992: 11–13, 203, 213, 223, 239) calls the "third term" that disturbs and destabilizes neat binaries and exposes a category crisis. The double and the related theme of boundary-crossing surface throughout *Un si tendre vampire* (1987) in characters who see each other in their masculine and feminine counterparts.[15] In an interview, Lê admitted her interest in androgyny, "pour [son] double masculin . . . J'écris pour l'homme qui est dans chaque femme et pour la femme qui est dans chaque homme, si vous voulez. C'est au livre de choisir ses lecteurs" [for her masculine double . . . I write for the man in every woman and for the woman in every man if you will. It's up to the book to choose its readers] (Maury 1987: 31).

The strong but undeveloped hints of sexual liaison between Louis and Philippe in *Un si tendre vampire* (1987) become the actual casting of a gay character, Vinh, in *Fuir* (1988). Nowhere is this sexual ambiguity more apparent, however, than in her collection of stories entitled *Les évangiles du crime* (1992a). In this text Lê takes special care to highlight areas that escape articulation, through sexual ambiguity (cross-dressing) and taboo (homosexuality and incest). According to the witnesses in "Le Professeur T.," the second section of the book, it is clear that the professor's son has a boyfriend, described as a perverse angel with blond hair (73) who tells an investigator about the sado-masochistic tastes of the son (77). The Professor refuses to confront reality despite the fact that the son and his friend make a great deal of noise while having sex in the middle of the night in the bedroom just next door (78). Between son and mother, both pushed away by the father/husband, the investigator suggests incest (73–4). In the last "évangile," Vinh and his accomplice on the boat become inseparable in their criminal association (their joint act of cannibalism). Later in France, Vinh sees him again in a pagoda, where he has become a monk: "J'eus l'impression de retrouver une jeune maîtresse," says Vinh. "Il était mon complice; mon amant criminel, ma mauvaise conscience" [I had the impression of having found a young mistress. He was my accomplice, my criminal lover, my bad conscience] (185).

Vietnamese writers of earlier generations who wrote in French implicitly expressed the hope of fitting in, whereas Lê's texts convey a desire to remain at the margins. In *Calomnies* (1993), the niece's editor Ricin advises: "Reste seule. Reste métèque. Cultive les marges" [Stay alone. Remain an interloper. Cultivate the margins] (33). Following this advice, the niece admires her uncle, who is mad but free of attachments (87). Nevertheless, the niece ultimately refuses to follow her uncle's model. The uncle writes that, given the choice of his example and her mother's, she

prevented herself from following either one (128–9). The niece resists straight-forward assimilation into any socially or politically defined category.

The desire to cultivate border zones is captured in the ambiguity of the two fathers: "A l'orgueil d'être une métèque écrivant dans une langue qui n'est pas la sienne, elle veut ajouter le soupçon de la bâtardise, cette semi-certitude d'être une sang-mêlée" [To the pride of being an interloper who writes in a language not her own, she wants to add the suspicion of being a bastard, the semi-certainty of being of mixed blood] (127). She intends to remain undefinable, different, alone. The niece's gesture of escape – from her past and from her editor – at the close of *Calomnies* indicates her choice to remain at the margins. What results is a blurring of borders and confounding of categories. Against the foundation of Western rational thought, Lê returns to the poetic. Phrases in *Calomnies* such as "terrain vague" [waste land] (148), "le demi-jour dans lequel tout est permis" [the half-light in which all is allowed] (129) and "brouiller les frontières" [blurring frontiers] (83) take on special weight.

What, then, is the reaction to a heterodox voice such as Lê's raised within the space of France? First, those who have faith in the precision and clarity of the French language would realize that writers such as Lê pose a strong challenge to its ability to classify, compartmentalize, and identify according to national or ethnic criteria. Several generations of Vietnamese writers, schooled in the colony and abroad, have attempted to make their place in a French literary tradition. They did not surrender their heritage, but instead retained their own traditions by making a place within their writing for indigenous philosophical outlooks, and by emphasizing the importance of Vietnamese culture and history, even though their autobiographical and/or realist narratives and attention to classical style appeared non-threatening.

The ambivalence of previous generations manifested itself in ways perceived as more acceptable by readers and critics. Lê has transformed this ambivalence into a willingness to shock and scandalize. Her early novels achieved this goal in their subject matter; however, esthetically and linguistically, *Un si tendre vampire* (1987) and *Fuir* (1988) show the same respect for French narrative traditions as the texts of many Vietnamese francophone writers before her.[16] Later, more experimental work, especially beginning with *Les évangiles du crime* (1992a), demonstrates what Lê terms a "littérature déplacée" [displaced literature], which is clearly written from an exilic position. The desire to create scandal and excess comes from being caught in a web of incompleteness and mourning for the loss of a language and culture, which exists alongside the partial acquisition of new ones (Lê 1995e; see also 1995d).

Yet the self-proclaimed traitor to her roots no longer feels guilty, but experiences a pride in her betrayal. Like the niece in *Calomnies* (1993), she will break all ties and reside in "la cité des mots" [the community of words]. Here again, the writer can stand in awe of the long French linguistic and literary tradition, or act as the insubordinate detractor (Lê 1995e), "messing up the parents' bedroom" (Lê 1995c). Lê chooses both to adore and detract, by cultivating the liminal space between the acceptable and the inadmissable, exposing the limits of language while blurring borders. In her own description, *Les dits d'un idiot* [The Sayings of An Idiot] (Lê 1995a) is both "prière et imprécation" [prayer and curse] (Lê 1995d), and a ironic "mélopée" [chant] (Lê 1995e). In this way, Lê simultaneously confirms and contests the authority of the French language by experimenting amidst a long and respected tradition of literary esthetics. She claims equal linguistic citizenship and challenges the power and authority of the language simultaneously.

Where, then, does Lê fit? She is a writer born in Viet Nam who lived there for fourteen years, was educated in French schools, and now lives in Paris, and writes and publishes in France. Bookstores in Paris alternately classify her on the shelves devoted to French writers (FNAC) or with Vietnamese francophones (Sudestasie). The colloquium in 1995 at New York University announced her as part of "A New Generation of *French* Women Novelists" (emphasis added). Yet, listeners were clearly disturbed by her reading from *Les dits d'un idiot* (1995a), whose anger, disdain, and tinges of grief made the audience visibly uncomfortable. Questions put to her afterward centered on the inaccessibility of her literary world, the excess that prevented entry into it, and the abnormal and normal. For these listeners, her voice seemed to resemble the legendary scream of a mandrake pulled from the ground (as in *Les dits d'un idiot*). In that same forum Lê stated how she had first approached the French language with respect and intimidation in the face of its authority, writing at first out of submission to it. She now disowns her first two novels – despite their controversial subject matter – perhaps because of their conventional narrative structure and straightforward technique. The move away from an emulative esthetics of composition and style becomes clear when one reads her books in chronological order. In the last, she claims to have found her authentic voice, first raised in *Les évangiles du crime* (1992a).

Lê's claim to be a citizen of French furthers her goal of contesting the authority of the language. Hers is not the same linguistic community defined by Senghor in terms of *francophonie* and *francité*, as French language and civilization (Senghor 1968, 1975). Today, the concept of citizenship usually implies a nation-state with clearly defined boundaries. Yet nationality, language and culture are never neatly

limited, for minority voices exist within them and often spill over and reach beyond political frontiers. Lê thus forces a redefinition of political entities such as France and its notions of territoriality and national identity, which are under cultural siege at the end of the twentieth century. In Lê's case, her political citizenship in France was assured through a mother naturalized as a French citizen. In this case, immigration to France was simultaneously a refugee's flight and repatriation. This undermines calls in France for linguistic and cultural purity. Claims for a monocultural French identity are illustrated perfectly in *Les dits d'un idiot*'s metaphor of the museum as a fortress where French high culture is a patrimony that is guarded against intruders (Lê 1995a: 72). Who, indeed, has the right to be French? Or Québécois (Yeager 1992)? Or American?

Lê creates her place within the French language, claims her rights within this linguistic community, and thus redefines what it means to be French, to speak French, and to write in French. Lê carves out a linguistic space, appropriates and reinvents language and the French novel, makes a linguistic and literary field in French her own state and nation and declares herself its citizen. Writing from this invented space she creates a homeland.

NOTES

1 I presented parts of this study as convention papers at meetings of the Conseil International d'Etudes Francophones (CIEF) (1990, 1993) and the North East Modern Language Association (NEMLA) (1994). My gratitude, as always, to Timothy Cook.

2 Madeleine Hage (1995) attributed these words to Linda Lê in introducing the writer at a colloquium on new French women novelists held at New York University in November 1995. Sylvie Genevoix (1994) puts forward a similar idea in describing Lê's literary journey, stating that the francophone Romanian writer Emile-Marcel Cioran had claimed the French language as his "patrie" [homeland] before her. Cioran's reflections have in turn been cited by Lê (e.g. 1995d, 1995e).

3 Some of these writers have seen their previous work reissued in the past decade (for details, see Yeager 1996b).

4 Blanc (1987) introduces Lê in this way in her review of *Un si tendre vampire*. She cites Lê frequently in her review, giving the impression that the writer describes herself as such.

5 See the brief review of *Un si tendre vampire* in *Lu* (1987); the exact quote in the introductory remarks is: "Ayant fait toutes ses études au lycée français, elle se sent tout à fait de culture française et occidentale" [Having completed all of her studies in a French high school, she feels completely French and Western]. In *Le Figaro littéraire*, Patrick Besson (1987) described Lê as "une parfaite Occidentale" [a perfect Westerner] but mistakenly calls this novel "l'un des premiers romans qui soient nés en France de la diaspora vietnamienne" [one of the first novels to come out of the Vietnamese diaspora]. For more biographical information, see Genevoix (1994), Guichard (1995), and Lê (1995b, 1995c).

6 Reviews of this and all Lê's other works of fiction that are analyzed in this chapter are on file with her publishers.

7 In 1995, she restated this idea to journalist Thierry Guichard: "Je ne voulais surtout pas que la part

autobiographique puisse apparaître" [Above all I did not want the autobiographical part to appear] (Lê 1995b: 6).

8 The French word "nègre" has as its primary meaning "negro"; connotations of exploitation associated historically with the slave trade are drawn on in a secondary meaning, "ghostwriter."

9 Lê has been routinely reviewed in such Paris papers as *Le Monde* and *Libération* since the appearance of her first novel in 1987. In 1993 she was dubbed the "dernière idole des lycéens des années 90" [the latest idol of '90s high-school students] (S.B. 1993).

10 This is not the only one of Lê's texts where filiation is examined through a father–daughter relationship. In her collection of short stories entitled *Solo* (1989), Lê presents the solitude of her title, what she described to me as an "exil intérieur" [interior exile] (1990) in the figure of a father, abandoned, alone and forgotten by his daughter who is in turn haunted by his absence and isolated far from her native land.

11 Esther Allen's English translation of *Calomnies* was published under the title *Slander* by the University of Nebraska Press in 1996.

12 The gesture of escape recalls that of Mô in Cung Giu Nguyen's *Le fils de la baleine* (1978; first edition 1956).

13 The family denigrates the Asian father as a peasant, "cet inculte qui ignorait le français" [that uneducated man who knew no French] (54).

14 In speaking of second-generation Vietnamese in France, Le Huu Khoa (1985: 93) describes his interviewees as feeling neither Vietnamese nor French, but outsiders. He also draws the distinction between the immigrant who chooses to leave in the hope of making a better life in the host country and the refugee, in exile, who is politically forced to leave home and must give up everything (69). Bousquet (1991: 4) distinguishes between the immigrant, settling in France before 1975, and the refugee, arriving after reunification. According to this schema, Linda Lê would be a refugee.

15 Elsewhere (Yeager 1996a), I have analyzed how the *métisse* is made double in Kim Lefèvre's *Métisse blanche* through the blurring of autobiography/fiction and the narrative interruptions of sexual ambiguity.

16 Lê has said as much (1995d).

REFERENCES

Bandon, Pierre (1979) "Situation du français dans les trois états d'Indochine," in Albert Valdmann (ed.), *Le français hors de France*, Paris: Champion, pp. 663–85.

Besson, Patrick (1987) "Les victimes éblouies de Linda Lê," *Le Figaro littéraire*, February 16.

Blanc, Pierrette (1987) "Tendre vampire," *Le Matin*, March 21.

Bousquet, Gisèle L. (1991) *Behind the Bamboo Hedge: The Impact of Homeland Politics in the Parisian Vietnamese Community*, Ann Arbor, MI: University of Michigan Press.

Cung Giu Nguyen (1978) *Le fils de la baleine*, Sherbrooke,Quebec: Naaman (first edition 1956).

Garber, Marjorie (1992) *Vested Interests: Cross-Dressing and Cultural Anxiety*, London/New York: Routledge.

Genevoix, Sylvie (1994) "Linda Lê: Exigeante et solitaire," *Page des libraires*, no. 30, September–October: 32–3.

Guichard, Thierry (1995) "Le 'Famille je vous hais!' de Linda Lê," *Le matricule des anges*, no. 13, August–October: 4–5.

Hage, Madeleine (1995) "Introduction to Linda Lê," "A New Generation of French Women Novelists" Colloquium, New York University, New York, November 3–4.

Le Huu Khoa (1985) *Les Vietnamiens en France: Insertion et identité. Le processus d'immigration depuis la colonisation jusqu'à l'implantation des réfugiés*, preface by George Condominas, Paris: CIEM/L'Harmattan.

Lê, Linda (1987) *Un si tendre vampire*, Paris: La Table Ronde.

——— (1988) *Fuir*, Paris: La Table Ronde.

——— (1989) *Solo*, Paris: La Table Ronde.

——— (1990) Conversation with Linda Lê, Paris, August 3.

——— (1992a) *Les évangiles du crime*, Paris: Julliard.

———— (1992b) Conversation with Linda Lê, Paris, March 19.

———— (1993) *Calomnies*, Paris: Christian Bourgois.

———— (1995a) *Les dits d'un idiot*, Paris: Christian Bourgois.

———— (1995b) "Linda Lê: 'Tout doit être sacrifié pour l'écriture,'" interview with Thierry Guichard, *Le matricule des anges*, no. 13, August–October: 6–7.

———— (1995c) "Interview" with Nicolas de Mecquenem, *Virgin Megapresse*, no. 6, October–November, pp. 38–9.

———— (1995d) Responses to questions, "A New Generation of French Women Novelists" Colloquium, New York University, New York, November 3–4.

———— (1995e) "La littérature déplacée," public lecture, Pine Manor College, Boston, November 7.

———— (1995f) Conversations with Linda Lê, Boston, November 7–8.

Lu (1987) Review of *Un si tendre vampire* by Linda Lê, February.

McConnell, Scott (1989) *Leftward Journey: The Education of Vietnamese Students in France, 1919–39*, New Brunswick, NJ/Oxford: Transaction Books.

Matzneff, Gabriel (1987) "Etudiante, Linda Lê publie un premier roman: Mention bien," *Le Figaro Magazine*, March 28.

Maury, Pierre (1987) "Elles sont femmes, elles écrivent . . . Comment? Sur quoi? Pour qui?" *Le Soir*, March 26.

Mermoud, Laurence (1988) "Conte de la cruauté extraordinaire," *L'Hebdo*, July 7, p. 60.

Nguyen Tran Huan (1975) "Difficultés de l'écrivain francophone au Vietnam actuel," *Culture française*, vol. 24, nos 3–4, pp. 77–8.

S.B. (1993) "C'est l'époque," *L'Express*, December 16.

Senghor, Léopold Sédar (1968) "La francophonie comme culture," *Etudes littéraires*, vol. 1, no. 1, pp. 131–40.

———— (1975) "Pour un humanisme de la francophonie," *Revue des deux mondes*, no. 2, February, pp. 276–84.

Simon, Pierre-Jean (1981) *Rapatriés d'Indochine: Un village franco-indochinois en Bourbonnais*, Paris: L'Harmattan.

Simon-Barouh, Ida (1981) *Rapatriés d'Indochine: Deuxième génération. Les enfants d'origine indochinoise à Noyant-d'Allier*, Paris: L'Harmattan.

Thuong Vuong-Riddick (1978) "Le drame de l'occidentalisation dans quelques romans de Pham Van Ky," *Présence francophone*, no. 16, Spring, pp. 141–52.

Yeager, Jack A. (1987) *The Vietnamese Novel in French: A Literary Response to Colonialism*, Hanover, NH/London: University Press of New England.

———— (1992) "Bach Mai's francophone Eurasian voice: remapping margin and center," *Québec Studies*, no. 14, Spring–Summer, pp. 49–64.

———— (1996a) "Blurring the lines in Vietnamese fiction in French: Kim Lefèvre's *Métisse blanche*," in Mary Jean Green *et al.* (eds), *Post Colonial Subjects: Francophone Women Writers*, Minneapolis, MN: University of Minnesota Press, pp. 210–26.

———— (1996b) *Vietnamese Literature in French*, New Orleans, LA: CELFAN Review Monographs.

INDEX